CURA AQUARUM IN CAMPANIA

D1718010

This international congress was held October 1-8th, 1994 at Pompeii and was organized by the Department of Classical Archaeology of the University of Nijmegen.

BABESCH

BULLETIN ANTIEKE BESCHAVING

Annual Papers on Classical Archaeology

Supplement 4 — 1996

STICHTING BULLETIN ANTIEKE BESCHAVING

CURA AQUARUM IN CAMPANIA

Proceedings of the Ninth International Congress
on the History of Water Management and Hydraulic
Engineering in the Mediterranean Region

Beiträge des neunten internationalen Symposiums zur
Geschichte der Wasserwirtschaft und des
Wasserbaus im Mediterranen Raum

Pompeii, 1-8 October 1994

edited by

NATHALIE DE HAAN & GEMMA C.M. JANSEN

Leiden
Stichting BABESCH
1996

Photo cover: Castellum aquae Pompeii
Ir. R. Kragting 1994

ISBN 90-6831-844-6
ISSN 0165-9367
D. 1996/0602/68

CONTENTS

Preface

Nathalie de Haan
Gemma C.M. Jansen

The symposium Cura Aquarum in Campania was the ninth in a series of international symposia on the history of water management and hydraulic engineering in the Mediterranean region. The symposia have been organised every 2 or 3 years since 1975. The aim of the meetings is to stimulate an interdisciplinary debate about water supply in antiquity. The participation of archaeologists, historians, civil engineers, hydraulic engineers, town planners and geologists ensures a regular exchange of the latest findings and insights in the different disciplines.

This was the first time the water supply of ancient Pompeii and its surroundings was made the main theme of a symposium. Although water supply systems inside a city have nowhere been as well preserved as at Pompeii, a great deal has as yet not been researched and remains unknown. A large number of the papers and 3 workshops were concerned with Pompeii, and it was especially the discussions about the *castellum aquae* and the water towers that provided much that was new.
Excursions to water supply installations in Campania illustrated the problems and solutions dealt with in the papers. In addition, there were visits – at the invitation of the Azienda Municipalizzata Acquedotto di Napoli (AMAN) and the Acquedotto Campano at Sarno – to the modern waterworks, which today use the same springs as in ancient times. We are grateful to Mr. U. Potenza of AMAN for making these visits possible.

The symposium was held under the aegis of the Department of Classical Archaeology of the University of Nijmegen this time. The organisation was in the hands of Gerda de Kleijn, Susanna Piras and the two editors these proceedings. They were supported by Prof. J.A.K.E. de Waele, Head of the Department, whose stimulating enthusiasm was indispensable. Special thanks are due to Prof. H. Fahlbusch (Fachhochschule Lübeck), who shared his experience from the previous symposia with us and assisted us in every possible way.
We would like to acknowledge the assistance of the Soprintendenza di Pompei and the Soprintendenza di Napoli as well as the Dutch Institute in Rome in the organisation of the workshops and excursions.
Without the financial support of the University of Nijmegen, the Stichting Utopa, the Frontinus-Gesellschaft, and the Dr. Wilhelm Mommertz Stiftung it would have been impossible to organise this symposium. We are very grateful for the invaluable help.
We would also like to thank Mr. T. Steupert and Ms. A.O. Koloski-Ostrow for their help in correcting the papers that were not written in the native language of the authors. Finally, we want to thank the Board of the Stichting Bulletin Antieke Beschaving for their willingness to publish the papers as Supplement 4 of *BABesch*.

A symposium should not only inform but also suggest new directions and research goals. Ideally it should even function as the first impulse to collaboration and new projects. We hope that the publication of these papers will contribute to the aim.

Vorwort

Nathalie de Haan
Gemma C.M. Jansen

Das Symposium *Cura Aquarum in Campania* war das neunte in einer Reihe von internationalen Symposien zur Geschichte der Wasserwirtschaft und des Wasserbaus im Mediterranen Raum. Seit 1975 werden diese Symposien alle 2 bis 3 Jahre irgendwo im Mediterraneum veranstaltet. Ziel dieser Tagungen ist, die Debatte über antike Wasserversorgung anzuregen, und zwar in einem interdisziplinären Rahmen. Archäologen, Historiker, Zivilingenieure, Wasserbauer, Städtepläner und Geologen beteiligen sich, und damit ist ein regelmäßiger Austausch der neuesten Kenntnisse aus den verschiedenen Disziplinen gewährleistet.

Es war das erste Mal, daß die Wasserversorgung des antiken Pompeji und seiner Umgebung zum Thema einer Tagung gemacht wurde. Obwohl die Systeme der Wasserversorgung innerhalb einer Stadt nirgendwo so gut erhalten sind wie in Pompeji, ist vieles kaum erforscht und noch ungeklärt. Viele der Vorlesungen und 3 Workshops vor Ort bezogen sich auf Pompeji, wobei namentlich die Diskussionen über das Funktionieren des *castellum aquae* und der Wassertürme viel Neues gebracht haben.

Exkursionen zu kampanischen Wasserversorgungsanlagen illustrierten die in Vorlesungen vorgeführten Probleme, Lücken und Lösungen. Außerdem wurden auf Einladung der Azienda Municipalizzata Acquedotto di Napoli (AMAN) und Acquedotto Campano in Sarno die modernen Wasserwerke besucht, die heutzutage noch dieselben Quellen benutzen wie in der Antike. Wir danken Herrn Ing. U. Potenza der AMAN, der diesen Besuch ermöglicht hat.

Die Organisation wurde diesmal von der Abteilung Klassischer Archäologie der Katholieke Universiteit Nijmegen übernommen. Die Ausführung war in Händen von Gerda de Kleijn, Susanna Piras und der beiden Redaktoren dieser Akten. Der anregende Enthusiasmus von Prof.Dr. J.A.K.E. de Waele, Haupt dieser Abteilung, war dabei unentbehrlich. Besonderer Dank gebührt Herrn Prof.Dr.-Ing. H. Fahlbusch (Fachhochschule Lübeck), der uns bei der Veranstaltung mit seiner Erfahrung der vorangehenden Symposien mit Rat und Tat zur Seite stand.

Die Mitarbeit der Soprintendenza di Pompei und der Soprintendenza di Napoli war sehr wichtig für die Realisierung der Workshops und Exkursionen, ebenso wie die praktische Unterstützung hierbei vom Niederländischen Institut in Rom.

Ohne die finanzielle Unterstützung der Katholieke Universiteit Nijmegen, der Stichting Utopa, der Frontinus-Gesellschaft, und der Dr. Wilhelm Mommertz Stiftung, wäre die Veranstaltung dieser Tagung unmöglich gewesen. Wir danken allen für die sehr geschätzte Hilfe.

Wir sind Herrn Dipl.-Ing. T. Steupert und Frau Ass.-Prof. A.O. Koloski-Ostrow dankbar für Hilfe bei der sprachlichen Korrektur jener Beiträge, die nicht in der Muttersprache der Autoren verfaßt sind. Schließlich danken wir dem Vorstand der Stichting Bulletin Antieke Beschaving für die Bereitschaft, die Beiträge des Symposiums als 4. Supplement von *BABesch* herauszugeben.

Ein Symposium soll nicht nur berichten, sondern auch neue Richtungen und Forschungsziele bieten, idealiter sogar ein Anstoß zu neuen Projekten und Zusammenarbeit sein. Wir hoffen, daß auch diese Veröffentlichung dazu einen Beitrag leistet.

Wasserwirtschaft in Pompeji

Liselotte Eschebach

Im ersten Teil dieses Beitrages wird die Versorgung mit Trink- und Brauchwasser auf dem Stadthügel der antiken Stadt Pompeji geschildert, und zwar in der Zeitspanne vom 6. Jh. v.Chr. bis 79 n.Chr.[1] Als Basis meiner Ausführungen benutzte ich die in unserer gemeinsamen Arbeit seit 1965 gewonnenen Erkenntnisse, die mein 1982 verstorbener Ehemann Hans Eschebach im Jahre 1977 bei einer Tagung über römische Wasserversorgungsanlagen in Lyon vorgetragen hat. Es folgten Publikationen über Thermen (1975, 1977, 1979a, 1991) und Laufbrunnen (1982, 1983), sowie über die Wasserwirtschaft Pompejis innerhalb des seit 1978 geplanten zweibändigen Gesamtwerkes über städtebauliche Erkenntnisse, das ich in zwei Ausgaben 1993 und 1995 publizieren konnte.

Anfallende Probleme der Abwasserbeseitigung und Kanalisation wurden ebenfalls beobachtet, und ich werde hier auch diese Ergebnisse und Hypothesen nach dem Themenbereich 'Wasserversorgung' zur Diskussion stellen.

TIEFBRUNNEN

Der Grundwasserspiegel Pompejis lag unter dem Stadthügel von Pompeji zwischen 37 und 20 m tief (in Nord-Südrichtung).[2] Bisher wurden 22 der archaischen Tiefbrunnen im ausgegrabenen Stadtareal festgestellt. Das geförderte Wasser roch schwefelig und war als Trinkwasser kaum genießbar.[3] Vom 3. Jh. v.Chr. ab wurden einige Tiefbrunnen zu Gewerbezwecken mit Wasserhebewerken versehen,[4] als Trinkwasser wurde gespeichertes Regenwasser genutzt.

SAMNITISCH-SULLANISCHE WASSERLEITUNG

Wann eine erste gemeindliche Wasserversorgung eingeführt wurde, ist bisher nicht geklärt *(Abb. 1)*.[5] Sie bot vermutlich keine ausreichende Deckung des Bedarfs, und man war - besonders in der heißen Jahreszeit - weiterhin auf Zisternen und Tiefbrunnen angewiesen. Murano[6] vermutete z.B. die Funktion einer

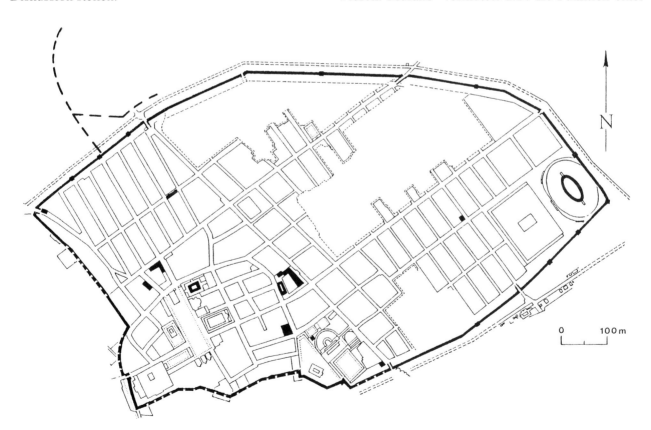

1. Pompeji, Straßenplan mit Eintragung der gesicherten und vermuteten Indizien für die samnitisch/sullanische Wasserversorgung.

1

2. Stabianer Thermen, Westflügel: sullanisch-republikanische Wasserarmaturen im Atrium eines früh-augusteisch beerdigten Hauses.

außerhalb stellen Rohrfragmente dar, die Maiuri[7] unter dem Merkurturm fand. Mit diesen korrespondieren im Bereich der antiken Stadt ein in über 1,5 m Tiefe unter dem Bürgersteig des Vicolo di Mercurio sichtbares Leitungsnetz, die sullanischen Wasserspeicher am Vico delle Terme (mit Resten eines Tonrohres) und am Großen Theater sowie der Hochbehälter auf den Stabianer Thermen (dort wurde ebenfalls ein Tonrohr im darunter liegenden Raum gefunden). Man könnte in diesen Zusammenhang auch die Tonrohre der samnitischen Thermen in der Insula VIII 5 einbeziehen, die erst bei Einführung der augusteischen Fernwasserleitung abgerissen und von augusteischen Privathäusern überbaut worden sind. Unter dem Westflügel der Stabianer Thermen ist eine *domus* beerdigt, die in der Mitte des 1. Jhs. v. Chr. eine Springbrunnenarmatur besaß *(Abb. 2)*. Deren (Blei-)Leitungen sind in 1,5 m Tiefe unter dem Bürgersteig des Vico del Lupanare gekappt. Zwei Laufbrunnen aus Tuff stehen vor der Porta di Stabia und an der Via di Nocera (von einem dritten Brunnen wurde nahe der Porta di Ercolano nur der Tuff-Pilaster mit der Protome des Vertumnus gefunden). Die Pilaster unterscheiden sich in Bezug auf Material und Gestaltung erheblich von denen der kaiserzeitlichen Lava- und Kalksteinbrunnen.[8] Da Laufbrunnen ohne Wasser-

samnitisch/sullanischen Wasserleitung, die später mit einem Abzweig aus der Serinoleitung vereinigt wurde. Indizien für eine frühere Wasserversorgung von

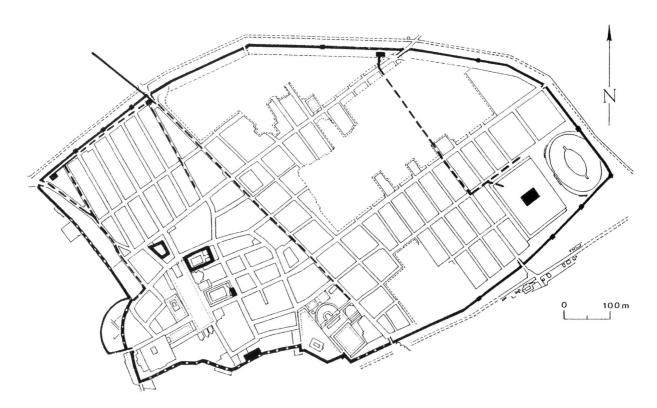

3. Pompeji, Straßenplan mit Eintragung der gesicherten und vermuteten Indizien für die augusteische Wasserversorgung.

zuleitung nicht denkbar sind, muß man hier das frühe Leitungssystem voraussetzen.

Vermutlich wurden zuerst Quellen aus dem Vesuvgebiet ausgebeutet.[9] Herculaneum erhält z.Zt. noch Wasser aus einer Vesuv-Quelle ('Acque San Ciro'). Die 'Fonte Salutare' in Pompeji und die 'Terme Nunziante' und 'Minerva' in Torre Annunziata wurden modern durch Vesuvquellen gespeist, diese versiegten jedoch nach dem Erdbeben von 1980. Beide Orte erhalten seitdem nur Wasser vom Sarno. Die 'Sorgente Sarno' liegt 40 m ü.NN, kam also in der Antike für die Versorgung der pompejanischen Leitung (höchster Punkt 43 m ü.NN) nicht in Betracht. Die 'Sorgente Pedosi-Acquaro' (Serino-Leitung) entspringt 96 km entfernt 370 m ü.NN, wurde aber erst in frühaugusteischer Zeit erschlossen.

DIE AUGUSTEISCHE WASSERLEITUNG

Seit etwa 35 v.Chr. versorgte die 96 km lange Fernwasserleitung kampanische Städte und vermutlich auch Pompeji mit Quellwasser aus den Avelliner Bergen (Abb. 3). Einen Anhalt für diese Datierung bieten Material und Bautechnik des Wasserschlosses, das im Osten an die Porta del Vesuvio angelehnt und mit der Rückseite in den *agger* der Stadtmauer eingelassen ist.[10] Sein Deckengewölbe wurde nach der Verschüttung durchschlagen, um Armaturen und andere wertvolle Metallteile zu entnehmen.[11] Der Sockel des Gebäudes besteht aus Lavamonolithen und wies 79 n.Chr. drei Öffnungen zum Austritt von Bleirohren auf, die das Wasser mit Gefälle in die Stadt leiteten. Der Zulaufkanal kam leicht schiefwinkelig von Nordwesten an die Stadtmauer heran, das Wasser passierte ein Sperrgitter und floß durch den Verteiler. Der Vorplatz, auf dem der Vicolo dei Vettii und die Via del Vesuvio vor dem Stadttor zusammentreffen, wurde über den Rohrbetten mit Lavapolygonen gepflastert und durch Prellsteine geschützt.[12]

Einen gleichzeitig erbauten Nebenverteiler haben wir in der Casa delle Vestali (VI 1, 6-8.24-26) erkannt (Abb. 4).[13] Dieser wurde in der letzten Bauphase des Privathauses in das Peristyl einbezogen, das den inneren Pomerialbereich der Stadtmauer überbaute. Der Innenraum gleicht einem Wasserreservoir, er hat einen viereckigen Grundriß und abgekurvte Ecken mit Wasserkehlen, Wände und Fußboden sind mit *opus signinum* verputzt. Dahinter lag ein unverputzter, niedriger und unbeleuchteter Tunnel, der unter dem *agger* der Stadtmauer nach Osten führte. Die Besitzer des erweiterten Privathauses haben den ersten Abschnitt abgetrennt und durch Zwischenwände gegliedert. Ursprünglich führte dieser Tunnel im rechten Winkel auf den Einlaufkanal des Wasserschlosses an

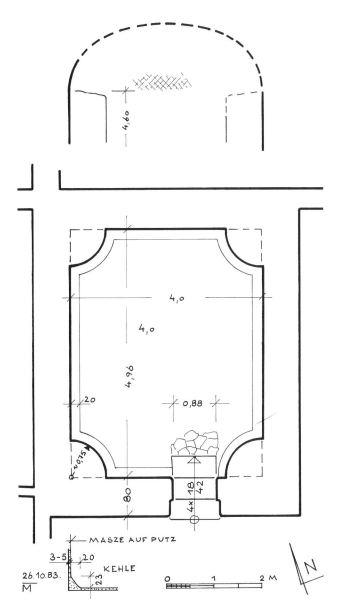

4. Grundriß und Schnitt des antik aufgegebenen augusteischen Nebenverteilers in der Casa delle Vestali (J. Müller-Trollius nach Aufmaßen H. Eschebachs).

der Porta del Vesuvio zu, wo er etwa 3 m vor dessen Mündung im Verteilerbecken antik abgemauert wurde.[14] Die Konstruktionen der beiden bisher bekannten 'Wasserschlösser' stimmen überein: Grundrißform und Größe sind etwa gleich. Sie waren beide in den *agger* der Stadtmauer eingebaut, Teile des Mauerwerks bestehen aus *opus reticulatum* in Noceratuff mit Ecken aus Tuffelli. Beide Innenräume sind was-

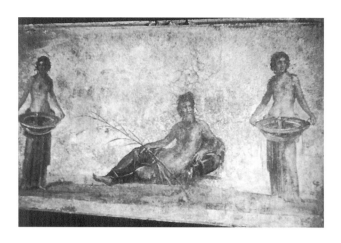

5. Wandbild an der an den Nebenverteiler direkt angrenzenden Nordwand der Exedra (Louvre, Paris).

6. Reste der Malerei im Hauptverteiler am Vesuvtor.

serdicht verputzt und haben eine Wasserkehle. Malereien 4. Stils wiesen die Wasserbauten als Quellheiligtümer aus. Sie stellten eine lagernde Wassergottheit *(Fons?)* mit Nymphen dar *(Abb. 5 und 6).*[15] Beim Umbau wurde im Nebenverteiler der Casa delle Vestali eine Türöffnung eingebrochen *(Abb. 7).* Das Wandbild befand sich laut Ausgrabungsbericht im späteren *oecus (exedra) - 'sacellum'* mit Nischen - des neugestalteten Peristyls, an der südlichen Außenseite des Tunnels. Zu dessen Fortsetzung nach Osten führte 1818 ein Fuchs seine Jäger durch die Reste des *agger* nördlich der Insula VI 2, was zweimal in den Grabungsberichten Fiorellis ausdrücklich betont wird.[16] Von etwa 35 v.Chr. bis spätestens 62 n.Chr. dürfte man von hier aus die ausreichende Versorgung der westlichen Stadtteile voraussetzen, doch sollte man für den Osten einen zweiten Nebenverteiler (in der noch ausgegrabenen Regio IV) annehmen, der ebenfalls seine Funktion einbüßte.[17] Ungefähr 3 m vor der nördlichen Stadtmauer zweigte im Bereich des ersten Revisionsschachtes ein (antik zugemauerter) Kanal vom Einlaufkanal nach Osten ab *(Abb. 8 und Beitrag Ohligs in diesen Akten Abb. 2).*[18] Größe und Bearbeitung beider Kanäle entsprechen sich. Der Ostkanal knickt vorerst leicht nach Nordosten ab, denn er mußte die Ausfallstraße vor dem Vesuvtor unterqueren, und trat wieder in den *agger* der Stadtmauer ein.

Diese frühaugusteische Anlage versorgte das westliche Stadtgebiet (mit einem Hauptrohr) über den Wasserturm neben dem Tiefbrunnen vor VI 1, 19 bis zu den Suburbanen Thermen; das Wasserschloß an der Porta Vesuvio war (mit 2 Rohren) für den mittleren Stadtbereich zuständig, eine Leitung für den östlichen Teil der Stadt mag in Nord-Süd-Richtung Via di Nocera verlaufen sein.

Das dreigeteilte Einlaufbecken der Anlage am pompejanischen Vesuvtor weist Spuren mehrerer Umarbeitungen und Putzschichten auf.

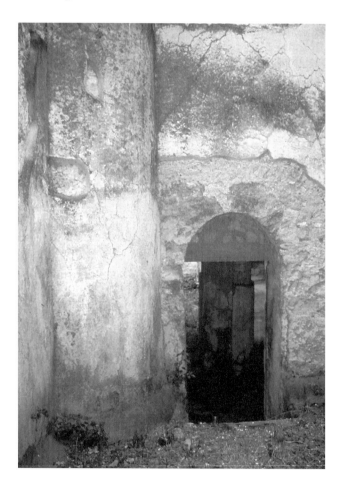

7. Südostecke des Innenraums im westlichen Nebenverteiler mit nachträglich eingebrochener Tür (C. Ohlig).

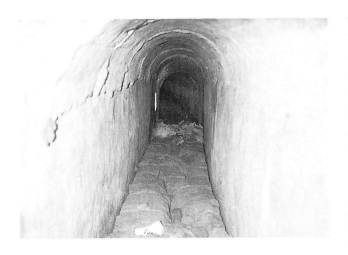

8. *Blick in den Seitenkanal nach O, im Hintergrund knickt er leicht ab und ist mit Lapilli gefüllt. Der Boden besteht aus eingetrockneten und rissigen Alluvionsmassen (C. Ohlig).*

Strömungsversuche C. Ohligs haben ergeben, daß man in der letzten Periode durch technische Umstellungen (unter Zuhilfenahme der Vesuvquelle) die Wasserverteilung in Pompeji auch auf ein einziges Bauwerk mit drei Austrittsrohren beschränken konnte *(Abb. 9).* Man fand Fragmente von Hauptrohren im Vicolo dei Vettii und im westlichen Bürgersteig der Via del Vesuvio/Via di Stabia.[19] Maiuri bezog diese Rohrkanäle auf die beiden äußeren Auslauföffnungen im Wasserschloß. Ich gehe davon aus, daß ein drittes Rohr unter dem östlichen Bürgersteig der Via di Stabia verlief, wo jedenfalls direkt an der Kreuzung der Via di Stabia mit der Via dell'Abbondanza ein Wasserpfeiler mit Brunnen steht *(Abb. 10).*[20] Die neuen Hauptleitungen nach Osten sind in den südlichen Bürgersteigen der Via di Nola (Rohrleitungen, ein Wasserpfeiler mit starken Sinterspuren) und der Via dell'Abbondanza (Rohrleitungen, drei Wasserpfeiler) festgestellt worden. Beide Leitungsrohre zur Via del Vesuvio benutzten vermutlich unter dem Vorplatz des Wasserschlosses dasselbe Rohrbett.

Das Gesamtareal Pompejis umfaßte nach Vander-Poel[21] innerhalb der Stadtmauern etwa 66 ha (660.000 m²), wovon auf das Gebiet westlich des Cardo ca. 30,6 ha, auf den östlichen Teil 35,4 ha entfallen. Die erforderlichen Förderungsmengen mußten dementsprechend anders gestaffelt werden als bisher angenommen, und zwar mengenmäßig von Osten nach Westen. Parallel dazu habe ich überschlägig die Anzahl der bisher ermittelten stark wasserführenden Betriebe (Tuch-und Wollindustrie, Leinenindustrie, Gerbereien, Wäschereien, Färbereien, Bäckereien) sowie der Eßlokale *(cauponae, popinae* und *thermopolia)*

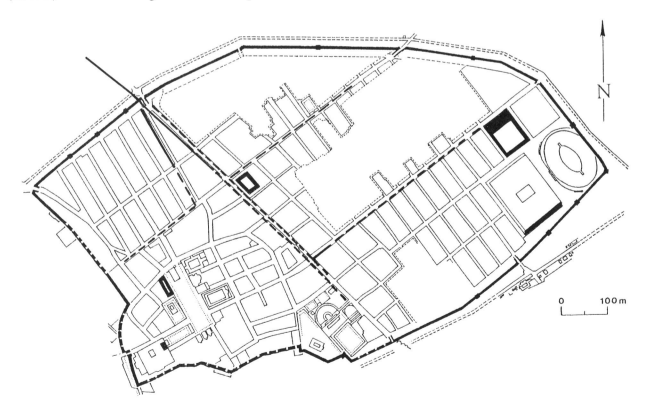

9. *Pompeji, Straßenplan mit Eintragung der gesicherten und vermuteten Indizien für die Wasserversorgung nach der 2. Hälfte des 1. Jhs. n.Chr.*

10. Wasserpfeiler und Brunnen an der Nordwestecke der Insula I IV, am östlichen Bürgersteig der Via Stabiana (G. Jansen).

berechnet, die von den drei Verteilersystemen abhingen, zuzüglich der öffentlichen Gebäude, die einen starken Wasserverbrauch hatten (Thermen, Palästren, Theater, Amphitheater, Macellum).

Der Teil der Stadt, der östlich des Cardo Via di Stabia - Via del Vesuvio bisher zu etwa 49% ausgegraben wurde, ist etwa um 4,8 ha größer als der fast völlig freigelegte Westteil. Er wird also eine angemessen größere Wassermenge benötigt haben: Bis jetzt fand man hier 29 Betriebe und 127 Eßlokale. Wenn man für die noch nicht ausgegrabenen 51% (wegen der vielen Gartenflächen) auch nur die halbe Anzahl annimmt, ergeben sich immerhin 44 Betriebe und 190 Eßlokale. Dazu gehören die Bewässerung der Obst-, Gemüse- und Weinplantagen, die Große Palästra mit *natatio,* das Bad der Julia Felix (II 4, 2-12), das Amphitheater und die im Bau befindlichen Zentralthermen. Einen etwas geringeren Wasserbedarf hatte die Stadtmitte (100% freigelegt) mit 44 Betrieben, 51 Gaststätten, 2 Thermen, sowie 3 Palästren, 2 Theatern und dem östlichen Forumsbezirk mit Macellum. Die Versorgung durch die Westleitung (das westliche Stadtgebiet ist etwa zu 97% ausgegraben) mußte für 22 Betriebe und 83 Gaststätten reichen.

Angeschlossen waren vermutlich die Forumsthermen sowie die Suburbanen Thermen. Es wurde auch festgestellt, daß man kurz vor der Verschüttung geplant hat, das veraltete sullanische Wasserreservoir am Vico delle Terme wieder in Betrieb zu nehmen, es zu entleeren, zu reinigen und an das nach 62 n.Chr. notdürftig zusammengeflickte Leitungsnetz der Stadt anzuschließen. Große Bronzearmaturen zum Füllen und Reinigen sind *in situ* erhalten (Verteilerrohr und Ablauf).[22]

Beachtenswert ist die Verteilung der bisher mindestens 15 (sichtbaren) Wasserpfeiler und 2 Ehrenbögen mit Bassins in der Attika und Einlassungen für Steigrohr und Verteilerarmaturen im bisher zu 3/5 ausgegrabenen Stadtgebiet. Sie wurden der jeweiligen Höhenlage angepaßt: Auf quadratischen bis zu 6 m hohen Pfeilern saßen offene Bleibassins.[23] Einige der 39 oder 40 bisher ermittelten öffentlichen Laufbrunnen[24] stehen an Straßenkreuzungen, oft in Verbindung mit Wasserpfeilern und Straßenheiligtümern.[25] Darunter waren mindestens drei Trinkbrunnen (Pilasterbrunnen ohne Becken). An der Kreuzung des *decumanus minor* (Via delle Terme) mit der Nordsüdachse der Regio VI (Via di Mercurio) enthielt der von einem Bleibassin in der Attika bekrönte 'Bogen des Caligula' zwei Lavabrunnen, die später zugunsten eines zweiteiligen Nymphäums mit Grottennischen und Marmorbecken im 'Bogen des Germanicus' aufgegeben wurden.[26] Die Laufbrunnen dienten der Trinkwasserversorgung der Untermieter, Ladenbesitzer und Passanten, sie waren auch Bestandteil der Oberflächenentwässerung, reinigten durch ihr Überlaufwasser das

11. Wasserrohre im Bürgersteig der Nordostecke der Insula VI 13.

Straßenpflaster und verbesserten das Klima an stik-kig-heißen Sommertagen. Ihre Reliefs mit Auslauf-öffnungen sind teilweise noch gut erhalten (dionysi-sche Themen, Götter- und Nymphenprotomen, ruhen-de Fluß- und Quellgötter, Tierköpfe, *paterae* bzw. Rundschilde). Vorherrschendes Steinmaterial ist tra-chitische Lava, wenige Brunnen (wohl Privatstiftun-gen) bestanden aus Marmor und Travertin.

Die kaiserzeitlichen Verteilerrohre waren im allge-meinen in einer Tiefe von bis zu 65 cm unter dem Niveau der Bürgersteige mit Gefälle verlegt *(Abb. 11)*. Provisorisch neuverlegte Rohrleitungen befanden sich nach dem Erdbeben von 62 n.Chr. auf Bürger-steigen und Peristylrinnen, sie wurden durch tönerne Muffen geschützt (die meisten Rohre wurden im 18. und 19. Jh. während der Ausgrabungen entfernt, ein-geschmolzen und verkauft, später undokumentiert in die Magazine verbracht). Das beweist wiederum, daß nach 62 n.Chr. das zerstörte oder beschädigte Lei-tungsnetz so schnell wie möglich instandgesetzt wor-den ist und widerlegt die These, daß das Wasserlei-tungsnetz im Jahre 79 n.Chr. noch nicht funktions-fähig war.[27] Ohlig stellte neue Berechnungen über die mögliche Leistung und den Wasserverbrauch an:[28] Bei 8000 Einwohnern ca. 200-400 l/Tag/Einwohner, Gesamtmenge 1700 m³ - 3400 m³/Tag. Ergiebigkeit 40 l/sek.

DIE KANALISATION

Die Tag und Nacht im Stadtbereich verteilten und durch das Niederschlagswasser ergänzten Mengen mußten die Stadt jedoch auch wieder verlassen *(Abb. 12)*.

Abwasserableitungen wurden bisher nur in Einzelbe-reichen der Stadt erforscht.[29] Sie wurden nicht plan-mäßig angelegt, man folgte nach und nach den jewei-ligen Bedürfnissen und Gelegenheiten. Das Oberflä-chenwasser floß ohnehin wie auch heute bei starken Regenfällen in Form von Gießbächen auf dem Stra-ßenpflaster den Hügel hinunter. Das Schmutzwasser aus Latrinen, Küchen und gewerblichen Betrieben wurde unter dem Pflaster in einen Kanalisationsstrang geleitet oder versickerte in 'pozzi neri' durch anste-hende Tuff- und Crumaschichten. Diese Abfall- und Sickergruben sind zylinder- oder birnenförmig und mehrere Meter tief.[30] Wir haben 1977 und 1978 im Auftrag der damaligen Grabungsleitung verschiedene pozzi neri in Bürgersteigen vermessen. Bei starken Regenfällen wurde auch Überlaufwasser aus Peristyl-zisternen und *impluvia* durch Kanalöffnungen über oder unter dem Bürgersteig in Gossen oder Kanalisa-tionen der Straßen geleitet, die dadurch auch durch-gespült wurden.

In samnitischer Zeit gab es vereinzelte Abwasser-gräben, die Reste aufgegebener Wallgräben mitbe-

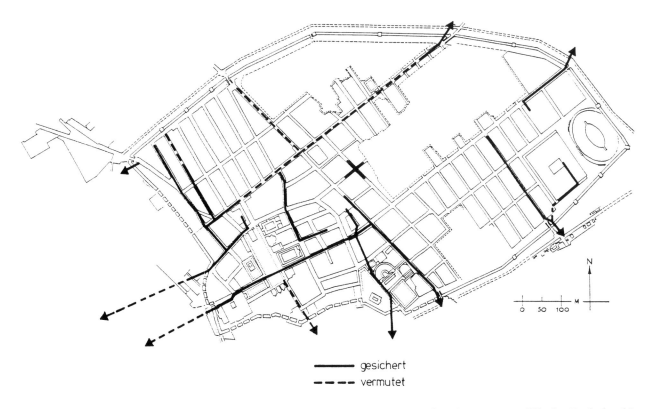

gesichert
vermutet

12. Straßennetz mit Einzeichnung der festgestellten und vermuteten Kanalisationsstränge (Hasko Eschebach).

13. *Via dell'Abbondanza, Einlauf in die Kanalisation (G. Jansen).*

14. *Porta di Nocera mit Kanalisationsausläufen: oben für Oberflächenwasser, unten für die Kloake.*

nutzten:[31] Ein ehemaliger Stadtgraben unter der Palästra der Stabianer Thermen wurde überdeckt und in eine Kanalisation umgewandelt, die sich im südlichen Wallgraben der Altstadt fortsetzte. So läßt sich das stumpfe, unvermittelte Ende des römischen Hauptkanals am nördlichen Bürgersteig der Via dell'Abbondanza an eben der Stelle erklären, an der er einst den samnitischen Hauptkanal aufnahm. Ein weiterer samnitischer Abwasserkanal, abgedeckt durch ein aus Dachziegeln verlegtes Paviment, verlief im Nordosten der Thermen, mit Gefälle nach Süden unter einer Lehmschicht mit einem Querschnitt von 31 x 36 cm^2 und dunkelgrauem Verputz an den Innenflächen. Er kam von Norden und traf im Süden auf den späteren römischen Kanal, der in der Mitte der claudischen Latrine ansetzt. Der samnitische Kanal wurde vermauert.[32] Außerdem fanden wir bei Sondagen in der Regio VI 5, unter dem Bürgersteig des Vico di Modesto, einen intakten Abwasserkanal aus dem 3. Jh.v.Chr., der später in das Abwassernetz der Via delle Terme mündete.[33]

Der Hauptkanal Pompejis hat eine große Einlauföffnung an der Via dell'Abbondanza in Nord-Südrichtung *(Abb. 13)* und nimmt auch das Oberflächenwasser mit, das von der Via di Stabia aus in einen großen seitlichen Einlauf hineinströmt. Dieser breite Kanal war in Abständen durch aufgemauerte Pfeiler abgestützt.[34] Ein weiterer Kanal folgte einst einer aufgegebenen Straße, die die Insula VIII 5 teilte. Unter der in VIII 5, 15.16.38 angelegten modernen Gärtnerei wurden Reste einer zerstörten Kanalisation sichtbar. Diese nahm vermutlich auch Abwässer der abgerissenen (35 v.Chr. bereits veralteten) Thermen auf, die nahe dem aufgegebenen Straßenstück lagen. Andere Abwasserleitungen beobachtete Maiuri im Norden und Osten des alten Bades.[35]

Am Südhang der Stadt, westlich der Porta di Stabia[36] und auch neben der Porta di Nocera *(Abb. 14)* befinden sich Auslauföffnungen, durch die das Abwasser in den Stadtgraben floß und versickerte. Die Abwässer aus der Insula VII 5 (Forumsthermen) wurden in die Insula VII 16 geleitet. Unter dem Vico dei Soprastanti verläuft ein großer Sammler, der durch zwei mit Lavadeckeln versehene Kontrollschächte zugänglich war.[37] Das Oberflächenwasser der Regio VI wurde in engen, unbefahrbaren Straßen aufgefangen, deren Fahrbahnen, von hohen abgeschrägten Bürgersteigen begleitet, nur noch der Entwässerung dienten. Das Wasser von der Via Consolare wurde z.B. vom Vico del Farmacista abgeführt. In der 2. Hälfte des 1. Jhs. v.Chr. wurde das samnitische Pflaster (vom Vico di Modesto ab) am Westende des *decumanus minor,* der Via delle Terme, durch einen Bürgersteig brückenförmig überbaut, darunter liegen Kanalöffnungen in Nordsüd- und Ostrichtung.[38] Das Überlauf- und Reinigungswasser des aufgegebenen westlichen Wasserkastells in der Casa delle Vestali (VI 1, 6-8.24-26) verlief unter dem Vico di Narciso und mündete hier ein. Die erhaltene samnitische Straßenpflasterung bot sich unter dem römischen Pflaster als Sohle für Abwasserkanäle an. Kanal- und Oberflächenwasser trafen sich zum Beispiel am tiefsten Punkt des Vico dei Soprastanti. Hier konnte ein großer Einlauf im Bürgersteig (etwa 60 x 80 cm) beträchtliche Wassermengen aufnehmen. Das Abwasser fiel durch einen tiefen Schacht lotrecht hinunter und mündete nach Angabe von G. La Mura zu Füßen des Steilhanges in einen von Ziegeln überdeckten Kanal, der es unter der Bebauung in die Hafenbucht abführte.

Der Forumsbezirk seitlich der Via Marina wurde nach dem gleichen Verfahren entwässert, das unter dem Vico dei Soprastanti festgestellt wurde. Östlich vor

dem Rücksprung der Tempelterrasse des Venusbezirks in die Via Marina liegt ein Kontrollschacht[39] ähnlich denen im Vico dei Soprastanti. Ein großer Kalksteinauslauf ist in der aufgelassenen Stadtmauer in Fortsetzung der Porticusrückwand der Villa 'Imperiale' unmittelbar südlich vom Tor ausgespart. Das Wasser fiel durch einen Schacht und wurde ebenfalls unterirdisch zur Lagune oder ins Meer geleitet.[40] Vermutlich wurden die geringeren Wassermengen im Osten aus der Porta di Sarno und der Porta di Nola von porösen Bodenschichten aufgenommen. In jedem Fall flossen hier die Abwässer links neben dem Tor durch eine Öffnung in der Stadtmauer und gelangten in einem offenen Kanal unter die Pomerialstraße und in einen Graben, der seinen Inhalt in die Straßensubstruktion ergoß. Dort versickerte das Wasser in Erdspalten.[41]

Zur Ableitung von Abwasser und Fäkalien aus den Obergeschossen wurden ganz selten Bleirohre verwendet. Man benutzte Tonrohre oder ineinandergesteckte Amphoren, die gewöhnlich in 'pozzi neri' einmündeten.[42]

Da 1994/95 im Auftrag der Grabungsleitung mehrere Bürgersteige der Hauptstraßen geöffnet wurden, sind von Nappo Publikationen mit weiteren Indizien zur Erforschung der Gebrauchswasserversorgung und Abwasserentsorgung Pompejis zu erwarten. Ohlig hat Vitruvs Theorien überprüft und erforscht in Zusammenarbeit mit dem derzeitigen Soprintendenten Guzzo die Funktionen des Wasserschlosses an der Porta Vesuvio mit Zu- und Ableitungen.[43]

BIBLIOGRAPHIE

Adam, J.P. 1979, Une fontaine publique à Bavay, *Revue du Nord* 61, Lille, 830.

Adam, J.P. 1984, *La construction romaine. Matériaux et techniques,* Paris.

Bassel, K. 1921, Die Wasserleitung von Pompeji, *Die Denkmalpflege* 5, 34-36.

Brands, G. 1988, Republikanische Stadttore in Italien, *BSR* 458.

Chiaramonte-Trerè, C. 1986, Nuovi contributi sulle fortificazioni Pompeiane, *Quaderni di Acme* 6, Milano.

Conticello, B. 1993, *Pompeji wiederentdeckt,* Katalog der IBM-Ausstellung in der Galerie der Stadt Stuttgart und im Museum für Kunst und Gewerbe Hamburg, Rom.

Cozzi, S./A.Sogliano 1900, La fognatura di Pompei, *NSc,* 587-599.

De Caro, S. 1979, Scavi nell'area fuori Porta Nola a Pompei, *CronPomp* 5, 61-101.

Della Corte, M. 1912, Trovamenti fortuiti, *NSc,* 70.

De Petra, G. 1870, *GdS* N.S. 2.

Dybkjaer-Larsen, J. 1982, The Water Towers in Pompeii, *AnalRom* 11, 41-67.

Elia, O. 1938, Un tratto dell'acquedotto detto <Claudio> in territorio di Sarno, in *Ist. Stud. Rom. Campania Romana* I, Napoli, 99-111.

Eschebach, H. 1975, Die Entdeckung eines Hauses unter den Stabianer Thermen, *CronPomp* 1, 82-117.

Eschebach, H. 1976, Ein nicht überlieferter, auch Pompeji betreffender Vesuvausbruch?, *RM* 83, 71-111.

Eschebach, H. 1977, Schola labri. Die Entwicklung der schola labri in den Vesuvstädten, dargestellt am Labrum des Männercaldariums der Stabianer Thermen Pompejis, *ChronPomp* 3, 156 ff.

Eschebach, H. 1979a, *Die Stabianer Thermen in Pompeji,* Berlin.

Eschebach, H. 1979b, Probleme der Wasserversorgung Pompejis, *CronPomp* 5, 24-60.

Eschebach, H. 1979c, Die Gebrauchswasserversorgung des antiken Pompeji, *AW* 10, 2, 3-24.

Eschebach, H. 1982, Katalog der pompejanischen Laufbrunnen und ihre Reliefs, *AW* 13, 3, 21-26.

Eschebach, H./T. Schäfer 1983, Die öffentlichen Laufbrunnen Pompejis. Katalog und Beschreibung, *PompHercStab* 1, 11-40.

Eschebach, H./L. Eschebach 1995, *Pompeji vom 7. Jahrhundert v.Chr. bis 79 n.Chr.,* Köln.

Eschebach, L. 1987, Pompeji. Geschichte der Wasserversorgung, *WAS* 2, 202-207.

Eschebach, L. 1989, Hafenstadt Pompeji, *AW* 20, 1, 40-54.

Eschebach, L. 1991, Die Forumsthermen in Pompeji, Regio VII, Insula 5, *AW* 22, 4, 257-287.

Eschebach, L./J. Müller-Trollius, 1993, *Gebäudeverzeichnis und Stadtplan der antiken Stadt Pompeji,* Köln.

Fiorelli, G. 1860-1864, *Pompeianarum Antiquitatum Historia,* (PAH) I-III, Napoli.

Fiorelli, G. 1875, *Descrizione di Pompei,* Napoli.

Garbrecht, G. 1993, Wasserversorgung geschichtlicher Städte. Die alte Stadt, in *Vierteljahreszeitschrift für Stadtgeschichte, Stadtsoziologie und Denkmalpflege* 20, 3, 191-206.

von Gerkan, A. 1940, *Der Stadtplan von Pompeji,* Berlin.

Gockel, B. 1982, Bilddokumente, *WAS* 1, 164-216.

Hodge, A.T. 1992, *Roman Aqueducts and Water Supply,* London.

Klementa, S. 1993, *Gelagerte Flußgötter des Späthellenismus und der römischen Kaiserzeit,* Köln.

Kockel, V. 1986, Funde und Forschungen in den Vesuvstädten II, *AA,* 443-489.

Lamprecht, H.O. 1988, Bau- und Materialtechnik bei antiken Wasserversorgungsanlagen, *WAS* 3, 129-154.

Lanciani, R. 1880/81, *Le acque e gli acquedotti di Roma antica*, Mem.Linc III/4, Neudruck 1975, Roma.

Löhberg, K. 1979, Beiträge der Metallkunde zur Archäologie, *JbBerlWissGes*, 48-62.

Maiuri, A. 1929, Contributo allo studio dell'ultima fase edilizia pompeiana *(Atti I. Congr.Stud.Rom.1928)* Rom 1929, 8-12.

Maiuri, A. 1930, Studi e ricerche sulla fortificazione di Pompei. III Torre della Via di Mercurio, *MonAntLinc 33*, 151-167.

Maiuri, A. 1931, Pozzi e condutture d'acqua nell'antica città, *NSc*, 546-576.

Maiuri, A. 1942, L'ultima fase edilizia di Pompei, Rom.

Maiuri, A. 1943, Isolamento della cinta murale fra porta Vesuvio e Porta Ercolano, *NSc*, 275-294.

Maiuri, A. 1950, Scoperta di un edificio termale nella Regio VIII, Insula 5, 36, *NSc*, 116-136.

Malandrino, C. 1977, *Oplontis*, Neapel.

Manderscheid, H. 1993, Bemerkung zur Wasserbewirtschaftung der Suburbanen Thermen in Pompeji, *AKorrBl* 23, 3, 337-346.

Mau, A. 1895, *RM X*, 49-50.

Mau, A. 1908², *Pompeji in Leben und Kunst*, Leipzig.

Mazois, F. 1828, *Les ruines de Pompéi II*, Paris.

Moormann, E.M. 1988, *La pittura parietale romana come fonte di conoscenza per la scultura antica*, Assen/Maastricht.

Murano, D. 1894, *Pompei, donde venivano le acque potabili ai castelli acquarii*, Napoli.

Mygind, H. 1917, Die Wasserversorgung Pompejis, *Janus 22*, 1917, 295-351.

Mygind, H. 1921, Hygienische Verhältnisse im alten Pompeji, *Janus 25*, 251-281, 284-324.

Mygind, H. 1977, Neudruck in: *Pompeiistudier*, Kopenhagen.

Nappo, S.C. 1995, Evidenze di danni strutturali, restauri e rifacimenti nelle Insulae gravitanti su Via Nocera a Pompei. *Archäologie und Seismologie. Colloquium Boscoreale 26.-27. November 1993*, München, 45-55.

Neuburger, A. 1919, *Die Technik des Altertums*, Leipzig.

Overbeck, J. 1875³, *Pompeji in seinen Gebäuden, Alterthümern und Kunstwerken*, Leipzig.

Overbeck, J./A. Mau 1884⁴, *Pompeji*, Leipzig.

Paribeni, R. 1903, Pompei - Relazione degli scavi eseguiti durante il mese di Novembre, *NSc*, 25-33.

Pemp, R. 1939, *Drei Wasserhebewerke Pompejis*, Würzburg.

Pesando, F. 1990, in: Carocci, et al., Le insule 3 e 4 della Regio VI di Pompei, Un analisi storico-urbanistica, *Archeologia Perusiana 5*, Roma.

Richardson jr., L. 1988, *Pompeii, An Architectural History*, Baltimore/London.

Schiøler, Th. 1973, *Roman and Islamic Water Lifting Wheels*, Odense.

Sgobbo, I. 1938, Serino. L'acquedotto romano della Campania: <Fontis Augustei Aquaeductus>, *NSc*, 75-97.

Sogliano, A. 1906, Relazione degli scavi fatti dal Dicembre 1902 a tutto marzo 1905, *NSc*, 97-100.

Spano, G. 1910, Scavi fuori Porta di Nola, *NSc*, 385-399.

Tran Tam Tinh, V. 1974, *Catalogue des peintures romaines (Latium et Campanie) du Musée du Louvre*, Paris.

Tuccinardi, M/R. Ruffo 1987, Saggi nel Vico dei Soprastanti, *RStPomp* 1, 135-140.

VanderPoel, H.B. 1981, *CTP* 5, Rom.

Wallat, K. 1993, Opus testaceum in Pompeji, *RM* 93, 353-382.

von Wölfel, W. 1990, *Wasserbau in den Alten Reichen*, Berlin.

ANMERKUNGEN

[1] Eschebach 1995, Abb. 41,1 (farbige Darstellung auf einem Plan).

[2] Maiuri l931, 548, Abb. 1.

[3] Maiuri 1931, 556 (esame chimico e microbiologico).

[4] Pemp 1939, 19-20; Schiøler 1973, 149-151; Für die Stabianer Thermen: Eschebach 1979a, 27-34, Abb. 11; Maiuri l950, l28-130, 136, Abb. 11-12 (terme di età repubblicane); Manderscheid 1993, 337 Anm. 3 (ehemaliges) Wasserhebewerk am Tiefbrunnen in den Suburbanen Thermen.

[5] Mau 1908, 235: Samnitisch; ders., 1895, 49 f.: Quelle Veseris; Murano 1894, 121-129: etrusk./-samn./sull.; RE IIIA, 2057 (K. Lehmann/Hartleben): Spätrepublikanisch; Sgobbo 1938 und Elia 1938: Römisch.

[6] Murano 1894, 123 Anm. 3; Eschebach 1979c, 3 Abb. 1.

[7] Maiuri 1930, 158; Maiuri, 1950, 120: "la sola traccia dell'impianto idrico sono i resti al fondo d'una tubazione di terracotta cementati incorniciati di malta"; 123 "che si aveva anche qui come altrove un condotto adduttore d'acqua dall'attiguo praefurnium" (es handelt sich um die nach 30 v.Chr. aufgegebenen, veralteten Thermen VIII 5, 36); Eschebach 1979a, 24; Maiuri 1929, 8-12 weist darauf hin,daß Patrizierhäuser seit dem Ende des 2., Kaufmannshäuser seit dem 1. Jh. v.Chr. Springbrunnen hatten; Beispiel: Eschebach 1975, 92 Abb. 11-13.

[8] Eschebach l983, 12 -13 (Nr. 6 und 37), 30.

[9] Zu Quellen aus dem Vesuvgebiet vgl. Malandrino, 1979, 46-49, 55-58; Weiter mdl. Auskünfte von A. Casale und M. Pagano: Sorgente Pedosi-Acquaro, Sorgente Sarno, Acque San Ciro und Fonte Salutare, Terme Nunziante und Minerva.

[10] Eschebach 1979b, 7-8; Wallat 1993, 365: Fassade augusteisch, Ziegel der Odeion-Gruppe.

[11] Maiuri 1942, 91, Taf. 27b: Wiederherstellung der Seitenwände in *opus reticulatum* nach dem Erdbeben von 62 n.Chr.; Paribeni 1903, 27, Abb. 3, 28 (alle Metallteile geraubt); Zum 'Mannsloch': Bassel 1921, 36; Kockel 1986, 543: "Wenig erforscht ist bisher die direkt nach der Verschüttung unternommene Bergungs- und Plünderungstätigkeit, deren Ausmaß meist viel zu gering eingeschätzt wird". Maiuri 1931, 562: Reparaturen nach dem Erdbeben von 62 n.Chr.; Nappo 1995, 51-54, Abb. 19-20 (Beschädigung der bereits reparierten Leitungen nach weiterem schweren Erdbeben vor 79 n.Chr.?); Antik verwendete Metalle: Löhberg 1979, 49; Lamprecht 1988, 134-135.

[12] Sogliano 1906, 97-100, 148-50.

[13] Fiorelli (1860-1864) 1, 2, 23-24, 26-39, 1784-87 (Casa delle Vestali, del Salve): 38, 26.7.1787: "In questa settimana si è evacuato uno stanzolino col pavimento di calcinaccio battuto, e tonica bianca; ed un corridoio, senza novità ... 23.8.1787: ... un corridojo, che resta alla immediazione dell'ultima stanza ... scoperta sotto il terrapieno delle mura della città; 30.8.1787: ... e questo corridojo viene diviso in quattro divisioni. Il pavimento è di terra, ed i muri sono senza

tonica"; (Niemand hat hier nach Spuren von Wasserleitungen gesucht).

14 Maiuri 1943, 279: Die Porta Vesuvio liegt 2,10 m höher als die Porta di Ercolano (es bestand also vom Wasserschloß her ein genügendes Gefälle für den Abzweig nach Westen zu dem von uns vermuteten Nebenverteiler). Ein Beweis für diese Anlage ist auch die Tatsache, daß es im Westteil der Regio VI nur 2 Wasserpfeiler gab; C. Ohlig suchte in der Wange des Zulaufkanals 2,75 m hinter dem Wasserschloß nach dem antik zugemauerten Ablauf nach Westen.

15 Malerei im Wasserschloß an der Porta Vesuvio: Paribeni 1903, 29; Mau 1908, 237 (sitzender Quell- oder Flußgott mit 3 Nymphen); Casa delle Vestali (Casa del Salve) VI 1, 25: Fiorelli (1860-1864) 1, 2, 26 (am 31.3.1785) gefunden, 33 (am 6.9.1786) abgenommen: "In una delle tre stanze che già compariscono nel fondo di questa abitazione, cioè quella di mezzo (4. Stil an der Nordwand der *exedra (oecus?),* die an das aufgegebene Quellheiligtum (Wasserschloß) anschließt) si è scoperta una pittura, che rappresentà un vecchio coricato appoggiato ad un vaso che versa acqua, e con una spezie di palma (canna!) in mano. Vi sono due altre figure di donne, uno per lato nude dalla cinta in sopra, portando ciascuna in mano una vasca come fonte che versa acqua"; Tran Tam Tinh 1974, 35-37; Moormann 1988, 168-169, Abb. 198,3 (Paris Louvre, Inv.Nr.P2); Es ist Mme Dr. Louise Claude (Paris) unter großen Mühen gelungen, mir ein Farbdia zu beschaffen. Das Fresko befindet sich in den Magazinen des Louvre und wird nicht ausgestellt; erwähnt bei Klementa 1993, 131 Anm. 390; Fiorelli 1875, 79: "... un vasto sacrario (?) decorato con nicchie (*oecus*)"; zum Thema vgl. v. Wölfel 1990, 157-159: Altröm. Quellgott Fons (Sohn des Janus und der Nymphe Jugurtha) dargestellt mit Nymphen im 'Quellhaus'.

16 Fortsetzung des Tunnels im Norden der Insula VI 2: Fiorelli (1860-1864) 1, 3, 214-215 (12.10.1818): Fund von menschlichen Skelettresten und Extremitäten (Arme und Beine) einer Apollonstatue in einem unterirdischen, niedrigen Gang unter dem *agger* der Stadtbefestigung.

17 Vgl. eine ähnliche Situation im Nordosten der Stadtmauer, ebenfalls als (zugeschütteter) Laufgang gedeutet: Chiaramonte-Treré 1987, 29-30, Taf. 5,2 (überwölbter Tunnel bei Turm VIII); Hinweise bereits bei Mygind 1917, 348.

18 Das Gelände fällt von der Porta Vesuvio zur Porta di Nola hin um fast 17 m ab.

19 Della Corte, 1912, 70; Maiuri 1931, 562-564; Mygind 1917, 331 (Leitung im Vicolo dei Vettii).

20 Vor I 4, 15 steht ein Wasserpfeiler, der mit der Hauptleitung unter dem östlichen Bürgersteig der Via dell'Abbondanza in Verbindung zu bringen wäre: Lanciani 1975, 407-408, 582. Taf. 10; Eschebach, 1979b Abb. 12 f, 13, 15; ders., 1979c Abb. 19, 25; Sollten die Wasserpfeiler längs der Hauptleitungen erbaut worden sein, bieten sich folgende Strecken an: In der Via del Vesuvio - di Stabia (NS), Via di Nola und Via dell'Abbondanza (O), Vico di Mercurio und Via delle Terme (W) und Vicolo dei Vettii - Vico di Eumachia - dei Dodici Dei (S).

21 VanderPoel 1981, XXI.

22 Fiorelli (1860-1864) 1, 3, 192 ff.: 1817 ausgegraben; Overbeck 1875, 190: "In allerjüngster Zeit völlig ausgeräumt" und dabei als (in der Antike) in der Ausbesserung (Abputzen der Wände) begriffen gefunden, es werden die intakten Auslauf- und Reinigungsöffnungen aus Bronze erwähnt.

23 Eschebach 1979b, 43-47, Abb. 10, 12a.b, 13; Dybkjaer-Larsen 41-67 (Plan Abb. 2 unvollständig); Herstellung der Bleirohre: Neuburger 1919, 437-438; Löhberg 1979, 51-53; Adam 1984, 276-277 mit Höhenangaben.

24 Mazois 1828, 38, Plan 4; Hodge 1992, 304; Adam 1979, 830 Abb. 4, 5, Taf. 5; Aufstellung und Katalog: Eschebach/Schäfer l983, 11-40. Vielleicht hat ein dritter Tuff-Brunnen mit der gefundenen Vertumnus-Protome (Nr. 43) an dem kleinen Platz vor der Porta di Ercolano gestanden. Und die im Abraum nahe dem Wasserschloß gefundene Löwenprotome aus Marmor (Paribeni 1903, 29; Maiuri 1931, 564) kann zu einem Marmorbrunnen auf dem Platz VI 7, 26 neben dem überdachten Altar gehört haben. Ergänzend zur Brunnengestaltung: Viele der pompejanischen Brunnenreliefs zeigen Rundschilde, die auch als *paterae* gedeutet werden (Eschebach 1983, 32-33); Eschebach 1983, 38: Einfache Rundbeschläge. 3 Brunnenmasken stellen gelagerte Fluß- oder Quellgötter dar. Interessant ist die gemalte Darstellung des Sarnus als Penate in der Bäckerei IX 3, 20 - Flußgott, bärtig (an seiner Mündung) mit Schilf bekränzt: De Petra 1870, 135 "... si poggia con la mano dritta ad una canna, e nella sinistra tiene una patera, dalla quale sorge una vena di acqua, che scendendo giù per la rupe, giunge al piano, sotto qui giuzzano cinque pesci" (vgl. oben Anm. 15). Weitere Personifikationen des Sarno bei Klementa 1993, 129-132.

25 z.B. vor I 4, 15; I 13,10; VI 1, l9; VI 7, 26; VII 1, 32; VII 9, 67; VIII 2, 25; IX 11, 1; vgl. Gockel 1982, 191-192 (Wasserverteiler), l94-195 (Laufbrunnen); Eschebach 1987, 202-207; 1995, 139 Abb. 46: ergänzter Brunnenplan.

26 Eschebach 1995, Taf. 34 1-3.

27 vgl. dazu Nappo 37-45.

28 Adam 1984, 267-268: "En fonction des sections de canalisation et de la pente moyenne, on a pu estimer le débit journalier de la plupart des grands aqueducs comme suit: Pompéi ... 6.460 cbm ... Si l'on estime, en chiffres maximum, la population de Pompéi a 12.000 habitants, chacun avait 540 l d'eau par jour et en donnant à Rome 1 million d'habitants, ses 11 aqueducs totalisant 1.127.280 cbm lui assuraient plus de 1.100 litres quotidiens par tête." Siehe Beitrag Ohligs (19-27).

29 Hodge 1982, 334-335, 340; vgl. Garbrecht 1993, 203 ff.; Overbeck/Mau 1884, 60 Abb. 22; Cozzi/Sogliano 1900, 587 ff. Abb. 1-19; Mygind l921, 268-281, Abb. 7; Maiuri l931, 571-574 Taf. 17; Pesando 1990, 205 (Vicolo del Farmacista, Via delle Terme); Eschebach 1995, Taf. 18.2, 41.3; Richardson 1988, 59-62; Conticello 1993, 20: Ein mit Hilfe von Computer erstellter Reliefplan mit dicht gesetzten Höhenlinien soll der kontrollierten Ableitung des Regenwassers dienen.

30 Mygind 1921, 316-318 'pozzi neri'; Vgl. die Sikkerschächte im Nordflügel der Stabianer Thermen: Eschebach 1979a, 52, Taf. 25 d.

31 von Gerkan 1940, 23-24, Abb. 3; Eschebach 1979a, 38-39, Taf. 29, 34a.

32 Ebenda 38, 55, Taf. 36 b, 35 c.

33 Eschebach 1976, 92-93.

34 Mygind 1921, Abb. 7, 3, 272-277: Via di Stabia, Via dell'Abbondanza; 273-275, Abb. 8-14: "Die Kloake folgt ungefähr der Mittellinie der Strasse, und gemauerte Säulen, die mit Zwischenräumen angebracht sind, stützen ihre gewölbte Decke ...".

35 Maiuri 1950, 126-127.

[36] Allgemein: Lamprecht 1988, 151-154; Cozzi/Sogliano 1900, 591-592; Overbeck/Mau 1884, 60; Mygind 1921, 263-265 Abb. 5.; Brands 1988, 180: 'Die Baumaßnahmen des 1. Jhs (v.Chr.!) beschränken sich im wesentlichen auf Verbesserungen verkehrstechnischer Art: 1. Nivellement im Vorgelände des Tores, 2. Pflasterung des Torweges und Anlage eines Bordsteines und 3. Anlage einer Abwasserleitung unter dem westlichen Tortrakt'; Mygind 1921, 278 f.; Eschebach 1995, Taf. 24.2, 25.1 (Porta di Stabia), Taf. 27.1, 41.4 (Porta Marina), Taf. 29.1 (Porta di Nola).

[37] Mygind 1921, 277-278, Abb. 17: Kloake der Forumsthermen; Tuccinardi/Ruffo 1987, 135-140: Grabungen im Vico dei Soprastanti (pozzi); Eschebach 1991, 279-280: Kanalisation der Forumsthermen; Eschebach 1995, Taf. 45.

[38] Mygind 1921, 264, Abb. 5.; Eschebach 1989, 51-52, Abb. 26-28; Eschebach 1995, Taf. 6.1-2.

[39] Mygind a.O. 1921, 279; Eschebach 1989, Abb. 31.

[40] vgl. Eschebach 1995, 94 Abb. 37.

[41] Spano 1910, 385 Abb. 4, 1-3; Maiuri 1930, 211, Anm. 2, Taf. 10 D-E-T; De Caro 1979, 80-82 Anm. 22; Abzug von der Straße: 62 Abb. 1(a).

[42] Mygind 1921, 269-270.

[43] Siehe Beitrag Ohligs (19-27).

AM DÜKER 11
D-26725 EMDEN
DEUTSCHLAND

Anomalies in Flow at the Pompeii Castellum

A. Trevor Hodge

Pompeii was served by an aqueduct coming in from the North, probably a branch of the Serino aqueduct that also served Neapolis (Naples) and Misenum, but perhaps an independent conduit originating around Nola. It entered Pompeii by the *castellum* (See *Fig. on cover*) located at the highest point of the town, the Porta Vesuviana, and there its water was divided up to serve the various districts and users. The dividing up was performed within the *castellum* by a series of crosswalls and channels of a design so complex that it is almost impossible to draw it, let alone understand it. The water then left the *castellum* through three large pipes *(Fig. 1)*. Buried under the paving of the street, these then distributed the water to the public fountains, private houses, and other users.

My starting point for this study was the striking difference between the large size of these three delivery pipes and the small size of the aqueduct that supplied them. The aqueduct tunnel itself is of normal dimensions, but the water was carried, apparently, only in a small gutter running down the middle of the floor; Eschebach[1] gives its dimensions as 25 x 30 cm, while in Paribeni's original excavation report[2] it scales off from his drawing as something rather smaller. Either way, it seems very small to supply three pipes of diameter 25 cm, 30 cm and 25 cm.

But what was the volume of water, the discharge, carried by the aqueduct? Eschebach[3] estimates 6,480 m³ daily, but we do not really know, for to calculate it reliably we would need to know the gradient, and, for this section of the aqueduct, we do not. Frontinus, in-

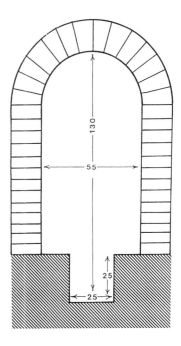

TOTAL CAPACITY WHEN RUNNING FULL

$$25 \times 25 \text{ cm} = 625 \text{ cm}^2$$
$$(179 \text{ q.})$$

$$(1 \text{ quinaria} = 3.5 \text{ cm}^2)$$

2. Cross-section of Pompeii supply aqueduct. The water ran in the square gutter in the floor, the rest of the tunnel providing access for maintenance crews.

deed, is often criticised for omitting this factor from his figures. But this objection is not unsurmountable. We are not concerned here with real figures for the actual discharge, but only with a comparison of the relative capacity of pipes and aqueduct, relative to each other. Assuming therefore a uniform speed of flow – even if we do not know what it is – we may compare the capacity of different channels on the basis of cross-section alone. That, after all, was how Frontinus did it, with his *quinariae*. And there are three things here to be compared: the supply from the aqueduct, the three delivery pipes carrying it to the city, and the actual needs of the various users in the city. Our comparison will, of course, be no more than a very approximate one, but, I think, valid enough to be worth the attempt.

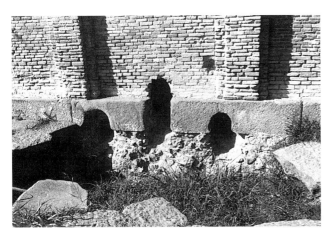

1. The three large discharge pipes of the castellum.

So, first, what is the cross-section of the aqueduct? Taking a rough figure, let us say the gutter in its floor is 25 x 25 cm, cross-section area 625 cm². This, be it noted, assumes that the cannel is running full. It will, of course, often have carried less than this. So, 625 cm² for the aqueduct supply. Frontinus' *quinaria* corresponds to the delivery of a pipe of 2.3 cm diameter,[4] giving a cross-section of about 3.5 cm². One *quinaria* being 3.5 cm², it follows that the 625 cm² of the aqueduct supply channel is equivalent to around 179 *quinariae (Fig. 2)*.

We move on to the three delivery pipes. The two outer ones are each of 25 cm diameter, let us say internal diameter (allowing for the pipe thickness) of 22 cm. That gives a cross-section of 380 cm². The middle pipe is bigger, 30 cm diameter, say internal diameter 27 cm. It's cross-section is then 573 cm². The three added together, 380 + 573 + 380, gives a total cross-section of 1,333 cm², or 381 *quinariae (Fig. 3)*. The supply aqueduct being of 625 cm², it follows that the capacity of the three delivery pipes together is more than twice what the aqueduct, running full, can supply. If they were all three in operation at the same time it therefore follows that they were not fully filled. It will be remembered that at Nîmes, Hauck and Novak's calculations[5] showed that there the large pipes leaving the *castellum* must have run only partly filled. So what happened to all this water? How great was the demand from all the users in the city? Here of course we are reduced to pure guesswork, but there is surely enough evidence for our guess at least to be an informed one. We do not know where those three pipes out of the *castellum* went to nor what they served, but we do have the well-known map of Eschebach,[6] showing the number of street fountains and private houses served by piped water. His map shows 124 private houses, each presumably served by a *quinaria* pipe, the smallest available. That gives a total of 124 *quinariae* for private use, or a total cross-sectional area of 434 cm². 40 public fountains have been found, and allowing for a 1-quinaria supply pipe for each one, that gives a total of 40 *quinariae,* or 140 cm². We may note in passing that the private houses thus created a demand three times that of the public fountains. And added together private users and public fountains thus require a supply of 164 *quinariae* or 574 cm². One third of Pompeii has still not been excavated and remains blank on Eschebach's map. Increasing our figures by one-third to allow for this, we therefore come to a grand total of 264 *quinariae,* or 861 cm² cross-section, to supply the needs of Pompeii as demonstrated by existing remains (and excluding, e.g., *palaestra* and theatre) *(Fig. 4)*.

We thus have three different figures to compare. In square centimetres, the aqueduct is 625. The delivery pipes are 1,333. And the city demands are 861. Here there seems to be a reasonable conclusion to draw: the aqueduct's capacity and the city's needs are in roughly the same order of magnitude, and can perhaps be reconciled; but the three pipes are about twice as big as that, and present a serious anomaly. Now let

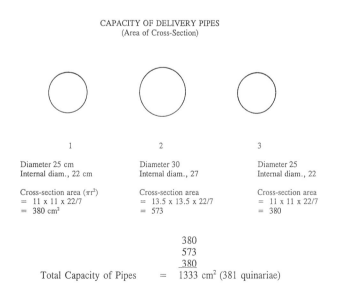

CAPACITY OF DELIVERY PIPES
(Area of Cross-Section)

1	2	3
Diameter 25 cm Internal diam., 22 cm	Diameter 30 Internal diam., 27	Diameter 25 Internal diam., 22
Cross-section area (πr^2) = 11 x 11 x 22/7 = 380 cm²	Cross-section area = 13.5 x 13.5 x 22/7 = 573	Cross-section area = 11 x 11 x 22/7 = 380

$$
\begin{array}{r}
380 \\
573 \\
\underline{380} \\
\end{array}
$$

Total Capacity of Pipes = 1333 cm² (381 quinariae)

3. Table showing cross-sectional area of delivery pipes (all dimensions in cm and cm²).

POMPEII - TOTAL CAPACITY/DEMAND OF USERS

Private houses excavated: at 1 quinaria pipe each =	124 124 q	=	434 cm²
Public fountains excavated: at 1 quinaria pipe each =	40 40 q 164 q	= =	140 cm² 574 cm²
Plus 1/3 of the city as yet not excavated =	82 q	=	287 cm²
TOTAL USE FOR CITY =	82 q 162 q 246 q	= +	574 cm² 287 cm² 861 cm²

TOTAL USE 861 cm²

4. Estimate (in cm² and quinariae) of water provided for city users.

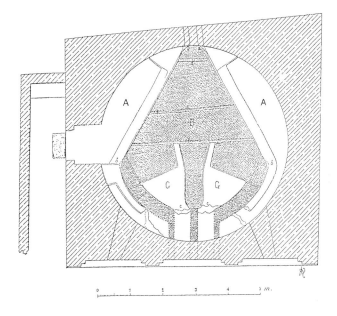

5. *Castellum: plan of internal arrangements, as published by Paribeni NSc 1903.*

us look inside the *castellum* and consider the mechanism for dividing up the water.

The *castellum* is a square building with a vaulted roof, and the floor is divided up into a number of distribution channels. At the end, the three delivery pipes are connected at a lower level, which would of course increase the head and hence the discharge, so they would actually carry more water than we have estimated. The layout of this distribution mechanism is, as we have noted, complex.

In the plan of Paribeni *(Fig. 5)*,[7] who excavated it, basically, there is a circular basin, rather like the Nîmes *castellum*, with the aqueduct coming in on one side. The arrangement of the distribution channels, however, is so complicated (not to say confusing) that one is tempted to see in it the results of several later alterations and rebuilds. At present they are all covered with plaster. Perhaps excavation would help.

The simplified plan *(Fig. 6)* by Eschebach[8] does clarify things somewhat. After passing through two grilles, the water faces three broad openings, themselves closed by solid gates, and it spills over the top of them, like a weir, before going on to reach the three delivery pipes. Basing himself on Vitruvius' description of the ideal *castellum*, Eschebach restored gates of differing heights, establishing a system of priorities between public fountains and private houses. We may as well note that his restored schematic elevation, below, is quite unrealistic: his highest gate, No. 3,

scales off at about 1.5 m high, while Paribeni gives the height as a sixth of that.

This isometric *(Fig. 7)* may perhaps give a better impression. The three gates, shown up above, are 25 cm high – Paribeni's figure – , while the three channels that they cover are very wide indeed. Let us go in and consider more closely how the water would be divided up among them. The elevation *(Fig. 8)* shows how the water would flow if there were no gates (or weirs) at all. The volume of water – 625 cm² from the aqueduct – being equally divided among the three channels, will be spread out very wide, but very shallow. The actual depth will be 2 cm, and none of the three offtake pipes will be filled. There just isn't enough water, even with the aqueduct running full. So how are we to divide up this volume of water by putting in gates of differing heights, to establish relative priorities?

This is what will happen *(Fig. 9)*. The gates have now been put in place and the water is overflowing the top of them. Their heights vary, so that in channel 1, left, enough overflows to give that channel one-sixth of the total supply. Half of the total goes to the middle channel, No. 2 (serving the big pipe), and one-third to the right-hand one. These proportions are chosen arbitrarily, just to show how the system works. And there is still not enough to fill any one of the three pipes. Much more important, the differences between the heights of the gates needed to produce this effect are so miniscule that you can hardly see them. Only

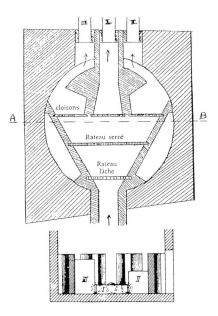

6. *(above) Simplified plan by Eschebach (1983, 103); (below) schematic elevation of control gates (not only not to scale, but with heights, and relative heigths, highly exaggerated).*

15

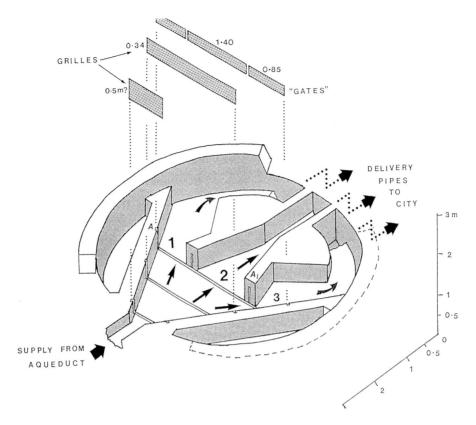

7. Internal layout in castellum (isometric, partly restored).

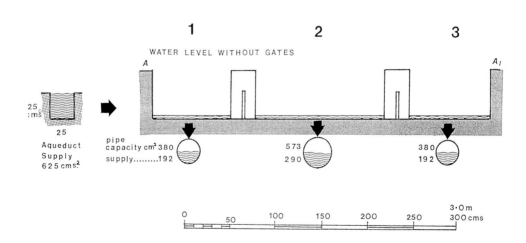

8. Elevation of internal channels, without control gates. Available water fills all three channels to a uniform depth of 2 cm.

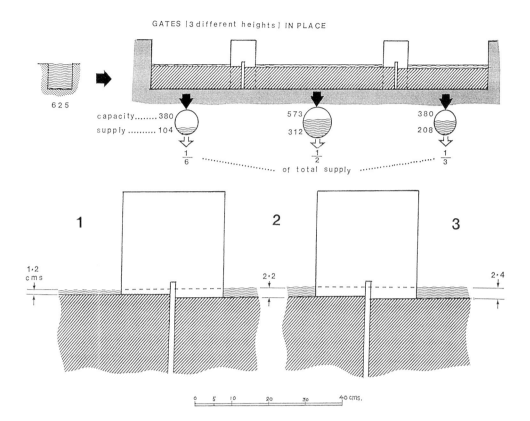

9. Elevation of internal channels, with gates in place. Gates are set at three different heights, illustrated in enlargement (below). Note: the middle channel (2) takes more of the total supply than the right-hand one (3) even though the middle gate rises higher and the water flow over it is shallower (2.2 cm deep as opposed to 2.4). This is because the middle opening is much wider than the two side ones.

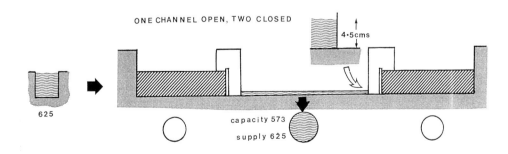

10. Elevation of internal channels, with one gate completely removed and the other two in place. All water now goes into the middle channel, producing in it a flow 4.5 cm deep.

in this enlargement can we clearly see the difference: the depths of water flowing over the three gates are, from left to right, 1.2 cm, 2.2 cm and 2.4 cm. These differences are tiny. To provide a supply of one third instead of one half the total, we need a gate two mm lower; and even so, the lower gate provides the lesser supply, because the central channel is much wider. This is fine tuning gone mad. Yet the tops of the gates have to be this close together. If any one of the three is, say, two cm lower than the others, then it will get all the water there is and the other two will be left high and dry, permanently. They might as well not be there.

There is surely a lesson in this. The attempt to divide up the supply into three priorities, on Vitruvian principles, results in height differences so minute and insignificant as to be unworkable, not to say ridiculous. The only way to change this would be to make the channel entrances narrower. But they are not. So let us try something else.

Here we have lifted out one gate completely and left the other two in place *(Fig. 10)*. All the water now goes to one pipe and fills it satisfactorily. The other two are left dry. We need not worry about the discrepancy between supply and capacity. These figures are only very approximate, and anyway the pipes' real capacity will be greater, running downhill under an increased head. I therefore think that this is a more likely and sensible explanation of the operation of the Pompeii *castellum.* The three channels were opened and closed in turn, manually, by lifting out the gates, as required. Usually there would not be more than one open at a time. That is why the pipes are so big. Each one might have to carry the entire aqueduct supply. And before we object that one could never shut off the pipe serving the public fountains, let us remember that we have no idea what these pipes served or where they went. They have never been traced. The division into fountains, houses, and public buildings rests only on Vitruvian theory, in a passage that is not even describing Pompeii. Moreover, inside the *castellum* there seems to have been no Vitruvian system of priorities established automatically by gates of differing heights, and any attempt to implement one proves quite impractical.

Vitruvius' specifications for a triple *castellum* are in any cases quite vague and imprecisely expressed. They have, I feel, been taken much too seriously. I know of no evidence that this triple system was ever put to use, and the Pompeii *castellum,* I suggest, is in fact an argument against it. True, there is still much about the *castellum* that we do not understand, but is is my hope that, by studying it from the approach that I have outlined, we may yet make some progress.[9]

BIBLIOGRAPHY

Eschebach, H. 1983, 'Gebrauchswasserversorgung Pompejis', in J.-P. Boucher (ed.) *Journées d'Etudes sur les Aqueducs romains,* Paris.
Hauck, G.F.W./R.A. Novak 1988, Water Flow in the castellum at Nîmes, *AJA* 92, 393-407.
Hodge, A.T. 1992, *Roman Aqueducts and Water Supply,* London, 299.
Hodge, A.T. 1996, 'In Vitruvianum Pompeianum' *AJA* 100, 261-276.
Paribeni, R. 1983, Pompeii – Relazione degli Scavi eseguiti durante il Mese di Novembre, *NSc,* 25-33.

NOTES

[1] Eschebach 1983, 88.
[2] Paribeni 1903, 29 fig. 5.
[3] Eschebach 1983, 101.
[4] Hodge 1992, 299.
[5] Hauck/Novak 1988, 396.
[6] Eschebach 1983, 104, 107.
[7] Paribeni 1903, 28 fig. 4.
[8] Eschebach 1983, 103.
[9] See also Hodge 1996.

CARLETON UNIVERSITY
DEPARTMENT OF CLASSICS
OTTAWA K1S 5B6
CANADA

Anmerkungen zum Funktionsmodell des Castellum Aquae im antiken Pompeji*

Christoph Ohlig

1. VORBEMERKUNG

Für die Frage, wie die Versorgung mit Trinkwasser in antiken Städten geregelt war, hat das *castellum aquae* in Pompeji - zumindest für den römischen Kulturbereich - eine bestimmende Rolle gespielt. Obwohl bislang kein anderes *castellum* gefunden wurde, das in seinem Innerern eine vergleichbare Konstruktion und ähnliche Regeleinrichtungen aufweist, wurde gerade dieses Bauwerk häufig als 'typisch' für die Wasserversorgung auch anderer antiker Städte angesehen.

Eine kritische Auseinandersetzung mit dieser Einschätzung ist hier aus Platzmangel nicht möglich. Deren Ergebnis würde lauten: Das von Vitruv beschriebene System der Wasserverteilung[1] ist in Pompeji nicht anzutreffen; es hat im dortigen *castellum aquae* keine Regelung durch ein dreifach gestuftes Wehr gegeben, das die Verbraucher bei Wassermangel in einer bestimmten Reihenfolge 'abschaltete',[2] ebensowenig gab es in der Stadt eine funktionale Versorgung von drei Abnehmergruppen über getrennte Rohrnetze, sondern es gab eine regionale Verteilung über drei Hauptrohre mit Unterverteilung über zwischengeschaltete Wasserpfeiler.

Jede Beschreibung, wie die Wasserzuteilung im *castellum aquae* von Pompeji technisch bewerkstelligt worden sein könnte, muß sich deshalb von allen oben skizzierten Denkansätzen freimachen und darf sich ausschließlich auf archäologische Befunde stützen.

Diese archäologischen Befunde werden zuerst vorgestellt. Dann wird von dem Versuch berichtet, durch Strömungsuntersuchungen in einem maßstabsgetreuen Modell *(Abb. 1)* weitere Hinweise auf die Art der Wasserverteilung in Pompeji zu bekommen. Schließlich werden die wichtigsten Ergebnisse der Diskussionen referiert, die bei den Präsentationen des Modells während des Symposiums geführt wurden.

2. ARCHÄOLOGISCHE FESTSTELLUNGEN

Abb. 2 gibt einen schematischen Überblick über die Gesamtsituation des Zuleitungskanals und des *castellum.*

2.1. Der Zuleitungskanal trifft nicht zentral auf die Verteilereinrichtungen im *castellum*, sondern ist um etwa 6° nach Westen verschoben. In die gleiche Rich-

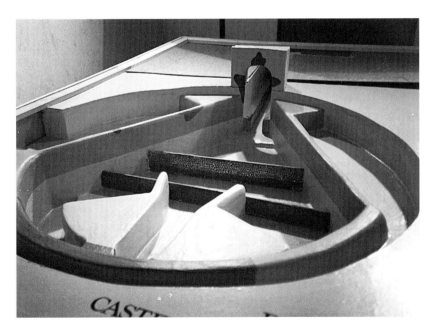

1. Funktionsmodell des castellum aquae von Pompeji im Maßstab 1:5.

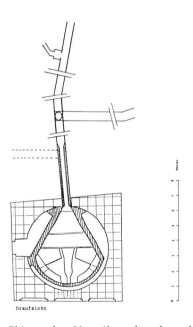

2. Skizze des Verteilergebäudes, des Zulauf- und mindestens eines Seitenkanals in Pompeji.

tung ist auch die Gebäuderückwand versetzt (daher die auffällige Trapezform des Gebäudes), so daß die Leitung zwar einigermaßen rechtwinklig auf diese (durch ihre Lage im *agger* dem Augenschein verborgene) Rückwand trifft, nicht aber zentral auf das Verteilerbecken im Gebäude selbst. Nach etwa 50 m (gemessen vom Einlauf des Kanals in das *castellum* = ca. 35 m vor der Stadtmauer) knickt die Leitung um ca. 12° in die entgegengesetzte Richtung (nach Norden zu) zurück. Folgt man der Leitung noch weiter, so trifft man etwa 62 m vom Einlauf ins *castellum* (= ca. 47 m vor der Stadtmauer) entfernt in der westlichen Kanalwange auf ein unregelmäßig eingebrochenes, bis auf die Kanalsohle reichendes Loch, von dem aus, wie schon Paribeni[3] berichtet, ein weiterer Kanal zuerst rechtwinklig, dann stumpfwinklig zurück nach Norden mit Richtung auf den Vesuv abzweigt. Dieser Kanal unterscheidet sich in seiner gesamten Konstruktion deutlich von der Hauptleitung; er wird deshalb für älter gehalten.

Ungefähr 17 m vor dem Einlauf ins *castellum* (= ca. 2 m vor der Stadtmauer) zweigt im Bereich eines Revisionsschachtes ein Kanal nach Osten ab, der die Via del Vesuvio unterquert und kurz dahinter mit Asche verschüttet zu sein scheint. Dieser Kanal ist in seiner Bauart der Hauptleitung recht ähnlich, wirkt aber niedriger. Er wurde im Bereich des Revisionsschachtes offenbar schon antik bis auf ein kleines rechteckiges Loch im oberen Bereich zugemauert.

Sollte es, wie L. Eschebach[4] vermutet, noch einen ehemaligen Abzweig von dieser Leitung nach Westen zum Wasserspeicher/-verteiler in der Casa delle Vestali (VI 1, 6-8 24-26) gegeben haben, so könnte dieser nur im *agger* verlaufen, etwa 3,5 m vor dem Einlauf ins *castellum* auf die Leitung treffen und ebenfalls bei einem Umbau des ganzen Systems verschlossen worden sein. In der Tat findet sich in diesem Bereich der Leitung ein Riß in der Kanalwange. Die Mauer gibt hier beim Abklopfen einen dunkleren Klang als die Umgebung wieder, was - neben vielen anderen möglichen Ursachen - auch auf einen dahinterliegenden Hohlraum deuten könnte.

2.2. Die beiden Spuren der Sperr-, Wehr-, Regel- oder Filtereinrichtungen ('Rillen') stehen nicht parallel zueinander, auch nicht parallel zur Südfassade, sondern sind um 1,5° (südliche Rille) bzw. um 3° (nördliche Rille) ebenfalls nach Westen verschoben. Ihr Abstand voneinander (ca. 90 cm) bzw. vom Einlauf in das Becken (ca. 180 cm) zeigt dieselbe Relation 1:2 wie diese Winkelverschiebung von der gedachten Mittelachse.

2.3. Die genannten 'Rillen' im Beckenboden haben eine auffällig unterschiedliche Gestalt: Die südliche ist tief und zeigt am Rand deutliche und großflächige Ausbruchspuren, die nördliche ist sehr flach und hat glatte Kantenbereiche. Daneben fällt auf, daß das Gebilde unmittelbar vor dem Dreiteiler, wie auch immer es gebaut war (ob Filter, Gitter oder auch nur ein Rahmen, um Holzbretter zur flexiblen Steuerung oder zur Vollsperrung dieser Ausläufe aufzunehmen), nicht nur im Boden, sondern auch an den Wänden und am Dreiteiler außerordentlich dicht eingebaut war. Die (tief in die Seitenwände eingelassenen) Metallreste, das vorgewölbte Profil der Seitenwände, das seitlich (und ähnlich auch von oben) auf diese Einrichtung hin mit *opus signinum* (fast wie bei einer Wasserkehle) abgerundete Profil der Mauerspitzen sowie auch das hinter der Einrichtung anstehende Bodenprofil (*Abb. 3, 1-3*) zeigen das Bemühen der Baumeister um absolute Dichtigkeit überaus deutlich.

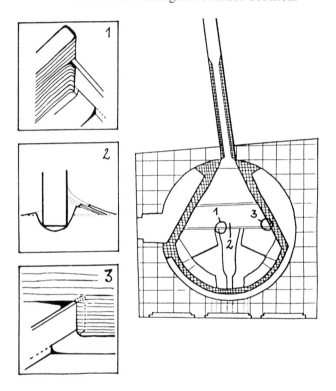

3. Detailskizzen zur Abdichtung der südlichen Steuer- oder Filtereinrichtung im Verteilergebäude.

2.4. Die 'Stufen' im Kanal sind nur 4 m lang. Sie schwingen an ihrem Beginn, ähnlich wie im Auslauf, sanft gebogen zur jeweiligen Kanalwange hin aus. Darstellungen, nach denen die dazwischenliegende Rinne in das Fundament des Kanals eingetieft worden sei, sind nicht haltbar. Es handelt sich vielmehr um eine Einschnürung des Wasserstroms, die (nachträglich) zur Verringerung seines Querschnitts in den Zulaufkanal eingebaut wurde.

2.5. Von außen erscheinen die Rohrbetten der drei

Ablaufrohre von unterschiedlicher Höhe. Messungen von innen ergeben, daß die drei Sohlen, auf denen die ableitenden Rohre in einem nur noch teilweise oder nicht mehr vorhandenen Mörtelbett aufgelegen haben müssen, fast vollkommen gleich hoch liegen. Es spricht also alles dafür anzunehmen, daß die Abläufe für die drei Rohre auf der gleichen Höhe lagen, lediglich die Neigungswinkel dürften sich geringfügig voneinander unterschieden haben.

2.6. Am unteren Beckenrand, aber auch am Beckenboden und in den Ausläufen, befinden sich deutliche Sinterablagerungen in ganz unterschiedlichen Formen und Ausprägungen. Diese können Hinweise auf das Fließverhalten des Wassers und charakteristische Wasserstandshöhen geben.

2.7. Wenn man die Nivellierung des Beckens im Bereich zwischen dem Einlauf und dem gemauerten Dreiteiler untersucht, so stellt man folgendes Gefälle fest: Von Nord nach Süd senkt sich das Becken in Fließrichtung des Wassers vom Einlauf bis zur Dreiteilereinrichtung um ca. 0,8% ab. Daneben gibt es aber auch noch ein deutliches Gefälle von West nach Ost: Während das Becken im nördlichen Teil, zwischen dem Einlauf und der ersten Rille, noch ziemlich waagerecht liegt, fällt es im Bereich dieser nördlichen Rille selbst um ca. 0,6%, unmittelbar vor der Dreiteilereinrichtung um ca. 0,7% nach Osten hin ab.

3. ZUM MODELL SELBST

Beim Bau des Modells habe ich mich soweit wie möglich an den noch erkennbaren Gegebenheiten des Originalbauwerks, für notwendige Rekonstruktionen jedoch an Überlegungen und Vorschlägen von Archäologen (vor allem Paribeni, Mau und Maiuri)[5] orientiert. Für von diesen nicht diskutierte Fragen (z.B. der Größe der ableitenden Rohre) habe ich möglichst Indizien aus Pompeji selbst herangezogen.

Alle relevanten Modellgesetze (vor allem das Froudesche Modellgesetz für Strömungen mit freier Oberfläche in einem unverzerrten Modell) wurden möglichst genau eingehalten.

Da das Gitter im Einlaufbereich des Zulaufkanals, das vermutlich nur den Zugang in das Gebäude verhindern sollte, keinerlei Kontakt mit dem Wasser hatte und damit auch keine Bedeutung für die Strömungsverhältnisse gehabt haben kann, wurde es im Modell weggelassen.

Bezüglich der nicht mehr vorhandenen Einrichtungen über den Rillen im Beckenboden habe ich mich mit den genannten Archäologen (die hier übereinstimmend Filter vermuten) für zwei durchgehende, durchlöcherte Platten entschieden, habe aber auch mit anderen Gestaltungen experimentiert.

Bezüglich der Größe der ableitenden Rohre schien es mir aus mehreren Gründen[6] nicht plausibel, mich an der Größe der Löcher im Sockel der Fassade zu orientieren. Stattdessen habe ich die Größe der Rohre zugrundegelegt, die Maiuri[7] im Jahre 1928 in der Via del Vesuvio (Entfernung vom *castellum* nur ca. 140 m) gefunden hat. Diese sind (in der typischen Tropfenform mit den Innenmaßen 22 cm x 16,8 cm) die größten Rohre, die man bislang in Pompeji gefunden hat. Sie entsprechen etwa der Nennweite *septuagenaria* bei Frontinus,[8] und da sie unmittelbar vor dem ersten Wasserpfeiler lagen, darf man m. E. annehmen, daß sie repräsentativ für die Größe der Hauptrohre sind.

4. WESENTLICHE ERGEBNISSE DER MODELL-UNTERSUCHUNGEN

4.1. Die seitliche Verschiebung des Zulaufkanals bewirkt im Modell eine unterschiedliche Mengenverteilung des Wassers auf die drei Ablaufrohre in der Prioritätenfolge Ost-Mitte-West. Die Wasserstandshöhen, die sich in dieser Versuchsanordnung im gesamten Modell einstellen, bieten eine hohe Übereinstimmung mit dem Bild der Höhe der Ablagerungen an den Seitenwänden des Beckens in Pompeji. Auch unter dem Aspekt möglicher jahreszeitlich bedingter Schwankungen des Wasserdargebotes behalten die drei Rohrstränge in dieser Versuchsanordnung konstante Proportionen zueinander (*Abb. 4*).

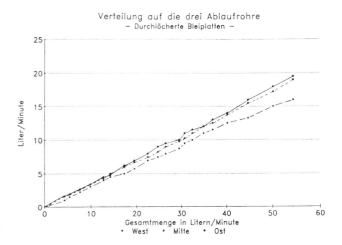

4. *Diagramm zur Mengenverteilung des Wassers im Modell.*

4.2. Die bisherigen Schätzungen[9] der in Pompeji zur Verfügung stehenden Wassermengen erscheinen mir zu hoch. Gestützt auf Beobachtungen am Modell (z.B. Stärke der Verwirbelungen, Wasserstandshöhen,

Übereinstimmung mit dem Bild der Höhe der Sinterablagerungen in Pompeji usw.), die natürlich auch eine subjektive Komponente haben, weiterhin gestützt auf überschlägige Computerberechnungen, die K. Rathke auf der Basis meiner Messungen des Leitungsprofils, seines Verlaufs sowie der Sinterhöhen für das *castellum* in Pompeji angestellt hat, nehme ich eine Tagesförderleistung von ungefähr 1700 m³ - 3400 m³ an. Dies würde einer Menge zwischen etwa 20 und 40 l/sec bzw. 200 - 400 l/Einwohner (bezogen auf die von H. Eschebach angenommene Einwohnerzahl) entsprechen. Diese Mengenangaben werden (zumindest für die Höchstmenge) auch durch die Berechnungen von P. Dicker[10] bestätigt.

4.3. Es zeigt sich im Modell bei höheren Wasserständen, daß nicht unerhebliche Luftmengen in die Rohrleitungen befördert werden, die die Stetigkeit des Wasserstroms sehr beeinträchtigen. Diese Luft tritt an der Meßstelle, die (wie die Wasserpfeiler in Pompeji) erhöht angebracht wurde, wieder aus. Deshalb stimme ich Peleg[11] zu, daß diese Wasserpfeiler neben ihren anderen Funktionen (Druckminderer, Regionalverteiler) auch eine wichtige Entlüftungsfunktion hatten.

5. Interpretation der Modellversuche

5.1. Die oben beschriebene unterschiedliche Mengenverteilung (Reihenfolge Ost/Mitte/West, *Abb. 4*) ergibt sich daraus, daß der Zulaufkanal nicht, wie erwartet und bislang meistens unterstellt, zentral in das Verteilergebäude trifft, sondern seitlich (nach Westen hin) versetzt ist. Die Wirkung dieser Strömungsveränderung wird durch die am Ende des Kanals vor dem Eintreffen ins Verteilergebäude eingebaute Einschnürung sogar noch verstärkt. Auch das Gefälle in diesem Teil des Beckens paßt mit seiner Tendenz nach Süden und Osten zu dieser Situation. Wenn man also von der oben beschriebenen, von den Archäologen postulierten Bauweise (durchgehende, nicht variierbare, siebartig durchlöcherte Filterplatten) und nicht von einer zusätzlichen Steuerungseinrichtung ausgeht (wie sie früher von Kretzschmer[12] als dreifach gestufte Wehrplatte und von Wasserbauingenieuren während des Symposiums als drei einzelne, flexibel einstellbare Wehrplatten mit unterströmendem Wasser in die Diskussion eingebracht wurde), kann man m. E. von einer festgelegten Steuerung der Wassermengen durch vorab geplante Baumaßnahmen sprechen. Unter dieser Annahme entstehen folgende kritischen Fragen:
a) Haben die antiken Baumeister die strömungsverändernde/steuernde Wirkung dieser Bauweise schon gekannt, und haben sie diese Bauweise in Pompeji im Hinblick auf die Verteilungswirkung vorab so geplant?
b) Entspricht die im Modell feststellbare Auswirkung dieser Bauweise den Bedürfnissen der Stadt und ihren gewachsenen Strukturen?
c) In welche Zusammenhänge lassen sich die Umbaumaßnahmen einordnen?

5.2. Zur ersten Frage: Falls die Verschiebung des Kanalverlaufs und der Gebäuderückwand nicht gewollt und geplant waren, könnte ihre Ursache zufällig sein und/oder auf Meßfehlern des Baumeisters beruhen. Vielleicht müßte man ihre Ursache aber auch in geographischen Besonderheiten im Gelände suchen, durch das der Zuleitungskanal geführt wird, oder es handelt sich um Faktoren, die man bislang noch nicht kennt.

Wenn man die fast unglaubliche Maßgenauigkeit gerade bei den Wasserbauwerken der Römer kennt, fällt es eher schwer, Zufälligkeiten oder gar Meßfehler der antiken Baumeister anzunehmen, denn es handelt sich bei der Abweichung ja nicht um eine Bagatelle: Die Ostwand, deren Länge das Ausmaß der Richtungsverschiebung der Rückwand bestimmt, ist um drei römische Fuß länger als die Westwand, und eine unbeabsichtigte Differenz in dieser Dimension scheint mir ausgeschlossen!

Zu den geographischen Faktoren: Im Ausgrabungsbereich selbst (ca. 50 m vor der Stadtmauer) ergibt sich kein solcher Anhaltspunkt für die Kanalverschiebung. Von den bekannten *villae rusticae* im Umfeld der Stadt liegt ebenfalls keine so, daß sie als Ursache für die beschriebene Trassenführung in Frage käme.

Ein Zusammenhang mit dem möglicherweise parallelen Trassenverlauf der Straße außerhalb des Vesuvtors ist nicht zu ermitteln, da dieser Bereich noch nicht freigelegt wurde. Soweit man den Verlauf der Straße abschätzen kann, erscheint mir ein solcher Zusammenhang aber eher unwahrscheinlich, denn der gesamte äußere Pomerialbereich ist für den Bau des Leitungskanals künstlich aufgeschüttet und neu gestaltet worden.[13] Spano[14] zeigt eine Skizze, in der der (durch neun aufgereihte Prellsteine geschützte) Kanal auch eher vom Nordsüd-Verlauf der Straße abweicht als ihr zu folgen.

Noch interessanter wird der Sachverhalt, wenn man den (nur zu vermutenden) weiteren Verlauf der Leitungstrasse diskutiert: Da das *castellum* auf ca. 44 m über NN liegt und Sgobbo[15] die Höhe der Serino-Leitung im Bereich Torricelle/Palma (wo sich ungefähr der Abzweig nach Pompeji befunden haben muß) mit 52,23 m angibt, bietet die 50-m-Höhenlinie nördlich von Pompeji zum Vesuv hin einen guten Anhaltspunkt für den möglichen Trassenverlauf dieser Leitung. Folgt man dieser Linie, so fällt auf, daß

sich von Boscoreale auf Pompeji hin in Nordsüd-Ausrichtung ein prähistorischer Lavasporn erstreckt, der sich auch in den Höhenlagen der Stadt weiterverfolgen läßt. Wenn man der genannten Höhenlinie nach Nordosten in Richtung auf die Stadt Palma hin folgt, so berührt diese Linie an einer einzigen Stelle (Ponte Tirone südwestlich von Palma, nahe Pirucchi) die entsprechende Höhenlinie der gegenüberliegenden Bergseite. In diesem Bereich dürfte der Anschluß an die Serino-Leitung erfolgt sein. Da das *castellum* nach Nordnordwest ausgerichtet ist, müßte der Kanal, von der Ostseite des Lavasporns herkommend, wenn er nur im Hinblick auf den Höhenverlauf gebaut worden wäre, von Osten (allenfalls noch von Norden) her in das *castellum* treffen. Dies aber tut er nicht, sondern er verläuft, vom *castellum* aus gesehen, zuerst in die 'falsche' Richtung (also die westliche Seite dieses Lavasporns), um erst später in die eher erwartete Richtung (nach Osten) abzuschwenken.

Zur zweiten Frage: Die Stadtstruktur lag bei Bau und Einrichtung der Fernwasserleitung[16] im wesentlichen schon abgeschlossen vor, und die Stadt hatte schon Jahrhunderte ohne den (sicher sehr angenehmen) Luxus einer Fernwasserleitung überstanden. Das Problem der Wasserversorgung war also im Grundsatz auch ohne diese Leitung bewältigt worden, und die Einrichtungen, mit deren Hilfe dies möglich war, wurden nach Bau der Fernwasserversorgung keineswegs alle aufgegeben. Zwar wurden die Tiefbrunnen zugeschüttet oder verschlossen, weil ihr Wasser nicht von besonders guter Qualität war,[17] die Regenwasserzisternen wurden aber vollständig weiter genutzt.[18] Das System der Wasserverteilung auf drei Stadtregionen müßte deshalb auf die beim Bau der Wasserleitung schon vorhandene Verbraucherstruktur, vor allem der Großverbraucher (z. B. der öffentlichen und privaten Thermenanlagen, Palästren usw.), Rücksicht genommen haben und schon vorhandene Einrichtungen sinnvoll ergänzen.

In ihren Beiträgen haben sowohl Eschebach als auch Wiggers Trassenverläufe für die Hauptleitungen in der Stadt aufgezeigt.[19] Solche Trassen müssen sich an den Höhenlagen des Stadthügels[20] orientieren. Mit Verweis auf den Vortrag von L. Eschebach, die dort gezeigt hat, daß die Reihenfolge der Mengenzuteilung Ost/Mitte/West der Größenverteilung der zu versorgenden Gebiete und den Anforderungen ihrer Verbraucher entspricht, verzichte ich hier auf weitere Erläuterungen zu dieser Frage.

Zur dritten Frage: Die Umbaumaßnahmen, die man im *castellum* und an der Kanalmündung beobachten kann, würde ich in folgenden Zusammenhang bringen: Zu einem Zeitpunkt, der noch nicht bestimmt ist, hat man den Seitenkanal nach Osten vor der Stadt

mauer (sowie, wenn es ihn dort wirklich gibt, den Abzweig nach Westen im *agger*) verschlossen (um die Wasserversorgung auf das *castellum* an der Porta Vesuvio zu konzentrieren?). Auch der Einbau der Einschnürung sowie die Aufhöhung der um das eigentliche Becken herumführenden Mauer im *castellum* könnte zu dieser Umbaumaßnahme gehört haben. (Was man sich von diesen Maßnahmen versprochen hat, und auch, ob diese - unbekannten - Erwartungen sich mit diesen Umbauten erfüllt haben, ist ebenfalls noch nicht geklärt.) Wenn es den von Eschebach[21] vermuteten Zusammenhang mit dem Wasserspeicher in der Casa delle Vestali (VI 1, 6-8 24-26) gibt, müßte dieser Umbau ausweislich der Dekorationen in diesem Gebäude (3. und 4. Stil) vor dem Erdbeben des Jahres 62 n.Chr. erfolgt sein.

Es ist weiterhin möglich, daß das Erdbeben des Jahres 62 n.Chr. auch die Serino-Leitung oder den Abzweig nach Pompeji beschädigt haben kann. Es ist nicht wahrscheinlich, daß die Wasserzufuhr völlig zum Erliegen gekommen ist.[22] Man könnte es in dieser Notsituation für sinnvoll gehalten haben, eine ältere Zuleitung, die Wasser vom Vesuv ableitete,[23] und die nach dem Bau des Abzweigs zur Serino-Leitung nicht mehr benötigt wurde und deshalb stillgelegt worden war, zu reaktivieren und wieder ins Versorgungssystem Pompejis einzubeziehen. Der von Paribeni beschriebene Kanal, der auf die Westseite des Lavasporns, also auf das Zentrum des Vesuvs zu zielen scheint, könnte diese Bestimmung gehabt haben, und seine unregelmäßig eingebrochene Öffnung in die westliche Wange der Leitung könnte ein weiteres Indiz für diesen Sachverhalt (Notmaßnahme) sein.

Zusammenfassend kann man feststellen: Nach dem derzeitigen Wissensstand läßt sich die seitliche Verschiebung des Zulaufkanals sowie der Rückwand des *castellum* als eine geplante grundsätzliche Regelung für die Wasserzuteilung auf drei unterschiedlich große Stadtbereiche entsprechend ihrer Größe und der Zahl der angeschlossenen Verbraucher weder eindeutig nachweisen noch widerlegen. Eine andere (zwingend erscheinende) Begründung für die genannten baulichen Veränderungen wurde noch nicht gefunden.

6. ERGEBNISSE DER DISKUSSION WÄHREND DES SYMPOSIUMS

6.1. In folgenden Punkten wurde Konsens gefunden:
6.1.1. Die Darstellung der Wasserverteilung bei Vitruv ist für Pompeji weder auf das *castellum* selbst noch auf das System der Rohrleitungen anzuwenden.
6.1.2. Alle auf den Überlegungen Vitruvs aufbauenden technischen Lösungsversuche mit einer dreifach gestuften Wehrplatte oder auch mit unterschiedlich

hoch angesetzten Ableitungsrohren sind für Pompeji zurückzuweisen.

6.1.3. Es hat in Pompeji vom *castellum* an der Porta Vesuvio aus keine dreigeteilte funktionale, sondern eine regionale Verteilung des Wassers über drei ableitende Hauptrohre gegeben.

6.1.4. Die als 'Stufen im Zulaufkanal' interpretierten Aufmauerungen sind als Einschnürung zu betrachten, mit der das Strömungsverhalten beeinflußt werden sollte.

6.1.5. Weil das Gitter im Einlaufbereich zwischen dem Aquädukt und dem Becken oberhalb des Wasserspiegels lag, kann es keine hydraulische Funktion gehabt haben.

6.1.6. Welche Funktion das nördliche, in das Becken eingelassene Gebilde auch immer gehabt hat (vgl. unten 6.2.), es muß aufgrund der in gleicher Höhe ununterbrochen durchgehenden Sinterlinie den Durchfluß des Wassers zugelassen haben.

6.2. Nicht mit völliger Übereinstimmung wurde die Frage diskutiert, ob die verschwundenen Einrichtungen in Pompeji eine Reinigungsfunktion hatten, wie Paribeni, Mau und Maiuri als selbstverständlich angenommen haben. Ellis[24] stellt diese Funktion in Frage.[25] Selbst wenn man für die nördliche Einrichtung zumindest auch eine solche Reinigungsfunktion annehmen kann, stand in der Diskussion seine Funktion als Gleichrichter bei den Wasserbauingenieuren im Vordergrund.

6.3. Strittig blieben folgende Fragen:

6.3.1. Meine eigene Interpretation der Winkelverschiebungen im Kanalverlauf, der Gestaltung der verschwundenen Einrichtungen im Becken des Verteilergebäudes als durchgehende Filterplatten und die Auswirkungen dieser beiden Bauelemente auf die Verteilung der Wassermengen erfuhr deutlichen Widerspruch. Der Haupteinwand bestand darin, daß diese Art der Steuerung durch Winkelverschiebung des Zulaufkanals (selbst unter heutigem Ingenieurwissen) sehr ungewöhnlich sei. Vor allem wurde bezweifelt, ob man eine solch ungewöhnliche Steuerung in der Antike überhaupt schon gekannt, und dann erst recht, ob man sie schon bewußt geplant haben könne.

6.3.2. Statt dessen wurde diskutiert, ob die (verschwundene) Metallkonstruktion (statt aus einer durchgehenden Platte) nicht vielmehr lediglich aus einer stabilen Rahmenkonstruktion (seitlich u-förmig, am Boden ebenfalls u- oder winkelförmig) bestanden haben könnte, mit deren Hilfe man durch eingeschobene Holzplatten die drei Ausläufe flexibel hätte steuern oder sogar völlig absperren können. Wenn man eine solche Steuerungsmöglichkeit annimmt, die mit unterströmten Wehren arbeitete (welche dann natürlich recht genau dem Bedarf der am jeweiligen Rohr-

strang angeschlossenen Verbraucher angepaßt werden könnten), würde die gesamte Diskussion um Winkelverschiebung und Trassenführung des Zulaufkanals entfallen: Was immer dort (zufällig oder mit richtigen oder falschen Intentionen geplant) geschehen ist, mit welchen Strömungsbedingungen das Wasser auch immer ankam, man hätte es durch die steuerbaren Wehre in gewünschter oder notwendiger Weise korrigieren und regeln können. Unbeantwortet bleibt bei dieser Erklärung allerdings, warum die antiken Baumeister dann nachträglich das System durch Umbauten verändert haben, und dazu noch in einer Weise (Einschnürung mit signifikanter Erhöhung der Strömungsgeschwindigkeit bei asymmetrischer Strömungsrichtung), die für eine Steuerung durch unterströmte flexible Wehrplatten negative Auswirkungen hat.

Für eine bauliche Gestaltung, die auch eine völlige Absperrung zuläßt, wurden weiterhin die gelegentliche Notwendigkeit von Reparaturmaßnahmen und der Hinweis angeführt, eine solche Absperrmöglichkeit sei in jeder antiken Leitung vor dem Beginn der 'sensiblen' Strecken anzutreffen, man müsse also auch für Pompeji davon ausgehen. Allerdings könnte ich mir vorstellen, daß man eine solche Vollsperrung eines einzelnen Stranges für kurze Zeit (Reparatur) als Provisorium auch mit einfacheren Mitteln hätte erreichen können. Sie wäre bei einer fest eingebauten, durchgehenden Platte, wie ich sie auch in meinem Modell angenommen habe, leicht z. B. durch vorgestellte Bretter möglich gewesen.

6.3.3. Die Möglichkeit von Vollsperrungen hatte auch Hodge[26] in seinem Beitrag diskutiert. Abgesehen von der angenommenen Wassermenge im Zulauf, die durch die Sinterhöhen im Kanal nicht bestätigt werden, stößt die vorgeschlagene Lösung einer im Tagesablauf zeitlich begrenzten Zuteilung der Gesamtwassermenge auf jeweils nur einen Strang (bei völliger Sperrung der anderen Stränge) m. E. auf mehrere weitere Probleme: zum ersten legen unsere antiken literarischen Gewährsleute allergrößten Wert darauf, daß alle Leitungen kontinuierlich Tag und Nacht mit Wasser versorgt werden.[27] Zum zweiten müßten wir in den Häusern (und auch in den öffentlichen Gebäuden!) von Pompeji flächendeckend Speicherbecken finden, die mindestens den jeweiligen Tagesbedarf vorhalten und außerdem auch noch genügend Druck für die vielfach anzutreffenden Springbrunnenanlagen liefern könnten. Dies ist aber nicht der Fall, und auch die Untersuchungen über den Wasserverbrauch bzw. die Speicherkapazitäten in den Thermenanlagen[28] sprechen dagegen. Zum dritten geht diese Annahme von außerordentlich groß dimensionierten Rohren aus: die genannten Querschnitte stoßen an die Obergrenze der bei Frontin aufgeführten Normgrößen oder

überschreiten diese sogar, und für Rohre dieser Größe fehlt bislang ein archäologischer Beleg. Wenn man eine getrennte Beaufschlagung im Modell simuliert, kommt es, weil die Rohrgrößen im Modell (in Analogie zur Größe *septuagenaria*, s. o.) wesentlich kleiner sind, bei dem Versuch, die Gesamtwassermenge über ein einziges Rohr abzuleiten, sofort zu einem raschen Aufstau im Becken und in dem betreffenden Auslauf, der nach kurzer Zeit die Aufmauerungen hinter den Sperren und diese selbst überflutet, so daß das Wasser dann doch wieder (allerdings in unterschiedlichen Mengen) in alle drei Rohre fließt.

7. WEITERE UNTERSUCHUNGEN

Ich hatte nach dem Symposium Gelegenheit zu einem ausführlichen Meinungsaustausch mit G. Garbrecht. Auch er bevorzugt entschieden den geschilderten Denkansatz einer flexiblen Steuereinrichtung unmittelbar vor dem Dreiteiler. Eine erste Analyse der Ausformungen der Sinterablagerungen an den Seitenwänden im Bereich dieser Einrichtung anhand von vergrößerten Fotos lieferte weitere Indizien, die diesen Interpretationsansatz zu bestätigen scheinen. Daneben aber entdeckte G. Garbrecht auf den Fotos Sinterablagerungen am Boden des Beckens sowie auch am Boden und an den Seiten der Ausläufe, die über Art und Verlauf von Strömungen und Verwirbelungen, und diese wiederum über die Art der Steuerung durch Filter- oder durch flexible Wehrplatten Auskunft geben könnten. Leider sind diese Befunde und ihre Wichtigkeit bislang noch nicht erkannt und dokumentiert worden. Die betreffenden Sinterschichten sind zum großen Teil noch unter Schmutz- und Algenschichten verborgen und müßten erst einmal gesichert werden. Hier sollen weitere Untersuchungen ansetzen, und es besteht möglicherweise Aussicht, die strittige Frage nach der Art der Steuerung auf diesem Wege klären und beantworten zu können.

Es wurde während des Symposiums vereinbart, das Modell zu zusätzlichen wissenschaftlichen Untersuchungen zur Verfügung zu stellen, um durch weitere Forschungen eine Lösung zu finden, bei der sich die technische Erklärung möglichst widerspruchsfrei mit den archäologischen und philologischen Befunden verbinden läßt.

BIBLIOGRAPHIE

Bassel, K. 1921, Die Wasserleitung von Pompeji, *Die Denkmalpflege* 5, 34-36.

Coarelli, F./E. La Rocca/M. de Vos-Raaijmakers/A. de Vos 1990, *Pompeji, Archäologischer Führer,* Bergisch Gladbach.

Eschebach, H. 1970, Die städtebauliche Entwicklung des antiken Pompeji, *RM Ergh.* 17.

Eschebach, H. 1977, Die innerstädtische Gebrauchswasserversorgung, dargestellt am Beispiel Pompejis, in: J.-P. Boucher (Hrsg.), *Journées d'Etudes sur les aqueducs romains,* 81-132.

Eschebach, H. 1979a, Die Gebrauchswasserversorgung des antiken Pompeji, *AW* 10, 2, 3-24.

Eschebach, H. 1979b, Probleme der Wasserversorgung Pompejis, *CronPomp* 5, 24-60.

Eschebach, H. 1979c, Die Stabianer Thermen in Pompeji, *Denkmäler antiker Architektur* 13, Berlin.

Eschebach, L. 1993, *Gebäudeverzeichnis und Stadtplan der antiken Stadt Pompeji,* Köln.

Fahlbusch, H. 1989[4], Über Abflußmessung und Standardisierung bei den Wasserversorgungsanlagen Roms, *WAS,* 1 München, 129-144.

Ioppolo, G. 1992, *Le terme del Sarno a Pompei,* Rom.

Jacobelli, L. 1993, Die Suburbanen Thermen in Pompei: Architektur, Raumfunktion und Ausstattung, *AKorrBl* 23, 3, 327-335

Kretzschmer, F. 1983[5], *Bilddokumente römischer Technik,* Düsseldorf.

Maiuri, A. 1931, Pozzi e condotture d'acqua nell'antica città. Scoperta di un antico pozzo presso Porta Vesuvio, *NSc,* 546-575.

Maiuri, A. 1942, *L'ultima fase edilizia di Pompei,* Rom.

Manderscheid, H. 1993, Bemerkungen zur Wasserbewirtschaftung der Suburbanen Thermen in Pompei, *AKorrBl* 23, 3, 337-346.

Mau, A. 1904, Ausgrabungen von Pompeji, Kastell der Wasserleitung, *RM,* 41-50.

Mau, A. 1908[2], *Pompeji in Leben und Kunst,* Leipzig.

Mygind, H. 1917, Die Wasserversorgung Pompejis, *Janus* 22, 294-351.

Ohlig, Chr. 1995, Vitruvs 'castellum aquae' und die Wasserverteilung im antiken Pompeji, *Schriftenreihe der Frontinusgesellschaft* 19, 124 - 147.

Paribeni, R. 1903, Relazione degli scavi eseguiti durante il mese di novembre, *NSc,* 25-31.

Sgobbo, I. 1938, L'acquedotto romano della Campania: 'Fontis Augustei Aquaeductus', *NSc,* 75-97.

Spano, G. 1910, Scavi fuori Porta del Vesuvio, *NSc,* 399-418.

Wallat, K. 1993, Opus testaceum in Pompeji, *RM,* 353-382.

antike Autoren:
Sex. I. Frontinus, *De aquaeductu urbis Romae.*
M. Vitruvius Pollio, *De architectura libri decem.*

ANMERKUNGEN

* Meine dem Bau des Modells vorausgehenden Untersuchungen und auch der Bau selbst wären ohne Auskünfte, Ratschläge und Hilfen vieler Fachleute verschiedener Disziplinen nicht möglich gewesen. Mein besonderer Dank gilt deshalb: Herrn Prof. Dr. B. Conticello, Soprintendente von Pompeji; Frau L. Eschebach, Emden; Herrn Prof. Dr. H. Gabelmann, Bonn; Herrn Prof. Dr.-Ing. Dr. G. Garbrecht, Lagesbüttel; Herrn Prof. Dr.-Ing. K. Rathke, Höxter.

[1] Vitruv VIII 6. 1 und 2; ausführlichere Analyse durch Verfasser 1995.

[2] Kretzschmer 1983[5], 62 ff.

[3] Paribeni 1903, 31.

[4] Beitrag Eschebach (1-12).

[5] Paribeni 1903, 28; Mau 1904, 46; Mau 1908[2], 237; Maiuri 1942, 92; Maiuri 1931, 562.

[6] Bleirohre von solcher Größe sind nirgendwo archäologisch belegt und kommen auch nicht in der Größenaufzählung bei Frontinus (vgl. Anm. 8) vor.

[7] Maiuri 1931, 557 (Beschreibung); 558 Fig. 5 (Foto); 559 (Zeichnung und Maße); Maiuri 1942, Taf. 27, fig. a; Abbildung der im Magazin von Pompeji gelagerten Rohre bei Eschebach, 1979a Abb. 14; Eschebach, 1977, Abb. 20.

[8] Fahlbusch 1989[4], Tabelle 4, 141.

[9] Eschebach 1977, 100 f.; Eschebach 1979a, 22; Eschebach 1979b, 58 .

[10] Persönliche Mitteilung von Frau P. Dicker.

[11] Beitrag Peleg (33-36).

[12] Kretzschmer 1983[5], 62 ff.

[13] Spano 1910, 401 f; Maiuri 1931, 562.

[14] Spano 1910, 400; vgl. Coarelli/La Rocca/De Vos-Raaijmakers/De Vos 1990, 377.

[15] Sgobbo 1938, 87.

[16] Wenn man von einer vermuteten älteren Leitung einmal absieht, die bei Eschebach 1977, 85ff; Eschebach 1979a, 7; Eschebach 1979b, 28 f. diskutiert wird, wird diese Leitung in die oktavianische oder frühaugusteische Epoche, also etwa in die Zeit um das Jahr 30 v.Chr., datiert (Mau 1904, 44: "Die ganze Bauart ist die der ersten Kaiserzeit."). Hingegen ist Maiuri 1942, 91 sicher ("segno evidente"), die Ziegelfassade des Verteilergebäudes sei nach dem Erdbeben des Jahres 62 erbaut, und mit dieser Meinung hat er sehr lange die Diskussion bestimmt, vgl. Coarelli/La Rocca/De Vos-Raaijmakers/De Vos 1990, 375 f. Dagegen belegt Wallat 1993, 365 durch Ziegeluntersuchungen die Errichtung der Fassade in augusteischer Zeit.

[17] Maiuri 1931, 556 f.

[18] Interessant ist in diesem Zusammenhang der Hinweis von Eschebach 1979b, 51, wiederholt bei Coarelli/La Rocca/De Vos-Raaijmakers/De Vos 1990, 285, daß z.B. die Bewohner des üppig ausgestatteten und dekorierten samnitischen Stadthauses des C. Iulius Polybius (IX 13, 1-3) kein Frischwasser aus der Wasserleitung bezogen, sondern daß sie für ihr Brauchwasser die 17 m lange Hauszisterne benutzten und das Trinkwasser vermutlich dem Straßenbrunnen vor I 9, 1 entnahmen; vgl. Eschebach 1993, 449.

[19] Beitrag Eschebach (1-12) und Beitrag Wiggers (29-32).

[20] Vgl. Plan der Geländeformation des Stadthügels von Eschebach 1970, 13; den Verlauf der Hauptleitungen kann man m.E. auch relativ deutlich wiedererkennen, wenn man die Verteilung der öffentlichen und privaten Thermenanlagen im Stadtgebiet zueinander in Beziehung setzt, vgl. die angehängte Karte bei Ioppolo 1992. Ähnliche Überlegungen kann man bezüglich der regionalen Verteilung der Betriebe mit hohem Wasserverbrauch bzw. der Privathäuser mit Springbrunnenanlagen anstellen, vgl. Karte bei Eschebach 1979a, Abb. 32. Die Versorgung der Häuser und Betriebe nördlich des Vico di Mercurio bleibt allerdings ungeklärt, weil der erste Wasserpfeiler dieses westlichen Rohrstrangs an der Nordostecke der Regio VI 13 für die Versorgung dieser Gebäude zu niedrig erscheint.

[21] Eschebach 1979b, 59 f.

[22] Untersuchungen von Jacobelli 1993, 329, belegen, daß gerade der Teil der Anlage, in dem sich ein großes beheiztes Schwimmbecken befindet, erst nach 62 n.Chr. errichtet wurde, und Manderscheid 1993, 344, zeigt - nach Untersuchungen zusammen mit G. Garbrecht -, daß diese Anlage mit ihrem hohen Wasserverbrauch ohne einen Anschluß an die städtische Wasserleitung überhaupt nicht zu betreiben gewesen wäre.

[23] Solche Leitungen wurden und werden immer wieder vermutet bzw. beschrieben, z.B. von Bassel 1921, 35. Nach mdl. Mitteilung von L. Eschebach gibt es noch heute eine Vesuvleitung nach Herculaneum, und bis zu den Erdbeben Anfang der 80-er Jahre wurden ein Brunnen im modernen Pompeji (Fontana Salutare) und zwei Heilbäder in Torre Annunziata mit Vesuvwasser gespeist.

[24] Beitrag Ellis (179-184).

[25] Nach dem Symposium erhielt ich allerdings von G. Garbrecht den Hinweis auf eine in ähnlicher Weise durchlöcherte Steinplatte im Verlauf eines Klärbassins der Pergamon-Leitung.

[26] Beitrag Hodge (13-18).

[27] Vitruv (VIII 6. 1) redet nur in Verben des Überfließens (*abundare, redundare*); Vitruv VIII 6. 2 *ne desit in publico* (- es soll im öffentlichen Bereich keinen Mangel an Wasser geben); Frontin 104,2: ... *dare operam, uti salientes publici quam adsiduissime interdiu et noctu aquam in usum populi funderent.* (- die Verantwortlichen sollen sich Mühe geben, dafür zu sorgen, daß die öffentliche Brunnen möglichst beständig Tag und Nacht Wasser zum Nutzen des Volkes fließen lassen.) Frontin läßt in Rom sogar die meisten Brunnen mit einem zweiten Anschluß an eine andere Leitung versehen (87,5: *atque etiam omni parte urbis lacus tam novi quam veteres plerique binos salientes diversarum aquarum acceperunt, ...*), um die Versorgungssicherheit zu erhöhen. Den Sinn dieser scheinbaren Verschwendung guten Wassers beschreibt Frontin in 111,2: *nam necesse est ex castellis aliquam partem aquae effluere, cum hoc pertineat non solum ad urbis nostrae salubritatem, sed etiam ad utilitatem cloacarum abluendarum* (- denn es ist notwendig, einen Teil des Wassers aus den Behältern abfließen zu lassen, weil das nicht nur der Gesundheit unserer Stadt dient, sondern auch nützlich ist, die Kloaken zu spülen.) Vor allem dieser hygienische Aspekt (besseres Klima, Sauberkeit der Straßen, bessere Atemluft usw.) steht auch in 88,3 f. im Vordergrund: *ablatae causae gravioris caeli, munda viarum facies, purior spiritus, quique apud veteres se<mper> urbi infamis aer fuit est remotus.* Dieser Aspekt, den Frontin für Rom beschreibt, dürfte in Pompeji noch viel wichtiger gewesen sein, weil

hier der weitaus größte Teil der Entsorgung, mangels flächendeckender Schmutzwasserkanäle, oberirdisch über die Straßen erfolgen mußte.

[28] Für die Stabianer Thermen: Eschebach 1979c, 32 ff.; für die Forumsthermen: Mau 1908[2], 234 und Mygind 1917, 311 beschreiben die zwar direkt neben der Thermenanlage (in VII 6, 17) liegende Großzisterne (430 cbm Fassungsvermögen).

Deren Boden liegt aber so tief unter dem Niveau der Thermen, daß sie für deren Versorgung ausscheidet; für die Suburbanen Thermen: Manderscheid 1993, 344: "Das täglich benötigte Volumen setzt einen Anschluß der Suburbanen Thermen an die städtische Wasserleitung voraus; nur derart konnte der hohe Bedarf gedeckt werden".

PARKSTRASSE 32
D-46487 WESEL
DEUTSCHLAND

The urban water supply system of Pompeii*

Jan B.M. Wiggers

1. INTRODUCTION

The water supply system as it existed in Pompeii before the destruction of the town was rather sophisticated. It consisted of an aqueduct, a so called *castellum aquae* at the end of the aqueduct, three large pressure mains, watertowers and secondary and tertiary water mains. The *castellum* had the function of dividing the arriving water over the three water mains. Likewise, the function of the watertowers was to enable the supply of the water to reach to the customers and public buildings.

This contribution explains the general operation of the water supply network in Pompeii. Conclusions are based on measurements carried out in Pompeii by students of the Technical University of Delft, the Netherlands, and computations excuted by them.

2. LAYOUT OF THE SYSTEM

2.1. LAYOUT OF THE SYSTEM IN POMPEII

Water entered the town at the north side of Pompeii. The incoming flow was divided in three parts in the *castellum aquae*. This *castellum* is situated at the highest point of ancient Pompeii. The water was delivered to the town by means of an aqueduct, which has been partially excavated.

From the *castellum* the water flowed to watertowers which are prominent features of present day Pompeii. From the watertowers the water was directed to the various points where water was needed. It flowed to private and public fountains, to toilets and kitchens and to fountains which played an ornamental role in the architecture of those days.

1. Likely route along which the water was distributed. ──── *40 quadragenaria;* ──·── *30 tricenaria;* ─ ─ ─ *20 vicenaria;* ········ *15 quinumdenum (drawing P. Dicker).*

Table 1

Watertower	Level m	Height m	Stretch	Distance
Castellum*	50.00		CA-1	146
1	48.93	6.20	1-2	84
2	47.00	6.35	1-14	368
3	42.96	6.05	2-3	135
4	38.85	6.60	3-4	136
5	38.05	4.20	4-5	136
6	33.93	2.74	5-6	273
7	48.07	4.90	CA-7	145
8	48.36	3.00	7-9	259
9	46.13	6.30	7-12	154
10	43.65	3.06	9-11	152
11	44.13	5.73	12-8	113
12	48.09	1.08	12-13	111
13	48.50	0.60	13-10	111
14	43.64	4.56		

* The treshold left of the middle discharge of the *castellum aquae* is choosen as a point of reference, 50 m+, which is not the actual height.

In regard to this system many questions can be asked. Due to the technical background of the researchers the question they found the most interesting was why so many watertowers had been in use compared to a modern water supply system. In modern times for a town of the size of Pompeii one watertower would be sufficient. In the excavated part of Pompeii, however, at least fourteen watertowers have been detected.

The water was led from tower to tower by means of lead pipes. The whole system operated by means of gravity.

2.2. A MODERN WATER SUPPLY SYSTEM

If a modern water supply system were to be designed for the ancient town of Pompeii two governing principles would apply;
- The pressure in the mains must be high enough to ensure a sufficient pressure and a discharge to enable the effective quenching of fires and
- The supplied amount should be sufficient to cope with normal demands during the day. In case of a fire, the pressure in some parts of the town could be allowed to be low since such a situation would be only temporary.

From the aqueduct the water would be pumped to a watertower which would carry a reservoir at its top.

The function of the tower is to allow for a sufficient pressure in the network, as in the case of drawing water from the network to be able to extinguish fires. The purpose of the reservoir is to enable the levelling of the demand which fluctuates over the day.

The pipes and mains would have to be made of cast iron or plastic in order to be able to withstand the pressure. As the price of the supplied water is not negligible the water would not flow freely. Taps at the end of the lines would be closed in case no water is used.

2.3. THE ANCIENT NETWORK OF POMPEII COMPARED TO A POSSIBLE MODERN NETWORK

In *Table 1* the level of the top of the excavated watertowers is given. This level can only be approximate as practically all the towers have suffered from erosion or have been damaged. In the table the length of the towers is also presented. From the collected data the direction in which the water flowed can be detected. The likely route which the water followed is presented in *Fig. 1*.

It is highly probable that the towers were connected to each other by one single conduit. At the top of the towers most likely lead boxes were present. The houses and other connections were attached to these boxes. The flow between two towers was determined

Table 2

| Location | Level | Height | Stretch | Gradient | Eq. diam.[2] | |
	m	m		-	-	
C	50.00	-	C-1	.0073	1.00	
1	48.93	6.20	1-2	.0230	0.74	
2	47.00	6.35	2-3	.0299	0.64	
3	42.96	6.05	3-4	.0302	0.57	
4	38.85	6.60	4-5	.0059	0.67	
5	38.05	4.20	5-6	.0150	0.43	
6	33.96	2.74				

by the interior size of the conduit and the difference in height between the water level in the boxes at the top of adjacent towers. If the difference in height is designated by the symbol H and the diameter of the conduit by D, the flow in the pipe is given by the following formula:

$$Q = \sqrt{2\,g\,\frac{H}{L}\,\frac{D}{\lambda}}\,A$$

L is the length of the pipe between the towers, A is the cross section of the pipe, and λ a constant which depends on the interior roughness of the pipe.

In the following, it has been assumed that from every tower one sixth of the total discharge to this part of the system was extracted. H/L is the so called hydraulic gradient. In *Table 2* the hydraulic gradient for every stretch of the line 1 to 6 is given.

If the diameters of the pipes connecting the towers would have been the same, this would have implied that the flow from the downstream stretch compared to the one in the upstream stretch would have been as follows: 1.77, 1.41, 1.00, 0.44 and 1.60. The exact meaning of these figures is that in case the value is larger than 1 the flow in the downstream pipe is larger than is supplied by the upstream pipe. For all the stretches except one, if the assumption is made that all diameters are the same, the downstream flow is larger than the upstream one. Of course this is impossible in the given case. This holds the more if one considers that at every tower a certain amount of water would have been deduced due to the supply of water to the customers.

If it is, however, assumed that every tower supplied an equal amount of water to the adjacent houses and other premises the needed diameter can be calculated such that sufficient water flowed from tower to tower. The needed relative diameters are presented in *Table 2.*

From the above, it has to be concluded that the diameters of the pipes between the towers differed in size. Unfortunately, the diameters of the pipes connecting the towers are not known, which means that the exact diameters can not be included in the computations.

Still, the question has not been answered why the Romans did not use one tower but many for distributing the water. There are two main reasons:

a. The introduction of towers made it possible to supply water to owners of houses as well as to public buildings under relatively low pressure. One tower for the whole town would have meant high pressures in part of the system. The material used and the way of constructing the urban water supply networks did not allow the needed high pressures.

b. The chosen solution made it easy to add connections to the network as well as closing them. If there were only a single tower from the main distribution line, it would have to be closed in the event that a building needed repair or when the whole system required any alteration. This, of course, would have cut off water temporarily to all customers. Clearly the use of towers as employed at Pompeii made repair and reconstruction easier.

3. THE FUNCTIONING OF THE NETWORK

Practically all towers show signs of calcarious crustations on the outside. The very existence of these crustations means that water leaked from the reservoir at the top of the towers. This paper does not present the calculations which can be made based on assumed possible diameters of the pipes which connect the towers. From such computations, however, we can conclude that it was inevitable that water leaked from the towers, which consequently resulted in the deposits of calcite on the walls of the towers. Only in

very limited combinations of supply to a tower, the amount supplied to the customers, and the outflow, could an equilibrium have existed such that no water was lost. The system in Pompeii clearly has been designed to allow for an abundant supply of water. The whole procedure was to keep the reservoirs at the top of the towers full and overflowing. This ensured the proper supply of water.

The Roman engineers did not have the tools to design a system that would fulfill the requirements. These tools were only developed in the middle of the last century. This means that the construction of the network was based part on experience and part on a trial and error method. When visiting Pompeii and observing the various watertowers, one clearly sees that many of them have been altered. They have been heightened and possibly also lowered, although this is difficult to prove given the condition of the masonry in the towers.

4. CONCLUSIONS

The water supply system of Pompeii, which existed at the time of the destruction of the town, has not been designed and constructed based on scientific knowledge. The chosen solution, however, is a clever one as it allowed changes and extensions of the system to be made with relative ease. In addition, when the water supply was inadequate in certain parts of the town, the system could easily be adjusted.

The reasons why the Romans chose the water supply system as it is found in Pompeii are:

- They lacked the scientific tools to design a more efficient and robust network and
- The quality of the used material did not allow for the construction of high pressure water supply networks.

NOTES

* This contribution is based on field work and research carried out to assist in the preparation of a doctoral thesis by Gemma Jansen. The field work was carried out by Paulette Dicker, Frank Jansen and Jaap van Leeuwen, at the time of the survey all three students at the Delft University of Technology.

[1] The geodetic data were collected in the summer of 1992 by Frank Jansen and Jaap van Leeuwen which at that time were students at the Delft University of Technology.

[2] = Equivalent diameter. If the diameter of the line from the *castellum* to tower 1 is set at 1,00 relatively, the diameter of the other stretches would then be as indicated in the column below.

FACULTEIT DER CIVIELE TECHNIEK
POSTBUS 5048
NL- 2600 GA DELFT
THE NETHERLANDS

Der Zweck und der Betrieb der Wassertürme von Pompeji

Jehuda Peleg

Einleitung

Die Wassertürme von Pompeji sind wohl bekannt. Sie werden in der Literatur als Verteiler, regionale *castella*, Abnahmepunkte und ähnlich bezeichnet. Doch fehlt bisher eine überzeugende Erklärung, warum gerade in Pompeji, und Herculaneum, diese Türme nötig waren und wie sie funktioniert haben. Das scheint daran zu liegen, daß die meisten Wissenschaftler, die sich bisher mit Pompeji beschäftigt haben, Archäologen oder Historiker waren, denen technisches Denken nicht unbedingt nahe lag.

Einer der Verfasser schreibt zum Beispiel:[1] "Wahrscheinlicher ist, daß die Piscina[2] das Wasser direkt aus einer Hauptleitung (also nicht von einem Turm) erhielt. Da von hier ein Gefälle von etwa 4 m bestand, benötigte das Wasser keinen Druckverstärker". – Wassertürme können aber sicherlich den Druck nicht verstärken.

Kretzschmer, Eschebach und Dykbjær-Larsen haben versucht den Zweck der Wassertürme zu erkennen und zu beschreiben, doch scheint es, daß eine vollständigere Erklärung ihrer Funktion und Bauart im Rahmen des ganzen Wasserversorgungssystems der Stadt noch fehlt.

Im Kanal der Fernwasserleitung floß das Wasser zu dem Wasserschloß, das an dem höchsten Punkte Pompeji's lag. Daran schloß sich das Innerstädtische Versorgungsystem an, das aus Bleidruckrohren bestand. Der niedrigste Laufbrunnen in der Stadt lag ungefähr 35 m tiefer als das Wasserschloß.

Der Unterschied zwischen antiken und modernen Systemen

Das System der Wasserversorgung in Pompeji und allgemein in der Antike war grundsätzlich andersartig als moderne Systeme. Heutige Systeme sind geschlossene Systeme, die von einem Hochbehälter oder einer anderen Einrichtung aus gespeist werden. Wenn kein Wasser gebraucht wird, somit kein Wasserhahn geöffnet wird, fließt das Wasser in der Leitung nicht. Nur wenn irgendwo Wasser aus dem Leitungsnetz entnommen wird, fließt es.

Antike Systeme waren offene Systeme, das heißt, daß das Wasser ständig lief. Der Überfluß aus den Laufbrunnen spülte die Straßen und die Kanalisation. (Frontinus *De Aqaeductu urbis Romae* 111). In vielen alten europäischen Städten erinnern die Laufbrunnen an diese Art der Wasserversorgung.

Einen Beweis für das offene System liefern uns die Normdüsen *(calix)*, die in Pompeji *in situ* gefunden wurden. Zum Beispiel an der Nordostecke der Insula II 1.[3] Solche Normdüsen bestimmten einerseits das Recht auf einen gewissen Wasserzufluß, andererseits aber damit auch die Höhe des Wassergeldes. Nur unter der Annahme, daß das Wasser stetig läuft, hat solch eine Einrichtung einen Sinn.

Druckzonen

Aufgrund der heutigen Kenntnis von hydraulischen Zusammenhängen, wissen wir um die Schwierigkeiten, ein offenes Druckrohrsystem in einem Terrain, in dem die Höhenunterschiede 35 m erreichen, zu installieren. Ohne eine Einrichtung, den Druck entlang des Abhanges in einzelne, unabhängige Abschnitte zu unterteilen, würden die oberen Stadtteile ohne Wasserversorgung bleiben.

Um die Stadt in einige Druckzonen aufzuteilen, wurden die Wassertürme errichtet und offene Becken auf ihnen installiert. Die Hauptleitungen führten zu ihnen hinauf und wieder herunter. Durch die Becken strömte das Wasser mit freiem Spiegel *(Abb. 1)*.

Auf diese Art war der Druck in jedem Teil des Versorgungssystems durch die Höhe des zugehörigen Turmes und entsprechend seiner topographischen Lage gesichert.

Der genaue Verlauf der Rohrleitungen in der Stadt ist unbekannt. Doch ist anzunehmen, daß eine Hauptleitung in der Via Stabiana, der Straße, die von dem Wasserschloß quer durch die Stadt lief, verlegt war. Entlang dieser Straße stehen 4 Wassertürme. Die Höhe der Türme liegt zwischen 6.05 und 6.6 m, die Unterschiede zwischen den geodätischen Höhen der Turmstandorte zwischen 2.5 und 4.1 m.[4]

Von den geringen Druckänderungen aufgrund der Strömungsunterschiede abgesehen, wird der Druck in der Leitung zwischen je zwei Türmen, von der Höhe des höheren Turmes und der jeweiligen topographischen Lage bestimmt.

1. Schematischer Plan der Verteilung der Wassertürme entlang der Leitung.

Daher betrug der Druck auf Bodenhöhe, in der Leitung entlang der Via Stabiana, zwischen 0.6 und 1.01 bar. Es ist anzunehmen daß auch in den anderen Leitungen in der Stadt ähnliche Druckverhältnisse herrschten *(Abb. 2)*.

Tabelle 1
Druckverhältnisse in der Leitung entlang der Via Stabiana

Turm	t	h	t + h	Δ t	Δ t + h
1	34.70	**6.20**	40.90		
				2.50	**8.70**
2	32.20	**6.35**	38.55		
				3.20	**9.55**
3	29.00	<u>**6.05**</u>	35.05		
				4.10	<u>**10.15**</u>
4	24.90	6.60	31.5		

t	=	topographische Lage
h	=	Höhe der Türme,
Δ t	=	$t_1 - t_2$
h	=	minimaler Druck zwischen zwei Türmen
Δ t + h	=	maximaler Druck zwischen zwei Türmen

Es ist zu betonen, daß die Türme nicht auf die Hauptleitung 'aufgesetzt' waren, sondern diese wurde in jedem Turm hinauf- und hinabgeführt.

Fraglich ist, ob der letzte Wasserturm jeder Leitung anders gestaltet war als die Türme entlang der Leitung. Zwei Wassertürme haben nur eine Aussparung statt der üblichen zwei. Es sind die Türme 11 und 12 in Dykbjær-Larsens Plan und sie liegen nahe dem südlichen, das heißt dem tiefer gelegenen Rande der Stadt. Diese Umstände scheinen anzudeuten, daß diese Türme Endpunkte von zwei Hauptleitungen, in diesem Falle im südwestlichen Teil der Stadt waren. Offensichtlich wurden die Rohre in den Aussparungen nur noch in den Türmen hochgeführt und das Wasser von hier an die umliegenden Verbraucher verteilt bzw. als Überlauf abgeführt.[5]

Dykbjær-Larsen zählt in Pompeji 11 Wassertürme auf und erwähnt noch den Bogen des Caligula am Ende der Via Mercurio, auf dem vielleicht ein Bleikasten als Hochbehälter stand. Eschebach zeigt in seinem Plan 10 Wassertürme und 6 Hochbehälter. Es ist wahrscheinlich, daß die Hochbehälter genau so wie die Wassertürme funktionierten.

2. Druckverhältnisse in der Leitung entlang der Via Stabia. Z = topographische Lage, h = Höhe der Türme, H= Druck in m Wassersäule.

ENTLÜFTUNG UND DRUCKSCHLAG VERMEIDUNG

Außerdem ermöglichte dieses System auch, daß Luft aus den Röhren über die Becken abgeschieden werden konnte und eventuelle Druckschläge vermieden wurden. In Strömungsuntersuchungen an einem Modell des *castellum aquae* von Pompeji, wurde während größerer Strömung Luft in die Leitungen eingezogen.[6] Das heißt, daß es in manchen Fällen Luftblasen in den Leitungen gab. Auch Druckschläge konnten während der Füllung oder Entleerung vorkommen. Beide schädlichen Erscheinungen wurden durch das Einschalten der Wassertürme wirksam gelöst. Damit ist nicht gesagt, daß diese Wirkung theoretisch geplant war.

DER WASSERDRUCK IN DEN ROHREN UND HÄHNEN

Die Wassertürme begrenzten den Druck in den Leitungen. Nach Kretzschmer[7] war die Notwendigkeit der Wassertürme durch die Konstruktionsart der römischen Wasserhähne bedingt. Nach seiner Meinung konnten die Hähne aufgrund ihrer Konstruktion höchstens einem Druck von 0,5 - 0,6 bar widerstehen. In modernen Hähnen sitzt das Küken in einer kegelförmigen Bohrung und wird durch eine Schraube mit einer Unterlegscheibe gehalten. In römischen Hähnen sind Bohrung und Küken zylindrisch. Ein eingelöteter Deckel schließt den Hahnkörper auf der Unterseite. Zwischen diesem Deckel und dem Küken gibt es einen Hohlraum. Das hier unter Druck stehende Wasser preßt das Küken nach oben und droht, es aus dem Körper herauszudrücken. Diesem Druck wirkte hauptsächlich das Eigengewicht des Kükens entgegen. Der präzise dünnwandige Bronzeguß und die Anfertigung

der Hähne auf einer Drehbank zeugen von dem hohen technischen Können der Römer *(Abb. 3).*

Nach Kretzschmer[8] war es aufgrund der Konstruktion der Wasserhähne erforderlich, daß das Drucksystem in Bereiche unterteilt wurde, in denen der Wasserdruck den vorher genannten Wert von 0,5 - 0,6 bar nicht überstieg. Diese Unterteilung wurde nach seiner Meinung mit Hilfe der Wassertürme erreicht. Die Berechnung der Druckverhältnisse entlang der Via Stabia nach *Tabelle 1* weist aber höhere Werte auf.

Die Ansicht, daß auch die Zugfestigkeit der Bleirohre solch eine Begrenzung des Wasserdruckes bedingte, ist nicht richtig. Schon am Ende des vorigen Jahrhunderts wurde in einem Versuch bewiesen, daß antike Bleirohre einem Druck von bis zu 18 bar widerstehen konnten.[9]

WASSERTÜRME ALS VERTEILER

Leider ist unser Wissen über die konstruktiven Details der Einrichtungen auf den Wassertürmen sehr begrenzt. Wir kennen nur die Pfeiler aus Mauerwerk mit Aussparungen für die Bleirohre, die hinauf und herunter führten. In manchen Fällen gibt es Abdrücke von Bleirohren im Kalksinter, der das Mauerwerk überzieht. Diese Abdrücke findet man aber nicht nur in den Aussparungen, sondern auch an Wänden. In der Tat sind sie dort zahlreicher. Das bedeutet, daß Rohre nicht nur in den Aussparungen geführt wurden, sondern auch an den Wänden angebracht waren. Es ist anzunehmen, daß diese Verteilerrohre waren.

In mehren Fällen sind in den Turmwänden Spuren von Eisenstiften zu sehen.[10] Sie sind paarweise angeordnet und weisen auf die Art der Rohrbefestigung mit Eisenstiften und Klammern aus Blei hin. Solche Klammern sind an den Bleirohren gegenüber des Vetti Hauses zu sehen.

Es wird allgemein angenommen, daß die Becken auf den Türmen Bleikästen waren. Ein solcher wurde in 1917 an der Insula II 2 ausgegraben. Seine Maße be-

3. Vergleich eines modernen Hahnes mit einem typischen römischen Hahn (Kretzschmer 1960).

trugen 65 x 65 x 65 cm und die Stärke der Bleiplatten 6 mm. An ihn waren an der Straßenseite zwei Rohre angelötet. Leider ist der Kasten nicht mehr auffindbar.[11]

ZUSAMMENFASSUNG

Pompeji und Herculaneum waren an Abhängen gebaut. Die wichtigste Funktion der Wassertürme war offensichtlich allen Abnehmern einen systemgerechten Druck zu sichern. Zu diesem Zwecke mußten alle Hauptleitungen durch die Becken auf den Türmen oder andere Hochbehälter führen. Außerdem wurden mit Hilfe dieser Einrichtung die Leitungen entlüftet und Druckschläge vermieden.

Die Wassertürme von Pompeji scheinen die Vorläufer der Suterasi,[12] der Wassertürme im Verlauf der türkischen Wasserleitungen, zu sein. Diese Wassertürme sind wenigstens äußerlich den Türmen von Pompeji sehr ähnlich. Nur werden hier die Rohre im Mauerwerk geführt und die Becken sind nicht aus Blei sondern gemauert. Suterasi waren, zum Beispiel in Akko (Israel), bis 1948 noch in Betrieb. Leider hat sich die Forschung mit dem Thema des Zweckes und der Betriebsweise der Suterasi bisher fast nicht beschäftigt.

Unsere Kenntnis über die Verteilung von Wasser in antiken Städten ist sehr begrenzt. Pompeji sollte eigentlich eine einmalige Gelegenheit zu der Erforschung dieses Themas bieten. Leider wurde bei den Ausgrabungen in der Vergangenheit dieser Frage nicht genug Aufmerksamkeit gewidmet.

BIBLIOGRAPHIE

Andreossy, M. 1828, *Constantinople et le Bosphore de Thrace*, Paris.

Belgrand, M. 1875, *Les aqueducs romains*, Paris.

Dybkjær-Larsen, J. 1982, The Water Towers in Pompeii, *AnalRom* 11 II, 41-67.

Eschebach, H. 1979, Die Gebrauchswasserversorgung des antiken Pompeji, *AW* 10, 3-24.

Forchheimer, P./J. Strzygowski 1893, *Die Byzantinischen Wasserbehälter von Konstantinopel*, Wien.

Frontinus S.J. : *De aquaeductu urbis Romae*.

Kretzschmer, F. 1960/61, Römische Wasserhähne, *JbSchwUrgesch* 48, 50-62.

Kretzschmer, F. 1967, *Bilddokumentation römischer Technik*, Düsseldorf.

Mau, A. 1908², *Pompeji in Leben und Kunst*, Leipzig.

Ohlig, C. 1995, Vitruvs 'Castellum Aquae' und die Wasserversorgung im antiken Pompeji, *Schriftenreihe der Frontinus-Gesellschaft* 19, 124-147.

KIBBUTZ MAAYAN ZVI
30805 ISRAEL

ANMERKUNGEN

[1] Eschebach 1979, 16.
[2] Die *piscina* der Großen Palästra.
[3] Eschebach 1979, 16.
[4] Alle topographischen Daten und Messungen der Türme sind Dykbjær-Larsen (1982) entnommen.
[5] Ich danke Drs. Gerda de Kleijn, die mich auf die wahrscheinlichen Endtürme aufmerksam gemacht hat.
[6] Persönliche Mitteilung von Herrn Ohlig (Ohlig 1995, 143).
[7] Kretzschmer 1960/61, 64.
[8] Kretzschmer 1960/61, 64.
[9] Belgrand 1875.
[10] Eschebach 1979, 14.
[11] Eschebach 1979, 16.
[12] Andreossy 1827, 389; Forchheimer/Strzygowski 1893, 23-29.

L'impianto idrico a Pompei nel 79 d.C. Nuovi dati

Salvatore Ciro Nappo

Le indagini archeologiche, finalizzate alla messa in opera di condutture moderne al servizio della città antica, effettuati tra il 1992 ed il 1994, hanno interessato i marciapiedi delle principali strade urbane *(fig. 1)*. Questi lavori hanno permesso di vedere su più vasta scala lo stato delle cose circa l'impianto idrico di Pompei nel periodo immediatamente precedente all'eruzione del 79 d.C. e di formulare nuove ipotesi circa il suo funzionamento.[1] Maiuri era dell'opinione che il sistema idrico urbano alimentato dall'acquedotto Claudio[2] e basato sul *castellum aquae* di Porta Vesuvio,[3] dotato come prescriveva Vitruvio di tripartitore e lamine di piombo per la purificazione delle acque,[4] e distribuito attraverso ramificazioni plumbee, nel 79 d.C. non era più in funzione a causa dei danni del terremoto del 62 d.C. e che si stava lavorando per il suo ripristino.[5] Maiuri riferisce che nel 1931 i lavori di posa di una nuova condotta idrica, dal nuovo serbatoio - posto nel terrapieno intramurale di Porta Vesuvio - fino ai Teatri, aveva reso necessario lo scavo lungo tutti i marciapiedi occidentali prospicienti le *insulae* di Via Stabia,[6] e che era stato rinvenuto '...in alcuni tratti...' una trincea piena di lapillo non sconvolto entro la quale erano stati rinvenuti due pezzi di grandi *fistulae* in positura originaria in corrispondenza dell'Isola degli Amorini Dorati (VI 16) e li interpreta come prova dell'asportazione delle condotte plumbee dell'impianto idrico di età augustea gravemente danneggiato dal terremoto del 62 d.C.; ricollegando allo stesso fenomeno il rinvenimento nel 1903 di altri due frammenti in prossimità dell'angolo sud-est della stessa insula ed il pezzo rinvenuto nel corpo orientale delle Terme Stabiane aggiunto su Via di Stabia,[7] ipotizza che, in previsione dell'allestimento del nuovo impianto idrico, gli *officinatores* stessero asportando le *fistulae* per rifonderle e quindi posare nuovo materiale. Frattanto, sempre secondo lo studioso, funzionava una rete di distribuzione provvisoria che garantiva l'acqua in case importanti come Casa dei Vetti, Casa del Menandro, Casa dell'Efebo, Casa di Trebio Valente, Casa di Loreio Tiburtino. Lo stesso Maiuri aveva ribadito queste convinzioni liberando dal lapillo il diverticolo che separa le *insulae* 1 e 2 della *regio* II e che collegava Via dell'Abbondanza con l'area della Grande Palestra e rinvenendo una trincea profonda quasi 1,5 metri completamente piena di lapillo da collegare con la valvola idraulica che si trova nell'angolo nord-occidentale del vicolo ed i

resti della condotta che alimentava la Grande Palestra e che egli stesso rinvenne.[8] Eschebach, al contrario, ebbe modo di affermare, con diverse osservazioni, che necessariamente un nuovo impianto idrico doveva essere in funzione negli anni successivi al terremoto del 62; lo studioso registrava che un gran numero di edifici sia pubblici che privati nel 79 d.C. comunque erano serviti da una condotta idrica plumbea e che gli ingenti e diffusi lavori di restauro non potevano fare a meno di una idonea e soddisfacente distribuzione dell'acqua pubblica. Infine Eschebach, per quanto riguarda l'incompletezza o l'apparente dismissione delle *fistulae*, dei serbatoi plumbei ecc. ritiene che questo sia imputabile a vari fattori e cioè alle asportazioni degli elementi di piombo durante gli scavi moderni senza opportune segnalazioni e ai recuperi fatti subito dopo l'eruzione dei materiali preziosi e riutilizzabili, ed il piombo era uno di questi.[9]

Le indagini ed i lavori recenti hanno permesso di riosservare il fenomeno su più vasta scala e di acquisire nuovi elementi che chiaramente sono riferibili solo alla parte esplorata.
Il primo dato rilevante è che lungo gran parte delle strade cittadine era presente un cavo antico vuoto e a cielo aperto riempitosi di lapillo al momento dell'eruzione del 79 d.C. *(fig. 2)*. Il cavo, posizionato quasi sempre a ridosso dei basoli che delimitano il marciapiede, ha una larghezza che varia tra i 60 ed i 90 cm ed una profondità che in qualche caso raggiunge i 160 cm dal piano del marciapiede *(fig. 3)*; generalmente è più profondo in corrispondenza degli attraversamenti viari basolati.

Per quanto riguarda Via di Stabia, sul marciapiede occidentale, si è potuto precisare che la trincea antica piena di lapillo non corre lungo tutti i marciapiedi, infatti manca proprio dall'ingresso della Casa degli Amorini Dorati (VI 16 (6).7.38) fino alla piazzetta antistante il *castellum aquae* di Porta Vesuvio, manca inoltre in corrispondenza delle botteghe VII 3, 15 e VII 3, 16, dall'ingresso secondario delle Terme Stabiane fino all'angolo sud-est dell'*insula,* ed infine in corrispondenza degli attraversamenti viari. In questi tratti, ove lo scavo attuale ha raggiunto quasi sempre gli strati sterili, non solo non si è trovata alcuna traccia di trincea piena di lapillo, né di *fistulae* ma neanche di nessuno scavo antico. Inoltre si sono rinvenuti

1. Tratti della città antica oggetto di indagine archeologica.

2. Rinvenimento del cavo riempito dal lapillo lungo i marciapiedi della città.

38

3. Rinvenimento del cavo riempito dal lapillo tra le insulae II 3 e II 2.

altri pezzi di *fistulae:* un lungo pezzo di conduttura *vicenaria* (3,6 m) davanti alla bottega VI 14, 31 entro il cavo pieno di lapillo e quasi alla stessa quota della conduttura sistemata nel 1931, e due *fistulae duodenariae* che penetrano la prima nella casa VI 14, 20 e la seconda in VI 14, 28. Lungo il percorso si è potuto notare che là dove in antico era stato praticato lo scavo, erano state interrotte tutte le canalette di troppo pieno a servizio degli impluvi. Si sono inoltre notate le penetrazioni dello scavo della trincea entro le case, anch'esse piene di lapillo pulito, che presumibilmente avrebbero ospitato in futuro le condutture plumbee. Per quanto riguarda il marciapiede orientale di Via di Stabia esso è stato indagato in vari punti: nella estrema parte settentrionale (V 6, 14-18) non si è individuato nessun cavo pieno di lapillo o altro; in corrispondenza di IX 1, 6, ove è stato condotto un saggio fino a raggiungere gli strati sterili, ugualmente non si sono trovate tracce di apprestamenti riferibili ad un impianto idrico; infine lungo tutto il fronte delle *insulae* 1, 2, 3, 4 della *regio* I, qui in corrispondenza dell'*insula* I 4 si è rinvenuto la trincea piena di lapillo con gli stessi fenomeni di interruzione delle canalette che sversavano acque piovane sulla strada e di penetrazioni all'interno delle case (I 4, 5; I 4, 10), ma non si sono rinvenute altre *fistulae*. Questo cavo è collegato a nord con quello che scende lungo il marciapiede meridionale di Via dell'Abbondanza verso est e si interrompe bruscamente a sud in corrispondenza della strada che divide le *insulae* 3 e 4 della *regio* I. Per il resto del percorso sul marciapiede orientale, fino a Porta Stabia, non si sono rinvenuti elementi che facciano pensare ad un impianto idrico. Restando nell'area della *regio* VI si è potuto accertare il cavo

pieno di lapillo nel Vico dei Vetti dall'angolo nord-ovest dell'*insula* 16 fino alla fontana n.21.[10] Questo cavo doveva presumibilmente continuare, scendendo verso sud, fino all'angolo sud-ovest dell'*insula* 14: qui inoltre l'indagine archeologica oltre a mettere in luce il cavo pieno di lapillo proveniente da nord, ha rivelato che lo stesso attraversava la strada per passare sul marciapiede meridionale di Via della Fortuna per proseguire verso ovest ma non verso est. Infatti sul marciapiede meridionale di Via della Fortuna (*insulae* VII 3, VII 4) il cavo pieno di lapillo è stato rinvenuto solo in corrispondenza dell'*insula* VII 4 ma interrotto, a tratti, all'altezza degli ingressi delle case n.57, 51 e 48 fino all'angolo nord-est dell'*insula*. Altro elemento interessante è che lungo lo stesso marciapiede si è rinvenuto a tratti una *fistula* di piccolo modulo posata a circa 20 cm dai blocchi che delimitano il marciapiede e posta ad una quota di -15 cm circa rispetto alla faccia superiore degli stessi. La *fistula* proviene da nord e, passando sotto la strada lastricata, si innesta

4. Rinvenimento di fistulae in corrispondenza di IX 4, 22.

sul marciapiede in corrispondenza dell'interstizio tra l'ultimo ed il penultimo basolo dello stesso, in prossimità dell'angolo nord-est dell'*insula* VII 4, purtroppo nessun elemento ha fatto capire dove fosse diretta.

Via di Nola è stata indagata solo lungo il marciapiede meridionale in corrispondenza delle *insulae* IX 4, IX 5, IX 8 fino alla fontana n.40 ed infine nell'angolo nord-ovest dell'*insula* IX 10. Anche qui è apparso per lunghi tratti il cavo antico riempito dal lapillo, e poiché è stato individuato anche in corrispondenza dell'*insula* IX 10 con chiare tracce di continuazione ancor più verso est, è evidente che il lavoro interessava il marciapiede meridionale di Via di Nola per l'intera lunghezza. Elemento di notevole interesse è il fatto che nei tratti in antico non scavati, e per la precisione in corrispondenza dei civici IX 4, 22 (oltre 6 m), IX 4, 17 (oltre 5 m, dall'ingresso verso ovest), sono stati individuati due tratti consistenti di *fistulae* di piombo vicenarie disposte a diversa profondità *(fig. 4)*. Nel primo tratto la conduttura posta alla quota più bassa, poggia su di uno strato molto compatto assimilabile ad un calpestio che si trova più o meno alla stessa quota della strada basolata. Questa conduttura, provenendo da nord, passa sotto il basolato stradale e sbocca sul marciapiede utilizzando lo spazio tra due basoli che contengono il marciapiede all'altezza del civico IX 4, 22 (sotto il 5° basolo a partire dall'angolo nord-ovest dell'*insula*). La seconda conduttura, posta ad una quota più alta rispetto alla prima, ha le stesse caratteristiche fisiche della precedente, anche se appare maggiormente usurata e ricoperta da uno strato di calce a mo' di scialbatura. Anche questa *fistula* proviene da nord passando sotto il basolato stradale, ma sbocca sul marciapiede incuneandosi tra il secondo ed il terzo basolo dell'estremità ovest del marciapiede. Il secondo tratto delle due condutture idriche (da 3,3 m ad est dello stipite meridionale del n.civico IX 4, 18 fino a 1,4 m ad est dello stipite orientale del n.civico 17) permette di stabilire con una certa approssimazione la quota delle due condotte idriche: quella superiore al livello del calpestio, quella inferiore a -32 cm dal

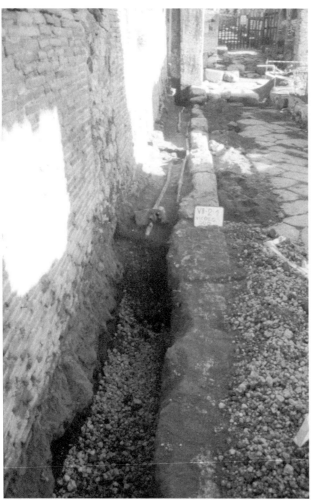

5. *Rinvenimento di fistulae e cavo riempito di lapillo nel Vico degli Augustali.*

6. *Rinvenimento del cavo riempito dal lapillo fuori Porta Ercolano.*

piano dei basoli di contenimento del marciapiede. La *fistula* alla quota più bassa corre anche in questo caso su di uno strato molto compatto da assimilare ad un calpestio. Le indagini stratigrafiche non offrono elementi che possano determinare una differenziazione cronologica tra le due *fistulae:* il piano duro sul quale insiste la condotta più bassa è pertinente alla basolatura di Via di Nola e sotto di esso appaiono subito strati sterili non antropizzati, il riempimento al di sopra di esso fino alla quota superiore dei basoli restituisce elementi che coprono tutto il I sec. d.C, eppure dovrebbe essere avvenuto contemporaneamente alla sistemazione dei basoli del marciapiede stesso, che è funzionale alla strada. Evidentemente lo scavo per controllare o forse in parte sostituire la conduttura più bassa è avvenuto in tempi relativamente recenti, cioè dopo il terremoto, ed il conseguente riempimento, come è prevedibile, è avvenuto con lo stesso materiale precedentemente sterrato. Appare comunque certo che le due *fistulae* non erano a servizio delle costruende Terme Centrali, sia per l'esiguo spessore delle stesse, sia perché non si è trovata nessuna traccia evidente del loro ingresso nell'*insula*. Una penetrazione all'interno dell'*insula* è stata rintracciata al n.civico IX 4, 20 ad ovest dell'ingresso, ed un'altra in corrispondenza del civico IX 4, 19, entrambe pertinenti, in quanto fisicamente collegate, al cavo riempito dal lapillo. Un elemento permette probabilmente di determinare che lo scavo della trincea riempita dal lapillo è cominciato quando i lavori di costruzione delle Terme Centrali erano già ad un buon punto, infatti la trincea taglia inesorabilmente una canaletta a circa 5,3 m ad ovest dello stipite occidentale del civico IX 4, 17; questa, con andamento sud-ovest-nord-est, proviene dal complesso termale e presenta un bacino rettangolare foderato di cemento idraulico di buona fattura senza segni di usura, è larga 27 cm ed è alta 22 cm.[11] In corrispondenza del marciapiede settentrionale dell'*insula* IX 5, i tratti risparmiati dallo scavo della trincea corrispondono esattamente agli ingressi IX 5, 6; IX 5, 9; IX 5, 11. Evidentemente i proprietari di queste case, adducendo chissà quali motivi, erano riusciti a ritardare lo scavo davanti casa ed a risparmiare per il momento il taglio delle canalette di troppo pieno collegate all'impluvio delle rispettive case.

Anche lo scavo condotto lungo lo stretto marciapiede settentrionale di Via degli Augustali, in corrispondenza delle *insulae* VII-2, ha rivelato una situazione abbastanza diversificata. L'angolo sud-est dell'*insula* è in parte occupato da un *castellum plumbeum* e probabilmente da esso discendevano le due condotte di piombo rinvenute nel primo tratto del marciapiede poste pochi centimetri sotto il piano di calpestio *(fig. 5);* le due *fistulae* che si spingono verso ovest, lunghe ciascuna quasi 9 m, sembrano essere una *octonaria* e l'altra *denaria.* I due tubi, in qualche caso anche riparati in antico, presentano saldature a distanze irregolari; la condotta di diametro minore, quasi nella parte terminale, ad ovest, presenta una cassetta di piombo dalla quale si dirama comunque un solo tubo. Le *fistulae* si interrompono proprio in corrispondenza dell'inizio del cavo riempito dal lapillo e sembrano essere in fase di dismissione, infatti sempre la *fistula octonaria* presenta nella parte centrale una lacuna, con una parte terminale incurvata verso l'alto e resecata irregolarmente. Il cavo riempito dal lapillo continua fino allo stipite orientale dell'ingresso VII 4, 50. A questo punto inizia una specie di galleria con volta a botte alta 103 cm e larga 80 cm, non è facile determinare la funzione di questa struttura in quanto al momento dell'eruzione essa non era più attiva, infatti presenta in gran parte la volta crollata ed è piena di materiale edile antico di risulta, è stato possibile verificare che essa inizia all'altezza del n.civico VII 2, 48 ed è leggermente inclinata verso est, presenta cemento idraulico molto rovinato ed è costruita in *opera incerta.* In effetti la progressione dello scavo della trincea riempita dal lapillo stava smontando anche questa struttura. Subito dopo si rinvengono nuovamente le stesse due *fistulae* della parte iniziale: la *octonaria* entra nel civico VII 2, 44.45 (Casa dell'Orso) passando in corrispondenza dello stipite orientale in laterizio, ma proprio a pochi centimetri dal muro si innesta su di essa una *fistula* di modulo minore *(quinaria)* che serve sempre la stessa casa ma entra in corrispondenza dell'ambiente G che è una cucina. La *fistula denaria* invece prosegue fino all'altezza dello stipite occidentale dell'ingresso della Casa dell'Orso ove si infila sotto i basoli che contengono il marciapiede, passa sotto la strada e scende giù lungo il Vico del Lupanare. Proseguendo verso ovest sul marciapiede settentrionale di Via degli Augustali fino alla fontana n.23 non si incontra nessun altro apprestamento idraulico.

Restando nell'area settentrionale della città, non si è rinvenuta alcuna traccia di impianto idrico sui due marciapiedi di Via del Foro, sul marciapiede meridionale di Via delle Terme, nel Vico di Modesto e sul marciapiede occidentale di Via Consolare. Invece le indagini archeologiche sul lato meridionale di Vico di Mercurio in corrispondenza delle *insulae* VI 6 e VI 8 hanno rivelato che nello strettissimo ambito del marciapiede era stato praticato lo scavo anche abbastanza profondo tanto da far crollare, durante i tragici momenti dell'eruzione, parte dei blocchi che delimitano i marciapiedi nella trincea scavata. Non immaginiamo

come avrebbero potuto proseguire i lavori per congiungere lo scavo di Vico di Mercurio con Via Consolare, visto che la strada in corrispondenza dell'*insula* VI 3 non consentiva alcun tipo di passaggio in quanto completamente basolata con i blocchi del marciapiede direttamente appoggiati ai muri, tanto che i recenti lavori per effettuare questo collegamento hanno dovuto cercare un'altra strada. Un altro tratto con il cavo riempito dal lapillo si è rinvenuto sul marciapiede orientale di Via Consolare dal civico VI 2, 7 fino al civico VI 3,10 risparmiando solo il tratto che corrisponde alla facciata di Casa di Sallustio (VI 2, 4). Di estremo interesse appare il rinvenimento del cavo di lapillo fuori Porta Ercolano visto per un piccolo tratto di fronte alla tomba n.4 del versante occidentale della necropoli *(fig. 6)*; il cavo qui si presenta molto profondo, oltre 1,8 m dal piano di calpestio attuale, è largo circa 55 cm e taglia tutta la sovrapposizione stratigrafica fino a scendere nello strato pozzolanico sterile di colore giallo. Infine un piccolo tratto è stato individuato su marciapiede settentrionale di Via delle Terme in corrispondenza del civico VI 6, 3, questo però sembra proseguire verso est, mentre si interrompe poco prima della Casa di Pansa (VI 6, 1.8.12.13).

Estremamente complessa e differenziata si presenta la situazione sul lungo tratto di Via dell'Abbondanza. L'indagine archeologica ha interessato tutto il marciapiede meridionale, dalla cosidetta Porta Sarno fino all'altezza della fontana n.28, da qui fino al Foro Civile si è lavorato sul versante settentrionale. Partendo da est, da Porta di Sarno, in corrispondenza delle *insulae* II 5 e II 4 fino al civico n.4 non si è rinvenuto alcun elemento riferibile ad un impianto idrico. Dal civico II 4, 3 fino a tutto il diverticolo che separa le *insulae* II 4 e II 3 è stato individuato il cavo antico riempito dal lapillo. Questo cavo, dopo una interruzione riprende all'altezza del civico II 3, 2 e prosegue verso ovest. Nel tratto senza cavo, che corrisponde alla Casa della Venere in Conchiglia fino alla fontana n.9, si sono rinvenuti 3 lunghi tratti di *fistula denaria* pertinenti alla stessa condotta che alimentava presumibilmente la fontana, dal momento che il frammento vicino ad essa presenta una chiara curvatura verso il pilastrino verticale posto alle spalle del bacino rettangolare della fontana. Il cavo riempito dal lapillo continua fino alla Casa di Loreio Tiburtino (II 2, 2) risparmiando però sia l'ingresso principale, n.2, che quello secondario, n.3. Il marciapiede in corrispondenza all'*insula* II 2 è molto largo tanto che lo scavo della trincea antica posta al centro, non toccava né i muri che delimitano le abitazioni né i blocchi che delimitano il marciapiede, tanto che a ridosso di questi ultimi correva una *fistula denaria* rinvenuta praticamente a livello di calpestio in più punti. Il cavo riempito dal lapillo prosegue fino a toccare la base del *castellum plumbeum* addossato all'angolo nord-ovest dell'*insula*. Senza dubbio erano alimentate da questo *castellum* le due *fistulae* rinvenute nelle sue prossimità entrambe denarie, la prima è quella che si dirige verso est e che forse alimentava la fontana n.9, la seconda invece proseguiva verso ovest e probabilmente alimentava la fontana n.8. Dallo stesso *castellum* parte il cavo riempito dal lapillo che verso sud si dirige verso la Grande Palestra e verso ovest prosegue sul marciapiede antistante l'*insula* II 1, ove in prossimità dell'angolo nord-est ospita la grande valvola che tuttora si vede entro un pozzetto moderno. Questa valvola non è collegata a niente infatti le *fistulae* ad essa afferenti sono di diverso modulo rispetto a quelli visti, inoltre si trova ad una quota molto più bassa. La trincea piena di lapillo prosegue sul marciapiede meridionale di Via dell'Abbondanza fino all'incrocio con Via di Stabia sempre con le stesse caratteristiche: larghezza variabile da 60 a 90 cm, profondità che varia da 1,2 m fino a 1,6 m soprattutto in prossimità e sotto gli attraversamenti stradali, interrompe la maggior parte delle canalette di troppo-pieno che escono dalle case che si affacciano sulla grande strada cittadina, si dirama verso sud lungo le seguenti strade: Via di Nocera lato est *(fig. 7)* e diverticolo che separa le *insulae* I 7 e I 6, anche in quest'ultimo caso il cavo pieno di lapillo correva lungo il lato est, esso è stato individuato anche in corrispondenza del confine delle case I 7, 17 e I 7, 18 ove a questo punto passava sotto la strada basolata per sbucare sul marciapiede opposto e penetrare entro l'*insula* del Menandro. Il cavo riempito dal lapillo, inoltre, penetra in varie case, ma non moltissime; partendo da est, sono le seguenti: II 1, 5; II 1, 2; I 13, 4; I 12, 3; I 12, 1; I 11, 5; I 9, 4; I 8, 3; I 6, 4; I 4, 25; I 4, 27. Lo scavo della trincea riempita dal lapillo comunque non era stato eseguito in corrispondenza solo delle seguenti case: I 11, 2; I 11, 1 e I 4 dal 24 al 21. Caso singolare in corrispondenza dell'intero fronte della casa I 13, 2, ove lo scavo era stato effettuato e successivamente riempito.[12] In vari punti si sono rinvenuti tratti di *fistulae* di piombo: in corrispondenza della bottega I 11, 2 *(fig. 8),* dove come detto in precedenza non era stato ancora scavata la trincea, si è individuata un lungo pezzo di *fistula vicenaria*. Questa *fistula*, ricoperta da pochi centimetri di terra e posata ad una quota di poco inferiore rispetto alla faccia superiore del blocco che delimita il marciapiede, è sistemata al di sopra delle due canalette di troppo pieno che escono da I 11, 2; inoltre, pur avendo la classica forma 'a pera' non si presenta nella giusta posizione, cioè con il listello di saldatura rivolto in alto, quanto piuttosto coricata di fianco, il limite

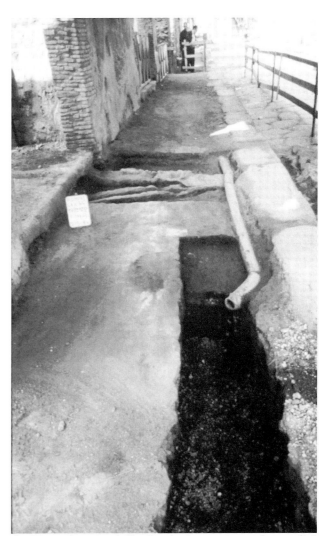

7. *Rinvenimento del cavo riempito dal lapillo su Via dell'Abbondanza con deviazione sotto Via di Nocera.*

8. *Rinvenimento della fistula in corrispondenza di I 11, 2.*

meridionale della *fistula,* è ripiegato e non si presenta resecato ma termina ad anello con diametro minore come se servisse per innestarlo entro un successivo elemento. In effetti si ha l'impressione che la *fistula* non fosse in opera e che fosse in fase di smontaggio, questa ipotesi è avvalorata dal fatto che in prossimità dell'angolo nord-ovest dell'*insula* I 11, si sono rinvenuti due piccoli pezzi della stessa *fistula* accoppiati senza alcuna funzione. Una lunga *fistula* con le stesse caratteristiche, ma poggiata col giusto verso, si è rinvenuta in corrispondenza di I 6, 4 fino a I 6, 8; si può ipotizzare che tutti questi pezzi di *fistula vicenaria* facessero parte della stessa conduttura proveniente dal *castellum plumbeum* posto all'incrocio di Via di Stabia con Via dell'Abbondanza e portasse l'acqua nella piscina della Grande Palestra, e la grande valvola posta all'angolo nord-est dell'insula II 1 la regolasse, visto che gli innesti appaiono della stessa grandezza. Sempre nello stesso tratto si sono rinvenute altre

due *fistulae denariae* che discendono dal *castellum plumbeum* posto nell'angolo nord-est dell'*insula* I 6: una si dirige verso la Fullonica di Stephanus (I 6, 7) penetrando dentro l'edificio in corrispondenza dello stipite meridionale, l'altra prosegue fino all'altezza di I 6, 8 e si infila sotto il basolato stradale dirigendosi verso nord. Tutte e 3 queste condotte coesistono con lo scavo della trincea riempita dal lapillo. Infine un ultimo tratto di *fistula,* sempre *denaria,* si è osservato sul marciapiede in corrispondenza del civico I 4, 24. Solo in due casi si sono rinvenute *fistulae* a notevole profondità e per la precisione sotto gli attraversamenti delle strade che dividono le *insulae* I 8 ed I 9 e I 8 ed I 7; in questi due casi si ha l'impressione che per l'agibilità delle strade sia stato fatto lo scavo, sia stata posata la *fistula* e si sia subito dopo costipato lo scavo fatto. Il cavo riempito dal lapillo si ferma da un lato immediatamente al di sotto del *castellum plumbeum* che domina l'incrocio di Via di Stabia con Via dell'Abbondanza, e

dall'altra continua verso sud scendendo lungo il marciapiede orientale di Via di Stabia (cfr.supra). Continuando verso ovest sempre sul marciapiede meridionale di Via dell'Abbondanza, il cavo riempito dal lapillo è stato individuato in corrispondenza dell'angolo nord-est dell'*insula* VIII 4, qui scende verso sud sul marciapiede occidentale di Via di Stabia e sembra passare sotto la stessa strada in direzione del *castellum plumbeum;* inoltre verso ovest continua fino al civico VIII 4, 14, poi riprende in corrispondenza del civico VIII 4, 6, unico punto ove entra anche dentro l'*insula*, fino a VIII 4, 2. Anche sul marciapiede in corrispondenza dell'*insula* VIII 4 si sono individuai tratti di condutture di piombo, sembra che una *fistula denaria* (?), proveniente da est, in corrispondenza del civico VIII 4, 7 si dividesse in due in modo che un braccio penetrasse entro l'*insula,* in corrispondenza del pilastro che separa i civici VIII 4, 6 e VIII 4, 7 forse per servire la Casa di Holconius Rufus (VIII 4, 4), ed un altro penetrasse entro la bottega VIII 4, 2. Elemento di estremo interesse, scaturito dallo scavo, appare il fenomeno, relativo a tutte le canalette di troppo pieno che sversavano sulla strade le acque piovane superflue dai civici 2, 4, 5, 11, 12, queste si trovano tutte ad una quota inferiore rispetto alla quota della strada, questo può solo significare che la strada ha subito un innalzamento lungo tutto il tratto corrispondente all'*insula* VIII 4.[13] Continuando verso ovest di Via dell'Abbondanza non è stato rinvenuto nessun altro cavo riempito dal lapillo, tenendo presente che dalla Via dei Teatri in poi l'indagine archeologica è proseguita lungo il marciapiede settentrionale. Su questo tratto due note di rilievo: la prima è che dal Vico di Eumachia scendeva una *fistula denaria* che correndo a ridosso dei basoli del marciapiede, sembra raggiungesse la fontana n.28; la seconda è che dal Vico della Maschera scendeva un canale (40 x 40 cm) rivestito di cemento idraulico e coperto da blocchi di pietra sarnese con vaschette di decantazione, scendeva verso est lungo il marciapiede settentrionale fino al civico VII 14, 7, ove girando ad angolo retto passava sotto la strada, attraversava in diagonale la parte orientale dell'*insula* VIII 5 per sbucare sul marciapiede occidentale della Via dei Teatri ove proseguiva verso sud. Solo in altri due punti è stato rinvenuto il cavo riempito dal lapillo: in corrispondenza dei Propilei dell'ingresso al Foro Triangolare lungo una linea ideale che congiunge la fontana n.34 con la fontana n.35 e lungo tutto il marciapiede occidentale di Via delle Scuole fino alle spalle della fontana n.31 ove si interrompe.

CONCLUSIONI

Appare chiaro che, pur avendo effettuato indagini su lunghi tratti dei marciapiedi di Pompei, le considerazioni valgono, fino a prova contraria, solo per quanto visto e vanno comunque considerate come ipotesi di lavoro sulle quali continuare la ricerca.

Siamo dell'opinione che l'impianto idrico di Pompei, allestito con l'arrivo in città dell'acquedotto Claudio, corresse completamente fuori terra o sotto pochissimi centimetri di terra. Le *fistulae* con la caratteristica forma a pera e con il listello di chiusura posto in alto,[14] sicuramente non potevano sopportare pressioni molto alte e necessitavano di manutenzione con una certa frequenza visto le numerose riparazioni. Molto probabilmente l'impianto pubblico serviva all'inizio tutte le fontane, le terme pubbliche e pochi altri edifici pubblici *(munera publica),* e solo successivamente alcune case private o imprese artigianali si sono collegate ai serbatoi di distribuzione posti sui *castella* con condotte individuali: in effetti tranne nel caso della condotta rinvenuta in corrispondenza del civico VIII 4, 7 non si sono mai rinvenute, durante i lavori attuali, *fistulae* di diametro maggiore alle quali si allacciassero più tubi di diametro minore per rifornire singole case; là dove avviene, VII 2, 45, serve la medesima casa in due punti differenti. Il *castellum aquae* di Porta Vesuvio nel rilievo della casa di Cecilio Giocondo (V 1, 23.25.26.27.10) unico tra i monumenti pubblici rappresentati, non appare danneggiato dal terremoto del 62 d.C., è probabile, quindi, che riparate velocemente le condotte piombifere lungo le strade, la distribuzione idrica fosse ripresa con una certa regolarità. Saranno i terremoti degli anni immediatamente precedenti l'eruzione[15] a danneggiare il *castellum aquae* di Porta Vesuvio e quindi a consigliare il rifacimento globale del sistema idraulico urbano e di conseguenza a sistemare le *fistulae* ad una certa profondità. É pertanto gli addetti ai lavori di scavo della trincea, man mano che procedevano lungo i marciapiedi, recuperavano le vecchie *fistulae* per riciclarle. Anche in questo caso lo scavo sembra sempre finalizzato a raggiungere soprattutto le fontane pubbliche, e le poche penetrazioni entro le case individuate sembra un fenomeno accessorio. É questa l'immagine che si ricava in seguito ai recenti lavori anche se molti problemi restano aperti, come per es. quando erano iniziati i lavori di scavo? Da chi erano patrocinati? Continuava ad arrivare l'acqua dall'acquedotto Claudio e come era irregimentata? Esistevano altri *castella aquarum* a nord di Pompei? Come si suppliva alla momentanea assenza dell'acqua pubblica?

BIBLIOGRAFIA

Andreau, J. 1973, Histoire des séismes et histoire économique: le tremblement de terre de Pompéi (62 ap.J.C.), *AnnEconSocCiv* 28.

Andreau, J. 1980, Il terremoto del 62, in *Pompei 79*, 40-55.

Bernardelli, R. 1971, Il tripartitore d'acqua di Porta Vesuvio a Pompei, in *Studi urbinati*, 3, 1152.

Elia, O. 1938, Un tratto dell'acquedotto detto 'Claudio' in territorio di Sarno, *Ist.Stud.Rom. Campania Romana* I, 99 ss.

Eschebach, H. 1979, Probleme der Wasserversorgung Pompejis, *Cr.Pomp.* V, 24-60.

Eschebach, H./T. Schäfer 1983, Die öffentlichen Laufbrunnen Pompejis. Katalog und Beschreibung, *PompHercStab* I, 11-40.

Etienne, R. 1966, *La vie quotidienne à Pompéi*, 1966.

Fassitelli, F. 1972, *Tubi e valvole dell'antica Roma*, Milano, (Pompei 58 ss).

Jacono, L. 1934-1935, La misura delle antiche fistule plumbee, *RStPomp*, fasc. 2.

Murano, D. 1894, *Pompei, donde venivano le acque potabili ai castelli aquarii*, Napoli.

Maiuri, A. 1931, Pozzi e condutture nell'antica città. Scoperta di un antico pozzo presso 'Porta vesuvio' *NSc*, 546-576, tav. XVII.

Maiuri, A. 1939, *NSc*, 200 ss.

Maiuri, A. 1942, *L'ultima fase edilizia di Pompei*, Roma.

Mau, A. 1904, *RM* XIX, 1904 41-50.

Mygind, H. 1917, Die Wasserversorgung Pompejis, *Janus* XXII, 1917, 294-351.

Nappo, S.C. 1995, Evidenze di danni strutturali, restauri e rifacimenti nelle insulae gravitanti su Via Nocera a Pompei, in *'Archäologie und Seismologie'*, Monaco, 45-54.

Paribeni, R. 1903, Relazione degli scavi eseguiti durante il mese di novembre, *NSc*, 25-31.

Sgobbo, I. 1938, Serino. L'acquedotto romano della campania 'Fontis Augustei Aquaeductus', *NSc*, 75-96.

Sogliano, A. 1911, in *Symbolae in honorem De Petra*, 85-92.

Utilitas Necessaria AA.VV. 1994, Utilitas Necessaria. Sistemi idraulici nell'Italia romana, a cura di I. Riera, Milano.

VIA MINUTELLA 6
I-80045 POMPEI (NA)
ITALIA

NOTE

[1] La necessità di dotare l'antica città di un impianto idrico moderno, finalizzato alla ripiantumazione dei giardini ed alla rifunzionalizzazione delle antiche fontane, e di una dorsale tecnologica (cavi elettrici e fibre ottiche) ha richiesto l'effettuazione di 85 saggi stratigrafici e lo scavo di una trincea lunga circa 2.000 m. I lavori sono stati seguiti dallo scrivente e dal prof. A. De Simone che cureranno lo studio complessivo delle tematiche emerse da questi lavori.

[2] Sgobbo 1938, 75 ss.; Elia 1938, 99 ss.; Utilitas Necessaria 1994, 243 ss. figg. 242, 252, 274.

[3] Paribeni 1903, 25-31; Bernardelli 1971, 1152 ss; Utilitas Necessaria 1994, 270-274.

[4] Vitruvio, *De arch.* VIII, 6, 1-2.

[5] Maiuri 1931, 546-576; e inoltre Etienne 1966, 20-22; Andreau 1973, 369 ss.; Andreau 1980, 42.

[6] La condotta idrica del 1931 era di circa 10 cm di diametro e fu posta ad una profondità di circa 40-50 cm dalla quota superiore dei massi che contengono il marciapiede.

[7] Maiuri 1931, 546 ss.; ma anche Maiuri 1942, 91 ss.

[8] Maiuri 1939, 200-202, fig. 21; inoltre Maiuri 1942, 91-94.

[9] Eschebach 1979, 54 ss.

[10] Per la numerazione delle fontane cfr. Eschebach 1983, 11-40, fig. 46.

[11] Si potrebbe anche pensare ad una canaletta pertinente alle costruzioni precedenti l'impianto termale, ma proprio la sua fattura, le sue caratteristiche e il suo stato di conservazione lo fanno escludere. La canaletta probabilmente, con funzione di troppo pieno, è riferibile al porticato interno delle Terme Centrali.

[12] Nappo 1995, 51-52, figg. 19-20.

[13] Di seguito si riportano le quote delle canalette rispetto alla strada assumendo come quota 00 la faccia superiore dei blocchi del marciapiede: VIII 4, 2, quota canaletta -49,5, quota strada -38,5; VIII 4, 4, quota canaletta -65,3, quota strada -58,3; VIII 4, 5, quota canaletta -38, quota strada -52; VIII 4, 11, quota canaletta -106, quota strada -49; VIII 4, 12, quota canaletta -72, quota strada -28; VIII 4, 12, quota canaletta -52, quota strada -34.

[14] Jacono 1934, 3.

[15] Archäologie und Seismologie, 1995.

Die Verteilung des Leitungswassers in den Häusern Pompejis[*]

Gemma C.M. Jansen

Römische Wasserhähne haben Archäologen und Ingenieure schon immer fasziniert. Kretzschmer (1960-61) hat sie in seinem bekannten Bericht eingehend besprochen. Fassitelli (1972) hat diesem Thema nahezu ein ganzes Buch gewidmet und Hodge (1992, 322-331) hat dies alles in seinem Buch über die römischen Aquädukte und Wasserversorgung nochmals zusammengefaßt. Was aber bei ihren Abhandlungen auffällt ist, daß die Wasserhähne wie eigenständige Gegenstände betrachtet werden, und daß man hauptsächlich die technischen Aspekte studiert, sowie den Produktionsprozeß oder die Druckfestigkeit. Welchem Zweck jedoch die Wasserhähne im Wasserleitungssystem innerhalb der Häuser dienten, läßt man im allgemeinen außer Acht. Als Einführung möchte ich zuerst die einzelnen Teile des Wasserleitungssystems der Wohnungen zeigen. Darauf werden die Teile im Kontext vorgestellt und die mögliche Funktion besprochen.

In den Ausgrabungslagern von Pompeji befinden sich verschiedene Bauteile dieses Systems: nicht nur unzählige bleierne Leitungen und einige bronzene Brunnenrohre, sondern auch fast 80 bronzene Wasserhähne (*Abb. 1*). Diese Hähne bestehen aus einem Zylinder mit zwei vorspringenden Teilen, an denen man die bleiernen Leitungen befestigen konnte. Im Zylinder steckt eine Hülse mit Durchgangsloch und einem Loch, in das man einen Schlüssel stecken konnte, um den Einsatz zu drehen. Auf *Abb. 1* ist an dem rechten Hahn zu sehen wie man mit einem Nagel versucht hat diesen Hahn zu öffnen. Das Durchgangsloch und das Drehloch korrespondieren (*Abb. 2*).

2. Hülse mit Durchgangsloch und Schlüsselloch.

Auch sind hier bleierne Verteilerkästen mit angelöteten Wasserhähnen zu finden (*Abb. 3*). Die Leitung bringt das Wasser von der einen Seite herein und es fließt über drei Leitungen mit Wasserhähnen heraus. Auf *Abb. 3* ist zu sehen, daß der linke Hahn offen ist, und der andere geschlossen.

Glücklicherweise sind in Pompeji noch 30 Wasserhähne und 15 bleierne Verteilerkästen an den ursprünglichen Stellen in den Wohnhäusern erhalten geblieben.[1] Leider aber ist nur in dem Casa del Balcone pensile (VII 12, 28) das ganze Wasserleitungsnetz noch komplett. Die Leitung ist einfach zu verfolgen vom Wasserpfeiler an der Straßenecke bis zur Vordertür. Hier tritt sie in das Haus hinein. Im Haus führt sie durch den Gang direkt in den Innenhof, wo sie mittels eines Verteilerkastens und vier Hähnen einen großen und drei kleine Springbrunnen sprudeln läßt (*Abb. 4*).

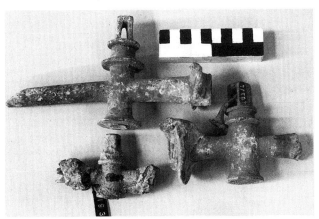

1. Wasserhähne aus dem Ausgrabungslager von Pompeji.

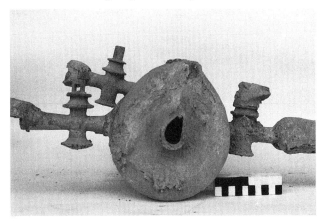

3. Bleierner Verteilerkasten mit angelöteten Wasserhähnen.

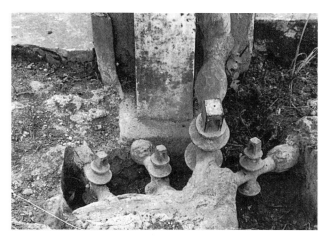

4. Bleierner Verteilerkasten mit vier Wasserhähnen in dem Casa del Balcone pensile (VII 12, 18).

Auch im Peristyl des Casa dei Vetti (VI 15, 1.27) kann man das Leitungsnetz mit den Wasserhähnen besichtigen. Hier hat man aber keinen Verteilerkasten

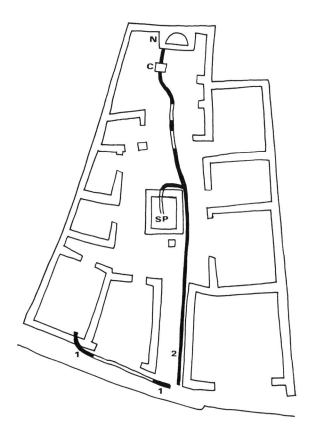

5. Casa dell'Orso (VII 2, 44.45). ■ *1 = sichtbare Leitung;* ■ *2 = mit Metalldetektor gefundene Leitung;* ═ *vermutete Leitung; SP = Springbrunnen; N = nymphaeum; C = bleierner Verteilerkasten mit 3 Wasserhähnen (Plan cf. Ehrhardt 1988).*

zwischengeschaltet. Leider sind wir nicht immer in der glücklichen Lage das ganze System aufzufinden. In den meisten Wohnungen sind die Leitungen verschwunden. Dies hängt mit der Tatsache zusammen, daß man Ende des vorigen Jahrhunderts den Leitungen wenig wissenschaftliche Aufmerksamkeit widmete und sie verkauft hat, um die Ausgrabungen weiter finanzieren zu können. Anderseits hat man sie auch herausgenommen, um sie gegen Vandalismus der Touristen zu schützen, die sie gerne als Souvenir mit nach Hause nehmen wollten.

Trotzdem gibt es mehrere Hinweise, an denen man sehen kann, wo die Leitungen innerhalb der Häuser gelegen haben. In den Mauern zum Beispiel sind vielfach kleinere Stückchen Leitungen sitzen geblieben. Aufgrund dieser Stückchen ist es manchmal möglich ein Teil des Systems zu rekonstruieren. Auch in den Tuff der alten *impluvia* gehauene Rillen geben Indizien für die Lage der Leitung. Außerdem zeigen Zerstörungen im Mosaik oder im Boden, wo damals eine Leitung gelegen hat. Aufgrund dieser Hinweise ist es zwar möglich etwas mehr über das System zu sagen, aber es ist nicht möglich es völlig zu rekonstruieren.

Mit der Genehmigung des Soprintendenten Pompejis haben wir in 16 Häusern Pompejis angefangen mit einem Metalldetektor zu arbeiten.[2] Die Arbeit mit dem Detektor brachte in einigen Häusern gute Ergebnisse.

In diesem Aufsatz möchte ich mich auf drei Beispiele beschränken: Das erste Beispiel ist das Leitungssystem im Casa dell'Orso (VII 2, 44.45). Hier ist nur eine Leitung sichtbar, welche von der Straße in die Küche hineinführt. Außerdem ist ein Marmorkasten zu sehen, in dem ein bleierner Verteilerkasten mit drei Wasserhähnen steckt. Diese gehören zum *nymphaeum* im Hinterhaus. Die Untersuchung mit dem Metalldetektor hat folgendes ergeben *(Abb. 5).* In der Küche war die sichtbare Leitung nicht weiter zu verfolgen, weil im Boden zu viele Metallteile, zum Beispiel Nägel, vorhanden waren und den Detektor ablenkten. Wir konnten aber eine Leitung entdecken, die von der Vordertür am *impluvium* vorbei führte, wo sie an einen Springbrunnen angeschlossen war.[3] Von hier verlief die Leitung zum Marmorkasten und Verteilerkasten und bewässerte die drei Fontänen im *nymphaeum.*

Ein anderes Haus in dem die Arbeit mit dem Metalldetektor erfolgreich war, ist das Domus Cornelia (VIII 4, 14-16.22.23.30). Hier war sehr gut zu beobachten wie die Leitung vorne an der Straße westlich der Vordertür in das Haus hineinführte. Im Haus selbst

wurden bleierne Verteilerkästen hinter dem *impluvium* und einige kleine bleierne Leitungen in den Säulen des Peristyls entdeckt. Außerdem wurden in der Peristylrinne und im Peristylrand einige Rillen gesehen, die ein Indiz geben für den Verlauf der Leitungen und die Lage der Fontäne. In diesem Haus war das Leitungnetz nahezu ganz aufzuspüren.[4] Die Leitung verlief den *fauces* entlang zum *impluvium* und zum bleiernen Verteilerkasten. Von hier ging eine Leitung zu den Brunnen mitten im *impluvium,* eine andere führte zum Peristyl, aber nicht quer durch das *tablinum,* sondern durch zwei kleine Nebenräume westlich des *tablinum.* Der Leitung war von hier aus der Nord- und der Ostseite des Peristyliumrandes entlang zu folgen. Im Süden verlief die Leitung (die jetzt nicht mehr vorhanden ist) vermutlich in der Peristylrinne selbst, worauf man schließen kann aus der Rille in dieser Rinne. Im Peristyl wurden mindestens sieben Fontänen bewässert.

Auch im Casa dei Vetti (VI 15, 1.27) führte die Untersuchung, trotz der Restaurierung anfangs dieses Jahrhunderts, um den Brunnen im Peristyl wieder sprudeln zu lassen, zu überraschenden Ergebnissen. Es stellte sich heraus, daß neben den zwei Leitungen, die in das Peristyl hereinführen, eine dritte Leitung in das Neben-*atrium* führt. Diese Leitung bewässerte eine einfache Fontäne dieses kleinen *atrium* und bog erstens ab zur Küche und zweitens zum Haupt-*atrium.* Dort lief die Leitung am modern angelegten marmoren *impluvium* entlang zum Peristyl, wo man am Ostende in der Peristylrinne noch immer den Anschluß an die Kreisleitung des Peristyls sehen kann. Im Peristyl wird diese Leitung an 14 Brunnen angeschlossen gewesen sein.

Aufgrund dieser Untersuchungen nach sichtbaren Leitungen, den Resten von Leitungen und den Untersuchungen mit den Metalldetektor können wir die folgende schematische Rekonstruktion aufstellen *(Abb. 6).* Die Leitung zum Haus beginnt beim Wasserpfeiler an der Straßenecke. Von hier führt sie zur Vordertür oder zu einem Punkt mit möglichst kurzem Abstand zum Wasserpfeiler. Sie tritt in das Haus ein und verläuft zum ersten Innenhof. Dort wird das Wasser mit Hilfe eines Verteilerkastens über die vorhandenen Springbrunnen verteilt. Dann läuft die Leitung weiter zu einen anderen Innenhof, wo das Wasser weiter mit einem Verteilerkasten mit Wasserhähnen zu den Springbrunnen verteilt wird. Manchmal zweigt die Leitung auch noch zur Küche, Badezimmer oder Abort ab.
Aufgrund dieser schematischen Rekonstruktion kann

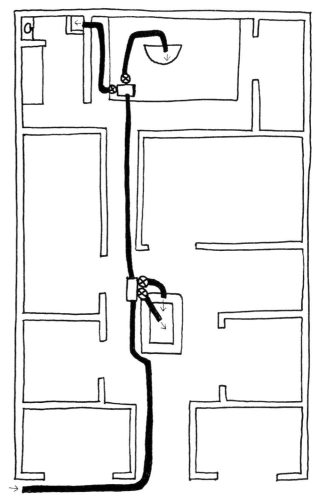

6. *Schematische Rekonstruktion Leitungsnetz Wohnhäuser.* ▬ = *Leitung;* ▭ = *bleierner Verteilerkasten;* ⊗ = *Wasserhahn.*

man einige Feststellungen machen. Erstens war kein einziger Wasserhahn innerhalb der Wohnhäuser ein Haupthahn oder ein Sperrhahn. Es hat sich herausgestellt, daß die ersten Hähne der Leitungen immer erst nach dem ersten Verteilerkasten zwischengeschaltet waren. Zweitens fällt auf, daß die Wasserhähne, mit oder ohne bleierne Verteilerkästen, sich immer direkt neben den Springbrunnen befanden. Mit den Hähnen konnte man nicht nur die Springbrunnen abschalten oder einschalten, sondern auch die Höhe des Wasserstrahls regulieren, wenn man den Hahn ein wenig mehr oder weniger aufmachte. Die Wasserhähne regelten deshalb nicht nur zu welchen Springbrunnen das Wasser ging, sondern auch die Menge des Wassers für die einzelnen Springbrunnen.

BIBLIOGRAPHIE

Erhardt, W. 1988, *La casa dell'Orso (VII 2, 44-46)*, München.
Fassitelli, E.F. 1972, Roma, *Tubi e valvole nel mondo*, Milano.
Hodge, A.Tr. 1992, *Roman Aqueducts and Water Supply*, London.
Kretzschmer, F. 1960-61, Römische Wasserhähne, *JbSchwUrgesch* 48, 50-62.

ANMERKUNGEN

[*] Seit 1991 untersucht die Autorin die Wasserversorgung der Stadt Pompeji im Rahmen einer Dissertation über die Wassersysteme in römischen Städten. Für weitere Informationen wird auf diese Dissertation verwiesen, die Anfang 1996 veröffentlicht wird. Gern möchte ich dem Soprintendenten Pompejis, Herrn Prof. Conticello, danken für die Einwilligung zu dieser Unterschung. Der NWO (Niederländische Organisation für wissenschaftliche Forschung) danke ich für ihre sehr geschätzte finanzielle Hilfe.

[1] Casa del Citarista (I 4, 5.6.25.26) Verteilerkasten mit Wasserhahn; Casa del Toro (V 1, 3.6-9) Verteilerkasten mit zwei Wasserhähnen; Casa di Caecilius Iucundus (V 1, 23.25-27.10) Verteilerkasten mit Wasserhahn; Casa delle Nozze d'argento (V 2, i) Verteilerkasten mit Wasserhahn und zwei Wasserhähnen; Casa degli Scienziati (V 14, 43) Verteilerkasten mit Wasserhahn; Casa di Orfeo (V 14, 18-20) Verteilerkasten mit zwei Wasserhähnen; Casa dei Vetti (VI 15, 1.27) neun Wasserhähne; Haus VII 2, 16 Verteilerkasten; Casa dell'Orso (VI 2, 44.45) Verteilerkasten mit drei Wasserhähnen; Casa del Balcone pensile (VII 12, 28) Verteilerkasten mit vier Wasserhähnen; Casa dei Postumii (VII 4, 2-6.49.50) Verteilerkasten mit Wasserhahn; Villa di M. Fabius Rufus (VII 16, 17.20-22) zwei Wasserhähne und Verteilerkasten mit zwei Wasserhähnen; Domus Cornelia (VIII 4, 14-16.22.23. 30) Verteilerkasten; Casa di Marcus Lucretius (IX 3, 5.24) Verteilerkasten mit Wasserhahn; Haus IX 3,18 Verteilerkasten; Haus IX 7, 24.25 Verteilerkasten.

[2] Casa di Paquius Proculus (I 5, 1.20); Casa dell'Efebo (I 7, 10-12.19); Praedia di Iulia Felice (II 4, 2-12); Casa di Trebius Valens (III 2, 1a); Haus V 1, 3; Casa del Toro (V 1, 3.6-9); Casa degli Epigrammi Greci (V 1, 11.12.18); Casa di Caecilius Iucundus (V 1, 23.25-27.10); Casa delle Nozze d'argento (V 2, i); Casa dei Vetti (VI 15, 1.27); Casa degli Amorini dorati (VI 16, (6.)7.38); Domus Siricus (VII 1, 25.-46.47); Haus VII 2, 16; Casa dell'Orso (VII 2, 44.45); Casa del Balcone pensile (VII 12, 28); Casa dei Postumii (VII 4, 2-6.49.50); Domus Cornelia (VIII 4, 14-16.22.23.30); Haus IX 7, 24.25.

[3] Ehrhardt 1988 18, und Anmerkung 21.

[4] Die Arbeit mit dem Detektor wurde einigermaßen erschwert durch eine bleierne Leitung vom Anfang dieses Jahrhunderts, die offensichtlich an den Brunnen aus Marmor in der Mitte des Peristyls angeschlossen war. Weil diese Leitung von Osten her angelegt war, war sie einfach vom römischen System zu isolieren.

KATHOLIEKE UNIVERSITEIT NIJMEGEN
GLTC, AFD. KLASSIEKE ARCHEOLOGIE
POSTBUS 9103
NL-6500 HD NIJMEGEN
NIEDERLANDE

The Use of Water in Pompeian Gardens*

Wilhelmina F. Jashemski

Water is an essential element in any garden. This paper discusses the use of water in three important types of Pompeian gardens that I have excavated.

WATER IN PRE-AQUEDUCT HOUSES

Before the introduction of the aqueduct at Pompeii, under Augustus, houses were dependent upon the rain water collected from the roof and stored in a cistern. The process of collecting water in a typical *atrium* house is familiar. During a rain, water falling through the *compluvium* was caught in the shallow *impluvium* below. The plug in the *impluvium* that led to the cistern underneath was closed and the one leading to the street was opened. The sloping streets must have run like rivers during this time. After the roof had been

washed and the water was clean, the plug to the street was closed and the one to the cistern opened. Water could be obtained as needed by lowering a bucket into the cistern through the *puteal* which covered the opening to the cistern.

In 1973 I excavated the peristyle garden in the House of Polybius (IX 13, 1-3) on the Via dell'Abbondanza *(Fig. 1)*. Rain water collected from the roof of the peristyle portico into the channel at the edge of the garden was stored in the cistern under the east portico. Roof water collected in the *impluvium* of the adjacent *atrium* was also stored in this cistern.

It was a great surprise when we excavated this garden to find the root-cavities of five large trees, for we had been accustomed to thinking of Pompeian gardens as having low formal plantings. Along the west wall we found eight more root-cavities – of young trees, that had been started in small pots *(Fig. 2)*. Six of the little trees had the soil around them shaped into a high

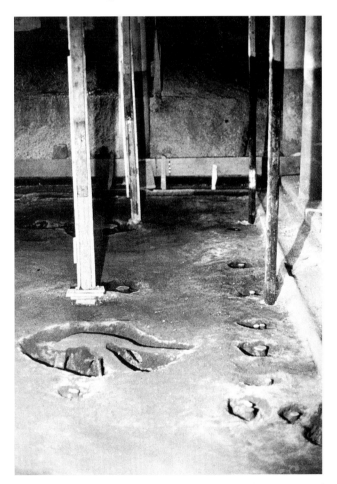

1. East part of the peristyle garden in the House of Polybius (IX 13, 1-3) (photo: Stanley Jashemski).

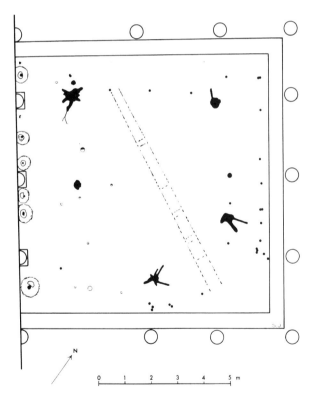

2. Plan of the peristyle garden in the House of Polybius (IX 13, 1-3). Roots are indicated in black (plan courtesy Soprintendenza alle Antichità, Campania-Napoli; garden details by Stanley Jashemski).

3. The garden of the Fugitives (I 21, 1). View toward the south. Casts of small root cavities are covered with white disks, casts of large tree-root cavities are painted white (Balloon photo: Julian Whittlesey Foundation).

mound, surrounded by a channel for water. It was obvious that something special had been planted here and that provision had been made for them to get considerable water while they were still young. There were still other cavities left by some smaller trees, and woody shrubs at the edge of the garden.[1] This raised the question of the type of plantings that had been used in the peristyle gardens of houses built before the aqueduct. I subsequently excavated seven other peristyle gardens, and I found that all but one were planted with trees.[2] This is not surprising, for after trees are started they require less water than other plantings.

GARDENS IN HOUSES WITH AQUEDUCT WATER

The introduction of the aqueduct, which made abundant water available, resulted in a second type of garden – one that could now have fountains, pools, and plantings requiring more water. The peristyle garden in the House of the Vettii (VI 15, 1.27), with its fourteen fountains is known to all, as are the even more elaborate water displays in the gardens in the House of M. Loreius Tiburtinus (II 2, 2).[3]

Not so well known is a perfect little jewel of a formal garden, in the House of the Bracelet (VI 17, 42-44), which I excavated at the rear of a three story house built over the west city wall, when the wall was no longer needed after Pompeii became a Roman colony. A beautiful high vaulted *diaeta* or garden room, decorated with fine garden paintings and a strikingly patterned marble floor, opened out on the north end of the east side of the garden. But it is the adjacent water *triclinium,* also decorated with fine but less perfectly preserved garden paintings, that concerns us, because of its lavish use of water. The water *triclinium* was dominated by an apsed mosaic fountain with water steps, over which water fell into a pool below between the couches and then rose in a jet. It eventually emptied into a rectangular pool with a semicircular extension, also painted blue inside, located in the garden in front of the water *triclinium.* Water rose in a jet from the low column in the center of the pool and from the twenty-eight jets in the rim of the pool.[4] A reconstruction of this garden made by the artist, Victoria I, catches the beauty of this garden before its destruction by Vesuvius *(Fig. 4).*

LARGE PRODUCE GARDENS BEYOND THE REACH OF THE AQUEDUCT

A third type of garden was found in the southeast part of the city, where my excavations uncovered many sizeable planted areas attached to houses – market gardens, orchards, vineyards, and a commercial flower garden. The ingenuity exhibited in providing the necessary water for growing crops in this part of the city, where the aqueduct had not reached, is remarkable. We became quite interested in discovering how the water would be provided in each new garden that we excavated. I will describe only two.

The first is a garden that every tourist is anxious to locate – known as the Garden of the Fugitives (I 21, 1) – for here are the casts made during the original excavation of the site in 1961-62, of the thirteen Pompeians, including six children, who died in this garden toward the end of the eruption.

When I examined this site (I 21, 1) in 1973, I found it overgrown with weeds and small trees. Unfortunately all of the lapilli had been removed in most of the garden by the original excavators, and the surface of the soil had been badly damaged by the passage of trucks. Even so, we were able to recover the soil contours and many root cavities.

The balloon photo *(Fig. 3)* shows the garden when we had completed our excavations in 1974.[5] The garden had been planted in rows approximately five Roman feet apart. They were separated by distinct water channels, which were also used as paths by the gardeners. A wider and deeper channel running in a north-south direction divided the garden into two parts. There were also passageways about two meters wide, along the east, south and west edges of the garden. The photo clearly shows the soil contours even in those areas where the soil was so compacted that we could find no root activities. Many of the root cavities in the rows had been badly damaged, and all were small. There were only a few large tree-root cavities, mostly along the east wall. The planting pattern disappeared at the north end of the garden, where there are no soil contours. This was probably a work area.

4. The garden and water triclinium in the House of the Bracelet (VI 17, 42-44) (Drawing: Victoria I).

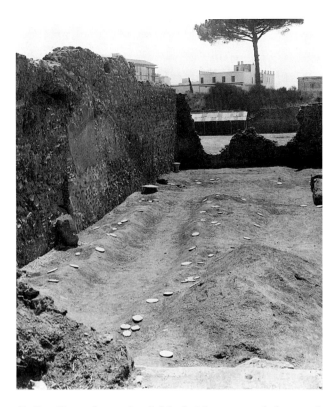

5. Small north garden I 21, 3. View toward the south and the Garden of the Fugitives (I 21, 1) (photo: Julian Whittlesey Foundation).

We discovered that the huge hole in the north part of the garden was the opening of a cistern. It was an extremely large cistern, which would have been useful in this sizeable garden. It apparently had been filled with water from the roofs of the houses to the north, but it seems doubtful that it functioned after the earthquake. What then was the source of water for this garden?

We were to find the answer when we excavated the small area on a higher level between the two houses at the north end of the *insula* (I 21, 3) *(Fig. 5)*. It either had the same owner as the house on the west, to which the Garden of the Fugitives (I 21, 1) belonged, or it was owned by a cooperative neighbor. Fortunately much of the east half of the area still had a substantial covering of lapilli, over two meters in places. We were able to determine that this area had been occupied by a building, which had been badly damaged by the earthquake; the area was subsequently cleared, and put under cultivation. This garden had two sources of water.[6] Water from the street on a higher level emptied into the garden through a tile-lined opening in the wall to the east of the top step. The water dropped to the level of the garden, divided, and flowed around the U-shaped bank of soil. Some of the

water flowed down the depression that formed a little channel in the west bank, where there were many root cavities; and part flowed in the space between the east bank of soil and the wall. During a heavy downpour, such as Pompeii frequently has during the rainy season, water would overflow from the channel in the west bank and spread over the west part of the garden; it could also be directed to flow down the wide channel or passageway enclosed by the U-shaped bank of soil and spread into the south part of the garden.

There was, however, a second source of water at the south end of the garden. This apparently came from the roof of the adjacent house on the east. Water entered the garden through a small opening at the base of the wall, and flowed through a short, crudely lined channel made of roof tile, the top of which was covered with two stones. The water then dropped into a embedded *dolium,* the overflow being channeled into the south part of the garden.

The southern part of the garden had been excavated thirteen years earlier down to the AD 79 level of the soil, but faint soil contours still preserved the outlines of rectangular beds, separated by water channels. Water from both sources appears to have flowed in these channels and then emptied into the Garden of the Fugitives (I 21, 1) below, where it flowed down the water channel that extended the length of this garden. From here it was led into the east-west channels to water the entire garden.

The ingenious use of street water, made possible because of the topography, is noteworthy. One has only to see a heavy downpour at Pompeii to appreciate the quantities of water made available in a short time, and the function of the irrigation channels in directing and conserving the water. Even the worn contours conserved the water during a heavy downpour that suddenly came up while we were working, and vividly illustrated for us how the water could be channeled and conserved for some time.

The Garden of Hercules (II 8, 6), also beyond the reach of the aqueduct, revealed a garden very different from any known thus far at Pompeii. Here we found a most interesting watering system. The original excavators (in 1953-54) found a large *aedicula lararium* on the east wall and near the shrine was the marble statuette of Hercules, from which the garden takes its name.

In 1971 it was almost impossible to enter the house. We cut our way through the growth of saplings in the *atrium* and encounterd a dense jungle of poplar trees and Spanish broom. It looked as if all evidence had been destroyed. But when the area was eventually

cleared, we found places still covered with considerable lapilli, especially in spots along the wall and a few in the garden. In these few places the original soil contours and root cavities were perfectly preserved.

The balloon photo *(Fig. 6)* shows the garden at the end of our third season.[7] We discovered that a footpath led from the door opening into the garden, continuing to a short distance beyond the cistern. At this point it turned left and continued to the *triclinium* and the altar in front of the *lararium.* Under a pile of original lapilli, we found a perfectly preserved ancient hoe. The happy worker who found it had a zappa at home that was an exact replica. The next morning he was at work early with a handle from his zappa ready to pose with his find. The tool was probably the one known to the ancient authors as the *sarculum.* Not far from the hoe we found another ancient tool, an exact duplicate of the martellina that our workmen were using to clean the weeds from the garden. The edge of this hatchet is not parallel to the handle, but is inclined toward it.

One of our most exciting finds in this garden was ancient pollen, for it was here that we found our first pollen. There were few places where the soil was adequately covered by original lapilli to yield an unpolluted sample, but we were able to take five samples from the beds to the south of the path and six along the walls. Professor G.W. Dimbleby of the Institute of Archaeology, at the University of London, found that the samples from the beds showed a strong dominance of olive pollen, ranging 75 to 89 percent. Those near the walls had significant, but much less, olive pollen, but also significant amounts of *Polypodium* spores; the sample near the northwest corner of the shrine was dominated by these spores (80 percent). But polypody fern grows on walls. The low values of pine, walnut, and hazel pollens, would indicate that these trees were not grown in the garden, for they are wind-pollinated. The olive tree is insect-pollinated and obviously grew in this garden.

To the west of the cistern we found a huge, but partially destroyed tree-root cavity, the largest that we had found, its longest dimensions at ground level approximately two meters. Dr. Carlo Fideghelli, of the Istituto di Frutticoltura, of the ministry of Agriculture, Rome, a specialist in the shape of roots, said it had the appearance of a very old olive root. This would explain the high concentration of olive pollen in this garden.

We wondered if the large *dolium* at the entrance to the garden had held olive oil, or other contents that might still be identifiable. The *dolium* was full of original lapilli, but when we emptied it, there was nothing.

In the root cavities that we found in the irrigation channel along the wall we began to find terra-cotta

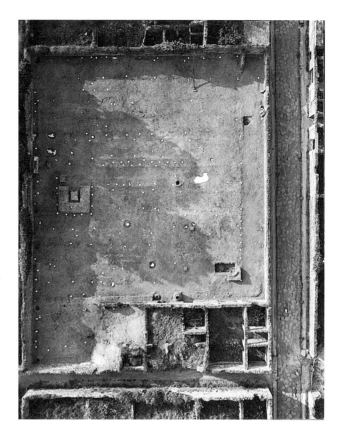

6. Garden of Hercules (II 8, 6). View toward the south *(Balloon photo: Julian Whittlesey Foundation).*

pots similar to those we had found in the garden of Polybius and elsewhere. They had three holes in the sides, one in the bottom. In 1973 we left one pot in the soil, for we did not want to destroy the root cavity in taking it out. When we pulled the soil from around the cast the following summer, it was an impressive sight to see a large tree root growing from a small pot. But what was most exciting was the discovery of a second pot nearby. The young tree that had been started in this pot had not grown, so the ancient husbandman had planted another in a pot nearby. Dr. Fideghelli immediately noticed the similarity of the root to that of a citron or lemon tree. The lemon trees found in Pompeian garden paintings suggest that this is perhaps another example of the Pompeians picturing on their walls the plants that they grew in their gardens.[8] A mosaic dated about AD 100, now in the Terme Museum in Rome (inv. no. 58596), depicting a basket of fruit which includes a lemon and a citron shows that the Romans knew both of these fruits.[9]

We found only eleven tree-root cavities that were 30 cm or more in their longest dimension. Near the southwest corner of the *lararium* we found carbonized fruits that Dr. Frederick Meyer, of the U.S. National Arboretum, in Washington D.C., identified as cher-

ries. They probably identify one of the trees nearby. Cherries, too, are pictured in the wall paintings.[10] There were also a number of smaller root cavities, perhaps those of fruit trees. But the unusually large number of stake cavities was difficult to explain.

It was the complicated soil contours, however, which divided the garden into many beds that make this garden unusual. Under a large pile of original lapilli to the south of the path leading to the *triclinium,* we found a perfectly preserved bed, in which, after a rain, we discovered many round formations. In the center of each there had once been a very small plant, but it was obviously too small for lapilli to have preserved its root cavity. Around each little plant was a depression for water. As we continued to clear the garden, we found evidence of other beds.

Careful provision had been made for watering whatever had been grown in this garden. Some rain water was collected from the roof into the *dolium* embedded in the earth next to the house, and also into the larger one to the east of the door, that we had emptied earlier. The remains of a foundation on the other side of the door suggested that it too had held a large *dolium.* The nearby pool also was filled with rain water from the roof, as part of the preserved channel which carried the water to the pool clearly showed.

Additional water to supplement the rain water was needed. This had to be carried in. It was poured from the streetside through an *amphora* tip inserted in the east end of the north wall, to fill the *dolium* embedded

7. *Water for irrigating the Garden of Hercules (II 8, 6) was poured from the streetside through the amphora tip at the east end of the north wall. The overflow watered the garden (photo: Stanley Jashemski).*

below *(Fig. 7).* When the *dolium* was full, the water spilled over into the channel along the east wall, thus watering the young trees growing in the channel. The water eventually reached an embedded half-*dolium,* and when this spilled over, the water continued to flow along the wall. Then for several meters we found no cavities, for the soil next to the wall had been cut far below the original AD 79 level; near the wall but some distance farther a large hole in the soil indicated where another half-*dolium* had been embedded. The water was led in front of the *lararium,* for the water channel continued along the east wall to a half-*dolium* embedded in the southeast corner of the garden; when it was filled, the water overflowed into the channel on the south side of the garden. A large round hole to the west of the tree near the center of the south wall suggested that a half-*dolium* had also been embedded there. A hole had been made in the wall projecting into the garden from the south wall so that the water could continue its flow along the wall. There are also water channels along the north and west walls in the northwest corner. Water from the channels along the walls, as well as water taken from the pool and from the cistern, was directed into the water channels that divided the garden into wide beds; from these channels the water was led as needed into the beds.

The balloon photo *(Fig. 6)* clearly shows the pattern of the cavities, and in a remarkable way reveals even badly damaged soil contours that could not be seen from the ground. The beds were not all on the same level. Those on the north were slightly higher than those on the south, thus conforming to the natural slope of the land. To ensure the flow of water from the higher to the lower levels, the water channels on the north were placed higher than the beds, those on the south lower than the beds. The modern Pompeian shapes his planting beds in the same way, even through the difference in the heights of the beds is sometimes much greater than in this garden.

The question remains as to what was grown in this garden. We have seen that there were relatively few large trees and quite a few stakes. Most of the garden was laid out in beds, for which water was carefully provided. This makes it certain that in these beds one of two things were grown, flowers or vegetable, perhaps some of both, at different seasons. The small amount of weed and grass pollen in these beds suggests that they were well weeded or shaded. Pompeii was a center of flower culture in antiquity, as it still is today. The ancient Pompeians grew flowers for making garlands and perfume. It is perhaps significant that a large number of glass perfume bottles were found in the little house to which this garden was attached. We also found many fragments of glass per-

fume bottles in the garden, as well as fragments of terra-cotta unguent containers. The evidence that olives were raised in this garden reminds us that olive oil was an important base used in making perfume.

The rich soil of Pompeii continues to yield at least three crops a year, as it did in antiquity. Today flowers are raised for seed and for cut flowers. Frequently land is sublet in small areas for a portion of the year to seed companies in Italy and abroad. Trees often shade these plots, or at times wooden frames covered with fiber mats, or plastic, shelter the young plants.

The posts that hold the frames at the edge of the beds are much like those in the Garden of Hercules (II 8, 6). One of the largest commercial flower growers in Pompeii today told me that the contours and cavities in the Garden of Hercules definitely indicate flower culture, and he showed me that his flowers were raised in the same type of beds today.

The ancient owner of this well-watered garden may well have found the advice of Varro very sound: flowers can be a very profitable crop.[11]

BIBLIOGRAPHY

Jashemski, W.F. 1979, *The Gardens of Pompeii, Herculaneum and the Villas Destroyed by Vesuvius,* Vol I, New Rochelle/New York.
Jashemski, W.F. 1993, *The Gardens of Pompeii, Herculaneum and the Villas Destroyed by Vesuvius,* Vol 2, New Rochelle/New York.

NOTES

[*] For a more detailed description, with plans, generous illustrations, and bibliographies, of the gardens discussed in this paper, see Jashemski 1979 and 1993.

[1] For the garden in the House of Polybius (IX 13, 1-3) see Jashemski, 1979: 25-30; 1993: 249-251, 368-369.
[2] Jashemski, 1979: 31-32.
[3] For the gardens in the House of the Vettii (VI 15, 1) see Jashemski, 1979: 35-38; 1993: 153-155, 346-347; for the gardens in the House of Loreius Tiburtinus (II 2, 2) see Jashemski, 1979: 45-47; 1993: 78-83, 328.
[4] Jashemski, 1993: 166-167, 348-358, 393.
[5] Jashemski, 1979: 243-247; 1993: 69-70.
[6] Jashemski, 1979: 247-250; 1993: 70-72.
[7] Jashemski, 1979: 279-288; 1993: 94-96.
[8] For lemon trees with fruit, see Jashemski, 1979: 78, Fig. 126; 281, Fig. 420.
[9] Jashemski, 1979: 281, Fig. 419.
[10] For cherry trees with fruit, see Jashemski, 1979: 75, Fig. 121; 280, Fig. 418. There are cherries in innumerable small wall paintings, especially with birds.
[11] Varro, *De Re Rustica,* 1.16.3.

415 PERSHING DRIVE
SILVER SPRING
MARYLAND 20910
USA

Die Wasserversorgung der Privatbäder in Pompeji[*]

Nathalie de Haan

"Non alienum est, si aquae copia patiatur, patrem familias de structura balnei cogitare, quae res et voluptati plurimum conferat et saluti."
"Es ist nicht unzweckmäßig, daß, wenn die Menge Wasser dies erlaubt, ein *pater familias* sich den Bau eines Privatbades überlegt. Solch ein Privatbad ist ja dem Komfort und der Gesundheit höchst förderlich."
(Palladius I 39,1)[1]

Mit diesen Worten fängt Palladius, ein Schriftsteller aus dem dritten nachchristlichen Jahrhundert, seine Abhandlung über Privatbäder an. Dieses Zitat illustriert die Wichtigkeit einer ausreichenden und gut funktionierenden Wasserversorgung für Privatbäder, das Thema dieses Beitrages.

PRIVATBÄDER IN POMPEJI

Mehrere Wohnungen in Pompeji waren mit einem Privatbad versehen. Solch ein Privatbad umfaßte ein oder mehrere Zimmer einer privaten Wohnung, die der körperlichen Hygiene dienten. Diese Funktion war permanent und nur für Bewohner des Hauses.[2]
Privatbäder finden sich in 30 Wohnungen in Pompeji.[4] Wenn wir mit insgesamt zirka 400 Wohnungen in Pompeji rechnen, bedeutet dies, daß etwa 7,5 % der Wohnungen eine eigene Badeanlage besaßen. Die Bewohner dieser Häuser waren also nicht – oder nicht ausschließlich – auf die öffentlichen Bäder angewiesen. In diesem Rahmen wird jetzt nicht näher auf

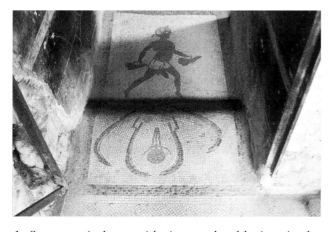

1. Sperre zwischen tepidarium und caldarium in der Casa del Menandro.

die Frage eingegangen, warum manche Hausbesitzer trotz hoher Kosten und der Möglichkeit des Badens in öffentlichen Badeanstalten, den Beschluß zum Bau eines eigenen Bades faßten. Evident ist allerdings, daß ein Privatbad eine Anzahl Vorbedingungen erforderte, die nicht jedes Haus erfüllen konnte. Außer dem im Hause vorhandenen Platz und den finanziellen Möglichkeiten der Hausbesitzer, dürfte eine ausreichende Wasserversorgung ausschlaggebend gewesen sein. In diesem Beitrag wird versucht zu erklären, wie man diese Erfordernisse erfüllte und wie die Zuleitung sowie der Abfluß des Wassers geregelt waren. Außerdem wird die Erwärmung des Badewassers besprochen.

DER WASSERBEDARF UND DIE ZULEITUNG DES WASSERS

Der Wasserbedarf eines Bades hängt erstens mit der Größe der Badezimmer und ihrer Wannen und zweitens mit dem Niveau der Versorgungen zusammen. Die pompejanischen Privatbäder können nach ihrer Größe und deswegen nach ihrem Wasserbedarf in drei Gruppen eingeordnet werden.
Das Bad der Casa dell'Efebo (I 7, 10-12.19), das zur Gruppe I gehört, war sehr einfach gestaltet: es hatte nur einen schmalen Raum. Während der Grabung wurde noch ein Waschbecken aus Bronze vorgefunden, das auf der Erhöhung der Hinterwand stand.[4] Das Bad hatte weder ein *hypocaustum* noch Wandheizung. Die Zuleitung des Wassers kann nicht mehr nachgewiesen werden, obwohl von Maiuri 1927 noch ein Rohr in der Hinterwand beobachtet wurde.[5] Das Bad der Casa dell'Efebo (I 7, 10-12.19) und das kleine Bad der Casa del Criptoportico (I 6, 2.(4).16) bilden die einzigen Beispiele für die Bäder der Gruppe I.[6] Es ist aber keineswegs undenkbar, daß es in mehreren Häusern vergleichbare Badezimmer gegeben hat, die sich aber schwierig erkennen lassen, wenn kein Waschbecken mehr vorhanden ist. Außerdem muß bemerkt werden, daß man sich zu Hause vermutlich oft mit solchen Becken oder Waschfässer versorgt hat, die in irgendeinem Zimmer des Hauses aufgestellt wurden. Weil der permanente Charakter fehlt, kann man hier aber nicht von einem Privatbad sprechen.
Die meisten Privatbäder (insgesamt 22) gehören aber zur zweiten Gruppe.[7] Sie gliedern sich in zwei

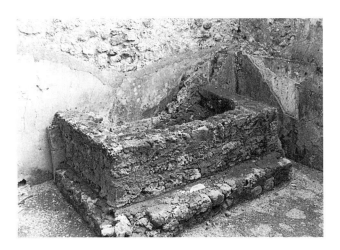

2. *Wanne des caldarium der Casa del Torello.*

3. *Bronzewanne aus der Casa dei Cervi in Hercula-neum (G. Jansen).*

Räume: erstens ein *apodyterium,* in dem man die Kleider ablegte und das zugleich das lauwarme Zimmer *(tepidarium)* bildete. Hier verbrachte man eine Weile, bevor man zum warmen Baderaum oder *caldarium* ging. Das Bad lag neben der Küche, meistens zwischen Diensträumen. Die Heizung des *caldarium* fand von der Küche aus statt.

Meistens waren beide Zimmer mit einem *hypocaustum* ausgestattet und nur das *caldarium* hatte Wandheizung. Die Lage neben der Küche war auch im Hinblick auf die Zuleitung und den Abfluß des Wassers eine praktische Lösung.

Der Wasserbedarf dieser Bäder war gering. Nur das *caldarium* benötigte Wasser; im Umkleideraum war Wasser natürlich nicht erwünscht. Als Illustration dafür kann die Sperre dienen, die sich in der Türöffnung zwischen *tepidarium* und *caldarium* im Casa del Menandro (I 10, 4.14-17) befindet. Diese verhinderte, daß Wasser vom *caldarium* in das *tepidarium* floß *(Abb. 1).*

Im *caldarium* fand die Reinigung des Körpers statt. Das *caldarium* enthielt eine Badewanne und ein Waschbecken. Diese Wanne war manchmal gemauert, meistens aber aus Bronze oder Ton hergestellt. Leider sind die transportablen Wannen aus den Privatbädern verschwunden.[8] Man kann nur noch feststellen, daß es sie gegeben hat, weil im *caldarium* fast immer eine Nische für die Wanne erkennbar ist. Die gemauerten Wannen sind aber *in situ* erhalten. Für die Privatbäder der Gruppe II kann die gemauerte Wanne des *caldarium* der Casa del Torello (V 1, 7.3.6.8.9) als Beispiel dienen. Diese Wanne *(Abb. 2)* mißt ca. 64,5 cm breit x 132 cm lang x 50 cm hoch und hat einen Inhalt von ca. 0,4257 m^3, was übereinstimmt mit ca. 430 Litern. Wenn man mit Eimern von 10 Litern rechnet bedeutet dies, daß das Bad mit etwa 43 Eimern gefüllt werden

konnte. Dies ist also die maximale Kapazität. Wenn man allerdings eine Wasserhöhe von 25 cm annimmt, wurden nur 220 Liter oder 22 Eimer benötigt.[9] Wahrscheinlich hatten die Bronzewannen einen durchaus vergleichbaren Inhalt, wie ein erhaltenes Beispiel einer solchen Bronzewanne bestätigt. Die Wanne wurde unter einer Treppe im Garten der Casa dei Cervi (IV 21) in Herculaneum vorgefunden.[10] Sie mißt etwa 159 cm lang x 60 cm breit x 53 cm hoch (Außenmaße) und hat einen Inhalt von ungefähr 0,3 m^3 (die Form der Wanne ist nicht regelmäßig) *(Abb. 3).* Das *labrum,* ein rundes flaches Becken auf hohem Fuß, bildete das zweite Element, das sich in fast jedem *caldarium* befand. In keinem der Privatbäder Pompejis wurde das *labrum* vor Ort gefunden, aber die halbrunden Nischen *(schola labri)* der *caldaria* deuten darauf, daß es sie gegeben hat. Am *labrum* konnte man sich mit kaltem Wasser waschen, bevor man sich in die gemeinsame Badewanne setzte. Außerdem verursachte der Wasserdampf eine warmfeuchte Atmosphäre. Viel mehr als den Inhalt einiger Eimer kann das *labrum* nicht gefaßt haben, wenn man auf die Größe der *scholae labri* achtet.[11]

Dies alles bedeutet meines Erachtens, daß Privatbäder dieser Größe nicht unbedingt fließendes Wasser in den Räumen brauchten. Obwohl die Mehrzahl der Häuser mit einem Privatbad einen Anschluß an das städtische Wasserleitungsnetz besaß, ist nicht sicher, ob das Leitungswasser auch in die Baderäume geführt wurde. Hinweise dafür fehlen meistens. Dies mag zusammenhängen mit der Tatsache, daß viele der Leitungen während der Ausgrabungen ohne jede Dokumentation weggenommen wurden. Es ist aber auch möglich, daß, obwohl das Haus zu einem bestimmten Zeitpunkt fließendes Wasser bekam, das Bad weiterhin mit Wasser aus Brunnen, Zisternen oder öffentli-

chen Laufbrunnen versorgt wurde.[12] Hier spielt auch die Frage der Chronologie eine Rolle: manche Privatbäder sind älter als das augusteische Wasserleitungssystem. Sie haben also eine gewisse Zeit ohne dieses System funktioniert. Dazu kann der genaue Zeitpunkt des Anschlusses eines Hauses an das städtische Wasserleitungsnetz kaum archäologisch fixiert werden.

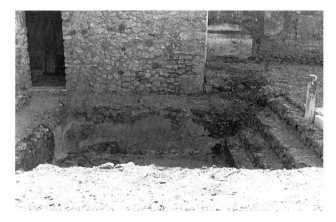

4. Piscina der Casa delle Nozze d'Argento.

Wenige Privatbäder (insgesamt 6) waren aber umfangreicher.[13] Das *apodyterium* und das *tepidarium* waren hier nicht in einem Raum kombiniert, sondern nahmen zwei separate Räume ein. Außerdem wurde noch ein Raum hinzugefügt, das *frigidarium* oder Kaltwasserbad. Ein Schwimmbad unter offenem Himmel *(piscina)* vervollständigte das Bad, das in seiner Einrichtung den öffentlichen Bädern nicht unterlegen war.

Im Vergleich mit den Bädern der zweiten Gruppe war der Wasserbedarf dieser Bäder viel größer. So hat zum Beispiel die *piscina* der Casa delle Nozze d'Argento (V 2, i) einen Inhalt von ca. 12,13 m³, was mit 12130 Litern übereinstimmt *(Abb. 4).*[14] Wenn man diese *piscina* mit Eimern hätte füllen müssen, wären 1213 Eimer notwendig gewesen! Hier war also die Benutzung von Leitungswasser unverzichtbar. Für alle Häuser der Gruppe III wurde fließendes Wasser in den Baderäumen tatsächlich nachgewiesen, mit Ausnahme der Casa del Criptoportico (I 6, 2.(4).16). Schließlich muß bemerkt werden, daß alle Privatbäder der Gruppe III erst entstanden, als das augusteische Wasserleitungssystem realisiert wurde. Ohne die Möglichkeit einer früheren städtischen Wasserleitung auszuschließen, kann doch festgestellt werden, daß es eine gewisse Beziehung zwischen der augusteischen Wasserleitung und dem Bau der aufwendigen und wasserreichen Privatbäder gibt.[15] Zusammenfassend kann festgestellt werden, daß die Größe und Einrichtung des Privatbades den Was-

serbedarf bestimmt haben. Die größten Privatbäder konnten nicht auf Leitungswasser verzichten.

DER ABFLUSS DES WASSERS

Der Abfluß des benutzten Wassers läßt sich meistens noch teilweise verfolgen. Der Abfluß findet sich meistens im *caldarium,* manchmal im *tepidarium.* Die Materialien der Abflüsse sind unterschiedlich. Hauptsächlich wurden Röhren aus Ton, manchmal auch Blei benutzt. Auch halbe tönerne Röhren wurden benutzt. Der Boden des Raums, abgestrichen mit wasserfestem *opus signinum* oder mit Mosaik verkleidet, fällt in die Richtung des Abflusses ab, so daß das Wasser problemlos durch die Röhre abgeleitet werden konnte. Bisher wurde ein Beispiel für einen Abfluß aus Marmor vorgefunden, und zwar im kleinen Bad der Casa del Criptoportico (I 6, 2.(4).16) *(Abb. 5).*
In der Casa del Fauno (VI 12, 1.2.3.5.7.8.) wurde das benutzte Wasser durch eine tönerne Röhre in die südlich angrenzende Latrine geleitet und spülte die Latrine. In anderen Privatbädern lag das *caldarium* neben der Straße und das Brauchwasser wurde in die Straße abgeleitet. Beispiele dafür werden von der Casa del Centenario (IX 8, 6.3.a) und vermutlich auch der Casa del Labirinto (VI 11, 9.10) gebildet.
Im *frigidarium* der Casa del Centenario (IX 8, 6.3.a) hatte die *piscina* keinen Abfluß im Boden, sondern einen Überlauf im Rand, der von einem Bleirohr gebildet wird *(Abb. 6).* Das Wasser wurde dann in einen Abfluß in der Ostwand des Raums geführt. Diese Konstruktion läßt vermuten, daß hier von einem ständigen Wasserzufluß die Rede war (ein *in situ* erhaltenes Bleirohr über dem südlichen Rand des Piscinabeckens belegt, daß das Bad mit Leitungswasser versorgt wurde). In öffentlichen Badeanlagen war dies gerade auch für die Badebecken der *frigidaria* der Fall.[16]

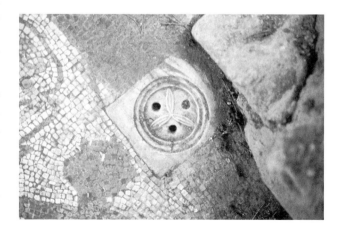

5. Abfluß im kleinen Bad der Casa del Criptoportico.

Dieser kurze Überblick macht deutlich, daß es mehrere Möglichkeiten gab, um das Brauchwasser abzuleiten und daß es schwierig ist, auf einen Standard zu schließen. Für den Abfluß war die Lage des Privatbades im Haus, z.B. direkt neben einer Straße oder nicht, zwischen Diensträumen, grenzend an den Garten u.s.w., ausschlaggebend. Weil aber jede Situation anders war, war auch jede Lösung anders.

DIE ERWÄRMUNG DES BADEWASSERS

Für die Erwärmung des Badewassers wurde ein Kessel benutzt, der über dem *praefurnium* im Heizraum oder in der Küche stand. Die Baderäume und das Badewasser wurden also zugleich von einem Feuer erwärmt. Leider sind in Pompeji die Kessel selbst überall verschwunden. Nur der Kessel des Privatbades der Villa La Pisanella in Boscoreale, einige Kilometer nördlich von Pompeji, ist erhalten geblieben *(Abb. 7)*.[17] Der zylinderförmige Kessel, der sich heute im Nationalmuseum in Neapel befindet, ist aus zwei großen aneinandergenieteten Bleiplatten hergestellt. Er stand auf zwei eisernen Balken über dem *praefurnium*. Der ganze Kessel war von einem gemauerten Mantel umgeben.[18] Dieser Mantel diente der Isolierung des Kessels und stützte zugleich den Kessel. Aus einem Becken in der Küche wurde das Wasser in den Kessel geleitet und dann nach Erwärmung in die Badewanne. Ein vernünftiges System von Röhren und Hähnen regelte die Zuleitung des warmen und kalten Wassers in die Wanne und das *labrum*.[19] In offener Verbindung mit der Wanne gab es die *testudo,* einen halbzylinderförmigen Behälter aus Bronze, der in der Wand zwischen dem Heizraum und der Wanne eingemauert war. Die *testudo*, die sehr nahe an der Feuerstelle lag, erwärmte aufs neue das in der Wanne abgekühlte Wasser. Das Wasser für den Kessel kam aus einem Bleibecken, das sich in der Küche befand.

Der Kessel mißt 58 cm im Durchmesser und ist 192 cm hoch.[20] Die Kapazität des Kessels kann also berechnet werden: h x πr^2 = 192 cm x π x 29 cm x 29 cm = 507279,25 cm³ = 0,5 m³. Von der Wanne im *caldarium* sind die Maße bekannt: 181 cm lang x 64 cm breit x 68 cm hoch. Die maximale Kapazität war also 0,79 m³. Wenn eine Wasserhöhe von 25 cm angenommen wird, war 181 cm x 64 cm x 25 cm = 0,29 m³ Wasser nötig. Der Kessel konnte also die Wanne knapp zweimal mit warmem Wasser versehen. Garbrecht/Manderscheid (1994, 31-32) sind der Meinung, daß die Badewanne während des Badens mit warmem Wasser nachgefüllt werden mußte, weil Wasser beim Ein- und Aussteigen verloren ging.

Wenn man aber die Menge Kaltwasser die dem warmen Wasser hinzugefügt wurde, mit in Betracht zieht, könnte mit den berechneten Verhältnissen zwischen Kessel und Wanne die Wanne zweimal gefüllt werden. Von einem ständigen Austausch des warmen Wassers kann also im Bad der Villa von Boscoreale, aber vermutlich ebensowenig in den pompejanischen Privatbädern, nicht die Rede gewesen sein, wie auch von Garbrecht und Manderscheid vermutet wird.[21]

Die Standorte der jetzt verschwundenen Kessel lassen sich oft dann ermitteln, wenn noch Reste des gemauerten Mantels erhalten sind, wie in der Villa von Diomedes in Pompeji *(Abb. 8)*. Die gemauerte Erhöhung,

6. Überlauf der piscina in der Casa del Centenario.

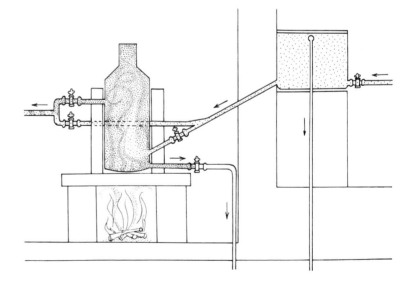

7. Die Kesselanlage der Villa la Pisanelle in Boscoreale (Zeichnung E. Ponten) (nach Schalles/Rieche/Piecht 1989, Abb. 39).

auf der das Kaltwasserbecken stand, läßt sich noch erkennen. Auch die Treppe in der Nähe des *praefurnium* weist auf einen Kessel hin. Diese Treppe diente dem Unterhalt und der Reinigung des Kessels.

8. Kesselanlage der Villa di Diomedes.

In anderen Privatbädern befand sich der Kessel in einer Nische, wie zum Beispiel in der Casa del Torello (V 1, 7.3.6.8.9). Der dreieckige Abschluß läßt sich nicht richtig erklären. Leider ist die Wand zwischen der Küche und dem *caldarium* zur Verstärkung mit modernem Zement abgestrichen, wodurch das ursprünglich vorhandene Loch der Röhre nicht mehr sichtbar ist.

Mit Hähnen wurde im *caldarium* der Zufluß des warmen Wassers aus dem Kessel und des kalten Wassers aus dem Sammelbecken geregelt. Die einzige Stelle, wo sich noch feststellen läßt, daß zwei Hähne geplant waren, findet sich im *caldarium* der Casa del Menandro (I 10, 4.14-17). Das Bad war, wie das ganze Haus, zur Zeit des Vesuvausbruchs einem großen Umbau unterworfen. Zwei Löcher in der Westwand der Nische für die Badewanne belegen, daß hier zwei Wasserhähne geplant waren.

LITERARISCHE QUELLEN

Der römische Architekt Vitruv, der in der Zeit des Kaisers Augustus seine Arbeit *De Architectura* verfaßte, erwähnt im Kapitel über die Anlage von öffentlichen Bädern, daß drei Bronzekessel im Heizraum aufgestellt werden sollten, einer für kaltes Wasser, einer für lauwarmes und einer für warmes Wasser.[22] Dieses literarische Zeugnis wird von archäologischen Funden in Pompeji bestätigt, in den Stabianer Thermen und in den Forumthermen.

In den Privatbädern hat es aufgrund des geringeren Wasserbedarfs nur zwei gegeben, einen für warmes Wasser und einen für kaltes. Beispiele für Privatbäder mit drei Kesseln gibt es bisher nicht. Dies wird auch bestätigt von zwei späteren Schriftstellern, Faventinus und Palladius, die beide im dritten Jahrhundert n.Chr. in ihren Arbeiten über Architektur die Anlage eines Privatbades beschreiben. Beide Autoren erwähnen einen Kessel für die Erwärmung des Wassers und ein Becken für kaltes Wasser.[23]

ABSCHLUSS

Die Wasserversorgung von öffentlichen Badeanlagen wie Privatbädern kann in großen Zügen geschildert werden, wenn alle archäologischen und literarischen Quellen benutzt werden. Jedoch gibt es in jedem Privatbad in Pompeji Einzelprobleme, die zusammenhängen mit der Tatsache, daß in jedem Haus und jedem Bad die Bedingungen und Möglichkeiten etwas abweichen konnten, ein Phänomen das ja gerade in der Hausarchitektur auftrat. Auch die Konservierung der Privatbäder allgemein und der Elemente der Wasserversorgung im besonderen ist sehr unterschiedlich. So müssen die gut erhaltenen Privatbäder als Beispiel dienen für jene Privatbäder, die nicht ausreichend konserviert sind.

In dem heutigen Stand der Forschung stellt sich folgendes Bild heraus:

- Der Wasserbedarf jedes Privatbades war direkt abhängig von der Größe der Baderäume und dem Niveau der Versorgung.
- Fast alle Privatbäder wurden mit fließendem Wasser des augusteischen Wasserleitungsnetzes versorgt, trotz der Tatsache, daß die meisten Privatbäder auch ohne dieses System funktionieren konnten, beziehungsweise funktioniert haben vor dem Bau der augusteischen Wasserleitung.
- Für den Abfluß wurde in jedem Privatbad eine eigene Lösung getroffen, weil die Lage des Bades im Hause die Möglichkeiten bestimmten.
- Die Kesselanlage der Villa La Pisanella in Boscoreale kann als repräsentativ für die in pompejanischen Privatbädern benutzten Kessel dienen. Daß dieses System lange ausgehalten hat, lassen die Beschreibungen von Palladius und Faventinus vermuten.

Es liegt aber auf der Hand, daß ein Vergleich mit den Wasserversorgungsmaßnahmen in Privatbädern anderer römischer Stadtwohnungen und Villen das Bild noch ergänzen kann.

BIBLIOGRAPHIE

De Haan, N. 1992, Privatbäder in Pompeji und Herkulaneum und die städtische Wasserversorgung, *MInstWasser* 117, 423-445.

Garbrecht G./H. Manderscheid 1994, Die Wasserbewirtschaftung römischer Thermen. Archäologische und hydrotechnische Untersuchungen, *MInstWasser* 118, A-C.

Maiuri, A. 1927, Pompei - Casa dell'Efebo in bronzo, *NSc*, 32-38.

Mau, A. 1894, Scavi di Boscoreale, *RM* 9, 349-358.

Pasqui, A. 1897, La villa pompeiana della Pisanella presso Boscoreale, *MonAnt* 7, 397-554.

Plommer, H. 1973, *Vitruvius and later Roman Building Manuals,* Cambridge.

Schalles, H.J./A. Rieche/G. Precht 1989, *Die römischen Bäder,* Köln.

Sogliano, A. 1895, Boscoreale - Scoperta di una villa rustica, *NSc*, 207-215.

Squassi, F. 1954, *L'arte idro-sanitaria degli antichi. Epoche preromana e romana,* Tolentino.

Strocka, V.M. 1991, *Casa del Labirinto (VI 11, 10),* München.

Tran Tam Tinh, 1988, *La Casa dei Cervi à Herculanum,* Roma.

ANMERKUNGEN

* Diese Forschung fand statt im Rahmen der Dissertation der Verfasserin, die römische Privatbäder als Thema hat. Die Forschung wurde finanziell unterstützt von der Niederländischen Organisation für Wissenschaft (NWO). Für die Genehmigung der Feldforschung vor Ort danke ich Herrn Prof. B. Conticello und Herrn Dr. A. Varone.

[1] Palladius hat seine Abhandlung auf ein Traktat von Faventius *'De diversis fabricis architectonae'* gestützt. Auch Faventius war ein Schrifsteller des dritten Jahrhunderts. Er hat vor allem Vitruv als Vorbild genutzt (cf. Plommer 1973, 1-2).

[2] Es handelt sich also nicht um öffentliche Badeanlagen die von privaten Leuten wirtschaftlich genutzt wurden. In der deutschen Sprache werden diese sogenannten *balnea meritoria* nämlich öfters mit dem Begriff 'Privatbad' übersetzt.

[3] Gruppe I: Casa del Criptoportico (I 6, 2.(4).16; kleines Bad); Casa dell'Efebo (I 7, 10-12.19).
Gruppe II: Casa del Citarista (I 4, 5.6.25.28); Casa di Paquius Proculus (I 7, 1.20); Casa di Trebius Valens (III 2, 1.a); Casa del Torello (V 1, 7.3.6.8.9); Casa di L. Veranius Hyspaeus (VI 8, 20.21.2); Casa del Fauno (VI 12, 1.2.3.5.7.8); Casa a tre piani (VI 17, 9.10.11); VI 17, 12.13.(14); Casa di Julius Polybius (VI 17, 19-26); Casa delle Nozze di Alessandro (VI 17, 42-44); Casa di Caesius Blandus (VII 1, 40-43); VII 2, 51; Casa dei cinque scheletri (VII 14, 9); Casa del Marinaio (VII 15, 1.2.15); VII 16, 1; VII 16, 12-16; Casa di Fabius Rufus (VII 16, 17.20-22); VIII 2, 28; VIII 2, 36.37; Casa di Giuseppe II (VIII 2, 38.39); Casa di Obellius Firmus (IX 14, 2.4.b); Villa dei Misteri.
Gruppe III: Casa del Criptoportico (I 6, 2.(4).16; großes Bad); Casa del Menandro (I 10, 4.14-17); Casa delle Nozze d'Argento (V 2, i); Casa del Labirinto (VI 11, 9.10); Casa del Centenario (IX 8, 6.3.a); Villa di Diomedes.

[4] Grabungsbericht vom 5. Juni 1925: "Sotto la parete di fondo v'è un poggiolo in muratura, uno di forma semicilindrica allungata, coperto d'intonaco bianco ed ornato di fasce rosse sia verticali {che} orizzontali. Finisce in alto bombato. Sopra di questo poggiolo v'è una bacinella di bronzo. (...) Bronzo: bacinella in gran parte frammentata, ma subito restaurata, che poggia su tre piedi, forse a zampa felina, dico forse perchè l'estremità sono murate. La bacinella è di forma quasi emisferica; le anse sono serpeggianti e ciascuna ornata {...} da tre borchie bombate e bacellate. La bacinella è alta = 185 e larga = 555." Heutzugate ist dieses Becken niet mehr *in situ*.

[5] Maiuri 1927, 38 ("condotto di immissione di acqua").

[6] Die Casa del Criptoportico besaß zwei Privatbäder: ein aufwendiges Privatbad, das sich gliedert in *apodyterium, frigidarium, tepidarium, caldarium* mit eigenem Heizraum im östlichen Trakt des *cryptoporticus* (großes Bad). Dazu noch ein kleines *caldarium* im südlichen *cryptoporticus* (kleines Bad).

[7] Cf. Anmerkung 3.

[8] Nach Squassi (1954, 85) finden sich in der Sammlung des Nazionalmuseums in Neapel zwei Bronzewannen: "Due vasche di bronzo sono esposte nella Sala dei commestibili e dei colori al Museo Nazionale di Napoli; provengono da Pompei." Eine dieser Bronzewannen ist abgebildet (Squassi 1954, 87 Fig. 94). Leider werden die Maße nicht erwähnt. Möglicherweise kommt die Wanne aus dem *frigidarium* der Casa del Labirinto (VI 11, 9.10), die laut des Grabungsberichtes den 2. Juni 1835 in diesem Raum vorgefunden wurde (zitiert in Strocka 1991, 56). Die Beschreibung dieses Grabungsberichtes ("un bagno di bronzo con quattro grossi anelli") stimmt nämlich mit der Wanne, die bei Squassi abgebildet ist, überein. Die Wanne ist dem Grabungsbericht nach ca. 158 cm lang und ca. 40 cm hoch. Die Breite wird nicht erwähnt.
In der Villa La Pisanella in Boscoreale, in der Nähe von Pompeji, wurden während der Ausgrabung zwei Bronzewannen vorgefunden, die von Pasqui (1897, 424) beschrieben werden: "Nel mezzo dell'area che cosituiva il cavedio erano deposte l'una contro l'altra due grandi vasche da bagno, fatte con robustissima lamina di bronzo, in un solo pezzo. La più grande, lunga m. 1,75, aveva largo orlo piano, corpo conico, ornato di quattro grandi maschere leonine, sulle quali ricadevano grandi anelli girevoli (fig. 16); l'altra un poco più piccola, ma di forma consimile, era priva di ornamento (fig. 17)".

[9] 0,21985 m3 = 220 Liter.

[10] Tran Tamm Tinh 1988, 107-108. Die Casa dei Cervi hat übrigens kein Privatbad.

[11] Nur in der *schola labri* des *caldariums* der Casa del Labirinto (VI 11, 9.10), weist das runde Loch in der Wand auf eine Wasserleitung, die das *labrum* mit Leitungswasser versorgte, hin.

[12] Cf. den Beitrag von Jansen (47-50), in dem die Benutzung des Leitungswassers im Hause, möglicherweise nur für Springbrunnen, diskutiert wird.

[13] Cf. Anmerkung 3.

[14] Die *piscina* mißt 385 cm x 300 cm x 105 cm, was mit einer maximalen Kapazität von 12,1275 m3 = 12127,5 Litern übereinstimmt.

[15] Cf. De Haan 1992.

[16] Cf. Garbrecht/Manderscheid 1994, 71-73.

[17] Die Villa ist leider kurz nach der Ausgrabung wieder zugedeckt und jetzt überbaut worden.

[18] In den meisten Rekonstruktionsversuchen und -zeichnungen wird der Mantel nur bis zur Hälfte des Kessels aufgemauert. Garbrecht/Manderscheid (1994, 34-35) haben jedoch überzeugend bewiesen, daß der ganze Kessel ummantelt war.

[19] Cf. die Beschreibungen von Mau (1894, 354-357), Sogliano (1895, 210) und Pasqui (1897, 450-455).

[20] Pasqui 1897, 449. Die Maßangaben von Sogliano (1895, 209) scheinen weniger sorgfältig zu sein: "(...) altezza complessiva di m. 2 di m. 0,50 di diametro." Mau (1894, 354) spricht von einer Höhe von 195 cm und einem Durchmesser von 59 cm. Für die Berechnung der Kapazität sind die von Pasqui erwähnten Maße benutzt worden.

[21] Manderscheid/Garbrecht 1994, 31 und 74-76. Sie bemerken, daß die aufwendige Aufbereitung des Wassers als Begründung hinreichend sein dürfte.

Im übrigen kann als Argument gegen einen ständigen Wasserwechsel hinzugefügt werden, daß bei einem ständigen Wasseraustausch eine *testudo* wenig sinnvoll gewesen wäre.

[22] *De Arch.* V 10, 1,: *Aenea supra hypocausim tria sunt componenda, unum caldarium, alterum tepidarium, tertium frigidarium, et ita conlocanda, uti, ex tepidario in caldarium quantum aquae exierit, influat de frigidario in tepidarium ad eundem modum, (...).*

[23] M. Cetius Faventinus, *De diversis fabricis architectoniae* 16: *"Plumbeum vas quod patenam aeream habet, supra fornacem conlocetur, alterum simile frigidarium secus, ut quantum caldae ex eo in solio admittatur tantum frigidae infundatur."*

Palladius, *De agricultura* I XXXIX 3: *"Miliarium vero plumbeum cui aerea patina subest inter soliorum spata forinsecus statuamus fornace subiecta. Ad quod miliarium fistula frigidaria dirigatur et ab hoc ad solium similis magnitudinis fistula procedat, quae tantum calidae ducat interius quantum fistula illi frigidi liquoris intulerit."*

KATHOLIEKE UNIVERSITEIT NIJMEGEN
GLTC, AFD. KLASSIEKE ARCHEOLOGIE
POSTBUS 9103
NL-6500 HD NIJMEGEN
NIEDERLANDE

Water-Lifting Devices at Herculaneum and Pompeii in the Context of Roman Technology

John Peter Oleson

There are few sites in the Roman world as rich as Pompeii in structures and artifacts that provide information about the details of day-to-day life in the first century AD. As a result, it is easy to assume that everything we see at this remarkable site – and at its regional counterpart, Herculaneum – is a valuable revelation of data lost elsewhere, a storehouse of irreproducible information typical of the period. In this paper I would like to explore the character of water-lifting technology at Pompeii and – to a lesser extent – Herculaneum in the context of the Roman empire as a whole. While the physical remains of mechanical water-lifting installations at these two sites are interesting in themselves, they take on added meaning in the context of our knowledge of Roman technology in general. Since we know so much about daily life in Pompeii and Herculaneum, these sites can serve as a useful foil to play against our overall understanding of the social place of technology in the late Republic and Empire.[1]

I will begin with a description of the water-lifting devices found at Pompeii and Herculaneum, then turn to an evaluation of how these devices reflect the social organization, economy, technological level, and urban infrastructure of these small cities. The results will allow an evaluation of how and why this technology is used here in a manner similar to or different from what we find elsewhere in the early empire.

Over the past two centuries, excavators have – to my knowledge – revealed only five probable or possible installations for mechanical water-lifting devices at these two sites: four bucket-chain installations at Pompeii, another possible one at Herculaneum. In addition, a fresco has been found in the House of the Ephebe (I 7, 10-12.19) at Pompeii representing a water-screw in use. Three of the bucket-chains at Pompeii were used to supply water to baths – the Stabian, Forum, and Republican Baths, while the fourth probably supplied water to a tannery at the House of the Queen of England (VII 14, 5.17-19). The possible bucket-chain installation at Herculaneum served the Forum Baths. I have not been able to visit the Suburban, Sarno, or Palaestra Baths at Pompeii or the Suburban Baths at Herculaneum, but the published plans and descriptions do not suggest the presence of water-lifting installations in any of them.[2]

STABIAN BATHS

The water-lifting installation serving the Stabian baths, the best preserved of the four related Pompeian examples, is located in the northwest corner of that complex *(Fig. 1)*.[3] A large well shaft (2.90 x 2.0 m, originally ca. 25 m deep, now cleared to a depth of 13 m) was fronted on the southwest by a long, rectangular room meant to contain the tread-wheel (L 5.8 m, W 1.2 m). The walls are built of concrete with *opus incertum* facing. The shaft terminates several metres

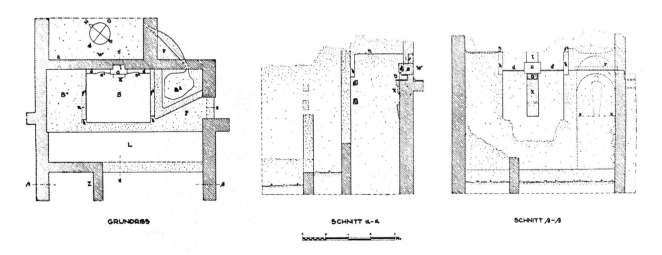

1. Pompeii, Stabian Baths: Plan of water-lifting installation (Pemp 1939: fig. 3).

2. Pompeii, Stabian Baths: View of well shaft.

3. Pompeii, Stabian Baths: View of interior of well shaft.

above the present ground level, level with the roof of this part of the building, and is framed on the northwest and southeast by two shallow basins that emptied into a large cistern adjacent to the shaft on the northeast (L 11.25 m, W 3.8 m, H 0.9 m; cap. 38.5 m³). The interior of the shaft *(Figs. 2-3)* is heavily encrusted with lime deposited by the water lifted within it, with the exception of two wide, shallow grooves worn in the upper two or three metres of the northeast wall, on either side of a beam hole in the centre of the wall, level with the roof behind.

On the basis of irregularities in design and evidence for alterations in this section of the bath, Pemp restored two stages of use of a bucket-chain device. In his first stage, a single individual trod the inside of a wheel which, through a complicated gear drive, moved two wheels carrying bucket-chains. Since no storage cistern was provided, the discharge must have been conducted to the bath heaters and tanks directly from the collecting basins. In Pemp's second stage *(Fig. 4)*, the roof of the building was raised by about one metre, and the basins redesigned to fill a newly-

erected cistern *(Fig. 5)*. The power was now supplied by two individuals treading the outside of a wheel. For both stages Pemp restored small, sack-shaped bronze buckets hinged loosely at their upper, inner lip to an iron chain, allowing them to flip over after passing over the wheel.

There are several problems with Pemp's restoration, resulting from his desire to explain the presence of two grooves on the same side of the shaft, grooves caused by the scraping of heavy buckets rising from the well. In the first place, the treader would not have walked inside the wheel of the first stage, since such an arrangement would not have made use of all his weight. Secondly, his reconstruction of the gearing is unnecessarily complex.[4]

The restoration of this device hinges on the design and orientation of the bucket-chain or chains. A single chain of containers must have been standard in antiquity, as it is with such devices today, but several peculiarities common to the devices in the Stabian Baths and the House of the Queen of England (VII 14, 5.17-19) suggest Pemp may be correct in resto-

ring a double chain system.[5] The most important factor is the presence of two basins: while a separate basin for each wheel is not absolutely necessary for a two-chain system, a single-chain system would certainly have use for only one. The location of the wall grooves suggests the mounting of bucket-chains the short way, across the shaft, and thus also implies the simultaneous presence of two wheels. The great depth of the well may have required the division of lifting capacity into two small rather than a single large chain, thus avoiding excessive strain on the chain links. The grooves worn in the shafts were undoubtedly created by the outer side of heavy, water-filled buckets about to pass over the wheel. The filled section of such chains rises almost vertically because of the weight of the water, reaching its maximum horizontal displacement at the wheel, while the empty portion of the chain curves markedly inward, drawn by the weight of the loaded portion. The empty buckets are thus not only light, but have little opportunity of coming in contact with the shaft walls.

The presence of two grooves in the same side of the well shaft in the Stabian Bath, however, still remains puzzling. Had these grooves been caused by the sides of the buckets, the marks would extend down the entire shaft. Furthermore, if the two grooves represented successive installations, one would now be more encrusted with calcium carbonate deposits than the other. This is not the case. Finally, even assuming that there were some advantages in designing the bucket-wheels to turn in the same direction, the addition of the required extra transmission gear would have displaced one of the wheels (and thus its groove) slightly towards one wall of the shaft. The grooves, however, are symmetrically located. A final possibility is that

5. Pompeii, Stabian Baths: View of reservoir on roof.

the bucket-wheels were simply too large for the shaft and caused the chains to rub its sides both rising and falling; had the upper portion of the southwest wall

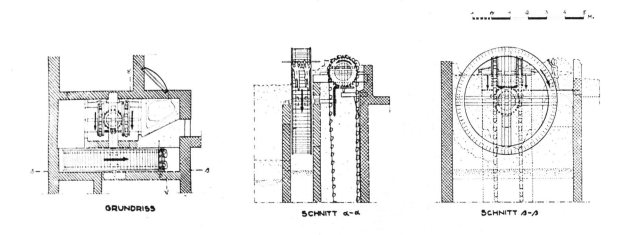

4. Pompeii, Stabian Baths: Reconstruction of water-lifting installations (Pemp 1939: fig. 11).

been preserved, in this case it might have shown a pair of identical grooves.

Conclusive evidence is lacking for the design of this machine, but (assuming that our interpretation of the grooves is correct, and that the mechanic correctly preferred the simplest possible gearing system) it is at least possible that the tread-wheel, gear train, and bucket arrangement were reversible. If the tread-wheel shaft carried a simple spur gearwheel that meshed directly with perpendicular teeth projecting from the outside of the bucket-wheels, and if the buckets were symmetrical and swung freely from attachments at either side of their upper openings, then the tread-wheel and chains could have turned in either direction. If such were the case, and if an attempt had been made to alternate the direction of the drive in order to even out the wear on buckets, shaft, and gear teeth, the present pattern of grooves would have resulted.

Through various reasonable, but unverifiable, assumptions and calculations, Pemp restores two men driving two chains of ca. fifty 3.25-litre buckets, yielding together 0.43 litre/sec.[6] It may not be accidental that the hypothetical daily discharge of this device (for twenty-four-hour operation) – 37 m³, is close to the capacity of the adjacent cistern – 38.5 m³. If the cistern capacity represents the daily requirements of the bath, the lifting device may have been kept working continuously in shifts to supply it.

After a piecemeal development, the bath reached its final form ca. 80 BC. There is no substantial evidence for Eschebach's proposal that a mechanical lifting device was first installed in the third century BC, and such an early date is unparalleled elsewhere.[7] The expansion of the bath and provision of separate facilities for males and females in the second century BC is a more likely moment for installation of the first bucket-chain, although the early first century BC is also possible. The second-stage lifting device must have gone out of use with the arrival of the municipal aqueduct during the reign of Augustus.[8] The earthquake of AD 62 destroyed this source,[9] however, and may have prompted the reinstallation of some device in the well; it is also possible that the bath was still out of use in AD 79.[10]

FORUM BATHS

There is an installation for a tread-wheel driven bucket-chain near the northwest corner of the complex (*Fig. 6*).[11] It has been enveloped by the north facade of the bath and drastically altered, but it may have involved a single bucket-chain. The rectangular well shaft (1.9 x 2.62 m; ca. 25 m deep, cleared to 15 m), originally rose to the level of the roof, but either after the earthquake of AD 62 or the excavations of 1824, it was vaulted over lower down. There is a narrow, irregular tread-wheel room (L ca. 5 m, W ca. 1.3-0.6 m) on the southwest side of the shaft, and there may have been basins adjacent to it on the northwest and southeast at the level of the roof. There are clear traces of a transverse arch within the well, and the walls are heavily coated with lime encrustation, but no grooves worn in the walls by a bucket-chain are visible at present. One explanation for the absence of such grooves is that any bucket-chain mounted in the shaft was oriented the long way and run on a garland wheel mounted directly on the axle of the tread-wheel. The bath was constructed at the foundation of the Sullan colony and was probably the only Pompeian bath still functioning at the time of the eruption

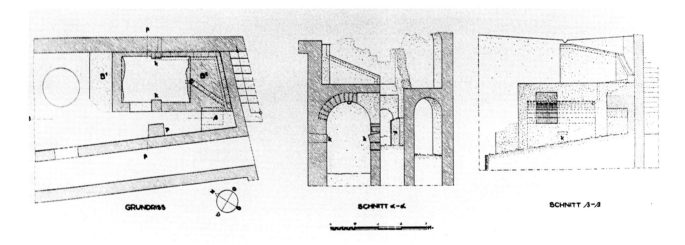

6. Pompeii, Forum Baths: Plan of water-lifting installation (Pemp 1939: fig. 5).

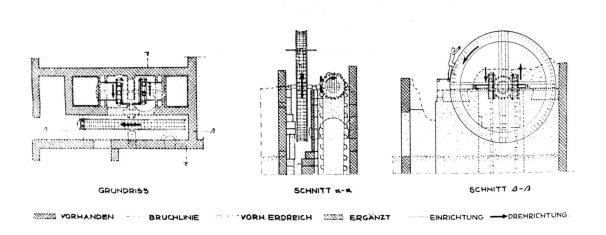

GRUNDRISS SCHNITT α-α SCHNITT β-β

▨ VORHANDEN ---- BRUCHLINIE ····· VORH. ERDREICH ▨ ERGÄNZT —— EINRICHTUNG → DREHRICHTUNG

7. Pompeii, House of the Queen of England: Reconstruction of water-lifting installations (Pemp 1939: fig. 11).

of AD 79, either through hand-hauling of water or reinstallation of a bucket-chain.[12]

REPUBLICAN BATHS

A square well shaft (2.4 m x 2.4 m) now cleared only to 5 m below ground level is all that remains of this hypothetical water-lifting installation.[13] It is located near the centre of a second-century BC bath structure that may have remained in use until 62 AD but was afterwards largely cleared away. The walls of the shaft were constructed of carefully-cut blocks of Sarno limestone, except for the upper portion of the east wall, which has been set back 0.2 m to the east and rebuilt of *opus incertum,* possibly to allow installation of a lifting device. At least the south and east walls of

the shaft carry lime encrustation, but no grooves are visible. No traces of elevated basins or a tread-wheel room remain. The presence of a water-lifting device in this shaft is possible, but unproven.

HOUSE OF THE QUEEN OF ENGLAND (VII 14, 5.17-19)

This installation is adjacent to a tannery shop, set up in the alley side of an expanded *atrium* house.[14] The long, narrow tread-wheel room (L 5.5 m, W 1.3 m) was reached at first by a door in the south wall, within the house, but structural alterations later provided an access door in the west wall leading in directly from the street *(Figs. 7-8).* The rectangular well shaft (L 2.6 m, W 1.5 m, cleared to a depth of 15 m) adjacent to the tread-wheel room is flanked on the east

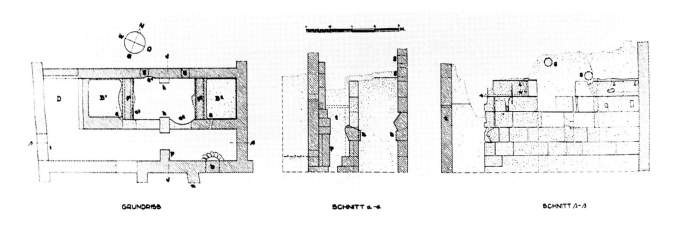

GRUNDRISS SCHNITT α-α SCHNITT β-β

8. Pompeii, House of the Queen of England: Plan of water-lifting installation (Pemp 1939: fig. 4).

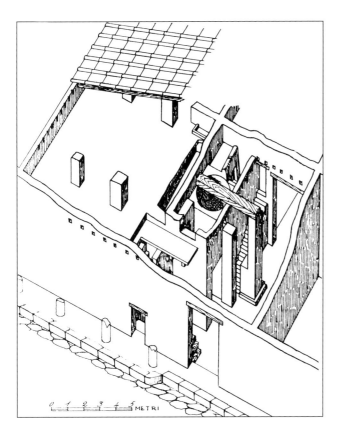

9. Herculaneum, Forum Baths: Axonometric view of water-lifting installation (Maiuri 1958: fig. 85).

It is not clear that there was in fact a mechanical water-lifting device installed in these baths.[16] A door in the northeast corner of the baths opens on a service corridor extending along the whole north side of the building. The corridor gives access to the furnaces, cisterns, and storage areas serving the baths, and possibly to second-storey apartments for bath personnel. A circular well shaft (D 2.25 m, depth 13 m) at the east end of the corridor extends to the level of the second floor (ca. 5.5 m above ground level), and water raised within it was discharged at this level into an interconnected series of cisterns built around it on all sides except the north *(Fig. 9)*. Lead pipes carried water from these cisterns to the heating tanks and the cold plunge. According to Maiuri, water was raised by means of a tread-wheel driven bucket chain installed on the second floor.[17] He restored this device only on the basis of the devices at Pompeii, and the presence in the shaft of a heavy bronze journal bearing. He assumes that the sharp-edged disk turned in a groove in the corresponding bronze plate, supporting one end of a bucket-chain axle and allowing it to turn freely. This type of bearing simply could not have functioned in such a manner.

There may have been a tread-wheel driven bucket chain operating in the well, although a square or rectangular rather than a circular well might have been expected in such a situation, but the remains of the structure provide no evidence for it at present. Since ground water can be found at a depth of only 8 or 10 m at Herculaneum, as opposed to 25 m at Pompeii, it is possible that the baths were served by a simple, but large-scale or multiple bucket-and-pulley system operated by hand.

HOUSE OF THE EPHEBE (I 7, 10-12.19)

The garden behind the House of the Ephebe contains a U-shaped triclinium bench that is stuccoed and frescoed on its inside and front surfaces with a long, low frieze of scenes of life in the Egyptian delta (L 9.05 m; H 0.5-0.6 m).[18] The river is shown in flood, isolating small islands occupied by buildings, surrounded by the typical details of Egyptian life: pygmies in boats and on land, scenes of sacrifice and crocodile-hunting, along with ducks, ibises, and the obligatory hippopotamus.[19] The scene on the right front surface of the bench (L 1.06 m; H 0.5 m) *(Fig. 10)* represents a canal, beside which stand two ramshackle structures: one is an open-air brothel or love-nest in which dancers and musicians perform around a pair of unembarrassed lovers; the other is a water-screw instal-

and west by two shallow catch basins (ca. 1.5 x 1.8 m, 0.11 m deep). The tannery tanks are just north of the north wall of the shaft. The impost blocks of a transverse arch are visible in the north and south walls of the shaft, which is coated with lime encrustation, while broad, shallow bucket-chain grooves can be seen on the western half of the north wall and the preserved portion of the eastern half of the south wall. It is likely that this shaft contained a device like that in the Stabian Baths: two bucket-chain wheels that meshed directly, at right angles, with a gearwheel mounted on the end of the tread-wheel shaft. A tread-wheel turning counter-clockwise (seen from the south) would have turned the bucket-wheels in the proper direction to produce with the rising portion of the chains the grooves now visible *(Fig. 7)*. Pemp makes a tentative calculation of its discharge (trod by one man) at 0.22 litre/sec. – an amount certainly sufficient for the needs of the tannery, even if worked only part of each day.[15] There is no substantial basis for dating the construction, but the late second or early first century BC seems the most likely period on the basis of comparison with the other lifting devices at Pompeii.

lation. The water-screw installation consists of two mud-brick walls or piers supporting a thatched or tiled roof that provides shade to a short figure resembling the pygmy typically found in Egyptianizing scenes. He supports himself on a pole while he treads the water-screw, which has only a slight upward tilt and empties its contents through a short spout into the mouth of a *dolium* buried up to its neck in the ground. This collecting tank was connected through an underground pipe to a partitioned tank in the foreground – a reservoir or artificially irrigated field. In view of the number of salaried irrigation workers mentioned in the agricultural papyri, the pygmy is more likely to have been free rather than a slave, and possibly was conceived of as irrigating his own plot of ground.[20] His unpleasant facial expression is an indication of the tedious and tiring character of the task, but it may also be intended as an artistic foil to the erotic highjinks taking place next door. Many papyri document the use of such water-lifting devices during the inundation, to lift water to an area above the level of the flood (ἄβροχηος γῆ).[21]

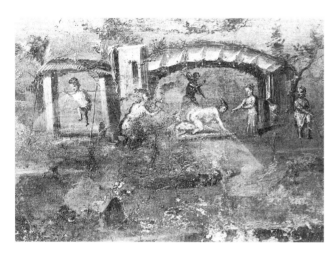

10. Pompeii, House of the Ephebe: Fresco of water-screw installation and neighboring structure.

REGIONAL SOCIAL AND TECHNOLOGICAL CONTEXTS

So much for description. How do these water-lifting devices (and the fresco) fit into the social and technological context of ancient Campania? I will consider the baths first.

The three baths at Pompeii represent the response to a growing enthusiasm by both genders in the later Republic for public baths with a graduated sequence of cool and heated water, dry and moist heat.[22] This widely-felt social need was addressed by both public money and private euergetism in the later second and early first centuries, a time of remarkable prosperity, expansion, and building in Pompeii. Although the custom of frequent hot bathing, often in the company of co-workers, friends, or family, had rural roots in Italy,[23] the elaborate bath structures of Pompeii are a typically urban phenomenon. Probably because of its more isolated location, smaller population, and less vibrant economy, Herculaneum received its only known public baths somewhat later, in the Julio-Claudian period.

These establishments had numerous enticements: steam or sweat rooms, ball courts, massage rooms, convenient and sociable latrines, depilation experts, and food vendors (see esp. Seneca *Epistulae Morales* 56.1-2).[24] Nevertheless, public bathing always required significant amounts of water, even in structures – like those at Pompeii and Herculaneum – where the immersion tanks are relatively small and most of the actual bathing was accomplished with a self-service splash from a large *labrum*. In pre-Augustan Pompeii, any need for a large, continuous supply of water meant that stored rainwater would not be sufficient, that some means had to be found to lift the water more or less 25 m from the local aquifer. The scale of the water use, combined with the height of the lift (increased even further by the need to store the water in roof cisterns for later delivery), enforced the use of bucket-chain devices. None of the other known pump designs – shaduf, water-screw, force pump, compartmented wheel, or Pater Noster chain – would have been suitable.[25] At the same time, the crowded urban context and elevated, roof-top location of the machinery would have made the application of human labour to the devices preferable to that of animals. The use of animals would have required installation of the heavy saqiya gear drive and provision of access ramps or wide stairs; there is no evidence for any of this.[26] Instead, installations were built for simple and efficient tread-wheels that in at least one case turned the bucket-chain directly, and in two cases possibly turned a pair of bucket-chains through a simple gear drive. The labourers, who probably worked in pairs, undoubtedly formed part of the staff of slaves that performed the many service tasks required in these complex and heavily-used structures.[27] This was a typical approach; Vitruvius (*De Architectura* X 4,2; X 6,3) refers in an off-hand manner to human labourers driving water-lifting devices, just as we might refer today to portable electric generators. There were no moral overtones, and it made perfect social, economic, and technological sense to him.

It never made sense, however, to lift water when and where gravity-flow supplies were available. In consequence, the baths must have been among the first

73

structures connected to the municipal gravity-flow water system made possible by the construction of an aqueduct to serve Pompeii in the reign of Augustus. Simultaneously, the bucket-chains were abandoned – undoubtedly to the relief of the slaves staffing the baths. It is not clear whether some of these installations were revived half a century later, when the earthquake of AD 62 put the aqueduct out of the commission. The Central Baths and Suburban Baths, constructed in the decade before the earthquake, were not provided with water-lifting devices, since the aqueduct was already in existence. It may not be co-incidence that these baths are located somewhat away from the others, outside the old city core with its system of centuries-old, deep wells.

The water-lifting system in the House of the Queen of England (VII, 14,5) served a tannery located in a shop associated with an expanded *atrium* house. It is possible that the well was dug originally to serve some other purpose, and even the lifting installation may have originally been built for some other purpose, but this cannot be proven. Although this manufactory was a private establishment, less demanding in its water-use than a public bath, tanning did require significant quantities of water for the soaking and rinsing tanks.[28] Like bathing, the processing of raw materials such as hides into semi-finished products was a typical part of the late Republican economy of Pompeii; woolen cloth and basalt millstones were two similar items (Cato, *De agri cultura* 22.3-4, 135.2).[29] Although somewhat smaller and less elevated above ground level than the water-lifting devices in the baths, the design and drive system in this structure resembled those in the baths, and slaves probably provided the power. Also like the baths, the well and associated manufactory were located in the old urban core, and the lifting device went out of service with the arrival of the aqueduct.

The fresco of a water-screw in the House of the Ephebe (I 7, 10-12.19) is completely different in character. It is a representation of a device, rather than a real installation, and it appears as an item of exotic local colour in a fresco cycle providing scenes of rural Egypt. The context was a private dining area – a garden *triclinium* – located in a villa outside the old urban core and cluster of deep wells, and away from the bustling commercial centre. The subject matter of the fresco cycle was meant for the enjoyment of the diners. The image of the water-screw reproduces a private, small-scale, rural agricultural activity worlds away from the urban reality of the baths and the tannery. Unlike the lifting devices in those structures, the water-screw was a relatively simple, inexpensive, low-lift design, so typical of Egypt that it

is represented there on many local votive terracottas as well as mentioned in the papyri.[30] In fact, the water-screw was invented by Archimedes specifically for use as an irrigation pump in the silty waters of the Nile delta (Posidonius frag. 117, in Diodorus 5.37.3-4).[31] Also in contrast to the other Pompeian devices, this one represented part of a centuries-old system and a seasonal rather than year-round activity. It is interesting that the same device is still used in Egypt today for the same purpose, while the more complex, more 'advanced' Pompeian systems are now obsolete. Finally, the papyri reveal that the sour-looking individual treading the water-screw probably was a free man, either irrigating his own fields or working for a daily wage.[32] It is likely that the sophisticated urban slaves of Pompeii and similar cities would have preferred their own lot to his.

THE CAMPANIAN DEVICES IN THE CONTEXT OF ITALY AND THE EMPIRE

Since the devices discussed above are only a small sample of the great amount of data that survives concerning Roman water-lifting devices, it is important to evaluate how typical the mix of devices and functions is in comparison to the empire as a whole. In fact, although there are differences in the proportions of the various types of devices, the general situation of water-lifting at Pompeii and Herculaneum reflects surprisingly well the character of this technology, and the 'flavour' of Roman technology in general. The application of four out of the five bucket-chains to a large-scale, public application (the baths) is typical of the use to which relatively complicated or high-lift pumping devices were put. Although by no means all Roman water-lifting devices were used in association with baths, this application is the equivalent in Pompeii of the pumps used elsewhere to drain imperial-owned mines, supply municipal water systems, or extinguish fires.[33] To be sure, pumping installations serving baths are attested in at least six papyri from Hellenistic and Roman Egypt, and installations have been found in the baths at Abu Mena.[34] It is interesting, however, to note that the majority of these lifting devices are low-lift mechanisms – shadufs, water-screws, and compartmented wheels – a reflection of the high water table in most Egyptian settlements. At Abu Mena a pot-garland, driven at first by a saqiya then by a tread-wheel, was necessary because of the 14 m depth, but still far less than the lift at Pompeii. There may also have been a low-lift device in an imperial bath at Leptis Magna.[35] In Italy outside of Pompeii, water-lifting devices have been attested in baths at Cosa and Ostia. At Cosa, because of space

restrictions in a small public bath complex, a tread-wheel driven bucket-chain lifted water only 4 m to an elevated cistern.[36] There were lifting devices in five imperial baths at Ostia, but because of the high water table the device used in all but one case was the compartmented wheel, sometimes installed as staggered pairs.[37] There may have been a bucket-chain at the fifth bath, even though the lift was only 4 m – probably because of space restrictions. It has been suggested that a bronze force pump found at Castrum Novum was used to lift water for a public bath, but this is a very unlikely application, given the relatively small capacity of the pump.[38]

The installation serving the tannery constitutes important, rare evidence for the use of a mechanical water-lifting device to serve a private, non-rural, commercial application. With the exception of bilge pumps in cargo ships, it is difficult to connect most pumping devices with a specific application of this type.[39] Most pumps that have been found elsewhere than in public buildings, mines, and shipwrecks were designed for household water supply or agricultural irrigation. For reasons of expense, most of these are rustic, wood-block force pumps, water-screws, or compartmented wheels. The tannery in the House of the Queen of England (VII 14, 5.17-19) made use of a bucket-chain because there was a pressing need for large quantities of water in such an establishment and the depth of the ground water did not permit the application of any other device. Bilge pumps were installed on ships for similarly urgent reasons. The relative cost of this device with respect to the revenue of the establishment must have been significant, but obviously it was not impractical. Perhaps the commercial application was made more economical by the pre-existence of a suitable well.

The Egyptian water-screw shown in the fresco in the House of the Ephebe (1 7,10-12.19) represents an application foreign to ancient Italy. Because of the difference in climate, agriculture in Roman Italy seldom made use of the irrigation pumps so typical of Egypt.

What is missing at Pompeii and Herculaneum? Because of the topography of both cities, we cannot expect to find water-screws at use, and thus their absence (other than as a fresco representation) is not surprising. The same is true of wheels with compartmented rims. They lift water somewhat higher than water-screws, but still could not have reached ground water here. Furthermore, once the aqueduct arrived at Pompeii, the pressurized pipe system raised water high enough to serve the bath cisterns without any lifting. The chain-and-disk pump design (often called the Pater Noster pump from its resemblance to a rosary), most likely an offshoot of the bucket-chain, was restricted in antiquity and the recent past to bilge pumping on large ships.[40] Force pumps are also missing, and their absence is a bit surprising, since they have been found at a number of terrestrial sites in Italy – Bolsena, Castrum Novum, and Rome – and in many shipwrecks in the West.[41] Although 25 m is a significant depth, and the connecting rods used to work the pistons from the surface would have required supports, it is possible that a well-machined, bronze force pump could have pushed water up from the aquifer at Pompeii. Furthermore, there is ample literary testimony for the use of *siphones* as fire extinguishers in Rome and other cities in the empire.[42] I am not aware of any surviving inscriptional evidence for *siphonarii* at Pompeii or Herculaneum, but any pumps installed in wells may still be there, awaiting discovery. The absence of these devices from the archaeological record thus may be simply accidental. Finally, pot garlands – in which specially-shaped ceramic jars are used instead of wooden or metal containers – are a variation on the bucket-chain design that is not attested in ancient Italy or the West.[43] All in all, Pompeii provides valuable information about pumps and their place in the Roman world.

BIBLIOGRAPHY

Arata, F.P. 1993, Il relitto di Cala Rossano a Ventotene, *Archeologia subacquea: Studi, ricerce e documenti* 1, 131-51.

Baudoin, C./B. Liou/L. Long 1994, Une Cargaison de bronzes hellénistiques. L'épave Fourmigue C à Golfe-Juan, *Archaeonautica* 12.

Blümner, H. 1875-87, *Technologie und Terminologie der Gewerbe und Künste bei Griechen und Römern,* 4 vols., Leipzig.

Bonneau, D. 1993, *Le régime administratif de l'eau de Nil dans l'Egypte grecque, romaine et byzantine,* Leiden.

Carre, M.-B. 1993, L'Epave à dolia de Ladispoli (Étruria méridionale). Étude des vestiges de la coque, *Archaeonautica* 11, 9-29.

Eschebach, H. 1979a, Die Gebrauchswasserversorgung des antiken Pompeji, *AW* 10.2, 3-24.

Eschebach, H. 1979b, *Die Stabianer Thermen in Pompeji,* Berlin.

Eschebach, L. 1991, Die Forumsthermen in Pompeji, Regio VII, Insula 5, *AW* 22, 257-87.

Forbes, R.J. 1964-72, *Studies in Ancient Technology,* Leiden.

Jongman, W. 1988, *The Economy and Society of Pompeii,* Amsterdam.

La Rocca, E./A. and M. de Vos/F. Coarelli 1976, *Guida archeologica di Pompeii,* Milan.

Maiuri, A. 1927, Pompeii, *NSc,* 59-60.

Maiuri, A. 1942, *L'Ultima fase edilizia di Pompei,* Roma.

Maiuri, A. 1950-1, Pompei: Scoperta di un edificio termale nella Regio VIII, Ins. 5, n. 36, *NSc,* 116-36.

Maiuri, A. 1958, *I Nuovi scavi di Ercolano,* Roma.

Manderscheid, H. 1988, *Bibliographie zum römischen Badewesen,* München.

Nielsen, I. 1990, *Thermae et Balnea. The Architecture and Cultural History of Roman Public Baths,* 2 vols., Aarhus.

Oleson, J.P. 1984, *Greek and Roman Mechanical Water-Lifting Technology,* Toronto.

Oleson, J.P. 1987, The Spring House Complex, in A.M. McCann, *The Roman Port and Fishery of Cosa,* Princeton, 98-128.

Oleson, J.P. 1992, The Human Side of Hellenistic and Roman Water-Lifting Technology, *MInstWasser* 117, 359-85.

Pemp, R. 1939, *Drei Wasserhebewerke Pompejis,* Diss. Würzburg/Aumühle.

Richardson, L. Jr. 1988, *Pompeii: An Architectural History,* Baltimore.

Strong, D. 1988[2], *Roman Art,* Baltimore.

Venit, M.S. 1988, The Painted Tomb from Wardian and the Decoration of Alexandrian Tombs, *JARCE* 25, 71-91.

Venit, M.S. 1989, The Painted Tomb from Wardian and the Antiquity of the Saqiya in Egypt, *JARCE* 26, 219-22.

Westermann, W.L. 1920, The 'Uninundated Lands' in Ptolemaic and Roman Egypt, *CLPhil* 15, 120-37.

Westermann, W.L. 1921, The 'Uninundated Lands' in Ptolemaic and Roman Egypt, *CLPhil* 16, 169-88.

Yegül, F. 1992, *Baths and Bathing in Classical Antiquity,* Cambridge MA.

NOTES

[1] Pemp (1939) discussed the design of the four Pompeian installations, but his reconstruction of the machinery is not convincing, and he does not discuss the technological context. For a full discussion of water-lifting machinery, see Oleson 1984. Richardson 1988 is an energetic discussion of Pompeii itself, although his chapter on the water and sewer systems (51-66) contains some surprising errors. Eschebach 1979a still provides one of the best discussions of the water-supply system of Pompeii. There are two excellent new studies of bath structures and bathing habits in the Greek and Roman world, both of which also consider the problems of water supply: Nielsen 1990 and Yegül 1992. A splendid resource for bibliography on baths is Manderscheid 1988.

[2] For bibliography and plans, see Manderscheid 1988, 121, 175, figs. 180, 303; Nielsen 1990, 7-8.

[3] See especially Eschebach 1979b; Oleson 1984, 242-46; Manderscheid 1988, 175; Nielsen 1990, vol. 2, 7 and refs., figs. 29-30, 32-36, 75.

[4] See the discussion in Oleson 1984, 242-46.

[5] A single chain, of course, requires less effort and expense to construct than a double-chain system, and would waste less work on overcoming friction and bucket weight; see Oleson 1984, 358-70.

[6] Pemp 1939, 57-9.

[7] Eschebach 1979b, 42.

[8] Richardson 1988, 54-55; Nielsen 1990, vol. 2, 33.

[9] Richardson 1988, 19; Maiuri 1942, 90-94.

[10] La Rocca et al. 1976, 26.

[11] See especially Eschebach 1991; Oleson 1984, 247; Manderscheid 1988, 173; Nielsen 1990, vol. 2, 7-8 and refs., fig. 8.

[12] Eschebach 1991, 279 implies the bath was still in use at the time of the eruption, although on a reduced scale; she suggests (281) that other baths may have been in use as well. La Rocca et al. 1976, 26 suggest that the aqueduct was still out of use in 79.

[13] See especially Maiuri 1950-51; Oleson 1984, 248; Manderscheid 1988, 175; Nielsen 1990, vol. 2, 7 and refs., figs. 27, 77.

[14] See Oleson 1984, 246-47.

[15] Pemp 1939, *passim.* For the soaking and washing processes involved in tanning, see Blümner 1875-87, vol. 1, 254-67; Forbes 1964-72, vol. 5, 48-53.

[16] See Maiuri 1958, 51, 107-8; Oleson 1984, 213-15; Manderscheid 1988, 121; Nielsen 1990, vol. 2, 7, figs. 43, 74.

[17] Maiuri 1958, 51, 107-8.

[18] See Maiuri 1927; Oleson 1984, 241-42; La Rocca 1976, 212-16.

[19] It is odd that the many other Egyptianizing frescoes and mosaics of the early Empire – or their Alexandrian models – do not show similar details, given how characteristic of Egypt these devices were. An exception in Egypt is the late Hellenistic Wardian fresco which shows a saqiya installation: see Oleson 1984, 184-85; Venit 1988, 1989. On the Egyptianizing fad, see Strong 1988, 56, 59 and notes.

[20] See the catalogue of papyri concerned with water-lifting in Oleson 1984, 140-71 for numerous examples of salaried 'pumpers'. Elsewhere, pumpers in both the Greek and Roman world generally were slaves, convicts, or prisoners of war; see Oleson 1984, 392-98; 1992.

[21] Westerman 1920, 1921; Bonneau 1993, 53, 62.

[22] Yegül 1992, 32-46, 57-66; Nielsen 1990, 27-36.

[23] Yegül 1992, 50-55.

[24] Yegül 1992, 33-40; Nielsen 1990, 144-46.

[25] For a discussion of the design of these devices, see Oleson 1984, 291-350. In brief, the shaduf involves a bucket hanging from one end of a long counterweighted pole mounted on a pivot over a water source. The Pater Noster pump involves a long loop of rope on which wooden disks are mounted. The loop is pulled through a tube and lifts blocks of water ahead of each disk.

[26] The Arabic term saqiya is used to refer to a pair of large star or crown gears used to transform the vertical torque produced by an animal walking around in a circle into horizontal torque used to drive a compartmented wheel or chain of containers. A similar problem of access was solved at the Cosa spring house by using human labour to drive a bucket-chain by means of a saqiya gear in an elevated room accessible only by ladder. In this case, the high elevation, relatively small area of the building, and light superstructure apparently did not allow use of the more efficient tread-wheel. See Oleson 1984, 201-4; 1987.

[27] Yegül 1992, 46-47; Nielsen 1990, 125-31.

[28] Above, n. 15.

[29] Jongman 1988, 155-86.

[30] Oleson 1984, 291-301.

[31] Oleson 1984, 22-23, 91-93, 291-94.

[32] Above, n. 20.

[33] Oleson 1984, 300-1, 323-25, 349-50, 369-70, 384-85.

[34] BGU 1258, P. Harr. 79, P. Lond. 131*, P. Lond. 131R, P. Lond. 1177, P. Oxy. 2244. Abu Mena: Oleson 1984, 181-83.

[35] Oleson 1984, 220.

[36] Oleson 1984, 201.

[37] Oleson 1984, 233-37.

[38] Oleson 1984, 198-99.

[39] Oleson 1984, 300-1, 323-25, 349-50, 369-70, 384-85.

[40] The discussion of this device in Oleson 1984, 356-57 is now obsolete. For a recent short discussion and bibliography see Oleson 1992, 363 n. 6, 365 n. 12. Now add Arata 1993, 132; Carre 1993, 25; Boudoin/ Liou/Long 1994, 102-3.

[41] Oleson 1984, 313-19.

[42] Oleson 1984, 324-25.

[43] Oleson 1984, 360-64.

UNIVERSITY OF VICTORIA
DEPARTMENT OF CLASSICS
BOX 3045
VICTORIA, B.C.
V 8W 3 P4 CANADA

Finding Social Meaning in the Public Latrines of Pompeii*

Ann Olga Koloski-Ostrow

THE IMPORTANCE OF STUDYING LATRINES

Attached to the woodshed of the nineteenth century Berkshire colonial farmhouse in western Massachusetts in which I grew up was an outhouse with three seats. The holes were large, medium, and small. No one, of course, expected any combination of our family members to use the facility simultaneously. Modesty from our European tradition certainly prevented that. But therein originated my fascination with the idea of a communal toilet operation. I have often wondered if the Romans of the first centuries BC and AD would have used our three-seater communally with unembarrassed ease. Did Roman men and women 'relieve themselves' in the same room at the same time? Was privacy for bathroom use among members of the same sex a major concern to the Romans? Were Roman public latrines the pleasant places for social interchange that the modern scholars[1] have consistently described? What about the quality of lighting and ventilation in these facilities, both public and private? Would the primitiveness of my family's Berkshire outhouse (cobwebs and an aged catalogue for toilet paper) and the putrid nature of the place been considerably below ancient standards and raised Roman eyebrows? These questions require more complicated answers than we might first imagine.

Until quite recently cesspits, sewers, and latrines have not drawn much attention from classical archaeologists. Bodily excretions have always been associated with various taboos (at least in western societies). In Latin writings, especially among early Christian texts, we can find a recurrent metaphor of the sewer as the dumping place for "spiritual" filth.[2] This might possibly have prevented investigators in earlier generations from these topics, which are, to say the least, unglamorous. Yet, as Scobie has clearly shown, they provide valuable data for evaluating Roman standards of public health.[3] The Romans are often, and quite justifiably, attacked for enormous deficiencies in sanitation

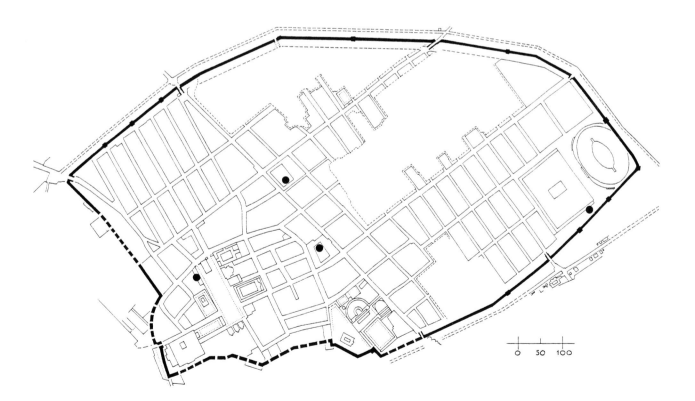

1. Map of Pompeii, main public latrines indicated by dot (adapted from L. Eschebach).

caused by inadequate protections from the law and by the realities of Roman housing. Since ancient writers on technological subjects paid little or no attention to sanitary problems, some have argued that the Romans were downright indifferent to this issue.[4] We shall make our primary focus the public latrines at Pompeii in the last years of the city in order to explore such a hypothesis *(Fig. 1)*. The Romans did eventually make the latrine a more or less standard feature of Romanization in their cities and towns (much like the amphitheater and the baths), but can we say when this happened and under what circumstances? Given the ubiquitous nature of latrines, it would seem that the Romans deserve at least some measure of credit for making serious strides in the disposal of human waste. I shall argue here that Roman contributions to improving urban sanitation were substantial, but that in the end, they often may be attributed more to accident than design.

DEBUNKING SOME LATRINE MYTHS

Public latrines *(foricae)* in the Roman world (with seating arrangements at times for surprisingly large numbers of clients—four, eight, twelve, twenty or upwards of one hundred) could on occasion be elegantly decorated and constructed with the most sophisticated of technological embellishments. They could also, however, be rather nasty places, to be avoided, and we need to look at a large number of them (not just one or two of our 'best' examples) at different sites and in different periods in Roman history without over-glamorizing the role we think they played in Roman daily life. Also we need to clarify what has been written about them to date.[5] Ancient latrines provide an opportunity to study an architectural type not fully examined before, along with its decoration (in some rare examples, especially outside Italy, in the form of paintings, marble and mosaic floors, and statuary). The chronology of latrine design needs to be worked out in detail. Despite an archaeological record quite rich in material remains of sewer-networks and latrines at many major sites, however, the extent of the underground sewer-networks of Pompeii, Herculaneum, Ostia, and Rome itself are still not well studied.[6] In addition, when the results from investigations of the archaeological evidence are combined with information from graffiti and the few extant literary references,[7] we can paint a more accurate portrait of several aspects of Roman character and social customs. This material needs to be pulled together and analyzed.

Probably deriving from military camp design, the Roman *forica* was public in the full sense of the term.

'Public', however, does not necessarily mean 'social'. Martial's epigram[8] about a certain Vacerra who dallies for hours while sitting in the toilets in order to get invited to dinner seems to be the primary source for many of our misconceptions about the ancient public latrine as a focal point for social activity. Some people might have met there, conversed, and exchanged invitations to dinner, and some rare latrines could be equipped with amenities and lavish decorations we are not accustomed to placing in such spots. Truly luxurious public lavatories are extremely rare in the Italian examples.[9] The mixture of delicacy and coarseness, solemnity of decorations along with common function of the space, has surely been fascinating for us when we see it in the archaeological record.

The scholars who have written about latrines have too frequently generalized with inaccuracy about the chief points of latrine construction. We find public latrines often described as having 'seats of marble'. Sometimes they did, as we can see in a few examples in Pozzuoli or Ostia *(Fig. 2)*, but this does not seem to be the norm, and certainly not for Pompeii. It has

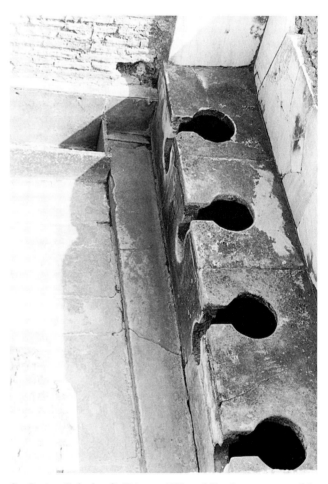

2. Ostia, Schola di Triano (IV v, 15), 4-seater marble latrine.

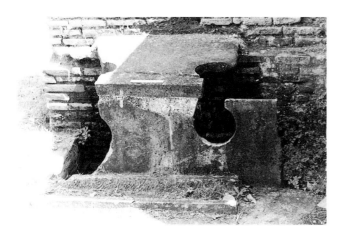

3. Ostia, Terme del Filosofo (V ii, 7), detail of latrine aperture and water channel.

been said that above the seats it was not unusual to see niches containing statues of gods or heroes.[10] While we have a good example of a shrine to the goddess of health and happiness, Fortuna, in one of the latrines in the barracks of the firemen at Ostia, this too is quite rare, especially in Italy. Sometimes there was a decorative fountain inside the latrine. Ballu gives us a splendid example from the ruins of Timgad.[11] To date I have found no comparable evidence at Italian sites, except possibly the fifth century latrine at Ostia, in the Terme del Filosofo (V ii, 7). These generalizations do not measure up in all areas and in all periods upon close examination of the remains.

We can agree that water flowed continuously in little channels at the feet of the rows of seats. Perhaps these channels were to collect urine which failed to enter the aperture in the face of each latrine seat *(Fig. 3).* Perhaps they were for rinsing out soiled sponges tied to the ends of sticks, which the Romans apparently used most frequently for toilet paper. The main evidence for this usage is a passage in Seneca.[12] A German animal fighter *(bestiarius)* about to meet his death in the amphitheater requests to go to a latrine where, to quote Seneca freely, "He found a wooden stick with a sponge attached to the end, stuffed the whole thing down his throat, and choked to death". If the water in these channels was used for wiping bottoms, it is very unlikely that it was clear and fresh, as some modern descriptions of latrines have suggested,[13] but more probably a murky brown color and odoriferous.

What does seem clear is that public latrines were not the 'watering holes' of the rich nor the very poor, who would have preferred jars in the streets used for urine collection by the fullers in particular.[14] Of course, the

humble client would also have recourse to chamber pots *(matellae* and *lasana),* and commodes *(sellae pertusae).*[15] But even the millionaire freedman Trimalchio grants his guests the opportunity to relieve themselves in his dining room with champer pots.[16] There was, of course, also 'the neighboring dungheap' and the 'malodorous cess trench' *(lacus)* in many back alleys, as Carcopino colorfully reminds us.[17]

Our notions about private latrines, especially in the houses of Pompeii and Herculaneum, are currently being challenged by the Dutch archaeologist G. Jansen, who has found that virtually every house in Pompeii and Herculaneum had a cesspit latrine. She identifies sixty-two private toilets at Herculaneum alone, for example.[18] Although large households had multiseaters (accommodating two to six people), most single seat latrines were located in the kitchen, in a shop or workshop, or under a staircase. The evidence for private cesspit latrines at Pompeii is equally compelling. It seems that continual flush toilets at Pompeii were rare, and not introduced until the post-Augustan period when a modest number of houses were connected to the main water supply systems.[19]

POMPEIAN PUBLIC LATRINES IN THE POST-EARTHQUAKE PERIOD

Let us now turn more specifically to the Pompeian evidence *(Fig. 1).* There are four main examples[20] of public latrines: in the grand palestra, in the Stabian Baths,[21] an unfinished latrine in the Central Baths, and the well-preserved forum latrine (VII 7, 28), also unfinished at the time of the eruption of Vesuvius in AD 79.[22] In addition, the *Praedia* di Iulia Felix (II 4, 2-12) and the Sarno Bath Complex,[23] south of the forum, also had fairly large latrines (seating about six to nine), but these were for the paying customers, a quite select clientele, of these operations.

The latrine in the Stabian Baths *(Figs. 4-5)* demonstrates the dark, dank nature that these facilities usually had. Windows *(Fig. 6)* were extremely narrow and high up on the walls, which here were decorated with zebra stripes (black and white with some red trim).[24] As I stumbled about in this poorly lit room to photograph the now dry sewer trenches, I could not help imagining the stench and germs that once filled this space. Ventilation in these facilities must have been a major problem. Hydrogen sulphide (H_2S) and methane (CH_4)[25] which escaped from sewers must have created very strong odors and constant dangers of fire and explosions. The forum latrine (VII 7, 28)[26] unfinished at the time of the eruption of Mt. Vesuvius in AD 79, is preceded by a vestibule. The doors from

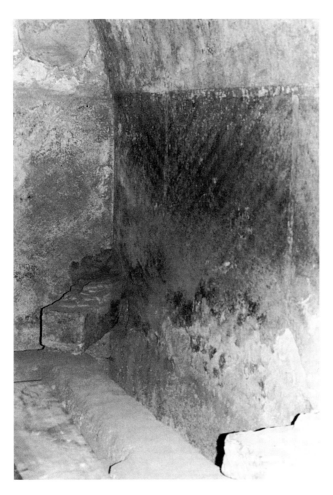

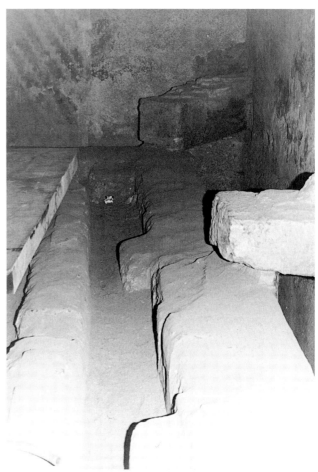

4. *Pompeii, Stabian Bath latrine, struts and wall decoration.*

5. *Pompeii, Stabian Bath latrine, water channel.*

the forum colonnade to the vestibule and from the vestibule to the latrine were staggered so that passers-by could not look into the main room from the forum *(Fig. 7)*.[27] We might compare what seems to be a revolving door arrangement in the forum latrine in Ostia, two doors at either side of a central brick pier. The hinge mark in the single threshold of a latrine in Minturnae also suggests a door that swung shut to preserve privacy. The architecture in these latrines clearly demonstrates some concern for privacy and quiet in this institution. The main room of the Pompeian forum latrine itself is surrounded by a sewer trench on three sides and could accommodate at least twenty persons *(Fig. 8)*. The latrine was of similar construction to the market next door, of which it was essentially an extension. Not only was there no painted decoration, but the undercoating of plaster was not yet placed on the walls, and the pipes for water to flush out the sewer apparently had not yet been laid. Struts to hold the seating and the little floor channels were of gray volcanic tufa, not marble. Lighting was

perhaps a bit better than in the latrine of the Stabian Baths *(Fig. 9)*, but proper ventilation still seemed to be lacking. Measurements of gutters, width and length of benches, seats, and facing apertures, where visible, are strikingly uniform to within a few centimeters in all the latrines at Italian sites. This standardization, although not surprising, is a significant feature of Roman city planning and engineering.[28]

SOME CONCLUSIONS

Allow me to offer some general conclusions with regard to Roman concern for health and sanitation from the evidence of public latrines at Pompeii. Juvenal's account of a passer-by fouled and injured by the dumped contents of a chamber pot verifies that walking the streets of a Roman city could be a dangerous and dirty enterprise.[29] Surely the Roman world was a tough, unhealthy place in which to live with disease and death lurking around every corner. The major reason for this general unpleasantness was the enormous

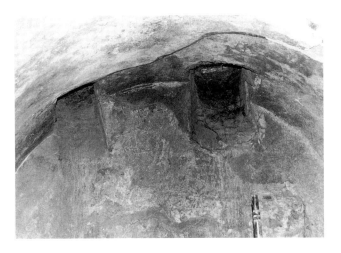

6. Pompeii, Stabian Bath latrine, E windows.

7. Pompeii, forum latrine, staggered entrance.

gulf which separated advantaged from disadvantaged in the Roman empire with respect to access to the legal system, education, and medical care. Were the public latrines at Pompeii built as a 'civilizing' architectural additions to the city, major improvements for the benefit of public health, or for some other reason? Whether or not the main waterworks in the city were interrupted after the major earthquake in AD 62 (or after earthquakes in later years closer to the eruption), very likely well water was badly affected in many private houses. Perhaps more and more people had to seek water from outside their homes for everyday uses. Many latrines in private houses, which were usually flushed with the discarded water from the kitchen, might have been temporarily put out of service, because they were too unpleasant to use with a dramatically diminished domestic water supply. Several public latrines were then conceived, their construction was begun, but they were unfinished for the

most part at the time of the eruption,[30] and we must wonder in any case if they would have seriously enhanced health and sanitation in the city.

Fecal discharges of ill and even of healthy persons contain large numbers of disease producing organisms, which can cause, among other illnesses, diarrhea, bacillary dysentery, infectious hepatitis, salmonella infection. Apparently all of these illnesses can be transmitted by mere exposure to sewage. Therefore, modern criteria that define improper disposal of human excreta and sewage - the major factor that threatens health - deserve review here and may help us to evaluate sanitary precautions, if any, taken by the Romans. Such criteria can also help us in distinguishing adequate from inadequate disposal of human (and other) wastes in Roman houses and cities. "Sewage is satisfactorily disposed of when 1) it will not be accessible to children or household pets, pollute the surface of the ground, or be exposed to the atmos-

8. Pompeii, forum latrine struts, S wall.

9. Pompeii, forum latrine window, W wall.

phere when inadequately treated. 2) It will not contaminate any drinking water supply. 3) It will not give rise to a public health hazard by being accessible to insects, rodents, pets, or other possible mechanical carriers that may come in contact with food or drinking water. 4) It will not give rise to a nuisance due to odor or unsightly appearance. 5) It will not pollute or contaminate the waters of any bathing beach, shell-fish breeding ground, or stream used for public, domestic water supply, or recreational purposes. 6) It will not violate laws or regulations governing water pollution or sewage disposal."[31] Since we do not have an aedile's handbook for Pompeii, we can not comment on how the construction of Pompeii's public latrines affected point 6, but we can say that Pompeii's public latrines would have alleviated only slightly the great sanitation concerns outlined in points 1-4. Since the major sewers of Pompeii poured into the Sarno river to the south and west of the city, which runs directly into the Bay of Naples, point 5 would have been woefully ignored. Problems with Pompeii's water supply in the final period in the city may have encouraged the construction of these new public facilities, but did Roman planning within individual towns (and in Pompeii in particular) take into account with some care the serious issues of health and sanitation? If we judge by the energetic latrine projects in the final years of Pompeii's life, given their distribution and high visibility in the post-earthquake period, we can at first read in them a concerted effort to provide comforts for a certain number of more advantaged citizens at frequent, key points within the city. Yet, as we have also seen, the standardized latrines of baths and those near *fora* were hardly free of problems, principally lighting and ventilation.

For Pompeii, it seems that the public latrines were new, handsome 'Romanizing' edifices that only accidentially would have offered any of the 'civilizing' features of improved sanitation. We might say that these public latrines served as yet another metaphor (like newly improved amphitheaters and baths springing up throughout the empire) for the largess of the Roman military state, this time coming to Pompeii at a time of crucial need and social disorder. We have noted that the basic design of the public latrine derived directly from the architecture of the Roman camps - the first installations marking a controlling Roman presence - and control would have been sorely needed after a disastrous earthquake. Perhaps a more accurate reading of the latrine projects in Pompeii might be that they were carried out as political patches on the unsanitary wounds in this city in crisis. Roman authorities were acquainted with the technology of sewage disposal, but they used it more for good political advantage than for improving health conditions. The same underlying motivation, that is, political advantage, ultimately led to more luxurious latrine projects in the next two centuries elsewhere in the empire as well.[32]

The sewer-networks and public latrines in Pompeii provide powerful new evidence for a changing cityscape, for new uses of the waterworks at the end of the first century, and with further study, they may give us a deeper understanding of the social fabric of Pompeii in the city's last years. The systematic study of the arrangements in latrines at various sites can remove a number of common misconceptions about private Roman habits concerning the bowel. Understanding the archaeology of latrines in individual Roman cities helps us address larger questions about the world of Roman hygiene, including the technologies of waste removal, public health, and the elimination of diseases. The archaeology and architecture of ancient Roman latrines and latrine sites involves mapping the advances of civilization itself, and sewers and latrines deserve to be placed more visibly on this map.

BIBLIOGRAPHY

Ballu, A. 1897, *Les ruines de Timgad* I, Paris.
Beccarini, P. no date, *New Excavations at Pompeii,* Milan.
Carcopino, J. 1911, *JSav,* 456-457.
Carcopino, J. 1973, *Daily Life in Ancient Rome,* Harmondsworth.
Coarelli, F. 1981, *Guide archeologiche Laterza: Roma,* Rome.
Dague, R. 1972, Fundamentals of Odor Control, *JWPCF* 44, 583-594.
de Haan, N. 1993, Dekoration und Funktion in den Privatbädern von Pompeji und Herculaneum, in *Functional and Spatial Analysis of Wall Painting. Proceedings of the Fifth International Congress on Ancient Wall Painting,* Supplement 3 BABesch, 34-37.

Eschebach, H. 1979, *Die Stabianer Thermen in Pompeji,* Berlin.
Evans, H. 1994, *Water Distribution in Ancient Rome, The Evidence of Frontinus,* Ann Arbor.
Hammond, M. 1972, *The City in the Ancient World,* Cambridge.
Hermansen, G. 1981, Ostia: *Aspects of Roman city Life,* Edmonton.
Hodge, A. 1992, *Roman Aqueducts and Water Supply,* London.
Jashemski, W. 1979, *The Gardens of Pompeii, Herculaneum, and the Villas Destroyed by Vesuvius* I, New Rochelle.
Jansen, G. 1991, Water Systems and Sanitation in the Houses of Herculaneum, *MededRom* 50, 145-165.

Jansen, G. 1993, Paintings in Roman Toilets, in *Functional and Spatial Analysis of Wall Painting. Proceedings of the Fifth International Congress on Ancient Wall Painting,* Supplement 3 BABesch, 29-33.

Koloski-Ostrow, A. 1990, *The Sarno Bath Complex,* Rome.

Landels, J. 1978, *Engineering in the Ancient World,* Berkeley.

Maiuri, A. 1942a, *Pompeii,* Rome.

Maiuri, A. 1942b, *L'ultima fase edilizia di Pompei,* Rome.

Mygind, H. 1921, Hygienische Verhältnisse im alten Pompeji, *Janus* 25, 251-281, 324-385.

Neudecker, R. 1994, *Die Pracht der Latrine,* Munich.

Reimers, P. 1989, 'Opus Omnium Dictu Maximum' Literary Sources for the Knowledge of Roman City Drainage, *OpRom* XVII: 10, 137-141.

Reimers, P. 1991, Roman Sewers and Sewerage Networks - Neglected Areas of Study, *OpRom,* 111-116.

Richardson, L. 1988, *Pompeii An Architectural History,* Baltimore.

Salvato, J. 1958, *Environmental Sanitation,* New York.

Scobie, A. 1986, Slums, Sanitation, and Mortality in the Roman World, *Klio* 68:2, 399-433.

Thédenat, H. Latrina, in Daremberg, C. and Saglio, E. 1875-1919, *Dictionnaire des antiquites grecques et rommaines* 3.2, Paris, 987-991.

Ward-Perkins, J. 1974, *Cities of Ancient Greece and Italy: Planning in Classical Antiquity,* New York.

NOTES

* This report represents a portion of a larger study I am writing on Roman public latrines in Italy and health and social issues around them. I travelled to Italy during the summer of 1992 (with a grant from the Whiting Foundation) to complete the first phase of the work. I am most grateful to Drs. N. de Haan, G. Jansen, G. de Kleijn, S. Piras, and Prof. J. de Waele of the Katholieke Universiteit of Nijmegen for inviting me to the conference, Cura Aquarum in Campania (Oct. 1-8, 1994) where I have been able to present the beginning stages of my work. This article is a revised version of my presentation. I also owe warm thanks to Undergraduate Fellow, D. Cohen, of Brandeis University for editorial help and advice.

[1] E.g., Carcopino 1973, 41 ff. Most of the standard scholarly works on Roman daily life or on the city in the Roman world seem to be lacking in accuracy or deficient in scope of their treatment of urban sanitation. See, for example, Hammond 1972, 221-235; Hermansen 1981, *passim;* Coarelli 1981, 40 ff; Ward-Perkins 1974, 24-36.

[2] Reimers 1989, this is a very useful article which contains a survey of passages in Latin literature which mention sewers and sewerage systems in the Roman world. The city of Rome is featured. See also Reimers 1991.

[3] Scobie 1986, 401 ff.

[4] Reimers 1989, 139.

[5] Virtually no work on public latrines in the Roman period has been done, although the situation is rapidly changing. Dr. R. Neudecker kindly gave me permission to cite ideas from his then unpublished manuscript, *Die Pracht der Latrine,* which was in press during the Cura Aquarum conference. The book, Neudecker 1994, has now appeared and offers a wealth of comparative material about luxury latrines in the east and in north Africa. I should also note in passing that A. Jones, a paleo-scatologist from the University of York in England, has worked extensively on excrement, diet, health, and sanitation from the medieval period in England.

[6] For Pompeii, e.g., cf. Mygind 1921, 251 ff.

[7] Cf. Scobie 1986, 408. The lack of archaeological reporting on these matters to date is not, alas, counterbalanced by evidence in our ancient literary sources for the construction and design of latrines. The literary record on Roman public latrines is extremely meager and includes no physical description. There is also no account of their administration. Scobie notes that Vitruvius, for example, is conspicuously silent about latrines. We do find in Vitruvius brief mention of drains themselves, however, in I 1, 11 and in V 9, 7. For other literary allusions on latrines see, Thédenat in Daremberg and Saglio, 987-991, also cited by Scobie in his n. 75.

[8] Martial *Epigr.* XI 77, 1-3: *In omnibus Vacerra quod conclavibus / consumit horas et die toto sedet, / cenaturit Vacerra, non cacaturit.*

[9] In conversation, Dr. Neudecker has concurred with me that, for the Italian examples, these are the exceptions, not the rules. Neudecker 1994 concentrates on one type of public lavatory, the luxurious buildings with columns, statues, mosaic floors etc. He has found that they are almost exclusively confined to sites in north Africa and the east during the 2nd and 3rd centuries AD, and he explores evolving medical theories, changes in social behavior, and political implications to explain this.

[10] Carcopino 1911.

[11] Ballu 1897, 112-114

[12] Seneca *Ep.* 70.20. Seneca actually relates the tale of the *bestiarius* because it demonstrates the Stoic belief that suicide is ultimate freedom, not for this interesting detail of Roman social practice. See also Martial *Epigr.* XII 48.7 where he says that a whole delicious dinner tomorrow or even today or even a moment from now will be nothing but a matter for the *infelix damnatae spongea virgae,* 'the unlucky sponge of the doomed stick or twig'. Again, this suggests a cleaning device in the toilet.

[13] Carcopino 1973, 41, eg.

[14] Cf. Suetonius *Vesp* 20. The fullers purchased their permission for urine collection (used in their cleaning and dyeing operations) from the emperor. One bit of Pompeian evidence for this is the graffito, *FVLLONES VLVLAM EGO, CANO NON ARMA VRVMQ.* on which see further, Beccarini, 25. In this amusing paraphrase of the first line of Vergil's Aeneid, "I do not sing of arms and the man, but I sing of the fullers and their scream," we imagine that 'their scream' was for urine. Martial *Epigr.* XII 48. 8 makes a direct reference to the roadside crock used as a urinal: *iunctaque testa viae.* Cf. *Epigr.* VI 93. 2. Trimalchio's worries that those passing by his tomb might defecate on it (Petronius *Satyr.* 71.8) suggests that the custom of using abandoned tombs for privies was not an uncommon practice.

[15] Carcopino 1973, 42. The collection of urine from house to house suggests the heavy use of chamber pots in many private dwellings.

[16] Petronius *Satyr.* 47.5

[17] Carcopino 1973, 42.

[18] Jansen 1991, 145 ff.

[19] Jashemski 1979, 53 ff. notes that she has found evidence of piped water in only two private latrines, in the Casa del Centenario (IX 8, 6.3.a) and in the *Praedia* di Iulia Felix (II 4, 2-12). Both of these latrines are associated with baths in private houses.

[20] From the 1988 publication Pompei - *L'Informatica al Servizio* (the printed form of the effort to computerize the cartographical data at Pompeii with the help of IBM) four other examples are indicated: three in Reg. VII (1, 23; 1, 59; and 14, 4), none of which I shall treat here since I have not had the opportunity to study them in detail, and one in Reg. I 10, 12. I might point out that Prof. R. Ling has agreed with me that this last is an unlikely 'public' lavatory, since it is in an odd position and is a single seater. This too, however, needs further study.

[21] Eschebach 1979, tafel 37 with plan of a reconstruction of the bath in the final period, and tafel 67 with a view of the west wall of the latrine.

[22] Maiuri 1942b, 70, 73, 74, 87.

[23] Koloski-Ostrow 1990, 58 and 89. I should point out that my ideas have changed considerably since I first wrote about the distribution of public latrines at Pompeii and Ostia.

[24] On the decoration of latrines and private baths at Pompeii and Herculaneum, see Jansen 1993 and de Haan 1993.

[25] Scobie 1986, 412 , n. 98, cites the work of Dague *JWPCF* 1972, 583-594 . This article is particularly interesting on the subject of sewer gases the dangers they cause.

[26] Maiuri 1942a, 23 and 33.

[27] Richardson 1988, 276. Prof. Richardson has given me many valuable suggestions to pursue with regard to lighting and ventilation in latrines, especially at Pompeii, for which I am most grateful.

[28] The intricacies of Roman technology and engineering have received some excellent attention in recent years, especially with regard to water distribution to and within cities, crucial for our understanding of public baths and latrines. Cf. e.g., Hodge 1992, *passim;* Landels 1981, 35 ff. In addition, Evans 1994, 11 ff., discusses the evolution of Rome's aqueduct system on a piecemeal basis over five hundred years, which greatly parallels developments in baths and latrines as well.

[29] Juvenal *Sat.* 3, 269-272.

[30] Again, cf. Maiuri 1942b, 70, 73, 74, 87.

[31] Salvato 1958, 186 ff. I obtained this reference from Scobie 1986, 407, n. 68.

[32] Ibid. supra n. 9.

BRANDEIS UNIVERSITY
CLASSICAL STUDIES
WALTHAM, MASSACHUSETTS
02254-9110 U.S.A.

Cura Aquarum in Campania - Eine Einführung*

Susanna A.G. Piras

In diesem Beitrag werde ich eine kurze Übersicht der Ausgrabungen präsentieren, die angewiesen waren auf die Wasserversorgung des römischen Serino-Aquädukts. Es ist nicht möglich an dieser Stelle den Wasserhaushalt Kampaniens in extenso zu besprechen, deshalb möchte ich mich hier beschränken auf die wichtigsten Fragen und Probleme der Serino-Leitung. Nach einer kurzen allgemeinen Einleitung wird eine alte Beschreibung mit den heutigen Resten des Aquädukts konfrontiert und seine Bedeutung für Kampanien analysiert.

Kampanien, etwa 150 km südlich von Rom, war von jeher relativ dicht besiedelt wegen seiner günstigen Position und natürlichen Beschaffenheit.[1] Diese natürliche Beschaffenheit Kampaniens kann folgendermaßen beschrieben werden: man unterscheidet den südöstlichen Teil, hauptsächlich gebirgig und wasserreich, den ziemlich flachen Norden und den Küstenstreifen mit zum Teil alt-vulkanischem Gebirge.
Schon die Griechen gründeten hier an der Küste ihre Kolonien Cumae und Parthenope. Mit den Römern kam eine weitere Urbanisation dieses Gebietes in Gang. Pompeji z.B. wurde eine römische *colonia,* Pozzuoli ein sehr wichtiger Hafen für Rom (der Hafen von Ostia mußte noch gebaut werden) und Kap Misenum wurde zum Flottenstützpunkt gemacht. Der Wasserbedarf des Hafens in Pozzuoli und des Flottenstütz-

punktes bei Kap Misenum wuchs so sehr, daß das Auffangen des Regenwassers nicht mehr ausreichte für soviel mehr Verbraucher. Das Grundwasser dagegen war in mehreren Teilen Kampaniens erst in großer Tiefe vorhanden und kam in zu kleinen Mengen hoch oder war von schlechter Qualität. Zusammen mit dem relativ hohen Grad der Bevölkerungsdichte, hat diese Situation zur Wassernachfrage in der Antike erheblich beigetragen.
Die Lösung für die wachsende Wassernachfrage wurde der Serino-Aquädukt (*Abb. 1*). Der Anfang dieses Aquädukts lag in den Bergen bei Avellino und von dort aus führte er über eine Länge von 96 km über Neapel bis in die Piscina Mirabilis, das Endreservoir in Bacoli. Dieses öffentliche Projekt, angefangen und beendet in der augusteischen Zeit, war im Hinblick auf Pozzuoli und Kap Misenum also sehr wichtig für Rom.

Die Bucht von Neapel ist wohl der bekannteste und berühmteste Teil Kampaniens mit den Hafenstädten Baiae, Pozzuoli, Pompeji, Herkulaneum und Stabiae. Außer den zahlreichen urbanen Handelszentren war Kampanien in der Antike ein sehr fruchtbares Agrargebiet. Vor allem rund um den Vesuv war die Erde so fruchtbar, daß mehrere Ernten pro Jahr für die *villae rusticae* dort möglich waren. Den Wein und das Olivenöl exportierte man in alle Teile des römischen

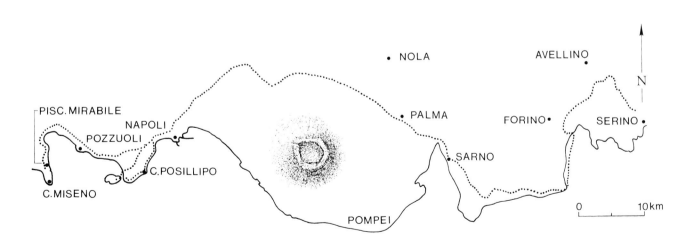

1. Plan mit dem Lauf des Serino-Aquädukts (Zeichnung E. Ponten).

Reiches. In der Literatur wird der Wein des Vesuvs sehr oft gelobt. Doch Kampanien ist ebenfalls bekannt wegen der Fisch- und Austernzucht im Lago d'Averno und Lago di Lucrino. Das Gebiet übte eine grosse Anziehungskraft auf die Kaiser und reiche römische Bürger aus, die hier alle eine Villa besaßen.[2] Nicht selten wird Kampanien in der Literatur genannt. Wer kennt das Baiae, *crimen amoris*, von Properz[3] nicht? Oder die Geschichte von Kaiser Nero, der einen Mordversuch auf seine Mutter Agrippina dort auf dem See ausübte?[4]

Verweise mit Bezug auf die kampanische Wasserversorgung lassen sich in den antiken Schriften nicht finden. Dies überrascht kaum, denn es handelt sich hier schließlich um ein System der Wasserversorgung wie jedes andere aus römischer Zeit. Die dürftigen materiellen Reste des Aquädukts zusammen mit einigen alten Beschreibungen sind übrig geblieben und ergeben Folgendes.

In einer Inschrift zur Zeit Konstantins, wahrscheinlich 324 n.Chr., an einer Stelle des wiederhergestellten Aquädukts, werden die Städte erwähnt, die zum damaligen Zeitpunkt Wasser von dem Serino-Aquädukt zugeführt bekamen *(Siehe Abb. 2 Beitrag Potenza)*. Diese Städte sind Pozzuoli, Neapel, Nola, Atella, Cumae, Acerrae, Baiae und Misenum. Selbstverständlich werden Pompeji und Herkulaneum nicht erwähnt in dieser späten Inschrift. Dennoch bekamen sie wahrscheinlich ebenfalls Wasser von der Serino-Leitung, so wie zahlreiche andere, kleine unerwähnte, Orte unterwegs. Obwohl der Anfangs- und Endpunkt des Aquädukts feststehen, ist aber nicht die genaue Zahl von Städten, die mit Wasser des Serino-Aquädukts versehen wurden, bekannt. Nach und nach bekam der Aquädukt viele Änderungen und Anpassungen, die es uns schwierig machen das Funktionieren und die Geschichte des Aquädukts zu fassen. Die Verschüttung von Pompeji und Herkulaneum durch den Vesuvausbruch sind ein Beispiel dafür. Erstaunlich wenig Zusammenhängendes ist übriggeblieben von dem 96 km langen Aquädukt.

Wir werden dem Aquädukt jetzt vom Anfang an folgen und ihn kurz beschreiben, wie Sgobbo in den *Notizie degli Scavi* von 1938. Er entnimmt die Beschreibung der des Architekten Felice Abate, der 1864 den Lauf des Aquädukts untersuchte.[5]
Im heutigen Ort S. Lucia di Serino befindet sich die antike Quelle des Serino-Aquädukts, Aquaro genannt, am linken Ufer des Flusses Sabato (*Abb. 2*). Die Quelle liegt 376 m über dem Meeresspiegel und beliefert heutzutage noch die Stadt Neapel. Der Ort ist sehr reich an Wasser und wunderbar gelegen am Fuß der

2. Auch heutzutage noch fließt das Wasser in S. Lucia di Serino reichlich für jeden.

Berge von Avellino. Um keine Höhe zu verlieren, legte man den Aquädukt, der zum grössten Teil unterirdisch verläuft, weitgehend den Höhenlinien folgend, mit einem großen Bogen nach Norden in Richtung Neapel an. In den ersten 20 km konnte man sparsam mit dem Gefälle sein, weil der Kanal noch hoch zwischen den Bergen lief. Allerdings mußte man fast sofort einen Tunnel durch die Berge von Forino anlegen. Nach dem Tunnel hatte der Aquädukt über einen Kilometer ein starkes Gefälle jäh nach unten. Danach verließ der Aquädukt die Berge. Unterirdisch ging es weiter bis zum nächsten Hindernis, dem Monte Paterno. Hier baute man einen Tunnel von 1903 m quer durch den Monte Paterno bis nach Sarno, wo es einen doppelten Ausgang des Aquädukts gab. Nach der Meinung Sgobbos kam es öfter vor, daß man bei Reparaturen große Teile des Kanals neu baute neben dem alten.[6] Über die Ausläufer der Berge zwischen Sarno und Palma führte der Aquädukt weiter, sowohl ober- wie unterirdisch, auch hier mit doppeltem Kanal. Man fragt sich, ob man den ersten Kanal vielleicht wegen seismischer Schäden nicht mehr hat nutzen können oder ob der Aquädukt wirklich in zwei Kanälen weiter lief.
Über die Ebene von Palma bis nach Neapel war der Aquädukt unterirdisch über eine Entfernung von bald 30 Kilometern. Der Kanal war meist 1.85 m hoch und 0.79 m breit. Es gibt aber auch Kanalgänge in 2 m Höhe und 0.75 m Breite, oder 2.2 m hoch und 1 m breit wie bei der Ponte Rossi in Neapel. Der letzte Trakt des Aquädukts führte von Neapel bis in das Endreservoir, die Piscina Mirabilis.

Die Beschreibung Sgobbos kann zum größten Teil nicht mehr verifiziert werden. Was wir bis jetzt vorfanden sind folgende Fragmente in verschiedenen

Orten. In der Nähe der Quelle des Sarnos in S. Maria La Foce, wo sich jetzt die Wasserwerke für die Vesuvstädte befinden, kann man ein erstes Stückchen des Kanals versteckt im Gebüsch sehen, das aus dem Berg dort hervorkommt. Es wäre logisch gewesen, wenn die Serino-Leitung hier durch die Sarno-Quelle ergänzt worden wäre. Dies war aber unmöglich, weil der Aquädukt auf einem höheren Niveau als die Quelle verläuft.

In Form eines unterirdischen Tunnels aus dem Norden bringt wahrscheinlich eine Abzweigung der Serino-Leitung Wasser in das pompejanische *castellum aquae*, worüber man während dieses Kongresses viel diskutiert hat. Dieser Trakt, wie man glaubt in Palma abgezweigt, wurde nach 79 n.Chr. zerstört. Herkulaneum benutzte wahrscheinlich die gleiche Abzweigung wie Pompeji. Jedenfalls ist das System der Wasserversorgung in Herkulaneum vergleichbar mit dem Pompejis, ohne daß aber das *castellum aquae* oder der ganze Stadtplan von Herkulaneum ausgegraben ist.

Die Ponte Rossi in Neapel soll ein weiteres Teil des Aquädukts darstellen und ist der einzige oberirdische Trakt. In Neapel angekommen, folgte der Aquädukt den Hügeln Capodimonte, Scudillo und Vomero bis an den Berg von Posillipo. Dort war eine Abzweigung zu der kaiserlichen Villa in Posillipo, bekannt durch ein Graffito aus 65 n.Chr. Ein Trakt des Kanals ist gut erhalten und folgte dem Tunnelweg, jetzt die Grotta di Seiano genannt, die Zugang gab zu der Villa Pausylipon (*Abb. 3*).

Von Neapel sind es noch 19 km bis zur Piscina Mirabilis, dem Endreservoir der Serino-Leitung. Um von Neapel in das flegräische Gebiet zu kommen, hat man, wie Strabo schreibt, unter der Leitung eines Architekten Cocceius, einen Tunnel durch den Berg von Posillipo gebaut, heutzutage die Crypta Neapolitana genannt.[7] Der Tunnel ist 5 m hoch, 700 m lang und 4.5 m breit, breit genug um zwei Karren nebeneinander durch den Tunnel zu führen. Nachdem er im ersten Jahrhundert n.Chr. eröffnet wurde, hat man in späteren Jahrhunderten viel geändert, so daß die ur-

3. Der Aquädukt bei Posilipo.

4. Die Crypta Neapolitana mit dem Kanal des Aquädukts an der rechten Seite.

sprüngliche Höhe nicht mehr festgestellt werden kann. Der Kanal der Serino-Leitung verläuft parallel zu diesem Tunnel auf einem höheren Niveau (*Abb. 4*). Der Überzug der Wände mit *opus signinum* ist gut erkennbar. Der Kanal wurde gleichzeitig oder etwas später als die Eröffnung der Crypta gegraben. Weiter führte der Aquädukt, durchstach Fuorigrotta, lief nach Bagnoli bis nach Pozzuoli, inzwischen die Thermen von Via Terracina und Agnano mit Wasser versorgend.

Nicht weniger als vier wichtige und grosse Wasserverbraucher, ebenfalls aus der Inschrift bekannt, befinden sich im letzten Teil, in den Campi Flegrei, nämlich Pozzuoli, Cumae, Baiae und Misenum.[8] In diesem Gebiet finden wir die meisten Reste der Serino-Leitung und der Reservoire, die einen Anschluß an den Aquädukt hatten. Oft finden wir hier den Namen des oben schon genannten Architekten L. Cocceius Auctus, eines *libertus*, der wahrscheinlich aus dieser Gegend gebürtig war und im Dienste Agrippas stand.

In Pozzuoli führte der Aquädukt zum höheren Teil der Stadt und füllte zahlreiche Zisternen in der Nähe des Amphitheaters. Die größte ist die Piscina Cardito, aus dem 2. Jahrhundert n.Chr. Diese mißt 55 m x 16 m. Das Dach wird von 30 Pilastern in drei Reihen getragen. Das Wasser, das durch zwei Eingänge einströmte, wurde erst durch zwei Gitter filtriert. Ursprünglich waren es zwei kommunizierende Zisternen, von denen eine erhalten blieb. Zwei andere Zisternen sind die Piscina Lusciano aus dem 1. Jhr. n.Chr., 35 m x 20 m groß, und die noch nicht ausführlich untersuchte Zisterne in der sogenannten Villa Avellino.[9] Pozzuoli wurde übrigens auch von einem anderen Aquädukt versorgt, dem Acquedotto Campano, der parallel an der Via Campana lief.

Weiter, hinter Pozzuoli, führte der Aquädukt in Richtung des Lago d'Averno, wo eine nächste Abzweigung für Cumae war. Von dieser Strecke ist uns nur die Grotta di Cocceio, ein Tunnel, übrig geblieben, entworfen von dem gleichen Architekten von dem die Crypta Neapolitana gebaut wurde. Der Tunnel ist in einer geraden Linie im Tuff des Monte Grillo ausgehackt über eine Länge von ungefähr einem Kilometer. Parallel zu diesem verlief an der Nordseite der Kanal des Serino-Aquädukts bis nach Cumae, auf dieselbe Weise wie bei der Crypta Neapolitana. Für die Beleuchtung und Entlüftung hat man sechs Brunnen geschlagen. In dem unteren Teil der Stadt Cumae angekommen, mündet die Serino-Leitung hier in die sogenannte Crypta Romana, einen Tunnel mit zwei Zisternen. Die Wände dieser Zisternen, gebaut in *opus reticulatum*, wie die Piscina Mirabilis und ande-

re erwähnte Zisternen, sind bis zu einer Höhe von drei Metern mit *opus signinum* bekleidet. Es ist schwierig den Originalzustand der Crypta Romana zu rekonstruieren. Es handelt sich im Prinzip um einen normalen Fußgängertunnel, vergleichbar mit den bereits vorher erwähnten. Er verbindet den unteren Teil der Stadt mit dem Hafengebiet und versorgt die Wasserversorgung für den Hafen und den unteren Teil der Stadt Cumae.

Von dem Lago d'Averno aus verlief der Haupttrakt der Serino-Leitung weiter, oben an Baiae vorbei. Die Abzweigung, die die bautechnisch komplizierten Thermenanlagen mit Wasser versorgte, ist sichtbar an der Westseite der obersten Terrassenanlage. Baiae war nie eine Stadt, weder in urbanistischer Hinsicht (keine öffentlichen Gebäude), noch gesetzlich (politisch war es abhängig von Cumae). Baiae war ein Konglomerat von Villen, Thermenanlagen und Gasthäusern. Der archäologische Park enthält also kein Total-Monument, sondern zeigt einen Teil des Kontinuums von Gebäuden. Der ursprüngliche Zustand und der Verlauf des Wassers der Serino-

5. Das Innere der Piscina Mirabilis.

Leitung in Baiae lassen sich nicht feststellen, auch hier sicherlich nicht zuletzt wegen der vielen Änderungen im Laufe der Zeit.

Endpunkt war die Piscina Mirabilis, im heutigen Bacoli, das gleichsam über Kap Misenum liegt: 15 m hoch, 70 m x 25 m gross und einen Inhalt über 12000 Kubikmetern, die größte römische Zisterne (*Abb. 5*). Der Raum ist durch 48 Pilaster in vier Schiffe geteilt. Das Hereinfließen des Wassers kann man nicht mehr richtig erkennen. Das Bassin mit Abfluß im Zentrum der Piscina Mirabilis wird wie eine *piscina limaria* interpretiert, zur Reinigung des Reservoirs. Wie das Wasser die Piscina wieder verließ, ist nicht sicher.

Meistens rekonstruiert man hydraulische Systeme und Kanalisationen. Die römische Flotte, *classis praetoria misenensis*, in Misenum wurde mit dem Wasser aus der Piscina Mirabilis versorgt. Eigentlich war der Aquädukt für die Wasserversorgung dieser Flotte angelegt worden. Kurz vor der Piscina Mirabilis wurden erst noch zwei grosse Zisternen, wahrscheinlich von jetzt zerstörten Villen, mit Wasser gefüllt, die Grotta Dragonara (50 m x 59 m, in Typologie vergleichbar mit der Piscina Mirabilis) und Cento Camerelle. Auch diese scheinen unmittelbar am weiterführenden Aquädukt angeschlossen gewesen sein.

Viele Fragen kommen bei der Beschreibung auf und sind bisher noch nicht beantwortet. Wie wurde das Wasser der Serino-Leitung verteilt? Wie funktionierten die verschiedenen Systeme nebeneinander: ein *castellum aquae*, das Wasser für eine Stadt erhält, und die Zisternen, die zwischendurch unmittelbar angeschlossen waren und Wasser für nur eine (kaiserliche) Villa bekamen? Diese wichtigen Fragen scheinen mit unserer heutigen Kenntnis nicht gelöst werden können. Es gibt zu wenig Anhaltspunkte. Weitere Forschungen, auch in anderen Teilen des römischen Reiches werden vielleicht einige Lösungen bieten.

Auch die Frage nach der Menge Wasser, die durch die Leitung lief, um alle Anschlüsse und Verbraucher mit Wasser zu versorgen, ist noch offen. Heutzutage gibt die antike Quelle Aquaro 500 bis 1000 l pro Sekunde. Für Pompeji haben niederländische Wissenschaftler das Dargebot berechnet auf 42 l pro Sekunde.[10] Nimmt man diese Zahl als Berechnungsgrundlage für die 12 bis 14 jetzt bekannten (großen) Abnehmer im Verlauf der Serino-Leitung, so ergibt sich mit ca. 550 l pro Sekunde ein durchaus realistischer Wert. In diesem Beitrag sind absichtlich die vielen *villae rusticae*, die Landbetriebe, außer Betrachtung geblieben. Wie wurden aber die vielen kleineren Villen, zum Beispiel in dem *ager pompeianus* mit Wasser versorgt? Verfügten diese über eine eigene Wasserversorgung? Es ist verhältnismäßig wenig bekannt über ihre Wassereinrichtungen, weil man diesem Aspekt wenig Aufmerksamkeit schenkt bei den Ausgrabungen. Hoffentlich aber wird die Wasserwirtschaftsforschung in Kampanien durch diesen Kongreß neue Impulse bekommen.

BIBLIOGRAPHIE

Amalfitano, P. et al. 1990, *I Campi Flegrei*, Venezia.
Beloch, J. 1879, *Campanien*, Berlin.
D'Arms, J. 1970, *Romans on the bay of Naples*, Cambridge Massachusettes.
Micci, B./U. Potenza 1994, *Gli Acquedotti di Napoli*, Napoli.
Sgobbo, I. 1938, Serino. L'acquedotto romano della Campania: <Fontis Augusti Aquaeductus>, *NSc*, 75-97.

ANMERKUNGEN

* Diese Arbeit konnte zu Stande kommen mit Hilfe der Niederländischen Organisation für wissenschaftliche Forschung (NWO). Dr. M. Vliegen möchte ich danken für die Übersetzung.

[1] Beloch 1879.
[2] D'Arms 1970.
[3] Properz 1, 11, 30.
[4] Tacitus *Annales* XIV, 4-5; Cass. Dio LXI, 14; Suetonius *Nero* 34, 2-4.
[5] Micci/Potenza 1994, 21ff.
[6] Sgobbo 1938, 88.
[7] Strabo V, 245; cf. für den Namen auch CIL X 1614.
[8] Amalfitano 1990.
[9] Amalfitano 1990, 114-117.
[10] Mündliche Kommunikation G. Jansen 1994.

GROESBEEKSEWEG 118
NL- 6524 DL NIJMEGEN
NIEDERLANDE

Gli acquedotti romani di Serino

Uberto Potenza

"un gran giorno per Napoli" ... "data da segnalarsi a lettere d'oro questa del 10 maggio 1885" ... "l'inaugurazione dell'acquedotto".

Questi alcuni titoli dei giornali che descrivevano l'inaugurazione dell'acquedotto napoletano: il ritorno a Napoli delle acque di Serino nel secolo scorso, così come già era avvenuto in età augustea alla fine del I secolo a.C.
Le sorgenti di Serino, da sempre rinomate per la qualità e la gradevolezza dell'acqua fornita, sono situate nel cuore dell'Appennino Campano, sgorgando dal massiccio carbonatico del Terminio-Tuoro, nel territorio della provincia di Avellino.
I gruppi sorgenti, distanti tra loro appena tre chilometri, furono prescelti per servire all'approvvigionamento della città di Napoli: quello superiore, che prende il nome di Acquaro e Pelosi, e sgorga a cicra 370 m sul mare, e quello inferiore d'Urciuoli alla quota di circa 320 m.

Lo studio idrogeologico effettuato prima di progettare le opere di allacciamento, dimostrò che le abbondantissime acque scorrevano su uno strato impermeabile posizionato ad una profondità media di 12 m sotto il livello del suolo; la vena acquifera, variabile da tre a quattro metri, è sempre costituita da sabbia, ghiaia e trovanti calcarei di diversa grandezza. Questo strato permeabilissimo, attraverso il quale filtrano le acque che, scendendo dalle lontane regioni montuose, si raccolgono qui per zampillare a fior di terra, è costantemente coperto da una crosta dit tufo nero abbastanza resistente e di spessore variabile, sopra il quale si adagiano infine la terra vegetale, la ghiaia, il limo e gli altri prodotti delle successive alluvioni.
Queste possenti e meravigliose polle sorgentizie, situate baricentricamente rispetto agli insediamenti campani, sono state captate nel tempo per l'alimentazione di ben tre acquedotti *(Fig. 1)*. Il primo di questi, in età romana, ovvero l'acquedotto augusteo, utilizzava il gruppo sorgentizio più alto detto dell'Acquaro-Pelosi,

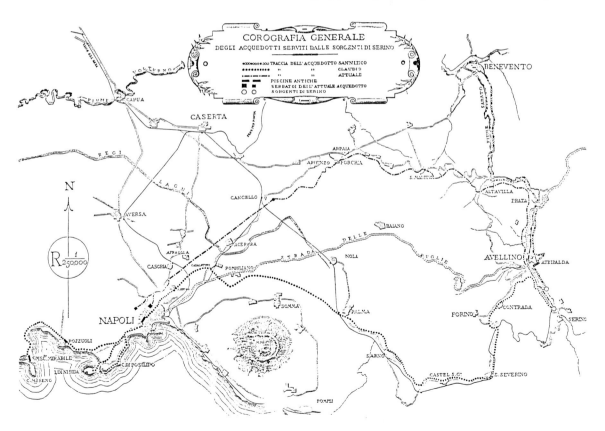

1. *Corografia generale degli acquedotti servili dalle sorgenti di Serino.*

93

```
DD+NN+FL+C ONSTAN
TINVS +MAX+PIVS+
FELIX+VICTOR+AVG+
ET FL IVL CRISPVS ET
FL·CL CONSTANT.N.S
    NOBB    CAESS
FONTIS   AVGVSTEI
ACQVAEDVCTVM
LONGA      INCVRIA
ET VETVSTATE CONR.PTVM
PRO MAGNIFICENTIA·
LIBERALITATIS CONS.ETAE
SVA·PECVNIA·R.F.CIIVSSERVN
ET·VSVI·CI..TAT.M INFRA
SCRIPTARVM   REDDIDERVNT
DEDICANTE·CEIONIO IVLIANO VC
CONS· CAMP· CVRANTE
PONTIANO·V·P PRAEP·EIVSDEM
     AQVAEDVCTVS
  NOMINA    CIVITATIVM
PVTEOLANA· NEAPOLITANA·NOLANA
ATELLANA· CVMANA· ACERRANA
BAIANA· MISENVM·
```

2. Lapide della fonte augustea.

I NOSTRI PRINCIPI:

FL. COSTANTINO, IMPERATORE PIO, FELICE E VITTORIOSO, FL. GIULIO CRISPO E FL. CLAUDIO COSTANTINO, NOBILI CESARI, COMANDARONO CHE FOSSE RICOSTRUITO, A LORO SPESE, COLLA MUNIFICA CONSUETA LIBERA-LITÀ, L'ACQUEDOTTO DELLA FONTE AUGUSTEA, ANDATO IN ROVINA COL TEMPO PER LA GRANDE INCURIA, E LO RESTITUIRONO ALL'USO DELLE CITTÀ SOTTOSCRITTE.

(QUESTA LAPIDE) DEDICA CEIONIO GIULIANO, VICE CONSOLE GIURISDI-CENTE L'AGRO PONTIANO, E PREPO-STO ALL'ACQUEDOTTO STESSO.

NOMI DELLE CITTÀ

POZZUOLI - NOLA - ATELLA - NAPOLI CUMA - ACERRA - BAIA - MISENO

S. MICHELE DI SIRENO - SORGENTI ALTE - (ACQUARO PELOSI) LAPIDE ROMANA IV SECOLO - RICOSTRUZIONE DELLA FONTE AUGUSTEA

TRADUZIONE PROF. SGOBBO

per il trasferimento delle acque verso le cittadine della piana campana, sino a Pozzuoli e Bacoli. Il secondo, anch'esso in età romana, trasferiva le acque del grup-po sorgentizio più basso, quello denominato Urciuoli, a Beneventum, ed infine nel tardo ottocento, l'acque-dotto di Serino conduceva a Napoli le acque di en-trambe le sorgenti per soddisfare le sempre crescenti necessità idropotabili della città partenopea.

Nell'agosto dell'anno 1936, durante i lavori per allac-ciare le sorgenti del gruppo Acquaro-Pelosi all'esis-tente acquedotto di Serino per la città di Napoli, ven-ne messa alla luce una pregevole lastra in marmo cipollino, recante una scritta romana databile tra il 317 ed il 326 d.C., probabilmente risalente al 324 d.C. (CIL X. 1805).

Tale lapide alta 190 cm, larga 87 e spessa 17 cm, tes-timoniava il restauro dell'acquedotto alimentato dalle sorgenti del gruppo alto a spese dell'Imperatore Anto-nino Pio e dei suoi figli Crispo e Costantino *(Fig. 2)*. La fonte viene definita 'Augustea' al pari di una epi-grafe mutila rinvenuta a Pozzuoli, dedicata ad un 'cur(atori) aquae aug(ustae)', rivendicando ad Augus-to la realizzazione dell'opera e confermando quanto già si ipotizzava con l'esame dei resti esistenti del canale in muratura, per il trasporto delle acque, canale eseguito in reticolato, di foggia tipicamente augusta. Lo Sgobbo (1938) che ha curato la traduzione italiana della lapide, sostiene che la successione con la quale vengono elencate le città, alimentate dall'acquedotto, dipende dal loro decrescente consumo idrico (e quindi dalla loro estensione ed importanza).

Gli studi e le ricerche fatti nel passato, su tale opera di primaria necessità per l'alimentazione idrica in Campania, sono stati sopratutto finalizzati al ripristino dell'antico acquedotto, per alimentare *in primis* la città napoletana, che nel tempo ha sostituito per importanza commerciale e strategica la città romana di Pozzuoli, con il conseguente aumento di popolazione, giusta ricompensa al desiderio di diventare capitale di un regno.

Il primo che ha studiato l'importante opera augustea è stato, nel 16° secolo, l'ingegnere napoletano Pietrantonio Lettieri, che, per incarico del viceré spagnolo Don Pedro di Toledo, per ben quattro anni, seguì i resti e le tracce dell'antico acquedotto sino a Napoli, lasciandone accurata testimonianza.

Ancora più particolareggiato risulta lo studio dell'architetto Felice Abate, che, verso la metà del 1800, con il saggio 'Studi sull'acquedotto Claudio e progetto per fornire di acqua potabile la città di Napoli', riproponeva il ripristino dell'acquedotto romano per riportare a Napoli le acque di Serino.

Tra gli altri studi è qui opportuno ricordare quelli di Sgobbo nel 1938 e di Elia nel 1978.

Probabilmente l'acquedotto Augusteo, necessario al porto di Miseno, viene edificato in un periodo nel quale vanno altresì aumentando le già sensibili richieste idriche degli importanti porti di Pozzuoli, città comunque già servita anche da un altro acquedotto locale, l'Acquedotto Campano, che captava alcune sorgenti del retroterra.

Tra il capo di Posillipo e capo Miseno, tra il I secolo a.C. e la metà del II secolo d.C. erano posizionati i porti più significativi del Mediterraneo: il porto commerciale di Pozzuoli, per lungo tempo porto di Roma, e quello militare costruito nei laghi di Lucrino e Averno: il 'Portus Iulius', realizzato dal console Vipsanio Agrippa, con la collaborazione dell'architetto Cocceio. La costruzione di tale porto è databile intorno al 37 a.C., nell'ultima fase della guerra tra Pompeo 'Magno' ed Ottaviano.

È probabile che, dopo il 30 a.C., con la pacificazione dell'Impero Romano per mano di Augusto, aumentando notevolmente i traffici commerciali ed agricoli tra Roma ed i territori d'oltremare, e quindi l'importanza del porto di Pozzuoli, si decise di spostare il Portus Iulius militare, liberando spazio per i moli commerciali e l'arrivo anche dei cittadini dell'Impero, secondo i canoni della 'Pax Augustea'.

Di fatto fu costruito sotto Capo Miseno un nuovo porto militare, vasto ed importante, capace di contenere la grande flotta imperiale. La zona ebbe una espansione edilizia, estesa e di pregio: di fatto si sentì la necessità di acqua abbondante e di qualità.

Lungo tutto il litorale sorsero numerose e lussuose ville, tra la otiosa Neapolis e la attiva Puteoli, numerose altresì le ville rurali e le terme.

L'acquedotto augusteo di Serino è quindi databile tra il 30 ed il 20 a.C. Si ricorda che il cognato di Augusto, Marco Vipsanio Agrippa, viene preposto nel 33 a.C. all'ufficio di *curator aquarum* e inizia grandi ed estesi lavori per migliorare l'uso degli acquedotti romani; lo stesso edifica in Roma nuovi acquedotti.

Le acque di Serino, prima di giungere a Pozzuoli e Miseno, dopo un percorso di circa 100 km, alimentavano numerose città, anche non prossime al canale di adduzione, mediante diramazioni spesso considerevoli. Si pensi a Pompei, il cui *castellum aquae* posizionato a Porta Vesuvio, il punto più alto della città, era rifornito mediante un canale derivato, probabilmente interrato, che, proveniva da Sarno, costeggiando le pendici del Monte Somma, dopo un percorso valutabile in sei chilometri, alimentazione certo distrutta a seguito dell'eruzione del 79 d.C.

Altre città, alimentate mediante lunghe diramazioni, erano certo Nola, Acerra, Cuma con una condotta libera in muratura parallela alla grotta della Pace. La città di Napoli, sfiorata dal canale augusteo, aveva il *castellum aquae* all'altezza degli attuali quartieri spagnoli, posizionato al di fuori della murazione.

L'opera acquedottistica romana, superata Napoli, era dotata di una diramazione alimentante le splendide ville della collina di Posillipo, sino alla Pausilypana. Il canale, traversata la grotta per Pozzuoli, ove era posizionato in destra all'altezza delle reni della volta, si divideva in due rami. Il primo dei quali, passando su un mirabile ponte canale sul mare, alimentava l'isolotto di Nisida, l'altro, il principale, interrato a mezza costa sulle colline prospicienti il mare, giungeva a Pozzuoli riversando le acque, prelevate dalle sorgenti dell'avellinese, in numerose cisterne di ampli volumi.

Le sezioni del canale dell'acquedotto augusteo non sono certo costanti, ma dipendenti dalla natura e tipologia dei terreni attraversati *(Fig. 3)*. Generalmente tale opera si sviluppava nei terreni collinari dell'Appennino, correndo a mezzacosta.

Numerose erano le gallerie in roccia: il traforo del monte Paterno, ad esempio, lungo 1.768 m, era altresì dotato di numerosi cunicoli verticali ed inclinati, costruiti per l'ispezione e la manutenzione; la costruzione di cunicoli montani verticali ed obliqui è caratteristica delle cripte augusteae delle zone misenate e cumana.

Per superare i dislivelli esistenti nelle valli l'opera correva su ponticanali, dei quali il più esteso risultava quello presso Pomigliano d'Arco, nella piana Cam-

pana, lungo oltre 3500 m con archi alti sino a 4-5 m. Prima di giungere alle vasche terminali della 'Piscina Mirabilis', avente una capacità di 12.600 m³, al probabile servizio del nuovo porto militare di Miseno, ed alla grossa vasca della Dragonara di volume circa la metà, forse al servizio dell'abitato locale e degli addetti al porto, l'acquedotto alimentava numerose ville rurali e sul mare e molteplici gruppi termali. Tra le altre terme note sono quelle presso Agnano in via Terracina, ma ancor di più il maestoso complesso di Baia.

La zona di Pozzuoli-Baia era dotata altresì di molteplici cisterne nelle quali giungeva anche l'acqua di un ulteriore acquedotto di non certa datazione: l'Acquedotto Campano.

Questo acquedotto municipale, che il Beloch (1879) definisce, senza tentativi di ulteriore precisazione, d'età greco-romana, serviva probabilmente la città di Pozzuoli già da prima che entrasse in funzione l'acquedotto augusteo, non potendo ipotizzarsi che in età repubblicana un porto già importante fosse sprovvisto con continuità di un congruo volume d'acqua. L'opera costituita da un canale di larghezza 70 cm per circa due metri di altezza, captava alcune sorgenti locali, posizionate nell'immediato retroterra, certo più copiose rispetto ad oggi, trasportando l'acqua lungo la via Campana, distaccandosene poi, per scendere nella parte più bassa della città nella piazza principale nella quale ha termine.

È interessante notare come le più capaci e significative vasche di accumulo, costituenti, il più delle volte, veri e propri serbatoi, fossero situate al termine del lungo canale augusteo. Ad avviso di chi scrive tale tipo di manufatto, tra l'altro costoso, si rendeva necessaria per conservare capaci scorte idriche per le navi e per le attività portuali, sopratutto durante i probabili fuori servizio del canale dell'acquedotto, per gli interventi di ispezione o peggio per le riparazioni che dovevano essere frequenti nell'antichità, così come avviene per gli acquedotti moderni.

Ricordiamo che agli interventi di ispezione e di riparazione provvedevano degli specialisti (cosi come avviene oggi), che erano addetti a lavori esclusivi, come sottolinea il *curator aquarum* Sesto Giulio Frontino nel suo *De aquaeductu Urbis Romae* alla fine del I secolo d.C.

Una notazione particolare va dedicata alla pendenza nell'acquedotto augusteo di Serino. Ricordiamo che la pendenza di un canale può esprimersi come il rapporto tra il dislivello tra due punti e la loro distanza orizzontale; si misura, generalmente in metri di quota persi per ogni chilometro di lunghezza di canale.

Le sorgenti di Serino, e precisamente quelle superiori di Acquaro-Pelosi, captate dai Romani, sono situate a 330 m circa sul livello del mare, la platea della Piscina Mirabilis, lontana da queste circa 100 km, è situata sui 2 metri sul livello del mare (al tempo di Augusto probabilmente intorno ai 10 metri, per il noto fenomeno del bradisismo flegreo).

Da tali dati si può dedurre che la pendenza media dell'acquedotto augusteo era di poco superiore al tre per mille, ovvero che l'acqua trasportata, perdesse tre metri per ogni chilometro percorso.

In realtà la pendenza variava tratto per tratto. Il già citato Abate, dopo gli studi sull'antica opera romana di Serino, divide il percorso in una serie di tratti a pendenza pressoché costante: dal primo tratto, che nasce dalle sorgenti, ove la pendenza è del 7,33 per mille, alla 'caduta della Laura' ove in 1,484 km si perdono 153,61 m, al traforo sotto il monte Paterno (0,52 m per km), al ponte canale di Ponmigliano (0,39 m per km), e così via sino all'ultimo tratto da lui studiato sino ai 'Ponti Rossi' ingresso alla città di Napoli, ove le pendenza risulta dello 0,16 per mille, e la platea del canale è posizionata a 41,4 m sul livello del mare. Dalle sorgenti Acquaro ai Ponti Rossi il canale, secondo Abate è lungo circa 75 km.

Acquedotto Sannitico Acquedotto Augusteo

Tipo di sezione con volta a sbalzo presso i Ponti Rossi.

3. Sezioni del canale degli acquedotti.

Nei moderni canali a pelo libero, costruiti per il trasporto dell'acqua potabile, la pendenza, certo di valore costante durante il tracciato, varia mediamente tra i 0,2 ed i 0,6 m per km. Tale risultato è certo dovuto alle diversità tecnologiche relative ai periodi considerati.

Al tempo dei Romani erano in uso, per il controllo del piano orizzontale strumenti come il *chorobates* e la *libra aquaria,* per la verticalità esisteva l'archipendolo o *dioptra* e la *groma* aiutava validamente per le triangolazioni e la divisione agrimensoria. Diversamente dagli strumenti moderni quali il livello (l'errore di quota, per un livello di media precisione, non deve superare l-2 mm per km), il tacheometro ed il teodolite, per gli angoli e le distanze.

È stupefacente come i Romani, con strumenti tanto rudimentali, siano riusciti a realizzare opere tanto avanzate.

La difficoltà di realizzare nei canali una pendenza costante, almeno per lunghi tratti, crea problemi di non piccola entità derivanti o dalla eccessiva velocità delle acque o dalla loro lentezza nello scorrere nello speco. Anche le brusche variazioni di regime idraulico determinano disconnessione della vena liquida con conseguente creazione di rigurgiti, schiume e risalto del pelo dell'acqua (salto del Bidoni). Da ciò ne conseguono il deposito del materiale a volte trasportato, l'erosione delle murature nei tratti ove la velocità si presenta troppo elevata, e soprattutto la deposizione, a causa dell'ossigenazione, dei sali di calcio lungo le pareti o sul fondo, sali che costituiscono quelle incrostazioni stratificate cui fa cenno Frontino nella sua opera. Tali incrostazioni diffuse nei canali romani, di misura tale che a volte ne viene impedito totalmente il passaggio della stessa acqua, come visto, richiedevano periodici interventi di pulizia con chiusura totale del flusso idrico. Tra l'altro non è certo facile eliminare tali incrostazioni, senza danneggiare altresì l'opera muraria.

Negli acquedotti attuali, realizzati con pendenze pressoché costanti, il fenomeno è di fatto inesistente, tranne in alcuni punti ove esiste una areazione più intensa: punti di sbocco o salti repentini di quota. Il canale principale di Serino, realizzato nel 1885, e con pendenza costante di 0,5 m al km nei suoi 110 anni di funzionamento non presenta lungo le pareti la minima traccia di depositi calcarei.

Interessante notazione può farsi sull'acquedotto romano per Benevento, anch'esso alimentato dalle sorgenti di Serino, più precisamente dal gruppo sorgentizio più bassso: Urciuoli, con portate maggiori, variabili tra i mille e duemila litri al secondo.

Tale opera idraulica, studiata tra il XVIII e XIX secolo, da tal Francesco Criscitelli, e databile tra la fine del I secolo d.C. e la metà del II, presenta svariate singolarità tecniche che vale la pena di menzionare.

Il canale dell'acquadotto, probabilmente lungo tra i 34 ed i 36 km, nasceva dalla polla principale del gruppo sorgentizio. Il *caput aquae* era posto a circa 324 m sul livello del mare; l'arrivo, in una cisterna dopo l'arco di Tito in Benevento, era situato ad una altezza non superiore ai 150 m di altezza. Da tali dati si ricava la pendenza media del manufatto di circa 5 m per km.

In effetti i tratti dell'opera che si succedevano lungo il percorso, che si sviluppava lungo il letto del fiume Sabato, attraversandolo anche con dei ponti-canale ad arcata unica, presentavano valori di pendenza diversi anche notevoli. Il tratto iniziale aveva una pendenza di 1 m al km; presso il villaggio di Prata tale valore saliva ad oltre 7 m al km, da Altavilla Irpina a Ceppaloni risultava di oltre 13 m al km, infine il valore succitato, nel territorio beneventano, era di 2 m al km.

Orbene lo spessore delle incrostazioni, rilevato nei vari tratti visibili del canale, è strettamente collegato con la pendenza locale dello stesso, e quindi alla velocità ed alla areazione dell'acqua trasportata.

Nel primo tratto succitato presso il *caput aquae,* le incrostazioni di calcare sono state misurate di 3 cm di spessore *(Fig. 4);* nel tratto presso la cittadina di Altavilla, furono valutate di spessore circa 25 cm a strati (come se durante il funzionamento dell'acquedotto vi fossero stati dei periodi nel quale il canale risultava asciutto). Il Criscitelli, nel terzo tratto del canale, tra i villaggi di Altavilla e Ceppaloni, ove maggiore era la pendenza, misurò incrostazioni in platea di spessore sino a 50 cm. Con valori ancora maggiori sui piedritti, nell'ultimo tratto del tracciato verso Benevento, ove come visto la pendenza diminuisce, lo spessore delle incrostazioni risulta minore, tranne alcuni tratti particolari, presso l'arco di Costantino, dove erano prevedibili variazioni di regime idrico.

Nell'acquedotto di Benevento fu riscontrata, altresì, un intervento tecnico di tipo particolare quasi sicuramente eseguito a causa sia della instabilità e pericolosità dei terreni attraversati dal manufatto, che dall'esistenza di polle d'acqua non buona al di sotto della platea del canale.

Il costruttore, o molto probabilmente il curatore di un restauro posteriore, ha ricoperto la platea del canale con lastre di piombo ricoperte poi di laterizio, in modo da isolare le acque da eventuali infiltrazioni idriche non gradite e ancor più per vanificare piccoli movimenti del terreno instabile che avrebbero danneggiato il canale stesso.

I piedritti dell'opera sono, generalmente eseguiti in

4. Acquedotto Romano per Benevento.

calcestruzzo, nel nucleo, con frammenti in ciottoli calcarei e con paramento in tufello e laterizi spessi 3,5 cm, alternati in filari di 10.

La sezione dell'opera di presa, esistente alle sorgenti Urciuoli, si presenta larga 0,7 m, alta 1,7 m, coperta con tegole in laterizio posate alla cappuccina.

Le pareti dei piedritti sono rivestite da un doppio stato impermeabile, il primo spesso 4,5 cm in cocciopesto, il secondo di 0,5 cm in cocciopesto finemente tritato e calce; al di sopra è disposata un'incrostazione calcarea di 3,5 cm.

L'ultimo degli acquedotti di Serino è, come si è detto inizialmente, quello inaugurato nel 1885. Costruito, in soli quattro anni, per trasferire a Napoli le portate idropotabili necessarie ad alimentare i cinquecentomila abitanti della popolosa città partenopea, era, per l'epoca nella quale veniva realiazzato, un'opera dai grandi contenuti tecnici, progettata con tale lungimi-

ranza che ha permesso di alimentare da sola sino al 1945 Napoli e numerosissimi comuni viciniori. Vero è che nel 1936 furono captate ed inviate, mediante i medesimi impianti, le sorgenti alte del gruppo Acquaro-Pelosi; con tale immissione il canale ancora oggi trasporta, nei periodi di morbida delle sorgenti, sino a 2350 litri al secondo.

I lavori dell'acquedotto furono divisi in cinque parti distinte che ne costituirono l'insieme:

1. L'allacciamento delle sorgive.
2. La conduttura libera in muratura a partire dalle sorgenti e sino ai castelli di presa dei grandi sifoni sulla collina di Cancello, eccezione fatta di due sifoni (rovesci) intermedi per gli attraversamenti dei valloni profondi di Tronti e Gruidi.
3. Le condotte forzate, o grandi sifoni a partire dalla collina di Cancello sino ai serbatoi sulle colline di Napoli.
4. I due serbatoi cittadini.
5. La distribuzione in città.

I lavori di allacciamento che furono compiuti nelle sorgenti Urciuoli diedero dei risultati eccellenti, superiori ad ogni previsione, giacché la portata che da esse si ricavò fu superiore ai 2 m^3 al secondo.

Il sistema di allacciamento, secondo il quale si procedette, è quello del drenaggio sotterraneo: diviso il territorio delle polle in tre zone, a seconda della posizione ed importanza delle varie sorgive, furono costruiti tre canali coperti, destinati a raccoglierne e convogliarne le acque, ed al principale tra questi, furono attribuite dimensioni maggiori che agli altri due.

La profondità alla quale furono collegati questi collettori, varia secondo la configurazione del soprasuolo; però in generale si trovano superiori alla vena acquifera, di maniera che dove essi giacciono incassati nel tufo non venne fatta alcuna platea; attraverso tale apertura risalivano le acque sorgive.

Le polle immediatamente laterali al percorso del collettore versano in esse le loro acque per apposite luci lasciate nel piedritto corrispondente, di apertura proporzionata alla importanza della medesima sorgiva.

All'esterno e lateralmente ai piedritti lo scavo si aprì per una certa larghezza in più e lo si riempì sino al livello della cappa di ciottoli calcarei puliti e lavati; di tal modo si avvolse il collettore in una incamiciatura permeabilissima, attraverso la quale anche le sorgive elevate possono trovare facile e comoda via.

Su tutto si distesero due strati di pura argilla fortemente battuta e cementata tra loro da un frapposto velo di calce idraulica in polvere e al di sopra un vagliato riempimento in terra, il tutto a protezione delle sorgive dalle acque superficiali.

La raccolta di queste acque avviene in un fabbrica-

to di pianta quadrata diviso in tre piani dall'ultimo del quale parte il canale dell'acquedotto per Napoli, presso il punto di partenza dell'acquedotto per Benevento.

Tale canale, lungo 59.551 m, si svolge lungo un percorso parte a mezza costa, parte in galleria naturale all'interno dei monti, parte in pianura secondo la configurazione naturale della zona attraversata e ove ciò non sia possibile su ponti canali anche di notevole lunghezza.

I ponti canali (Fig. 5) sono oltre 20 con uno sviluppo di oltre 1800 m, il più lungo dei quali passa sopra Rio Noci con 31 arcate e quasi 500 m di lunghezza. Da sottolineare la somiglianza di tali manufatti con quelli costruiti dai Romani.

I profondi e scoscesi valloni dei Tronti e dei Gruidi sotto Altavilla Irpina, furono attraversati dall'acquedotto con due batterie di tubazioni metalliche (in ghisa).

Il problema di fornire giornalmente la città di Napoli dalla collina di Cancello, punto nel quale arriva l'acquedotto principale in condotta libera, ora descritto, fu efficacemente risolto da una conduttura forzata metallica in ghisa, composta da tre grandi sifoni rovesci, uno con diametro interno di 700 mm, destinato all'allimentazione del serbatoio alto e gli altri due, col diametro interno di 800 mm, destinati per il servizio basso della città.

L'origine dei sifoni ha luogo in due vasche o castelli di presa posti a differente altezza sul versante del colle di Cancello verso Napoli.

Dai succitati castelli di presa, costruiti con solida muratura fino ai serbatoi cittadini si sviluppa, iniziando dai piedi della collina, parte della piana campana, nella quale sono interrate le grosse condotte di adduzione.

Queste dopo un percorso di oltre 22 km forniscono i due serbatoi cittadini dell'epoca delle portate destinate alle due reti ad essi connessi.

Il serbatoio più basso posto in vicinanza della reggia di Capodimonte, in sottosuolo, ha un volume di oltre 82.000 m^3, per l'epoca veramente considerevoli; esso è costituito da cinque vasche scavate nel tufo giallo napoletano alte l0,8 m, larghe 9,25 m e nelle quali l'acqua si pone a 8 m; la quota altimetrica rispetto al mare è di 92,5 m.

Il secondo serbatoio più alto dello Scudillo, posto alla quota di 183 m sul mare, aveva una capacità complessiva di 20.000 m^3. Tale serbatoio alimentava tutte le utenze medio alte della Napoli di fine 1800. Nel tempo la capacità di tale serbatoio è stata aumentata sino a 145.000 m^3.

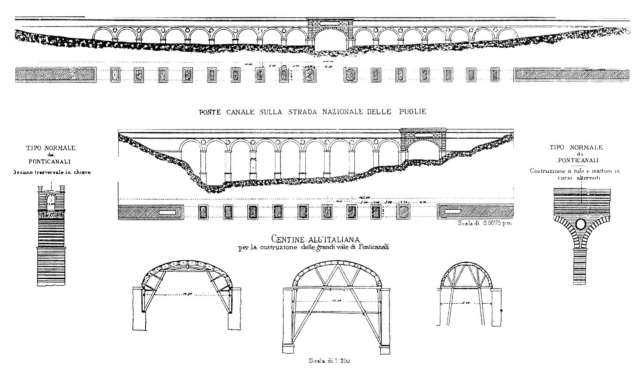

5. Acquedotto di Napoli.

Dalla descrizione in vero sommaria e parziale che sino qui è stata fatta, risaltano comunque grosse analogie costruttive dell'opera moderna rispetto al più antico acquedotto romano di Serino e di acquedotti analoghi della romanità: sia per le opere drenanti per la captazione delle sorgive, che per la condotta in muratura per il trasferimento a distanza della acque, ma anche per l'attraversamento delle valli e delle montagne, si può ben affermare che le tecniche costruttive, fatta salva la diversa capacità realizzativa dei relativi periodi storici, non erano di molto cambiate nei diciannove secoli intercorrenti tra le rispettive realizzazioni.

Infatti i Romani solevano alimentare le città con condutte in pressione generalmente in piombo, tale rete, ove necessario, idrica veniva servita da serbatoi di accumulo; i canali a pelo libero che riempivano i serbatoi erano adeguati ai terreni attraversati e ai dislivelli incontrati; i sistemi di captazione adottati permettevano una presa delle acque igienica e sicura; infine lo stesso sistema di gestione ed esercizio di tutta l'opera acquedottistica prevedeva, con il lavoro delle *familiae,* una organizzazione agile e moderna, che permetteva pronti interventi.

Anche la legislazione romana sugli acquedotti prevedeva la salvaguardia del servizio idrico e del bene pubblico acqua considerato una conquista sociale per ogni tipo di cittadino.

In conclusione il concetto della *res publica* era ben radicato nella società romana; non ci deve quindi stupire, e possiamo condividere quanto afferma Sesto Giulio Frontino, nominato dall'imperatore Nerva *curator aquarum,* per la riorganizzazione dell'amministrazione delle acque nel 97 d.C. Tale incarico di solito veniva affidato agli uomini più ragguardevoli della città. Frontino nel suo trattato *De aquaeductu Urbis Romae* (cap. 1) afferma: "ogni incarico dell'imperatore richiede particolare attenzione ed io stesso sono stimolato da una naturale sollecitudine e da una operosa lealtà, non solo a svolgere ma ad amare l'incarico commessomi. Ora che Nerva Augusto, imperatore non so se più solerte o più amante della cosa pubblica, mi ha affidato l'amministrazione delle acque per l'uso, l'igiene ed anche la sicurezza della città, incarico sempre ricoperto dagli uomini più illustri della città, ritengo di primaria importanza e, soprattutto, indispensabile essere bene a conoscenza del compito intrapreso, così come ho sempre fatto nei precedenti incarichi".

BIBLIOGRAFIA

Adam, J. P. 1984, *L'arte di costruire presso i Romani,* Milano.

Beloch, J. 1879, *Campanien,* Berlin.

Elia, O. 1938, Un tratto dell'acquedotto detto 'Claudio' in territorio di Sarno, in *Campania romana: Studi e materiali,* Napoli, 99-111.

Frontino, S.G., De aquaeductu Urbis Romae, in *gli acquedotti di Roma* di Pace P. 1986, Roma.

Gunter, T.R. 1993, *Posillipo romana,* a cura di Viggiani D., Napoli.

Johannowsky, W. 1952, Contributi alla topografia della Campania antica, *RendNap* 27, 83-146.

Miccio, B./U. Potenza 1994, *Gli Acquedotti di Napoli,* AMAN, Napoli.

Pozzi, E. et al. 1985, *Napoli antica,* Soprintendenza archeologica per le province di Napoli et Caserta, Napoli.

Rea, R. 1978, *L'acquedotto di Serino,* tesi di laurea, Istituto di topografia di Roma e dell'Italia antica.

Sgobbo, I. 1938, Serino-l'acquedotto romano della Campania: 'Fontis Augustei Acquaeductus', *NSc* 75-97.

Società Veneta, 1883, *L'acquedotto di Napoli,* Barsano.

Vitruvio, P.M., *De architectura,* 1990 traduz. Mingotto L., libri VIII-X.

AZIENDA MUNICIPALIZZATA ACQUEDOTTO DI NAPOLI (AMAN)
VIA CONSTANTINOPOLI, 98
I-80138 NAPOLI
ITALIA

Note su alcuni acquedotti romani in Campania

Mario Pagano

Lo studio degli acquedotti romani esistenti nell'ambito dell'odierna regione Campania è stato per molti anni piuttosto trascurato. Solo sporadici rinvenimenti sono stati scientificamente segnalati e sono mancate, salvo qualche eccezione, ricerche dettagliate su interi condotti e sulle emergenze monumentali di maggiore rilievo. Chi scrive ha in corso sull'argomento alcuni studi, nel quadro di più ampi lavori topografici. Si presentano in questa sede i risultati preliminari di tali ricerche, che offrono nuovi e importanti dati sulle opere idrauliche antiche in Campania.

TERRITORIO ERCOLANESE: ACQUEDOTTO E SERBATOI ROMANI DI TORRE DEL GRECO

A Torre del Greco sono state individuate, a 3,7 km a Sud-Est degli Scavi di Ercolano, due grandi ville marittime romane sepolte dall'eruzione del 79 d.C., separate da un vallone, e sono state parzialmente indagate in questi ultimi anni, con risultati assai importanti: quella di contrada Sora e quella denominata, dallo studioso che nel 1880-81 la esplorò parzialmente, G. Novi, "Terma-Ginnasio" *(Fig. 1 e 2)*.[1] Quest'ultima è posta fra la ferrovia Napoli-Salerno e il mare, 360 m a Sud-Est del cimitero.

Le esplorazioni condotte in questa località hanno dimostrato che la vita riprese sul sito già nel II secolo d.C. (a differenza di quanto pensava il Novi, che non distinse bene le due fasi). La parte scavata della villa distrutta nel 79 d.C. comprende due terrazze parallele, sostenute da muri in reticolato articolati da nicchie. La terrazza più bassa (lungh. della parte messa in lu-

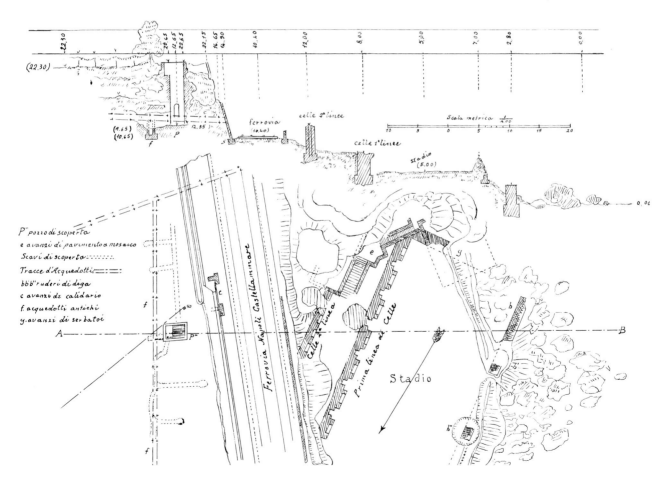

1. *Torre del Greco, loc. 'Ponte di Rivieccio'. Pianta dei ruderi della cosiddetta Terma-Ginnasio, all'epoca dello scavo del Novi.*

101

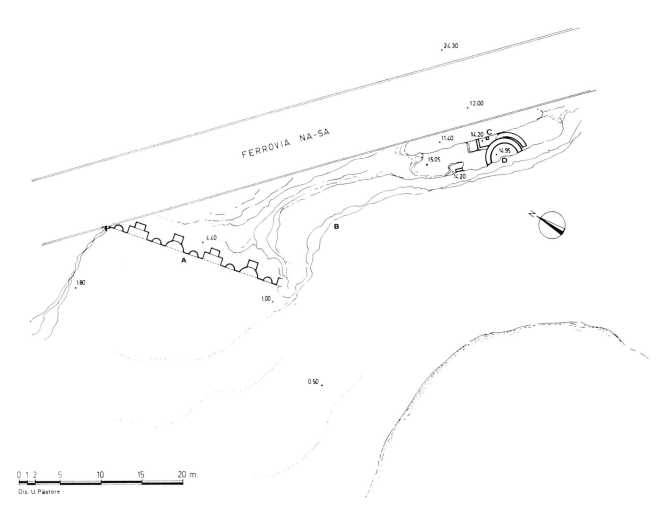

2. *Torre del Greco, loc. 'Ponte di Rivieccio', cosiddetta Terma-Ginnasio. Pianta degli scavi 1991-93 (arch. U. Pastore): A. Terrazza in reticolato; B. Resti di acquedotto, ora franato; C. Serbatoio distrutto dall'eruzione del 79 d.C.; D. Edificio circolare del II-III secolo d.C.*

ce: 41,7 m; largh. 4,1 m) era limitata da una balaustra bronzea sostenuta da ermette bifronti. All'estremità verso mare di questa terrazza fu edificato, ad un livello più alto e con diverso orientamento, sopra le ceneri del 79, un serbatoio in mattoni (lungh. conservata 6,75 m; largh. 7,48 m; altezza fino all'imposta della volta: 6,87 m) *(Fig. 1, g),* coperto da una volta a botte di concreto. Le pareti erano rivestite di spesso cocciopesto. La base del serbatoio era formata da un letto di calcestruzzo, alto 1,5 m, cui era sovrapposto lo strato di signino, spesso 0,13 m. Gli angoli inferiori interni erano smussati. All'esterno del serbatoio si trovava una scaletta di muratura. Il Novi, che demolì il serbatoio per completare l'esplorazione dell'edificio più antico, riferisce che "innanzi alla gran vasca, o *castellum* era uno sfiatatoio coronato da una orlatura di pie-

tra vulcanica, facente l'ufficio di pozzo o colonna per la libera uscita dell'aria mossa dall'acqua in moto".
Il serbatoio era alimentato da monte per mezzo di un acquedotto scavato nel banco di cenere *(Fig. 1, f; 2, B),* rivestito di spesso cocciopesto. Esso presenta due rami, e al loro incrocio, sottostante il belvedere circolare, uno spazioso allargamento, che ho potuto intravedere recentemente grazie ad un cunicolo praticato obliquamente da scavatori clandestini, e che è ora quasi completamente interrato. Più a monte si dipartiva un altro condotto *(Fig. 1, f),* rilevato dal Novi, che corre in direzione Nord-Ovest Sud-Est, dunque quasi parallelo al mare.
Alla sommità del rilievo preistorico sul cui fianco furono costruite le terrazze in reticolato è stata scavata una cisterna con pilastro centrale, distrutta dall'eru-

102

zione del 79 d.C. *(Fig. 2, C)*. Sulle rovine di questa installazione idrica fu edificato un ambiente circolare *(Fig. 2, D)*, probabilmente il belvedere di una nuova villa marittima edificata sul sito nel II secolo d.C. Il belvedere crollò nel corso della prima metà del III secolo d.C.

La dimostrata datazione al II-prima metà del III secolo d.C. delle strutture della villa romana più tarda e del serbatoio cui l'acquedotto era collegato, induce a riferire il condotto individuato alla stessa epoca. Se è possibile che possa trattarsi di un canale che utilizzava sorgenti locali (le falde del Vesuvio ne sono abbastanza ben fornite), si potrebbe anche pensare, vista la direzione di uno dei condotti, parallela alla linea di costa, che si tratti di un ramo dell'acquedotto del Serino ricostruito dopo la fatale eruzione pliniana lungo questo versante del Vesuvio per alimentare i numerosi e fiorenti insediamenti sparsi che si svilupparono di nuovo, a partire dal II secolo d.C., nell'area, per raggiungere il massimo addensamento nel IV secolo.

Questa ipotesi andrà verificata con nuove e più puntuali ricerche. Se essa coglie nel vero, il condotto da questo lato poteva arrivare anche fino a Napoli, e questa possibilità andrebbe tenuta presente nella ricostruzione della rete idrica dell'antica città.

L'ACQUEDOTTO ROMANO DI CASTELBARONIA (PROVINCIA DI AVELLINO)

In Irpinia, nel comune di Castelbaronia (che domina la valle dell'Ufita, una delle principali vie di collegamento con la Puglia), vengono a giorno tre sorgenti denominate Acquara, Molinello e Tufara, che hanno una portata complessiva di 21/23 lt./sec. *(Fig. 3, A)*.

Una ricognizione nel canale di adduzione moderno della più profonda delle tre sorgenti, la Molinello, ha permesso di individuare un tratto del condotto di captazione di età romana.[2]

Il tratto di acquedotto romano conservato *(Fig. 4)*, costituito da una spessa ed accurata gettata di opera

3. *Castel Baronia (Av): localizzazione delle sorgenti in loc. 'Acquara' (lett. A; stralcio dalla pianta, in scala 1:100000 dell'I. G. M., F. 174-Ariano Irpino).*

4. *Castel Baronia (Av), loc. 'Acquara', sorgente Molinella. Tratto del condotto di captazione romano.*

cementizia nella quale è utilizzato il tipico conglomerato locale, si trova a 50 m dalla vasca di raccolta e a 60 m dalla strada di accesso, alla confluenza di due ramificazioni che servivano a captare due diverse scaturigini. Di queste due captazioni l'una ha direzione Est-Ovest, l'altra Nord-Ovest Sud-Est. La prima è conservata per una lunghezza di 1,2 m, l'altra per meno di 1 m. Ambedue sono pavimentate con tegole a doppio margine rialzato, larghe fra i due bordi 22 cm nel primo caso e 45 cm nel secondo caso.[3] L'altezza massima del condotto è di 1,25 m. Il condotto principale, formato dalla confluenza delle due captazioni, è conservato solo per poco più di un metro, ha direzione da Nord-Est a Sud-Ovest, presenta le medesime caratteristiche strutturali ma è più largo (60 cm). La copertura è a sezione triangolare, rivestita da tegole accostate alla sommità, ora mancanti, ma delle quali si notano le impronte nella malta.

L'altezza (4 cm) della spessa incrostazione calcarea presente sulle tegole del condotto permette, con i dati sulla pendenza e della rugosità del materiale, il calcolo della portata, che doveva essere simile all'attuale (4/6 lt./sec.).

All'esterno non sono visibili tracce dell'antico acquedotto derivato dalla sorgente, ma si deve tenere conto sia della forte franosità del terreno, sia dei successivi interventi, effettuati in epoche diverse. Solo presso l'inferiore sorgente Tufara si vede un condotto sopra-

elevato di epoca piuttosto recente, che alimentava un mulino ancora esistente.

L'accuratezza dell'opera di captazione fa pensare probabilmente ad un'opera pubblica di buona età romana, che va ad aggiungersi alle poche ma significative testimonianze di età romana nella Baronia (anche se non è possibile una datazione più precisa). La ricerca archeologica in quest'area è stata fino ad anni recenti trascurata. In seguito ad una prima ricognizione del territorio numerose sono state le presenze preromane individuate, che dimostrano che esso era al centro di scambi piuttosto intensi.[4] Anche per l'età romana recenti ritrovamenti hanno rivelato presenze inattese, in primo luogo l'abitato anonimo, con impianto regolare (forse una *colonia* di età graccana), in località Fioccaglia di Flumeri nella sottostante valle dell'Ufita *(Fig. 3, C)*,[5] dove corre un'antica e importante via di comunicazione (l'Appia percorsa da Orazio), ben documentata da miliari a partire dall'età repubblicana. Non mancano, anche nella stessa Castelbaronia, alcune iscrizioni di età romana e rinvenimenti archeologici vari.[6] In particolare è significativo che in località 'Isca del Pero', allo sbocco del vallone Macchioni, subito a valle delle sorgenti, sia stata di recente individuata una notevole villa di età repubblicana *(Fig. 3, B)*. Il Mommsen e il Salmon supposero ipoteticamente l'esistenza del vicino municipio di Trevicum (Trevico), che fu poi sede vescovile, ma certo economicamente il territorio doveva gravitare sul ben più importante centro di Aeclanum.[7]

Per la considerevole portata, sufficiente ad alimentare una cittadina moderna, l'acquedotto dovette essere realizzato per rifornire insediamenti significativi. Uno di tali insediamenti potrebbe ragionevolmente essere quello di Fioccaglia di Flumeri; comunque l'acquedotto doveva servire le ville che si disponevano, nella valle dell'Ufita, lungo la via Appia.

L'importanza dello sfruttamento delle sorgenti anche nel Medioevo è documentata dalla donazione, nel 1136, nel luogo dove era il casale dell'Acquara, della chiesa di S. Giovanni e di un mulino al monastero di Montevergine.[8] Nel sito fu poi fondato un monastero. Quindi, nel Medioevo le sorgenti furono utilizzate per una notevole attività molitoria. Vi erano infatti altri mulini, siti nelle vicinanze, ricordati dai documenti.

ACQUEDOTTI E GRANDE CISTERNA ROMANI
PRESSO CAIAZZO (PROVINCIA DI CASERTA)

Ricerche sistematiche chi scrive ha condotto, su incarico dell'Associazione Storica del Caiatino, nel territorio di Caiazzo, l'antico municipio romano di Caia-

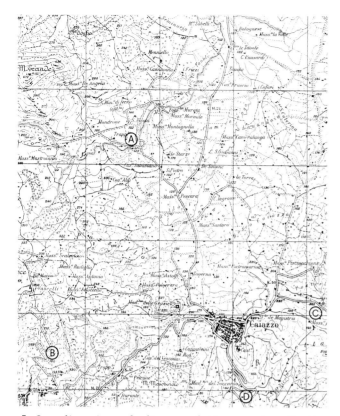

5. *Localizzazione degli acquedotti romani e di altre installazioni idriche nel territorio di Caiazzo (stralcio dalla pianta, in scala 1: 25000, dell'I.G.M., F. 172 I S. E.-Caiazzo): A. Cunicolo di drenaggio in loc. Trappeto; B. Captazione e acquedotto in loc. 'Fontana in Cima'; C. Grande serbatoio in loc. Formale; D. Captazione e acquedotto in loc. 'Fontana Fistola'.*

una spessa incrostazione calcarea, alta 9 cm. Il condotto, la cui datazione precisa rimane incerta, doveva servire ad alimentare le grandi ville, alcune delle quali solo ora individuate, site lungo la valle del Volturno e situate lungo l'importante strada che da Capua conduceva a Caiatia e di lì ad Alife e a Telesia.

Un secondo acquedotto, con funzioni analoghe, convogliava a valle l'acqua di una più piccola sorgente, sita sulle pendici sud-est del monte S. Croce, in località 'Fontana in Cima', nel comune di Piana di Monte Verna (quota 160 m) *(Fig. 5, B)*. Nel 1867 fu rinvenuta sul sito un'importante iscrizione su un piccolo blocco di calcare, di recente riesaminata dal Solin,[10] tuttora conservata presso il luogo di rinvenimento. L'epigrafe (CIL X 8236), probabilmente di età graccana, recita:

> Q. Folvius Q. f. , M. n.
> hance aquam
> indeixit apud
> P. Atilium L. f.
> pr(aetorem) urb(anum).

L'iscrizione, con un accenno ad un'acqua ufficialmente dichiarata presso il pretore urbano, dimostra l'ingerenza dello stesso nella regolamentazione delle acque, che non poteva essere di natura giurisdizionale (avendo i censori la competenza amministrativa). Poco chiaro resta il ruolo di Fulvius, probabilmente un senatore. Credo probabile che questi abbia fatto la denuncia in qualità di proprietario terriero per essere garantito contro possibili usurpazioni di diritti. Meno probabile, mancando la citazione della carica, mi sembra l'ipotesi che egli abbia agito in qualità di *praefectus Capuam Cumas*, o perchè la fonte era proprietà del popolo romano, come pensava il Mommsen.[11]

Tutti e due i personaggi sono ignoti. Q. Fulvius potrebbe essere figlio di Q. Fulvius M. f., console nel 153 a.C., e quindi nipote del famoso generale M. Fulvius, se non figlio di Q. Fulvius M. f., cooptato nel 180 a.C. nel collegio sacerdotale dei *septemviri epulonum*.

Del canale di captazione romano che convogliava verso valle l'acqua di questa sorgente è ben conservato e tuttora utilizzato il primo tratto, scavato nella roccia calcarea e rivestito di calcestruzzo *(Fig. 6)*. Attualmente la portata della fonte è di circa 10/15 lt. al minuto. A Sud-Est della masseria ho potuto osservare un piccolo tratto di acquedotto, descritto nel secolo scorso, che era costituito da coppi curvi legati con calce (largh. 11 cm; alt. 5 cm), protetti da lastre di calcare bianco appositamente sagomate (largh. 35 cm; alt. 20 cm; vi è una risega, larga 15 cm e alta 12 cm).

tia, sito lungo la valle del Volturno a breve distanza dall'antica Capua.

L'acquedotto romano più vicino alla città è quello che convogliava verso valle, in direzione della frazione di Cesarano (toponimo attestato già con sicurezza nel 982, che sembra rispecchiare l'esistenza di una proprietà imperiale) l'acqua di una copiosa sorgente *(Fig. 5, D)*, sita alle radici della collina del castello (l'antica arce), nota col nome di Fontana di Caiazzo o fontana 'Fistola'.[9] Fino agli inizi di questo secolo essa costituiva la principale fonte di approvvigionamento di acqua corrente per gli abitanti della cittadina. Del condotto, in forte pendenza, è visibile presso la masseria D'Agostino un tratto di oltre 300 m. Il canale era sostenuto da un muro in opera cementizia molto compatta, realizzata con schegge di calcare bianco, largo 75/80 cm (altezza visibile 75 cm). Il condotto, a sezione rettangolare, conservato solo nella parte inferiore, è largo 25 cm (21 cm alla base), ed è rivestito di cocciopesto. Cli angoli inferiori sono smussati. Presenta

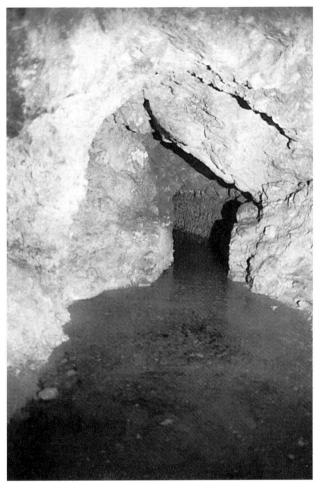

6. *Piana di Monte Verna. Captazione romana in loc. 'Fontana in cima'.*

lungo 22,83 m e largo 4 m, coperto con volta a botte di concreto, diviso in 7 campate sostenute da sei coppie di pilastri appoggiati alle pareti laterali, sui quali poggiano grandi arconi di bipedali. Verso l'esterno si diparte un condotto voltato in calcestruzzo, privo di intonaco idraulico, tompagnato verso l'interno. Nella volta si notano una successiva apertura e un foro per convogliare in una conduttura l'acqua piovana. Sulla parete di fondo, in corrispondenza di una piccola feritoia nel muro, si trova una spessa incrostazione calcarea, segno della presenza, in quel punto, di scorrimento di acqua. Pur essendo la falda d'acqua affiorante, non esiste attualmente una sorgiva. L'edificio funge tuttora da cisterna per l'irrigazione dei terreni sottostanti, per la qual cosa è possibile solo intravedere attraverso l'acqua la parte inferiore della muratura; la pavimentazione è interrata. Saggi di recente effettuati intorno all'edificio hanno confermato che esso è del tutto isolato, e non collegato ad altre strutture romane. Sorprende la mancanza, in una costruzione così accurata e monumentale, di un rivestimento di cocciopesto. Tuttavia non mancano analoghi esempi di opere idrauliche prive di rivestimento di cocciopesto: basti ricordare la grandiosa cisterna, ora oggetto di nuove indagini di scavo, della villa di località S. Vincenzino (Marina di Cecina) in Etruria, che conserva addirittura ancora al loro posto le lastre forate di calcare che servivano a filtrare l'acqua dalle impurità.[13] Il monumento presenta una struttura molto simile a quella di un edificio, sempre in mattoni, di Firmum Picenum,[14] del quale si discute se si tratti di una cisterna o di un *horreum*.
Gli studiosi locali hanno ipotizzato che il monumento

Più a monte e a breve distanza dalla masseria ho rilevato un tratto di muro in opera vittata mista in posizione di crollo, con differente direzione (Sud-Ovest) e, poco oltre, una struttura in opera cementizia. Questi resti potrebbero essere riferibili o ad una villa, o piuttosto a strutture connesse con la regolazione del flusso dell'acqua, forse per una differente diramazione. In ogni caso, esse documentano che lo sfruttamento sistematico della sorgente continuò a lungo, almeno fino alla piena età imperiale. Il condotto si dirigeva verso le sottostanti località di Piana di Monte Verna, di Villanova e di Marano, dove ho individuato resti di grandi ville romane di età repubblicana e dove si trova anche il grande sepolcro, in opera incerta, detto di Aulo Attilio Caiatino.[12]
Un grande e interessante monumento, databile al II secolo d.C., è il 'Formale', posto in posizione dominante (quota 250 m) lungo la strada che conduce alla frazione di S. Giovanni e Paolo, 1 km in linea d'aria dalla città antica (proprietà Sangiovanni) *(Fig. 5, C e Fig. 7)*. Si tratta di un edificio rettangolare in laterizio,

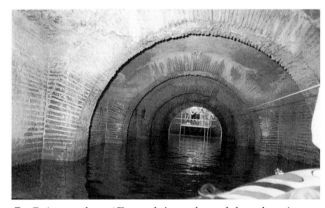

7. *Caiazzo, loc. 'Formale': veduta del serbatoio romano del II secolo d.C.*

fosse il *caput aquarum* del principale acquedotto della città in età romana.[15] Per la quota, tale ricostruzione sarebbe possibile. Tuttavia, la mancanza di una

8. Sessa Aurunca, via Cecasole: tratto di acquedotto romano.

A Sessa Aurunca, subito all'esterno dell'antica cerchia muraria ad Ovest, lungo la via Cecasole, si trova, sezionato, un lungo tratto di acquedotto *(Fig. 8)*, che corre in direzione Nord-Est/Sud-Ovest ed è scavato nel banco di pozzolana. Esso è largo 90 cm e alto 1,9 m, ed è rivestito di cocciopesto, spesso 2 cm, impostato su di un letto di malta spesso 5/6 cm. In una fase successiva, il fondo del condotto fu distrutto per cavare la pozzolana, approfondendo il cunicolo. Sulle pareti è visibile, per un'altezza di 65 cm, l'incrostazione calcarea dovuta al passaggio dell'acqua: dunque essa era particolarmente abbondante, e doveva provenire dalle copiose sorgenti di Roccamonfina, contese nel Medioevo fra Teano e Sessa, dove sono state individuate due notevoli captazioni di età romana in opera reticolata con copertura a volta.[17] Di questo acquedotto, che doveva poi biforcarsi per raggiungere le varie zone della città e del territorio, il De Masi[18] osservò altri due tratti, l'uno in località 'la Gorga' e l'altro presso il villaggio di Tuoro. Il primo tratto era in *opera reticolata* e della stessa larghezza di quello ora individuato, ma di maggiore altezza (2,4 m).

Un altro tratto, sempre in *opera reticolata,* è stato individuato sulla stessa linea di quelli ricordati dal De Masi in località 'Costa Malegrano', a Nord-Est della città antica.[19] Il condotto, scavato nel tufo, è rivestito in *opera reticolata* con ricorsi di mattoni ed è coperto a sezione triangolare. L'acquedotto è probabilmente databile alla prima età imperiale.

Gli acquedotti di cui si è trattato costituiscono un non piccolo arricchimento del quadro delle installazioni idriche romane in Campania e lasciano intravedere quanto ancora si debba fare per ottenere almeno delle prime conclusioni generali esaurienti su questo aspetto così importante dell'ingegneria e della civiltà romane, in una regione che fu uno dei cardini principali in quel periodo storico.

copiosa sorgente mi induce a scartare tale ipotesi e a pensare piuttosto a una grande cisterna connessa all'irrigazione di parte di una grande proprietà, forse lo stesso latifondo imperiale adombrato dal toponimo della frazione di Cesarano, sita proprio allo sbocco della valle dominata dalla località 'Formale'.

Va ricordato anche che l'area urbana di Caiazzo era munita di un grande sistema di serbatoi pubblici, tuttora funzionante, in corso di rilevamento, siti sotto la piazza del Duomo.[16]

BIBLIOGRAFIA

Arthur, P. 1991, Romans in Northen Campania, *Archeological Monographs of the British School at Rome* 1, London.

Bonvicini, P. 1972, *Le cisterne romane di Fermo,* Fermo.

Caiazza, D. 1990, *Roccamonfina. Orto della Regina,* Napoli.

Colucci Pescatori, G. 1991, Evidenze archeologiche in Irpinia, in *La romanisation du Samnium aux IIe et Ier siècle av. JC,* Naples, 85-122.

Colucci Pescatori, G./M.T. Cipriano (a cura di) 1992, *La romanizzazione dell'Irpinia. Il complesso di Fioccaglia di Flumeri,* Flumeri.

Conta Haller, G. 1978, *Ricerche su alcuni centri fortificati in opera poligonale in area campano-sannitica,* Napoli.

De Francesco, G. 1928, Il monumento sepolcrale di Aulo Attilio Caiatino in Piana di Caiazzo, *Annuario del R. Istituto Magistrale di Capua,* 3-6.

De Masi, T. 1761, *Memorie istoriche degli Aurunci,* Napoli.

Di Dario, B. 1941, *Storia della città e diocesi di Caiazzo,* Lanciano.

Faraone, G. 1881, Caiazzo, *NSc,* 170-171.

Fiorelli, G. 1881, Torre del Greco, *Nsc,* 60-61 e 92.

Gaggiotti, M./D. Manconi/L. Mercando/M. Verzar, *Umbria-Marche,* Guide archeologiche Laterza, Bari.

Galasso, M/M. Pagano 1992, L'acquedotto romano di Castelbaronia, *Vicum* X, 3-4, 97-103.

Gangemi, G. 1987, Osservazioni sulla rete viaria antica in Irpinia, in *L'Irpinia nella società meridionale* II, Avellino, 117-122.

Gangemi, G./W. Johannowsky 1992, *Insediamenti e necropoli a Carife e nella Baronia dalla preistoria ai Sanniti,* Avellino.

Johannowsky, W. 1987, Note di archeologia e topografia dell'Irpinia antica, in *L'Irpinia nella società meridionale* II, Avellino, 103-114.

Johannowsky, W. 1991, Insediamento urbano tardoellenistico nella valle dell'Ufita, *PP,* 452-468.

Mommsen, Th. 1881, Inschrift aus Caiatia, *Hermes,* 16, 495-498.

Mongelli, G. 1956, *Abbazia di Montevergine. Regesto delle pergamene,* I, Roma.

Novi, G. 1885, Degli scavi fatti a Torre del Greco dal 1881 al 1883, *AttiAcPontan* 16, 1-36.

Novi, G. 1895, Un pago o vico sepolto tra Ercolano e Pompei, *AttiAcPontan* 25, 1-24.

Novi, G. 1898, Nuove ricerche idrologiche e archeologiche a Torre del Greco, *AttiAcPontan* 28, 1-8.

Pagano, M. 1991, La villa romana di contrada Sora a Torre del Greco, *CronErcol* 21, 149-185.

Pagano, M./F. Russo/F. Terrasi/C. Tuniz 1994, Antropizzazione e attività vulcanica nei siti archeologici di Torre del Greco, *Atti del Seminario internazionale:'Il sistema Uomo-Ambiente tra passato e presente',* Ravello, in corso di stampa.

Poccetti, P. 1981, Documenti oschi e latini da Roccamonfina, *RendNap,* n. s. 56, 183-197.

Scatozza Horicht, L. 1985, Ville nel territorio ercolanese, *CronErcol* 15, 131-165.

Salmon, E. T. 1967, *Samnium and the Samnites,* Cambridge.

Solin, H. 1993, *Le iscrizioni antiche di Trebula, Caiatia e Cubulteria,* Caserta.

Sparano, C. A. 1983, *Cesarano, frazione di Caiazzo,* Napoli.

Valenza, N. 1970, Caiatia, in *Enciclopedia dell'Arte antica, classica e orientale,* Suppl. I, Roma, 171-172.

Valletrisco, A. 1977, Note sulla topografia di Suessa Aurunca, *RendNap,* n. s. 52, 59-73.

NOTE

[1] Novi 1885; 1895; 1898; Fiorelli 1881; Scatozza Horicht 1985; Pagano 1991; Pagano/Russo/Terrasi/Tuniz 1994. Ho potuto inoltre rintracciare il giornale di scavo del 1881.

[2] Galasso/Pagano 1992.

[3] I margini rialzati delle tegole sono spessi 3 cm e alti 5 cm rispetto alla parte piana.

[4] Gangemi/Johannowsky 1992.

[5] Johannowsky 1987; 1991; Gangemi 1987; Colucci Pescatori-Cipriano 1992.

[6] CIL IX 1413; Colucci Pescatori 1991, 119.

[7] Mommsen, in CIL IX, 121; Salmon 1967, 48.

[8] Mongelli 1956, 80, n. 228; Galasso/Pagano 1992, 102.

[9] Sparano 1983.

[10] Faraone 1881, 170-171; Solin 1993, 92-94.

[11] Mommsen 1881.

[12] De Francesco 1928; Valenza 1970; Conta Haller 1978, 12-19.

[13] Lo scavo sistematico di questo complesso archeologico, probabilmente proprietà della grande famiglia senatoria volterrana a cui appartenne Caecina Albinus è in corso a cura del Dipartimento di Archeologia dell'Università di Pisa.

[14] Bonvicini 1972; Gaggiotti/Manconi/Mercando/Verzar 1980, 274-275.

[15] Di Dario 1941, 66-67.

[16] Di Dario 1941, 65-66; Conta Haller 1978, 19, tav. X, H.

[17] De Masi 1761, 186-187 e 262-266; Valletrisco 1977, 71-72.

[18] Poccetti 1981; Caiazza 1990, 22-23.

[19] Arthur 1991, 56 e 120, S 3.

SOPRINTENDENZA ARCHEOLOGICA DI POMPEI
VIA PROVINCIALE DI PORTA MARINA
I-80041 POMPEI
ITALIA

Standard und Luxus in römischen Bädern - Überlegungen aus der Sicht der Hydrotechnik[*]

Hubertus Manderscheid

in memoriam Heinrich Bauer (1935-1993)

Der Unterschied zwischen römischen öffentlichen Bädern wie den Terme del Foro in Pompei und den Terme di Caracalla in Rom oder zwischen den Terme Suburbane in Herculaneum und den Barbarathermen in Trier ist ein mehrfacher. Die evidenten Differenzen liegen in Zeitstellung und Typologie, in Architektur und Ausstattung, in der Grundfläche und damit in der möglichen Zahl der Benutzer. Darüber hinaus und nicht zuletzt gibt es aber auch Unterschiede in der Wasserbewirtschaftung.[1]

Anlagen wie die Terme del Foro in Pompei sind in ihrer Frühphase aus Tiefbrunnen bzw. Regenwasserzisternen versorgt worden. Beide Systeme haben evidente Nachteile: muß beim Tiefbrunnen das täglich in etwa gleichbleibender Menge zur Verfügung zu stellende Wasservolumen mühsam mit Tier- oder Menschenkraft gehoben werden, so sieht es beim Rückgriff auf Regenwasservorräte noch schlechter aus: nur solange Wasser im Vorratsbehälter vorhanden ist, kann der Betrieb aufrecht erhalten werden. Der Bau von Fernwasserleitungen und der Anschluß der innerstädtischen Wassernutzer an diese bezeichnet einen tiefgreifenden Wandel, eben auch für das Badewesen: nicht nur, daß jetzt, sozusagen automatisch, immer die gleichbleibende Menge Wassers zur Verfügung steht, es ist häufig auch qualitätvoller und − vor allen Dingen − handelt es sich um ein Vielfaches des vorher vorhandenen Volumens; dabei fällt das mühevolle Heben bzw. Schöpfen per Handarbeit, vorher ein Tag für Tag sich wiederholender Vorgang, ersatzlos weg. Diese Entwicklung hat, zeitlich versetzt, d.h. hier früher, dort später, nicht zu übersehende Folgen für das römische Badewesen gehabt:
- Ohne weiteres kann für viele Zwecke jetzt Fließwasser benutzt werden, insbesondere für die Kaltbadebecken.
- Die Grundfläche der Bäder und mit ihr die Beckenvolumina können gesteigert werden, so daß größere und besser ausgestattete Thermen zur Verfügung stehen.
- Von einer gewissen Zeit an, wohl spätestens der flavischen Epoche, ist ein Standard im Bäderbau

erreicht, der sich in den Bauten des gesamten Römischen Reiches widerspiegelt; dieser Standard betrifft außer Architektur und Ausstattung auch die Technik, und hier eben auch die Wasserbewirtschaftung.

In aller Deutlichkeit zeigt sich dabei die enge Verflechtung zwischen der Architektur der Thermen und ihrer Wasserbewirtschaftung; denn alle hydrotechnischen Einrichtungen müssen bei Bauplanung und Bauausführung stets berücksichtigt werden, so auch bei den Unkosten (Material- und Arbeitskosten für Bau, Thermentechnik und Ausstattung).

In der Vesuvregion sind die Konsequenzen aus dem Bau der Fernwasserleitung[2] für die Bäder in mehrfacher Hinsicht erkenn- und meßbar: zunächst bei den bestehenden Thermen, bei denen jetzt unter anderem regelrechte Frigidarien mit Fließwasserzufuhr eingerichtet werden; bei den Terme Stabiane wird darüber hinaus zusätzlich eine Freiluftnatatio errichtet, auch sie sicherlich mit Fließwasser beschickt. Bei den Bädern, die erst nach dem Anschluß der Stadt an die Fernwasserleitung gebaut werden, sind die neuen Errungenschaften gleich mit in den Bau einbezogen worden; dies zeigt, daß sie offenbar schon zum Standard gehört haben: sowohl die Terme Centrali als auch die Terme Suburbane in Pompei[3] haben großdimensionierte Frigidariumspiscinen, in die Fließwasser in dekorativ verbrämter Weise geströmt ist; die Terme Centrali weisen zusätzlich eine hypäthrale *natatio* auf.

Eine *natatio,* also das Schwimmbecken, das meist unter freiem Himmel den eigentlichen Badesälen vorgelagert ist, ist in römischen Bädern zwar nicht immer, aber doch so häufig vorhanden, daß sie zum Standard gerechnet werden kann. Außer den Beispielen in den pompejanischen Thermen und dem in den Terme di Caracalla in der Hauptstadt sei hier nur noch dasjenige in den Hadrianic Baths in Leptis Magna genannt.[4] In vielen Fällen erfolgte die Fließwassernutzung dieser Becken im dekorativen Kontext von Statuen.

Außer den Frigidariumspiscinen und der *natatio* ist eine Reihe weiterer Abnehmer mit Wasser zu versorgen, allen voran das (oder die) Warmwasserbecken. Die dafür geschaffenen Kesselanlagen passen sich der Entwicklung der Badebecken an, so daß es dann von der Technik her gesehen keine Rolle mehr spielt, ob eine Wanne bzw. *piscina* 2 oder 25 m³ Volumen hat. Der entsprechende heiz- und wassertechnische Mehraufwand muß lediglich bei den Unterhaltskosten Berücksichtigung finden. Die weiteren Wassernutzer, also das *labrum* im *caldarium* und gelegentlich auch in anderen Baderäumen, Trinkwasserbrunnen, Waschbecken und Fließwasserrinnen in den Aborten, Zierbrunnen und weiteres mehr sollen hier nur erwähnt werden.[5] Die wasserwirtschaftliche Standardeinrichtung einer römischen Thermenanlage – in der Vesuvregion wie außerhalb von ihr – ist damit beschrieben.

Gelegentlich gibt es Wassernutzer in den Bädern, die mit diesem Standard nichts mehr zu tun haben. Zunächst einmal sind hier die Wasserspiele zu nennen, die in Architektur und Ausstattung nicht selten an Nymphäen erinnern. Teilweise stehen sie in Zusammenhang mit Badepiscinen, wie es etwa bei der *natatio* der Terme di Caracalla der Fall ist, teils sind sie ohne diesen Kontext, wie z.B. bei den Terme di Traiano in Rom, d.h. sie erfüllen keinen praktischen Zweck, sondern haben nur eine dekorative Aufgabe. In mehr als einer Hinsicht stellen diese Wasserspiele einen Aufwand und damit einen Kostenfaktor für den Bauherrn (und dann auch für den Betreiber) der betreffenden Badeanlage dar: einmal bezüglich der Architektur und der Ausstattung, zum anderen im Hinblick auf die Wasserbewirtschaftung. Bei letzterer sind wiederum zwei Aspekte zu berücksichtigen: einmal der Bau (und die Instandhaltung) von Zu- und Ableitungssystem, zum anderen das Verbrauchsvolumen, das ja von vornherein, d.h. schon beim Bau der hydrotechnischen Anlagen, in die Kalkulation des täglichen Bedarfs einbezogen worden sein muß. In der Vesuvregion bieten insbesondere die Terme Suburbane in Pompei ein Wasserspiel, das in Relation zum Gesamtbau kaum weniger bescheiden ist als dasjenige in einer der hauptstädtischen Monumentalthermen.[6]

Die Standardeinrichtung der *natatio* hat gelegentlich eine Steigerung erfahren, die sich in den sogenannten *piscinae calidae* manifestiert. Dabei handelt es sich um beheizte, d.h. mit Hypokaustierung und Wandtubulierung versehene Säle, die in der Regel etwas abseits der kanonischen Baderäume *frigidarium – tepidarium – caldarium* gelegen sind. Sie werden fast ganz von Piscinen eingenommen, die in ihren Maßen durchaus Freiluftnatationes vergleichbar sind. Durch das Faktum der Beheizung von Raum und Badebecken unterscheiden sie sich jedoch grundsätzlich von jenen. Ihre 'Erfindung' respektive Einführung in die Bäderarchitektur wird Maecenas zugeschrieben;[7] auch bei anderen Schriftstellern wird eine *piscina calida* erwähnt, ohne daß sich aber aus den Quellen Details entnehmen ließen. Die Typologie dieser Becken ist wohl von den Piscinen der Thermalbäder abgeleitet; dort sind großflächige Badebecken, die häufig (fast) den ganzen Saal einnehmen, die Regel, mit dem fundamentalen Unterschied, daß eine künstliche Beheizung von Raum und *piscina* aufgrund der natürlichen Wassertemperatur nicht erforderlich gewesen ist.[8] Der finanzielle Aufwand für Bau und Betrieb der *piscinae calidae* liegt – außer in der Einrichtung eines gesonderten Saales großer Dimensionen mit der entsprechenden dekorativen Ausstattung und der Errichtung von Hypokausten und Wandtubulatur samt gesondertem *praefurnium* – insbesondere bei den zusätzlich zu denjenigen der konventionellen Badesäle erforderlichen Heizkosten und bei einem dem Beckeninhalt gemäßen großen Wasservolumen, für das natürlich eine entsprechend leistungsfähige Versorgung (Rohrleitung) wie auch Entsorgung (Kanalisation) zu planen und zu schaffen war. Als Beispiele seien hier lediglich die *piscinae calidae* in der Kaiservilla von Sabaudia sowie in den Barbarathermen in Trier genannt;[9] im letzteren Fall sind es sogar zwei Piscinen, die außerdem zu den größten bisher bekannten Badebecken dieser Sonderform gehören. Man kann sich, gerade im Falle der Trierer Thermen, gut vorstellen, wie groß der zusätzliche Aufwand an Bau- und Heizkosten sowie derjenige an Wasservolumen gewesen sein muß. Die geringe Zahl der *piscinae calidae* in den Thermen des Römischen Reiches – sei es in öffentlichen wie in Privatbädern – macht deutlich, daß es sich dabei nicht um eine Standardeinrichtung gehandelt hat. Vielmehr müssen sie als Ausnahmeerscheinung angesehen werden, die nur im Falle 'betuchterer' Bauherren als besonderer Luxus in eine Badeanlage eingebaut worden sind.

Auch die Einrichtung der *piscina calida* hat dann noch eine Steigerung erfahren. Es handelt sich um Badebecken, die nur in einem heiztechnischen Detail von den 'normalen' *piscinae calidae* divergieren; dieses Detail ist jedoch von entscheidender Bedeutung: in der Beckenmitte ist ein oben offener Metallbehälter in den Boden eingelassen, der für den *fornacator* durch einen unter der *piscina* bis an den Rand des Behälterbodens führenden Bedienungsgang zugänglich war. Durch diesen konnte er bis an ihn herangelangen,

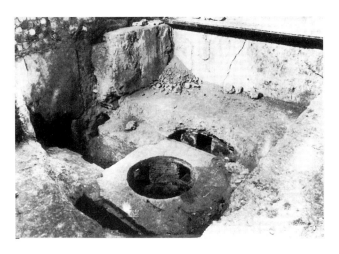

1. Stabiae, Villa di San Marco: piscina calida mit 'Samowar' (Camardo et al. 1989, 55 Abb. 54).

um unter ihm das Feuer anzuzünden, Brennmaterial nachzulegen und zu kontrollieren, ob der Verbrennungsvorgang ordnungsgemäß ablief. Der Metallbehälter, von U. Pappalardo 'Samowar' getauft,[10] liegt auf einer außen quadratischen, innen runden Fundamentierung auf, wurde wahrscheinlich aber zusätzlich von Eisenträgern gestützt.[11] In der Aufmauerung sind mehrere Öffnungen, durch welche die Heizgase unter den gesamten Bereich der *piscina* und weiter unter den ebenfalls hypokaustierten Piscinenumgang gelangen konnten. Drei Beispiele aus der Vesuvregion sind erhalten, welche diese Konstruktions- und Funktionsweise belegen: in den Terme Suburbane in Herculaneum, das gleichzeitig das am vollständigsten erhaltene, wenn auch noch nicht komplett freigelegte Beispiel ist, in den gleichnamigen Thermen in Pompei sowie in der Villa di San Marco in Stabiae *(Abb. 1)*.[12]

Wie die 'einfache' *piscina calida* sich von der hypäthralen, mit Kaltwasser beschickten *natatio* abhebt, so auch die 'Samowar'-*piscina* von der 'normalen' *piscina calida;* auch hier ist die Steigerung in Bau- und Unterhaltskosten wiederum beachtenswert. Zusätzlich zum hypokaustierten und tubulierten Badesaal muß das Fundament für den Metallbehälter in der Beckenmitte errichtet werden, zusammen mit dem Heizgang unter der *piscina* bis an den 'Samowar' heran;[13] außerdem sind die Kosten für Konstruktion und Anbringung des Metallbehälters selbst zu berücksichtigen. Da die Stelle, an der Metall und hydraulischer Mörtel aneinanderstoßen, besonders empfindlich ist, muß hier – genau wie bei den *testudines*[14] – eine Impermeabilisierung angebracht werden; sie besteht – wie bei jenen – in einer dünnen Bleiplatte, die in den Beckenestrich ein-

gelassen und mit dem Rand des Metallbehälters verlötet ist.[15] Darüber hinaus sind die Heizkosten höher, und der Aufwand hinsichtlich der Wasserversorgung steigert sich dann, wenn – wie zumindest bei den Terme Suburbane in Herculaneum und denjenigen in Pompei zu vermuten ist – die betreffenden Piscinen mit Fließwasser versorgt worden sind.[16]

Außer den drei genannten Befunden in der Vesuvregion gibt es zwei gesicherte *piscinae calidae* mit 'Samowar' auf italischem Boden: zum einen in den Terme Marittime in Ostia, zum anderen in den Thermen von Massaciuccoli (bei Lucca) *(Abb. 2)*.[17] Weist der Befund von Massaciuccoli keine Besonderheiten gegenüber den 'Samowar'-Piscinen der Vesuvregion auf, so ist im Falle der Terme Marittime in Ostia auffällig, daß der Metallbehälter nicht in der Beckenmitte, sondern näher zum *praefurnium* hin angebracht ist. Von ingenieurwissenschaftlicher Seite wäre zu prüfen, inwieweit dies zu Temperaturunterschieden des Wassers im Badebecken geführt haben kann; eventuell niedrigere Temperaturen glichen sich vermutlich aber dadurch aus, daß hier ein großdimensionierter Kessel für eine zusätzliche Warmwasserversorgung sicher vorhanden gewesen ist.[18] Während im Falle der Terme Suburbane in Pompei zu vermuten ist, daß die in einer Umbauphase modifizierte Kessel-

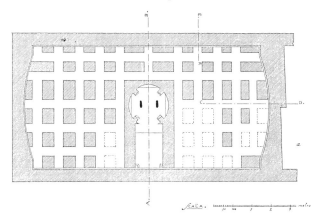

2. Massaciuccoli, Thermen: piscina calida mit 'Samowar' (Minto 1921, Taf. 4, Ausschnitt).

anlage auch der Versorgung der 'Samowar'-*Piscina* gedient hat, macht in Ostia die Position des Kessels klar, daß er einzig und allein für dieses Becken bestimmt gewesen ist – mithin ein nochmals beträchtlich höherer Aufwand, nämlich im Hinblick auf die Errichtung und den Unterhalt des Kessels, dessen Feuerung und des Wasserversorgungssystems.

Diesen fünf gesicherten 'Samowar'-Piscinen sollen hier vier weitere, bisher nur hypothetisch bestimmbare angeschlossen werden. Zwei von ihnen befinden sich auf dem Boden Italiens; zum einen in der Villa von Saturo (bei Taranto), zum anderen in Bocca di Magra (bei La Spezia).[19] Im ersteren Fall ist der Boden der (fast) den ganzen Raum einnehmenden, hypokaustierten *piscina* komplett erhalten; er weist etwa in der Mitte eine kreisrunde Öffnung auf, die den Verdacht auf den ehemals hier vorhandenen Metallbehälter nahelegt. Im Falle von Bocca di Magra handelt es sich anscheinend ebenfalls um eine hypokaustierte 'Ganzraumpiscina' mit einer kreisrunden Öffnung in der Mitte des Beckenbodens und (teilweise erhaltenem) darauf zuführendem Heizgang.

Die beiden weiteren hypothetischen Befunde liegen außerhalb des italischen Kernlandes, einmal in Spanien (Italica, 'Los Palacios'), zum anderen in Frankreich (Izernore). Anscheinend sind auch sie bisher nie in dieser Richtung gedeutet bzw. überhaupt beachtet worden. In beiden Fällen gibt jedoch der Grundriß bereits einen ersten Hinweis auf eine mögliche Interpretation in diesem Sinn.[20] Im Falle der *piscina calida* der Thermen 'Los Palacios' in Italica hat dann eine Autopsie im Jahre 1993 die Wahrscheinlichkeit steigen lassen, daß die Vermutung richtig gewesen ist.

Der in den Grundriß eingetragene Doppelkreis in der Beckenmitte ist eine Vertiefung, die mit dem im Norden des Beckens liegenden Bedienungsbereich durch einen gerade auf sie zulaufenden 'Graben' – vermutlich der ehemals unter dem Piscinenboden bis an den Rand des 'Samowars' heranführende Bedienungsgang – verbunden ist.[21] Der Grundriß der Thermen in Izernore (Dép. Ain) zeigt im Norden einen Raum P-R, auf den von Norden her ein schmaler Gang S zuläuft. In der Mitte liegt eine *piscina* R, die fast den ganzen Raum einnimmt; an ihrem nördlichen Rand ist eine kreisförmige Konstruktion T in sie eingelassen, die anscheinend mit dem erwähnten Gang S in Verbindung steht. Ohne nähere Untersuchung des offenbar gänzlich unpublizierten Befundes kann zwar noch keinerlei Sicherheit bezüglich einer Deutung als 'Samowar' erzielt werden, doch sei immerhin auf die Ähnlichkeit mit demjenigen in den Terme Marittime

in Ostia hingewiesen, bei dem der 'Samowar' ja auch nicht in der Piscinenmitte, sondern näher zum Beckenrand liegt.

Es scheint, daß die auf der Basis des äußerst beschränkten Denkmälerbestandes beruhende ursprüngliche Vermutung, die 'Samowar'-Piscinen seien in verschwindend wenigen Exemplaren, nur im italischen Kernland, verbreitet gewesen, jetzt revidiert werden muß; dabei bleibt natürlich abzuwarten, ob sich die diversen Vermutungen bei näherer Untersuchung verifizieren lassen.[22] Dennoch kann man auch schon beim gegenwärtigen Kenntnisstand eines feststellen: in stärkerem Maße noch als die 'normalen' *piscinae calidae,* die im Bestand der – öffentlichen wie privaten – Bäder schon nicht gerade häufig anzutreffen sind, müssen die 'Samowar'-Piscinen als Luxuseinrichtung betrachtet werden. Jene beinhalten insofern schon ein gewisses Maß an Badeluxus als bei ihnen statt der hypäthralen *natatio* ein in einem geschlossenen Saal gelegenes, beheiztes (beheizbares[23]) 'Schwimm'-Becken vorhanden ist; bei ihnen wurden der Raum und das Wasser in der *piscina* jedoch lediglich mittels Hypokaustenheizung erwärmt, was kaum zu mehr als (gemäßigter Raum- und) lauwarmer Wassertemperatur geführt haben kann. Demgegenüber war die direkte Beheizung der *piscina* durch den Metallbehälter in der Beckenmitte – oder nahe davon – sicherlich weit effektiver; mit ihm muß ein wesentlich höherer Wärmegrad des Wassers erzielt worden sein.

Die Normalform der Wasserzufuhr in Caldariumspiscinen ist die aus der Kesselanlage. Darüber hinaus haben sehr viele Caldariumsbecken eine *testudo;* diese dient der Erhaltung der Wassertemperatur auf gleichem Niveau während des Badetages und ist so angebracht, daß ihre direkte Unterfeuerung vom *praefurnium* her gewährleistet wird.[24] Bei der Größe der 'Samowar'-Piscinen kann man sich vorstellen, daß das System der *testudo* für eine effiziente Warmhaltung des Wassers nicht ausgereicht hätte. Offenbar kam es infolgedessen zur Erfindung des neuartigen Metallbehälters, der – in der Beckenmitte angebracht – seiner Aufgabe gerecht werden konnte.[25]

Ausgehend hiervon kann man sich nun fragen, wo wohl die Erfindung des 'Samowars' zu lokalisieren sein könnte. Trotz des bisher recht spärlichen Materials fällt auf, daß die Vesuvregion mit drei (gesicherten) Beispielen (gegenüber nur sechs weiteren – gesicherten bzw. vermuteten – Befunden im übrigen Römischen Reich) an der Spitze der 'Statistik' steht. Darüber hinaus hat es den Anschein, als ob die dorti-

gen Befunde auch die frühesten seien. Trifft dies zu, dann wäre von dort aus eine Ausbreitung zunächst im italischen Kernland und dann auch in die Provinzen vorzustellen, wobei möglicherweise ein und dieselbe Spezialwerkstatt für eine Reihe von 'Samowar'-Anlagen anzunehmen ist. Beim jetzigen Kenntnisstand kann dies lediglich eine Arbeitshypothese sein, die von den weiteren Untersuchungen erst noch Bestätigung erfahren muß. Es sei jedoch gestattet, noch darauf hinzuweisen, daß die Vesuvregion schon bei der Erfindung der Hypokaustenheizung[26] (und vielleicht auch bei derjenigen der Kesselanlage für die Bäder) eine entscheidende Rolle gespielt hat.

Die Einrichtung der 'Samowar'-*piscina* ist sowohl in öffentlichen wie in privaten Bädern vertreten. Unter ersteren stechen zwei hervor: die Terme Suburbane in Herculaneum und die Terme Suburbane in Pompei. Beide zeichnen sich dadurch aus, daß sie am Stadt-rand gelegene, kleindimensionierte, aber gut ausgestattete und reich dekorierte Badeanlagen darstellen.[27] Deswegen möchte man davon ausgehen, daß sie von privaten Bauherren errichtet worden sind; diese selbst oder aber Pächter haben sie betrieben. Neben dem imposanten Wasserspiel im Kontext der Frigidariums-*piscina* (in den Terme Suburbane in Pompei) zeigen vor allen Dingen die 'Samowar'-Piscinen, daß diese Bauherren ihren Klienten etwas Besonderes bieten wollten und die notwendigen Kosten für Bau und Unterhalt nicht gescheut haben. Nun macht aber gerade ihre geringe Größe klar, daß diese Bäder für den Massenbetrieb ganz und gar nicht geeignet gewesen sind; vielmehr ist es wahrscheinlich, daß es eine Einschränkung des Zuganges gegeben hat. Diese könnte am ehesten mittels eines 'gepfefferten' Eintrittsgeldes erfolgt sein – auch das Nonplusultra des römischen Badeluxus' hatte wohl seinen Preis.[28]

BIBLIOGRAPHIE

Bargellini, P. 1991, Le Terme Centrali di Pompei, in *Les thermes romains, Actes de la Table Ronde,* Rome 1988, Collection de l'Ecole Française de Rome, 142, Roma, 115-128.

Bartoccini, R. 1929, *Le Terme di Lepcis (Leptis Magna),* Bergamo, Africa Italiana, Monografie, 4.

Camardo, D./A. Ferrara/N. Longobardi, 1989, *Stabiae: le ville,* Castellamare di Stabia.

Carcopino, J. 1977, *Rom. Leben und Kultur in der Kaiserzeit.* Neu herausgegeben von E. Pack, Stuttgart.

Chanel, E. 1913, Fouilles d'Izernore, *BAParis,* 183-192.

Ciampoltrini, G. 1994, Gli ozi dei Venulei. Considerazioni sulle 'Terme' di Massaciuccoli, *Prospettiva* 73-74, 119-130.

Dell'Aglio, A. 1992, Scavi e scoperte. Leporano (Taranto), Saturo, *Taras* 12, 340.

De Meis, A.M. 1986, Una villa di età imperiale nel suburbio dell'antica Antium, *BCom* 91, 45-48.

Fabbricotti, E. 1976, I bagni nelle prime ville romane, *CronPomp* 2, 29-111.

Frova, A. 1976, Bocca di Magra, in *Archeologia in Liguria. Scavi e scoperte 1967-75,* 55-58.

Garbrecht, G./H. Manderscheid 1994, Die Wasserbewirtschaftung römischer Thermen. Archäologische und hydrotechnische Untersuchungen, *MInstWasser* 118 A-C.

Jacobelli, L. 1993, Die Suburbanen Thermen in Pompei. Architektur, Raumfunktion und Ausstattung, *AKorrBl* 23, 327-335.

Lattanzi, E. 1973, La villa romana di Porto Saturo presso Taranto, *Cenacolo* 1-3, 43-52.

Manderscheid, H. 1993, Bemerkungen zur Wasserbewirtschaftung der Suburbanen Thermen in Pompei, *AKorrBl* 23, 337-346.

Manderscheid, H. 1994, Aspetti della gestione idrica delle terme nella regione vesuviana (Vortragsresümee), in *Actas XIV Congreso Internacional de Arqueología Clásica, Tarragona 1993,* 2, Tarragona, 253-254.

Manderscheid, H. 1995, Hydrotechnik und Heizsystem der Terme Suburbane in Herculaneum, *AW* (im Druck).

Mazzoni, A. 1959, Saggio di scavo sui resti dell'edificio romano in Bocca di Magra, *GiornStorLun* 10, 80-83.

Minto, A. 1921, Le terme romane di Massaciuccoli, *MonAnt* 27, 405-448.

Nielsen, I. 1993, *Thermae et balnea. The Architecture and Cultural History of Roman Public Baths,* Aarhus[2], I. II.

Pappalardo, U. 1995, Die Terme Suburbane in Herculaneum, *AW* (im Druck).

Zanker, P. 1987, Pompeji. Stadtbilder als Spiegel von Gesellschaft und Herrschaftsform, *TrWPr* 9, 1-46.

ANMERKUNGEN

* Für die Aufnahme des Beitrages, der als Vortrag auf dem Symposium nicht gehalten werden konnte, in die Akten sei den Veranstalterinnen bestens gedankt. Die ursprüngliche Vortragsform ist teilweise verändert worden; die Anmerkungen beschränken sich auf das Notwendigste. Die Freilegung des Befundes in der *piscina calida* der Terme Suburbane in Pompei im Sommer 1993 durch den Verfasser war der Anstoß zu einer näheren Auseinandersetzung mit diesem speziellen Aspekt des römischen Badewesens. Frühere Überlegungen zum Thema kamen bereits im Rahmen eines Vortrages auf

dem XIV Congreso Internacional de Arqueología Clásica, Tarragona 1993, zur Sprache (vgl. Manderscheid 1994).

Für finanzielle Förderung der Arbeiten in Pompei und Herculaneum in den Jahren 1992 und 1993 sei der Fritz Thyssen Stiftung (Köln), für vielfältige Unterstützung V.M. Strocka (Freiburg), B. Conticello (Pompei), A. d'Ambrosio (Pompei), L. Jacobelli (Neapel) und U. Pappalardo (Neapel) bestens gedankt. Das Thema wird im Rahmen der Gesamtpublikation der Terme Suburbane in Pompei ausführlicher behandelt werden (in Bearbeitung).

[1] Zu Wasserbewirtschaftung römischer Thermen vgl. allgemein Garbrecht/Manderscheid 1994.

[2] Vgl. zuletzt Zanker 1987, 34ff. Vgl. allgemein Garbrecht/Manderscheid 1994, Bd. A, 158 (Lit.).

[3] Terme Centrali: Bargellini 1991, 115ff.; für die Vermutung (117), das *frigidarium* habe auch als *apodyterium* gedient, gibt es keinen Hinweis. Terme Suburbane: Jacobelli 1993, 330; Manderscheid 1993, 337, 339, 343.

[4] Zur *natatio* der Terme di Caracalla vgl. Garbrecht/-Manderscheid 1994, Bd. A, 115f., 118f., 126ff. (Lit.), zu derjenigen der Hadrianic Baths in Leptis Magna Bartoccini 1929, 31ff. Vgl. allgemein zur *natatio:* Nielsen 1993, I. 71ff., 82ff., 88ff., 106f., 109ff., 139, 154f.; Garbrecht/Manderscheid 1994, Bd. A, 21f., 71f.

[5] Vgl. dazu allgemein Garbrecht/Manderscheid 1994.

[6] Pompei: Jacobelli 1993, 330; Manderscheid 1993, 337, 339, 343; Abb. 1 und 3. Rom: Garbrecht/Manderscheid 1994, Bd. A, 55 ff., 112ff.

[7] Cassius Dio 55.7,6. Vgl. Nielsen 1993, I. 48, 156.

[8] Nielsen 1993, I. 48; Garbrecht/Manderscheid 1994, Bd. A, 46.

[9] Zu Sabaudia und Trier vgl. Garbrecht/Manderscheid 1994, Bd. A, 45f.; Bd B, Kat. C 23, D 182. Weitere Beispiele: Nielsen 1993, I. 46, 48f., 51, 71f., 84; Garbrecht/Manderscheid a.O. 44ff.; Kat. A 19, C 34, D 38, D 76, D 77, D 189.

[10] Vgl. Pappalardo 1995.

[11] Vgl. den Rest eines derartigen Trägers im Bereich des 'Samowars' in Ostia, Terme Marittime (Garbrecht/Manderscheid 1994, Bd. B, Kat. B 35).

[12] Herculaneum: Pappalardo 1995; Manderscheid 1995. Pompei: Unpubliziert; vgl. vorläufig Manderscheid 1993, 342, 346. Stabiae: Unpubliziert; vgl. vorläufig Fabbricotti 1976, 98f. mit Abb. 43a-c; Camardo/Ferrara/Longobardi 1989, 45, 55 Abb. 54.

[13] In zwei Fällen (Pompei; Stabiae) sind diese Heizgänge – ganz offensichtlich aus Platzgründen – sehr lang (sie führen unter dem Thermenhof bzw. unter einem benachbarten Baderaum hindurch) und haben dadurch zusätzliche Baukosten verursacht.

[14] Zur Impermeabilisierung der Nahtstelle zwischen *testudo* und hydraulischem Mörtel vgl. Garbrecht/Manderscheid 1994, Bd. A, 40 ff.

[15] Reste einer derartigen Bleiplatte haben sich in der 'Samowar'-*piscina* der Terme Suburbane in Herculaneum (unpubliziert; vgl. Manderscheid 1995), in derjenigen der gleichnamigen Thermen in Pompei (unpubliziert) sowie derjenigen der Thermen in Massaciuccoli (Garbrecht/Manderscheid 1994, Bd. A, 42; Bd. B, Kat. C 9) erhalten.

[16] In Pompei weist darauf das Faktum hin, daß die dortige 'Samowar'-*piscina* einen Überlauf besitzt (unpubliziert). Zu Herculaneum vgl. Manderscheid 1995.

[17] Ostia: Garbrecht/Manderscheid 1994, Bd. A, 47f.; Bd. B, Kat. B 35. Massaciuccoli: ebda. 47f.; Kat. C 9. Die Hypothese von Ciampoltrini 1994, 119ff. bes. 125ff. zu letzterem Befund ist unbegründet.

[18] Vgl. Garbrecht/Manderscheid 1994, Bd. A, 4; Bd. B, Kat. B 34-35.

[19] Saturo: Für den Hinweis auf diesen so gut wie unpublizierten Befund sei M. Pagano (Ercolano) bestens gedankt. Vgl. bisher Lattanzi 1973, 45 (mit Erwähnung der "grande apertura circolare ..." und der Vermutung eines "riscaldamento diretto, forse per mezzo di un recipiente cilindrico di bronzo, detto *testudo alvei* ..."); Grundriß: Abb. S. 49; Photo: Dell'Aglio 1992, Taf. 135,1. Bocca di Magra: Mazzoni 1959, 80ff. (ohne Erwähnung der entsprechenden Strukturen, die aber im Grundriß [80 Abb. 1] und im Photo [82 Abb. 3] zu erkennen sind). Frova 1976, 55f. (56 die Vermutung, die Befeuerung sei mittels eines "forno ... a cupola" erfolgt; dieser stehe mit einem "cunicolo ... verso nord-est" in Verbindung); Grundriß: 55 Abb. 70.

[20] Italica: vgl. zuletzt Nielsen 1993, II. 119 Abb. 112. Izernore: vgl. Chanel 1913, Abb. S. 185. Vgl. zu beiden Befunden die Vermutung bei Garbrecht/Manderscheid 1994, Bd. A, Anm. 232; s.a. Bd. B, Kat. D 76.

[21] Wegen starken Bewuchses und insbesondere wegen Grundwassers waren weitere Erkenntnisse bei dieser ersten Autopsie nicht zu gewinnen; eine nähere Untersuchung ist für 1996 geplant.

[22] Schon jetzt kann jedoch eine Hypothese aus der Diskussion ausgeschlossen werden, diejenige J. Carcopinos nämlich (vom Autor nicht als solche gekennzeichnet, sondern als Faktum hingestellt), in der Mitte des *caldarium* der Terme di Caracalla habe sich "ein gewaltiges Bronzebecken" befunden, "dessen Wasser vom unmittelbar darunter befindlichen Hauptofen der *hypocausis* auf der erforderlichen Temperatur gehalten wurde" (Carcopino 1977, 353 [vgl. auch die Erstausgabe: La vie quotidienne à Rome à l'apogée de l'Empire (Paris 1939) 297]). Zur Frage der 'Zentralpiscina' im *caldarium* der Terme di Caracalla vgl. zuletzt Garbrecht/Manderscheid 1994, Bd. A, 115 mit Anm. 526. Es ist immerhin bemerkenswert, daß es sich bei Carcopinos Hypothese offenbar um die älteste Annahme des 'Samowar'-Prinzips überhaupt handelt; es wäre interessant zu wissen, was den Autor dazu gebracht hat.

[23] Trotz der Bestimmung sowohl der *piscinae calidae* als auch der 'Samowar'-Piscinen als beheizte Bade- bzw. 'Schwimm'-Becken darf man wohl nicht ganz ausschließen, daß je nach Jahreszeit – oder, bei privaten Anlagen wie der Villa di San Marco, auf individuellen Wunsch hin – die Beheizung reduziert oder gar ganz unterlassen worden ist.

[24] Zur Kesselanlage vgl. Garbrecht/Manderscheid 1994, Bd. A, 26ff., 33 ff.; zur *testudo* ebda 37ff.

[25] Man könnte den 'Samowar' auch 'Zentraltestudo' nennen; dieser Begriff entspräche zwar der Position und der Funktion des Metallbehälters in der Piscinenmitte, würde aber seiner Form nicht gerecht, da der Begriff der *testudo* mit dem halbzylinderförmigen Bronzebehälter verbunden ist.

[26] Vgl. zuletzt Nielsen 1993, I. 20ff. (mit älterer Lit.).

[27] Zu den Terme Suburbane in Herculaneum vgl. zuletzt Pappalardo 1995, zu den Terme Suburbane in Pompei Jacobelli 1993, 327ff.

[28] Nach Abschluß des Manuskriptes sind zwei weitere vermutliche 'Samoware' hinzugekommen, einmal in einer aufgelassenen, überbauten *piscina* auf dem Palatin in Rom (für den Hinweis darauf und für die Möglichkeit zur Autopsie sei H. Broise [Rom] bestens gedankt), zum anderen in einer Villa in Anzio (vgl. vorläufig die kurze Fundbeschreibung von De Meis 1986, 47; 45 Abb. 1 [Plan]; 47 Abb. 4 [Photo]). Darüber hinaus hat die Autopsie des Befundes in Saturo (September 1995) ergeben, daß es sich wirklich um einen 'Samowar' handelt.

c/o Deutsches Archäologisches Institut Rom
Via Sardegna, 79
I-00187 Roma
Italien

Piscina Mirabilis in Campania, Italy, and Sepphoris, Israel: Comparison between Two Large, Ancient Reservoirs

Tsvika Tsuk

INTRODUCTION

This article compares the characteristics of two reservoirs built during the Roman period, but separated by a distance of more than 2,200 km on the ground. Both are prime examples of the technological skills, engineering capabilities and hydrological erudition which were developed in Imperial Rome. Today, both sites are foci of tourism – monumental testimonials to the wisdom of the ancient world.

The two reservoirs were built at the end of lengthy water systems, just a few hundred meters from their final destinations. Their functions – storing water and regulating its flow to the target area – were marked by shared technological attributes, some of which were so similar as to be nearly identical, and others serving the same purposes, but markedly different in design and construction. This article examines these characteristics, comparing the hydraulic engineering of the two reservoirs' storage and regulation functions.

1. PISCINA MIRABILIS

In the village of Bacoli, situated on the western side of the Bay of Pozzuoli, the Romans dug a huge water

reservoir on the upper part of the hill. The reservoir acquired the appellation Piscina Mirabilis, which means 'The Wondrous Pool' *(Fig. 1)*.

1.1 DESCRIPTION OF THE RESERVOIR

The reservoir was built as part of the port project carried out at Misenum during the second half of the first century BC, at the beginning of the reign of Augustus. It is one of the most attractive reservoirs of its time, from both the architectural and monumental viewpoints.

The reservoir was 66.06 m long, 25.3 m wide and 15 m deep *(Fig. 2)*. The volume of stored water has

1. Map of Bacoli and the coves at Misenum, showing the location of Piscina Mirabilis (after Maiuri).

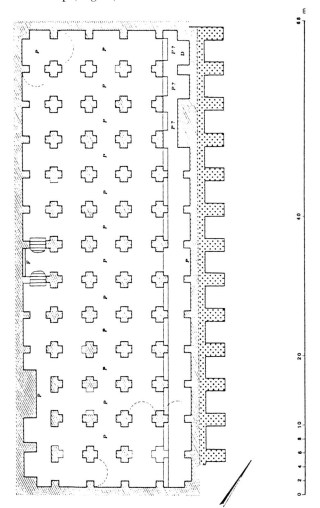

2. Plan of the Piscina Mirabilis reservoir (after Boriello & D'Ambrozio).

been estimated at some 12,000 m^3. The roof was supported by arches resting upon 48 gigantic pillars in the shape of square crosses arranged in four rows along the long axis and 12 rows along the short axis, making five expanses along the length and 13 along the width *(Fig. 3)*. Two flights of easy stairs, supported by three arches, enabled one to descend to the floor of the pool. The stairs appear at its northwest and southeast corners. Along the base of the walls there was a *pulvinus* (Latin for 'pillow'), a very practical architectural element made of plaster which filled in the sharp angle where the floor met the rising vertical wall. The central widthwise area, lower by 1.2 m than the floor of the reservoir, served – in the opinion of Maiuri – as a sedimentation basin *(piscina limaria)* (Maiuri 1958, 99). It was slightly slanted toward the south, where an opening enabled draining out the accumulated dirt which had precipitated in the sedimentation basin.

Maiuri wrote that the water entered the reservoir through a port alongside the entryway on the eastern

3. The Piscina Mirabilis reservoir – general view to the southeast.

side and that at the time of seasonal cleaning, the water ran out through the drainage port of the *piscina-limaria*. Because no other exit ports were found, he assumed that for normal operation the water was raised with water wheels or other lifting devices to terrace level, where it entered a conduit or aqueduct system for delivery to the port (Maiuri 1958, 100). In the author's opinion, based on structural and topographical details, the inlet was in the north west corner near the stairs and not as Maiuri wrote. Windows for the entry of light and air were found high up on the walls of the long sides. The walls were built of bricks, using the *opus reticulatum* technique, while the pilasters were constructed of blocks of tufa. Two heavy layers of plaster of *opus signinum* (crushed potsherds mixed with river sand from the city of Signinum) covered the walls.

1.2 THE SOURCE OF THE WATER AND THE FUNCTION OF THE RESERVOIR

Piscina Mirabilis is the large waterworks found at the end of the Serino Aqueduct. The fresh water was used by the ships of the Roman fleet which sailed in the Tyrrhenian Sea. Misenum, as well as Ravenna, were the principal military ports of the Roman Empire. The naval base at Misenum was designed in 37 BC by Agrippa. It was an enormous project based upon two natural coves. As part of the project, the reservoir was built, and the aqueduct – 96 kilometers long - was constructed to bring fresh water from the Apennines. The aqueduct, also called Aqua Claudia, began in Serino, and its route was: Serino – Pomigliano d'Arco – Neapolis (today's Napoli) – Puteoli (Pozzuoli) – Bauli (Bacoli) – Misenum (Eschebach 1987, 202). A fourth century inscription tells of a repair, giving a list, in order of decreasing importance, of the cities which received the water: Puteoli, Neapolis, Nola, Attela, Cumae, Acerrae, Baia and Misenum. Until 79 AD the water also came to Pompeii (d'Arms 1970, 79-80) via a secondary aqueduct called the 'Canale di Sarno' which branched off to the Serino aqueduct (Eschebach 1987, 202).

The Piscina Mirabilis reservoir was situated equidistant (about 250 m) from the two coves which comprised the port. The eastern cove is presently known as 'Porto di Miseno'. The western cove is 'Lago Miseno', although it was known in the past as 'Mare Morto' *(Fig. 1)*. In the author's opinion – in opposition to the thinking of Maiuri – the exit port of the reservoir is the 'drainage opening' mentioned by Maiuri. This place is enclosed today by a later plastered wall. There was no need to lift the water with water wheels from the reservoir since its bottom was higher by

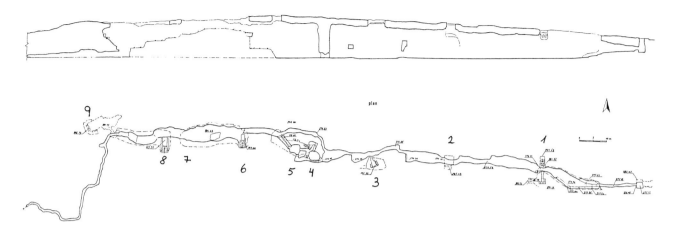

4. Map and cross-section of the Sepphoris reservoir.

some 20 m than sea level. It may be assumed that on the exterior of the reservoir there was a stopcock which could be opened or closed, from which a conduit conveyed the reservoir water to a place where the ships could be filled using a special installation operated by gravitation. It is not beyond the realm of possibility that there were two such points: one at the eastern dock and the other at the western. In the two coves, however, no remnants of the port and its installations survived, with the exception of two breakwaters in the eastern cove.

2. SEPPHORIS RESERVOIR

The ancient city of Sepphoris in Israel's Lower Galilee was one of the most important cities in the Land of Israel during the Roman and early Byzantine periods. The excavation of a large reservoir at the site was recently completed. The reservoir got its water from springs in the mountains about five km away. The reservoir was found about one km east of the city. Its function was to store water and regulate its flow to the city. The reservoir was some 260 m long, eight m high and three m wide, on the average *(Figs. 4-5)*. The volume of water which could be stored in it has been estimated at approximately 4,300 m³. The reservoir was hewn from the bedrock, a soft, chalky native limestone known in Hebrew as 'kirton', while the north wall is supported by hard limestone bedrock. Location of the reservoir was determined at the closest point to the city where 'kirton' bedrock of the appropriate depth could be found. It was already obvious from a previous study (Tsuk 1985, 34-36) that the water entered the reservoir from one side and flowed along its bottom surface toward the city. The great impression made by the reservoir brought about

a financial and touristic opportunity at the end of 1992, which enabled its excavation.

Excavation of the reservoir was carried out in 1993-94 by a team from the Institute of Archaeology – Tel Aviv University under the direction of the author, assisted by Arik Rosenberger and Martin Peilstocker

5. The Sepphoris reservoir – general view.

119

and a crew of 30-70 workmen. The project was financed by the National Parks Authority of Israel. At the time of excavation, which lasted 46 weeks, the following objectives were fixed:
1. Locating the point where the water entered the reservoir.
2. Excavating special sections along the length of the reservoir, which included walls, dams, shafts and more.
3. Locating the point where the water exited the reservoir.
4. Finding the missing section of conduit west of the reservoir, the extension of which carried water to Sepphoris.

2.1 THE SEDIMENTATION BASIN – ENTRY POINT OF THE WATER INTO THE RESERVOIR

The water conduit, which at this point measures about 30 x 30 cm, terminates in a chute which descends to a sedimentation basin (*piscina limaria*) measuring 2.1 x 1.8 m, with a depth of about five m. About one m above the bottom of the sedimentation basin there is a narrow opening in the western wall measuring 80 x 41 cm, through which the water flowed into the reservoir. On the floor of the sedimentation basin were found a large number of ceramic vessels, which can be dated to the end of the Byzantine period, or the seventh century AD.

2.2 THE RESERVOIR

The sedimentation basin opens into the cavity of the reservoir itself. Its length is approximately 260 m, of which the first 205 m have a storage depth of about eight m, and the remaining 55 m comprise a low, narrow tunnel leading to the outlet of the reservoir. Of the aforementioned 260 m, the team excavated the first 140 m and the last 60 m down to the floor, leaving between them an unexcavated section 60 m long *(Fig. 4)*.

Two distinct layers of plaster are recognizable along the entire length of the reservoir, with the second layer very well preserved in many places. In a number of places this layer has been applied over potsherds dated to the fourth century AD. The first layer can be dated to the second century AD (Porath 1984). In accordance with the foregoing, the reservoir was in use from the second to the seventh centuries AD.

Across the width of the reservoir, four supporting vaults extend between the north and south walls. Two of them are constructed barrel vaults, one is hewn from the rock, and the fourth – also constructed – has been destroyed.

The walls of the reservoir are generally rock covered with plaster, but in places where cracks in the rock occurred, or where soft, brittle material was hewn (only on the south wall), a stone wall was built and plastered over. The most exemplary place is in the eastern section of the reservoir, where a retaining wall was built of ashlars 30-40 x 60 cm in size. The wall is preserved to the height of six courses. The collapse of the upper section of the wall caused buckling of the ceiling in that section.

In the ceiling of the reservoir were nine openings for different purposes: primary rock-cutting, removal of hewn material, acces to the interior, maintenance, drawing water, and similar activities. Four of the openings (Nos. 1, 3, 6 and 8) come in from the sides, and each has a flight of stairs – in the upper section only – which descends to a plastered landing, the height of which is above the line of the highest water level; two of the openings (Nos. 2 and 5) are vertical. There are two other side openings (Nos. 4 and 9), each with a long flight of stairs which descends to a height of approximately three m above the floor of the reservoir which were used as the main openings for descending to the water level.

Their positions, one in the center of the reservoir and the other at the end, are compatible with this concept. There is also one opening (No. 7) which was so poorly preserved that it was difficult to categorize. An ancient engineering symbol similar to the Greek letter β (Beta) inside a square was found carved in the rock adjacent to, and north of, opening No. 2.

Opening No. 4 descends via a flight of stairs to the eastern section of the reservoir. This part is connected to the western section by means of a short tunnel at the floor level of the reservoir, one to two m high and about five m long. The tunnel runs northward, and connects with a section of the reservoir which at first was thought to be a blind alley (and accordingly was called 'the caecum' in Tsuk 1987, 74), but is now clearly recognized as an integral part of the reservoir.

A small, shallow pool – which is not an integral part of the reservoir – runs westward from opening No. 4. It measures 3.3 x 2.6 m, and its depth never exceeds 0.8 m, so that its maximum volume is only about seven m³. On its western side is a narrow channel which enabled water to flow onwards into the reservoir. When the reservoir was full of water, the entire pool was submerged. When the water level in the reservoir dropped below the level of the bottom of the pool, the narrow channel could be closed off and leave water in the pool even when the level of water in the reservoir dropped to its minimum height. In this way the reservoir's maintenance crew could use the water for their various requirements, or draw it up

through the vertical opening No. 5, located precisely above the pool. The western end, in the area of opening No. 9, was in the right place to represent the extremity of the reservoir.

2.3 EGRESS FROM THE RESERVOIR – THE RESERVOIR TUNNEL

Following removal of huge boulders and slabs, which were part of the buckled ceiling using machinery, the remainder of the work was done manually. At last, an opening was discovered in the floor of the reservoir leading westward, the beginning of the reservoir's exit and the start of an impressive tortuous tunnel some 55 m in length. The tunnel was 0.7-2.0 m high and 0.6-0.8 m wide. In thirteen places along its length, at various heights and on either side, protuberances were observed which were apparently shelves for small oil lamps. These were plastered, as the entire tunnel was coated with plaster from top to bottom. The tunnel terminates at its narrowest cross-section, which is approximately 0.6 x 0.8 m, at which point a wall had been built to seal it off. A lead pipe about 11 cm in diameter and 5.8 m long (*Fig. 6*) had been inserted into the wall, representing the sole egress from the reservoir. Mathematical calculation of the flow rate of the pipe brought us to the incontestable conclusion that in order to store water in the reservoir, it was necessary to close off the exit port, otherwise all the water entering the reservoir would not accumulate inside the cavity, but would immediately run out through the lead pipe.

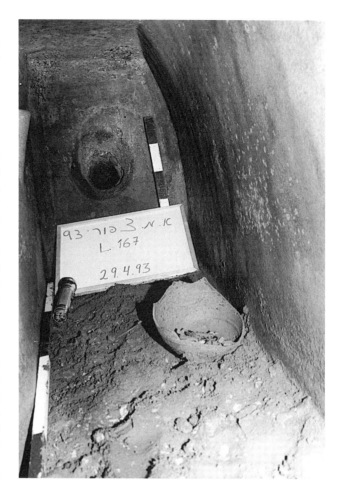

6. Lead pipe at the end of the reservoir tunnel.

2.4 TUNNEL OF THE SIX SHAFTS

On the other side of the pipe a tunnel was discovered which had six shafts. In the tunnel, the water flowed downward toward Sepphoris through a conduit with a gradient of 4‰, while the surface declivity of the area was greater. Thus, after about 235 m of tunnel, the conduit emerged to ground level.

On the surface, there were no visible signs of either the tunnel or the shafts. Only in one place was a small hole discovered in the ground, which did not look promising. Nevertheless, digging down through its depth finally bore fruit: discovery of the tunnel at the third shaft. The sixth shaft was laid bare later while digging along the conduit. Every shaft which was excavated was full of soil and stones down to its base, but a little to the side there were unfilled sections of the tunnel. The other shafts (Nos. 1, 2, 4 and 5) were discovered and precisely measured from below in the tunnel, and after their locations had been determined on the surface above, their excavation was begun

from the surface downwards. All of the shafts were angled, and included carved stairs descending to the horizontal tunnel in the base of which was a plaste-

7. The lead pipe at the bottom of shaft No.1.

red channel. The tunnel measured approximately 235 m in length, 0.8-1.8 m in height, and 0.6-0.8 m wide. The maximum dimensions of the channel were about 45 cm wide and 45 cm deep.

The most interesting point was the end of the lead pipe at the base of shaft No. 1 *(Fig. 7)*. The pipe terminated a little above the floor of the plastered channel, and exactly at the end of the stairs in the shaft. About 50 cm from the end of the pipe, a metal lug was discovered, solidly fastened into the floor. It appears that in this section there was a gate valve or stopcock which was opened and closed as required for filling the reservoir and supplying the needs of the town. This stopcock disappeared in the distant past, but it is likely that it resembled the bronze stopcock discovered by Oleson in Humayma, South Jordan (Oleson 1988, 123-124 Pl. 7).

The shaft tunnel is typical of the Roman rock-digging technique (Grewe 1986, 72-73). The shafts were cut at a steep angle that reflects a compromise between ease of descent and the need to raise the hewn material nearly vertically. From the bottom of each shaft, the digging crew tunneled in two directions, in order to meet the workers cutting their way toward them from the adjacent shafts. Four such places where the cutters met were clearly evident because of the deviations necessary to correct the cumulative directional error. In one place there was an error in the vertical level; thus in that section, the height of the tunnel approaches some three m, despite the fact that the height of the meeting point is only about one m *(Fig. 8)*. In the other places the correction was made on the horizontal level.

Along the length of the walls were found many niches where oil lamps had been placed. To the west of the tunnel, the water conduit emerges to the surface, appearing suddenly out of the rock. Initially located in a cut in the rock at a depth of about a meter, after some 15 m it comes to the surface, built on a foundation of natural rock which is not too deep. In this section the stones covering the conduit survived in their entirety, and it is one of the best preserved upper sections of the water conduit.

From this point, the water conduit continues in the direction of the town.

3. COMPARISON BETWEEN THE TWO RESERVOIRS

In light of the knowledge obtained by the author's excavation at Sepphoris, certain truths can be learned about the reservoir at Bacoli concerning those sections not yet unearthed, and especially the way in which the water was conveyed to the port. The author suggests that the water was moved from the bottom of

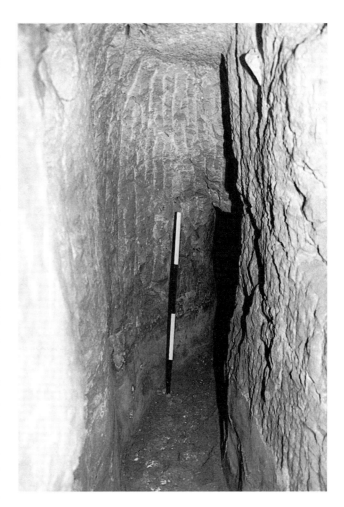

8. Meeting point of the cutting crews between shafts Nos. 1 and 2.

the reservoir, and not – as Maiuri submits – drawn by means of water wheels. In addition, it may be assumed that before the water flowed into the reservoir, it entered a sedimentation basin, which was located outside the entrance, and not in the floor of the reservoir.

It appears that the technological and engineering principles used were common to both reservoirs, while construction methods differed in accordance with the character of the bedrock and the capability of the entity which carried out the work.

3.1 COMMON FEATURES

Many features are common to the two reservoirs. Among them: storage of water in a place suitable to, yet at a certain distance from, its destination – a town or port; maximizing accumulation of water (because the quantity available was low in relation to the need), and supplying it during certain peak hours of

use each day; ingress of water from above and its egress from below; the shape of the gallery at Sepphoris or its fivefold repetition at Piscina Mirabilis; support of roof and walls by advanced architecturial techniques (columns, pilasters and arches at Bacoli, vaults and retaining wall at Sepphoris); their water sources (springs); entrance via two flights of stairs (on the two sides at Bacoli, at the center and end at Sepphoris); plaster of excellent quality, suitable for use with water even today; and certain architectural and engineering elements such as the *pulvini* and *piscinae limariae.*

3.2 DIFFERING FEATURES

There were a number of minor differences between the reservoirs at Bacoli and at Sepphoris, but the two major disparities were in size and construction. The volume of Piscina Mirabilis was almost three times that of the Sepphoris reservoir: some 12,000 m^3 at Bacoli contrasted with only 4,300 m^3 at Sepphoris; and the materials and construction at Bacoli were of imperial quality, while those at Sepphoris were of local quality.

CONCLUSION

While the reservoir of Bacoli was built in the first century BC, and that of Sepphoris in the second century AD, their objectives were the same: namely, the storage of water and the regulation of its dispensation to the final consumers – in these cases, the port and the city respectively. In both reservoirs, differences in water demand depended upon the needs of the fleet in Bacoli and of the residents in Sepphoris. These demands changed rapidly: there was a conspicuous difference between day and night demand, and probably a noticeable change in water requirements even from hour to hour. The need for building reservoirs was dictated by the limited amounts of water coming in via the aqueducts.

Despite the separation of the two subject reservoirs by two centuries of time and over 2,200 km of distance, and the differences in their architecture and dimensions notwithstanding, the regulation systems of both reservoirs were – in the considered opinion of the author – exactly the same. This conclusion is the result of an extensive archaeological excavation of the Sepphoris reservoir carried out by the author, during which the regulation system was unearthed. The discovery of this system suggested, because of the many other similarities between the two reservoirs, that the still concealed and as yet unexcavated regulation system of Piscina Mirabilis was the same as that of Sepphoris.

BIBLIOGRAPHY

Boriello, M./A. D'Ambrosio 1979, *Baiae-Misenum,* Firenze, (*Forma Italiae, Regio I, XIV*).
D'Arms, J. 1970, *Romans on the Bay of Naples,* Cambridge Massachusettes.
Eschebach, L. 1987. Pompeji, *WAS* 2, Mainz, 202-205.
Grewe, K. 1986, Zur Geschichte des Wasserleitungstunnels, *AW*, 65-76.
Maiuri, A. 1958^3, *The Phlegraean Fields,* Rome.
Oleson, J.P. 1988, Nabataean and Roman Water Use in Edom: The Humayma Hydraulic Survey, 1987, *EchosCl* XXXII n.s. 7, 117-129.

Porath, Y. 1984, Lime Plaster in Aqueducts – A New Chronological Indicator, *MInstWasser* 82, 1-16.
Tsuk, Ts. 1985, *The Aqueducts to Sepphoris,* M.A. thesis, Tel Aviv University (Hebrew with English Summary).
Tsuk, Ts. 1987, *Zippori and its Surroundings,* Tel Aviv (Hebrew).
Tsuk, Ts. 1991, Zippori Aqueducts, *Excavations and Survey in Israel,* Vol. 10, 97-98.
Waterman, L. 1937, *Preliminary Report of the University of Michigan Excavations at Sepphoris, Palestine in 1931,* Ann Arbor.

18A JOSEF HAGILILI ST
RAMAT - GAN 52416
ISRAEL

Antike Straßentunnel in Kampanien*

Klaus Grewe

Die Zweckbestimmung antiker Tunnelbauten war durchaus vielfältig. Neben den Aquädukttunneln, der am häufigsten vertretenen Art, gab es Tunnel für Seeabsenkungen und Flußumleitungen sowie Straßentunnel. Letztere sind in römischer Zeit einerseits sehr selten gebaut worden, andererseits finden wir Straßentunnel antiker Zeitstellung gerade im Gebiet um Neapel auffällig häufig vertreten. Diese Auffälligkeit hebt die Tunnel in Kampanien aus der Liste antiker Tunnelbauten deutlich heraus.

Zwei dieser Tunnel stehen mit dem Ausbau des antiken Kriegshafens Portus Julius in direkter Verbindung. Einer von ihnen, die Grotta della Sibilla, ermöglichte die Verbindung zwischen dem Hafenbecken, dessen Rest als Lucriner See erhalten ist, und dem Averner See. Der zweite, größere Cocceius-Tunnel (Grotta di Cocceio, auch Grotta della Pace genannt) machte Zugang und Zufahrt zum hinter dem Hafen gelegenen Flottenstützpunkt im Averner See von Cumae aus möglich. Die Hafenanlagen waren von Agrippa im Jahre 37 v.Chr. für Augustus angelegt worden, erwiesen sich wegen der Seichtheit des Sees aber schon bald als ungeeignet, weshalb am Kap Misenum Ersatz geschaffen wurde.

Der Cocceius-Tunnel ist eines der wenigen Bauwerke der Antike, die den Bezug auf ihren Baumeister zulassen. L. Cocceius Auctus hat für seine Zeit sicherlich nicht die Bedeutung erlangt wie beispielsweise Apollodoros für die Zeit Kaiser Trajans, dennoch gilt er als Architekt und Ingenieur, dem zu Zeiten Agrippas größere Bauwerke zugeschrieben werden. Sein voller Name mit der Berufsbezeichnung *arictectus* ergibt sich aus einer in Pozzuoli gefundenen Inschrift, wonach er der Freigelassene zweier Herren war (CIL X, 1614).

Der Tunnel zwischen Averner See und Cumae wird ihm von Strabo zugeschrieben: "Cocceius, der jenen Gang anlegte, folgte dabei wohl der ... Sage, indem er es vielleicht auch als eine dieser Gegend eigentümliche Gewohnheit betrachtete, die Wege unter der Erde fortgehen zu lassen" (V. 245). Der Cocceius-Tunnel mit seinen rund 1000 m Länge verfügt über ausgebaute Mundlöcher und gepflasterte Zufahrten.

Auch der Cripta Romana genannte Stadttunnel von Cumae wird Cocceius als Baumeister zugeschrieben. Er verband die antike Stadt mit dem Hafen und war groß genug dimensioniert, um Gespanne passieren zu lassen. Bei dem mitten im Tunnel zu sehenden Schacht dürfte es sich um einen antiken Bauschacht handeln. Besonders das auf der Hafenseite gelegene nicht überbaute Ende der Tunnelstrecke ist mit einem gut erhaltenen Retikulat-Mauerwerk versehen, wodurch nicht nur die Wandungen des offenen Bergeinschnittes standfest gemacht worden sind, sondern wodurch auch die qualitätvolle Ausführung der Bauarbeiten sichtbar wird.

Regen Verkehr dürfte der von Neapel Richtung Pozzuoli führende Tunnel, der als Cripta Neapolitana Eingang in die Literatur gefunden hat, bewältigt haben. Auch dieser Tunnel wird Cocceius zugeschrieben. Gleich zwei antike Quellen behandeln ihn.

Zum einen gibt uns die Beschreibung Senecas einen kleinen Einblick in die Verkehrslage eines antiken Tunnels. Er schreibt in einem Brief an seinen Freund Lucilius ("Seneca Lucilio suo salutem"): "Nichts ist länger als dieser Kerker, nichts trüber als diese Fakeln, die uns nicht durch die Dunkelheit, sondern nur die Fackeln selbst sehen lassen. Im übrigen, auch wenn der Ort Licht hätte, würde der Staub es schlukken, selbst in freiem Gelände eine beschwerliche und lästige Plage: erst recht dort, wo er in sich herumwirbelt, und da er ohne jeden Luftzug eingeschlossen ist, gerade auf die zurückfällt, von denen er aufgewirbelt worden ist." (57,2)

Der Tunnel hat eine Länge von 705 m und war im Altertum 3-4 m breit und 3-5 m hoch. Im 15./16. Jahrhundert hat man ihn auf mehr als den vierfachen Querschnitt vergrößert, so daß er bis zum Ende des 19. Jahrhunderts seinen Zweck erfüllen konnte. 1885 wurde er durch einen unweit daneben liegenden Neubau ersetzt, der heute noch seinen Dienst tut.

Es ist vermutlich diese Cripta Neapolitana, die als einziger antiker Tunnelbau sogar in der Tabula Peutingeriana verzeichnet ist *(Abb. 1)*. Bei der Tabula Peutingeriana handelt es sich um eine in mittelalterlicher Kopie erhaltene spätantike Straßenkarte, in der das gesamte, fast 100.000 km umfassende Fernstraßennetz des römischen Reiches dargestellt ist.

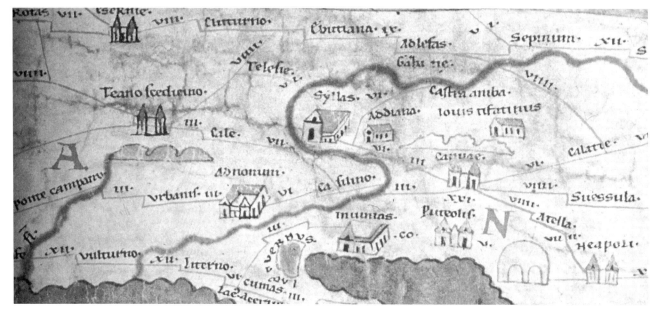

1. *Cripta Neapolitana in der Tabula Peutingeriana.*

In dieser Straßenkarte sind die Straßenstationen entsprechend ihrer Ausstattung und die verbindenden Straßen mitsamt Entfernungsangaben verzeichnet. Außer den Straßen und Stationen sind nur wenige Details eingetragen, die einen technischen Bezug haben. Dazu gehören die Häfen von Ostia oder Arles, die Aquäduktbrücke von Antakya und eben die Signatur für einen Straßentunnel zwischen Neapel und Pozzuoli.

Dargestellt ist ein Berg, vermutlich der Posilip, der

durch zwei torartige Öffnungen als von einem Tunnel durchstochen erkennbar ist. Die beiden Mundlöcher scheinen zu ein und demselben Tunnel zu gehören, denn sie liegen auf einer Höhe; perspektivisch sind sie in der Zeichnung ein wenig verzerrt, denn sie sind beide in frontaler Ansicht dargestellt. Die zugehörige Straße, die von Neapel nach Pozzuoli führte, ist in der Karte gar nicht verzeichnet; dem Zeichner scheint der Tunnel als solcher wichtiger gewesen zu sein, als die durch ihn hindurchführende Straßenverbindung. Möglicherweise ist die Straße aber auch ein Opfer des

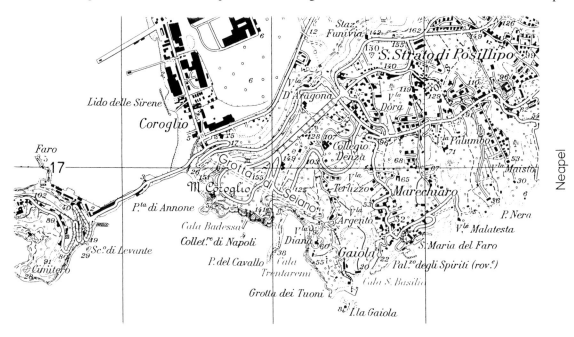

2. *Lage der Grotta di Seiano.*

126

3. Grotta di Seiano.

mittelalterlichen Kopisten geworden, denn die dazugehörige Meilenangabe (V Meilen) ist zwischen Tunnel und Pozzuoli eingetragen.

Der Posilip wird noch von einem weiteren Tunnel durchstochen: der Grotta di Seiano *(Abb. 2 und 3)*. Seine Bezeichnung soll dieser Tunnel nach einem Minister gleichen Namens unter Kaiser Tiberius erhalten haben. Damit kann aber kein Hinweis auf seine Erbauungszeit verbunden sein, denn auch dieser Tunnel wird dem zuvor erwähnten Cocceius zugeschrieben. Seiano (ca. 20 n.Chr) könnte danach allenfalls mit einer Reparatur in Verbindung gebracht werden.

Vermutlich hat Strabo die Grotta di Seiano gemeint, als er schrieb: "Es ist auch hier ein unterirdischer Gang durch den Berg zwischen Dikaiarcheia (Pozzuoli) und Neapolis, ebenso gebaut wie der bei Cumae; es ist ein mehrere Stadien langer gangbarer Weg, auf dem zwei Gespanne einander ausweichen können: das Licht fällt von der Oberfläche des Berges durch Löcher, die an vielen Stellen eingehauen sind, in die Tiefe" (V. 246). Mit den Lichtlöchern können nur die drei Seitenstollen gemeint sein, die vom Tunnelinneren zur Trentaremi-Bucht führen. Sie dienten der Beleuchtung des Inneren, haben aber während der Bauzeit auch dem Abtransport des beim Tunnelbau angefallenen Steinmaterials gedient. Der längste dieser drei Stollen ist 130 m lang.

Der 780 m lange Tunnel hatte in der Antike Querschnittsmaße von 4-6 m in der Breite und 4-8 m in der Höhe. Das scheint ein weiteres Indiz dafür zu sein, daß Strabo mit seinen Text die Grotta di Seiano gemeint hat, denn nur bei dieser Breite war ein Gegenverkehr mit Ausweichstellen möglich.

Mag der Tunnel anfangs nur eine Verkehrsverbindung zur Villa Pausilypum des Vedius Pollio gewesen sein, spätestens seit der Spätantike war er das Bindeglied einer von Neapel nach Pozzuoli führenden Straße. Die Strecke war zwei Meilen länger als die durch die Cripta Neapolitana, die Inschrift eines Meilensteins belegt eine Entfernung von sieben Meilen zwischen Cumae und dem Westmundloch des Tunnels (CIL X, 6930). Sie führt weiterhin in die Regierungszeit von Kaiser Constantius II (337 - 361 n.Chr.). Die zweite im Tunnel gefundene Inschrift belegt eine Reparaturmaßnahme unter Kaiser Honorius (395 - 414 n.Chr.) (CIL X, 1488).

Danach verliert sich die Geschichte des Tunnels für eine lange Zeit. Bergrutsche und Einstürze machten seine Passage unmöglich, und es ist anzunehmen, daß er in mittelalterlicher Zeit außer Nutzung war. Angeregt durch Berichte seiner Ingenieure, wurde der Tunnel unter dem Bourbonenkönig Ferdinand II. im Jahre 1840 erneut ausgebaut *(Abb. 4)*. Zu seinem

4. Grotta di Seiano, neu ausgebautes Mundloch am Westende.

Westende hin wurde die Fahrbahnsohle 5 - 6 m tiefergelegt; dadurch war der Anschluß an die Küstenstraße Richtung Pozzuoli einfacher geworden, denn die abwärtsführende Serpentine konnte mit weniger Kurven ausgestattet werden. Im Juli 1841 wurde der Tunnel erneut dem Verkehr übergeben. Nach Nutzung als Luftschutzraum und Depot im Zweiten Weltkrieg ist der Tunnel in jüngster Zeit erneut freigelegt und für den öffentlichen Besuch hergerichtet worden.

BIBLIOGRAPHIE

Grewe, K. 1981, Antike Entwässerungstunnel in den Albaner Bergen, *Der Vermessungsingenieur* 32, 203-206.
Grewe, K. 1986, Zur Geschichte des Wasserleitungstunnels, *AW* 17, 2 Sondernummer, 65-76.
Grewe, K. 1989, Etruskische und römische Tunnelbauten in Italien, *MInstWasser* 103, 131-152.
Pagano, M/M. Reddé/J.-M. Roddaz 1982, Recherches Archéologiques et Historiques sur la Zone du Lac d'Averne, *MEFRA* 94, 271-323.
Weber, E. 1976, *Tabula Peutingeriana, Codex Vindobonensis* 324, Graz.

ANMERKUNGEN

* Antiker Tunnelbau ist das Thema eines derzeit laufenden Forschungsprogramms, das besonders die Untersuchung der Methoden von Tunnelplanung und -trassierung zum Ziel hat. Dieses Forschungsprogramm wird von der Frontinus-Gesellschaft nachhaltig gefördert, und es wird voraussichtlich im Jahre 1998 abgeschlossen sein. Da für das Symposium Cura Aquarum (Pompeji 1.-8.10.1994) der Wunsch nach einem Vortrag über antike Tunnelbauten in Kampanien während der laufenden Forschungsarbeiten geäußert wurde, war während der Tagung nur ein vorläufiger Bericht zu erwarten und vorzutragen. Die schriftliche Fassung dieses Vortrags muß aus denselben Gründen vorläufig bleiben und kann wegen vieler noch ungeklärter Fragen lediglich in Form einer Übersicht abgegeben werden. Zum Thema Geschichte des Tunnelbaus ist bereits ein Vorbericht erschienen (Grewe 1989).

RHEINISCHES AMT FÜR
BODENDENKMALPFLEGE
ENDENICHER STRASSE 133
D-53115 BONN
DEUTSCHLAND

Das archaische Wasserleitungsnetz für Athen

Renate Tölle-Kastenbein †1995

Einleitend zu einer Ausgrabung in Nordafrika konstatierte ein französischer Archäologe: "Es gibt Archäologen, die suchen und finden; und es gibt Archäologen, die finden, was sie suchen." Zu letzteren gehörte zeitweilig Dörpfeld, und damit begannen all die Verwirrungen um die archaischen Wasserbauten in Athen. Dort hatten nach Thukydides die Peisistratiden um 520 v.Chr. die Quelle Kallirrhoe im Ilissostal mit einem Brunnenhaus, besser gesagt mit einer Krene, fassen lassen, die nach ihren neun Ausflüßen Enneakrounos genannt wurde. Diese Enneakrounos suchte Dörpfeld nicht im Ilissostal, sondern westlich der Akropolis am Fuß des Pnyx-Hügels - und fand sie dort! Er schloß sie an die südlich der Akropolis verlaufende Wasserleitung an, und damit waren alle frühen Wasserleitungen Athens aus peisistratidischer Zeit und von Tyrannenhand bewerkstelligt. Dieses Bild hielt sich annähernd hundert Jahre und zog weitere Verwirrungen in der Forschungsgeschichte nach sich.

Allein eine klare Unterscheidung zwischen Quellhaus und Wasserleitung löst einige Probleme: die Kallirrhoe/Enneakrounos muß im Ilissostal verbleiben, wo sie im vorigen Jahrhundert noch Wasser spendete; und das archaische Wasserleitungsnetz muß mit anderen Mitteln datiert werden.

Die chronologischen Ergebnisse, bei denen in diesem Fall Kriterien sehr unterschiedlicher Natur zusammenfließen und die im allgemeinen erst am Ende einer Untersuchung stehen können, nehme ich hier vorweg und stelle die Haupt- und Nebenleitungen zusammen mit ihren Datierungen vor. Auf diese Weise können die in spätarchaischer Zeit gelegte Grundlage und die nacharchaischen Erweiterungen und Erneuerungen sauber voneinander abgesetzt werden.

Unter Hippias, dem letzten Peisistratiden, der von 514 bis 510 v.Chr. allein regierte, wurde der Grundstein für die wahrscheinlich längste Wasserleitung der archaischen Zeit gelegt. Die unterirdische, vor Fremdeinflüßen geschützte Leitung wurde fast durchgehend im Stollen-Schacht-Verfahren angelegt, das Quellwasser aber nicht über die Sohle, sondern durch massive Tonrohre geleitet. Auch in den wenigen und kurzen Kanalabschnitten sowie im Doppelstollenbereich, auf den später zurückzukommen ist, fanden sich tönerne Wasserleitungsrohre.

Das Quellgebiet, das der Geologe D.K. Richter dankenswerterweise analysierte, liegt abgerundet 8 km vom Stadtkern entfernt, am westlichen Abhang des nördlichen Hymettos *(Abb. 1)*. Bis hierher hat sich das heutige Athen ausgedehnt, so daß alle Abschnitte – auch die der Fernleitung – heute überbaut sind. Dennoch konnte die Streckenführung außerhalb des antiken Athen dank einiger Untersuchungen und Beobachtungen des vorigen Jahrhunderts wiedergewonnen werden, gleichsam in Detektivarbeit.

Insgesamt folgt die Leitung dem Verlauf des Ilissos-Flusses, den sie den Höhenverhältnissen zufolge zweimal unterquert (bei F und G), um dann in den ebeneren Gebieten durchlaufend auf der Nordseite des Ilissos-Tales mit seinem für eine Wasserleitung guten Gefälle zu bleiben – bis hin ins alte Stadtgebiet.

Noch außerhalb der themistokleischen Stadtmauer, die erst etwas später, nach 480 v.Chr. erbaut wurde, liegt im heutigen Nationalpark hinter dem Schloß ein besonders gut erhaltener Schacht, 14 m tief, mit aufgemauertem oberen Teil. Ebenfalls noch vor der Stadtmauer befindet sich bei M eine kleine Abzweigung von der Hauptleitung, die bis heute als Beginn jenes Stranges angesehen wird, der nördlich der Akropolis bis zur Agora führt. Nachuntersuchungen haben jedoch gezeigt, daß es sich um einen Abzweig römischer Zeit zur Versorgung einer kleinen Thermenanlage handelt.

Bestätigend haben unpublizierte Rettungsgrabungen erbracht, daß der archaische Nordstrang zur Agora bei O abging. Hier also lag die Gabelung in den Nordstrang und in den Südstrang, die die Akropolis beiderseits umfahren und die die einzelnen Stadtteile mit Wohnhäusern, Geschäftsvierteln und Handwerkerbetrieben versorgten.

Diese Stelle bei O ist auffällig, denn nur hier konnte die Leitung nicht unterirdisch verlegt werden. Hier nämlich befand sich in griechischer Zeit eine kleine Senke mit einem Niveau unterhalb des Leitungsniveaus. Wie dieses Problem bautechnisch gelöst wurde, ist nicht mehr auszumachen. Die Tatsache aber, daß die Aufteilung in die beiden Hauptstränge des Stadtgebietes einerseits an einer gefährdeten, andererseits an einer wartungstechnisch leicht zugänglichen Stelle angelegt wurde, kann mit dem hohen Alter zusammenhängen, kann wasserbautechnisch die Unkenntnis eines Dükers belegen, kann historisch besagen, daß man zu dieser Zeit die Persergefahr noch nicht erkennen konnte.

Der Nordstrang folgt sowohl der 80 bzw. 85 m-Höhenlinie bis zur römischen Agora als auch zwei antik bedeutsamen Straßen (heute Odos Lysiou und Odos Dioskourion), von denen aus er gut anzulegen und zu warten war *(Abb. 2)*. Der Stollen, der den längsten Teil des Nordstrangs bestimmt, geht kurz vor Erreichen der

griechischen Agora in einen gedeckten Kanal über, der im Tagebau erstellt werden konnte. Innerhalb der Agora mündet die Leitung gleich im Südosten in die Rückwand einer Krene, der Südost-Krene, auf die unten im Zusammenhang mit den anderen Krenai genauer eingegangen wird. Insgesamt ist der Nordstrang bestens bekannt und bietet keine Probleme.

Dasselbe trifft leider nicht für den Südstrang zu, da es sich hier um mehrere Phasen, um eine Verlegung und um großflächige Überbauungen der klassischen und hellenistischen Zeit handelt. Die archaische Stollenleitung unterläuft nach der Gabelung (O) die antike Straße Thespidos, die ursprünglich zum Dionysostheater führte, sowie das erst unter Perikles erbaute Odeion. War zu Ende des 6. Jhs. v.Chr. das Dionysostheater noch klein, unausgebaut und bescheiden an den natürlichen Hang angelehnt, so wurde es später vergrößert, nach Norden erweitert und in Stein und Marmor ausgeführt. Damit wäre die Leitung unter dem perikleischen Odeion, dem Dionysostheater und weiteren nicht ganz so großen Bauten unzugänglich geworden; daher wurde sie nach Süden verlegt. Die Stelle des Zusammentreffens der jüngeren südlichen Trasse und der archaischen Leitung ist bekannt und liegt südwestlich des Herodes-Atticus-Odeion.

1. Fernwasserleitung.

Der westlichste Abschnitt des Südstrangs belegt nicht nur die archaische Leitung sondern zeichnet sich darüberhinaus durch ein Pänomen aus. In diesem gesamten Bereich bis zum Weststrang ist das kreidehaltige Gestein derart brüchig, daß man einfache Stollenstrecken in nacharchaischer Zeit durch einen Ausbau mit Tonplatten sicherte. Über den größten Teil dieser Strecke aber wurden archaisch zwei Stollen übereinander aufgefahren, Doppelstollen, wie auch auf Samos und in Syrakus bei gleich drei Wasserleitungen. Im oberen Stollen konnte unmöglich eine Tonrohrleitung verlegt werden, das verbieten die Schächte, das Auf- und Absteigen der Firste sowie streckenweise ein

Gegengefällle.
Die bisherigen Erklärungsvorschläge für die oberen Stollen, nämlich Reinigung, Wartung oder Instandhaltung, befriedigen insofern nicht, als diese Arbeiten auch in einstöckigen Stollen durchgeführt werden können und weil damit der hohe Aufwand für den oberen Stollen nicht gerechtfertigt erscheint. Die Deutung des oberen und waagerechten Stollens als Schutzstollen zur Gebirgsdruckentlastung wird dem Markscheider J. Palm verdankt. Der Gefahr nämlich, daß ein Leitungsstollen einbricht und damit die Wasserversorgung lahmgelegt wird, kann man wirkungsvoll begegnen, wenn man über dem unteren Stollen

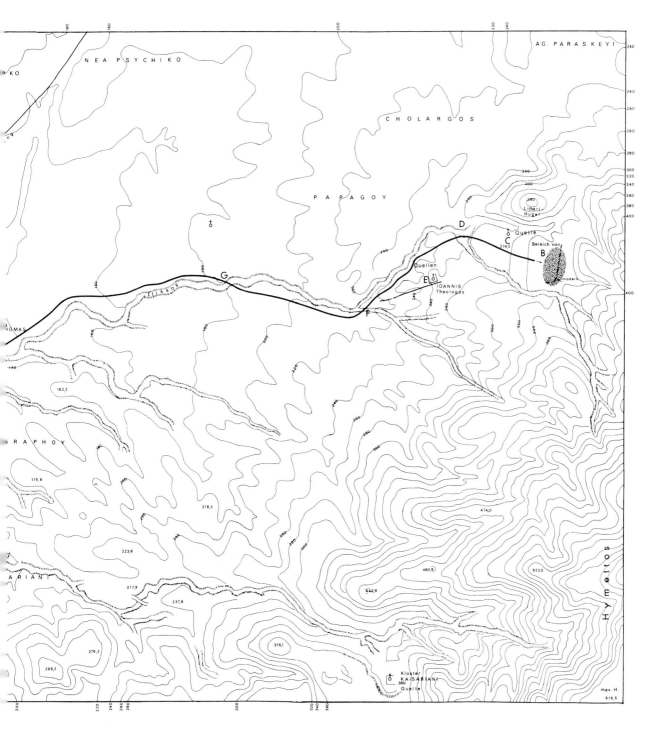

2. Stadtkern, Gabelung in Nord- und Südstrang.

einen weiteren Stollen zu dessen Schutz anlegt. Im Falle einer Gebirgsbewegung oder eines Gebirgsschlags (speziell um bergmännische Hohlräume) wirken sich die Kräfte auf den oberen Stollen aus, dieser bricht stellenweise ein, und von dort gehen die Druckwellen nach außen, umlaufen den unteren Stollen, ohne diesen zu erreichen. Der Leitungsstollen liegt im Druckschatten und bleibt damit unbeschadet.

Im Bereich des heutigen Aufgangs zur Akropolis biegt die Leitung nach Norden um, und der Stollen geht in einen gedeckten Kanal über. Bislang konnte der Weststrang als eigenständiger Teil des Wasserleitungssystems deshalb nicht in Erscheinung treten, weil Dörpfeld den Weststrang 33 m nördlich des Kanalbeginns zum Pnyx-Hügel abführte, um so die gesuchte, peisistratidische Enneakrounos zu erreichen. Eine unveröffentlichte Zeichnung im Grabungstagebuch dokumentiert jedoch, daß der Kanal unter dieser antiken Straße bei W2 weiter nach Norden verlief, unter der er sich bis in die Höhe des Areiopag-Hügels verfolgen läßt *(Abb. 3)*.

Bei W2 zweigt hingegen ein relativ kurzer Nebenarm ab, der ein spätklassisches Krene-Gebäude versorgte, von dem einige charakteristische Architekturstücke in späterer Verbauung gefunden wurden. Damit gehört die sogenannte Dörpfeld-Enneakrounos zum Leitungsnetz, sie wird hier wegen ihrer Lage Pnyx-Krene genannt; hier liegt aber nicht das sogenannte 'Ende der peisistratidischen Wasserleitung', wie es in allen Plänen heißt.

Die Kanalstrecke im Weststrang ist solide und sauber gearbeitet; leider sind die Kanaldeckel verloren, andernfalls wären sie die ältesten bekannten Kanaldeckel. Diese Strecke gehört zu einer grundlegenden Renovierung des Weststrangs nach der Mitte des 4. Jhs. v.Chr., die also rund 170 Jahre nach der Erstanlage durchgeführt wurde. Hierbei wurden alle archaischen Rohre entfernt, die teils andernorts wiederverwendet wurden, und durch neue ersetzt. Daß der Weststrang tatsächlich Bestandteil des archaischen Leitungsnetzes war, belegen mehrere Befunde ebendieser Zeit im Kerameikos und ein längerer Leitungsabschnitt zwischen Areiopag und Kerameikos. Das Ende des Weststrangs muß daher im Stadtteil Melite bzw. im äußeren Kerameikos gesucht werden, also in antiken Stadtteilen mit dichter Besiedlung und Handwerkervierteln.

Bis hierher handelte es sich um die Wasserleitungen

3. Weststrang.

der spätarchaischen Zeit. Unter den nacharchaischen Strängen und Nebenarmen, die hier nicht alle zu Wort kommen sollen, muß an erster Stelle die Akademie-Leitung hervorgehoben werden, weil sie – bald nach 460 v.Chr. angelegt – nur wenig jünger und weil sie besonders effizient ist.

Die Akademie-Leitung wurde im Osten Athens, zwischen der themistokleischen Stadtmauer und der Gabelung in Nord- und Südstrang, von der Hauptzuleitung bei N abgezweigt. Sie führt in einem großen nordwestlichen Bogen zum Nordteil der griechischen Agora, was ältere, punktuelle Grabungen belegen. Jüngere amerikanische und griechische Grabungen ha-

ben diese Leitung auf längere Strecken freigelegt. Sie nimmt – wie der Plan zeigt – deutlich Rücksicht auf die Stoa Poikile, die durch die Wandmalereien berühmter Künstler um 460 v.Chr. datiert ist, und muß daher danach angelegt worden sein – bald danach, wie die Rohre und die Fortsetzung im Kerameikos lehren. Dort verläuft sie östlich des Dipylon, und in dieses unter Themistokles nach 480 v.Chr. erbaute Stadtmauertor wurde stadtseitig eine Krene integriert. Wegen dieses Zusammenhangs wurde die ältere Dipylon-Krene bisher um 470 v.Chr. datiert – ohne jedoch nach der Wasserherkunft zu fragen. Jetzt läßt sich positiv sagen, daß sie von der Akademie-Leitung gespeist wurde, eben erst nach 460 v.Chr. Sie muß beim Torbau von vornherein geplant worden sein, konnte aber erst später an das Netz angeschlossen werden. Mit der Inbetriebnahme der Akademie-Leitung und der Dipylon-Krene wird rückblickend verständlich, warum die oben nur gestreifte Fortsetzung des Weststrangs nach Norden im Kerameikos bald nach 450 v.Chr. aufgegeben wurde. Diese Funktion übernahm die Akademie-Leitung, die als direkter Zufluß effizienter war als der lange Umweg über den Südstrang mit seinen Gefälleproblemen. Letzteres wird auch dadurch deutlich, daß die Akademie-Leitung noch weit über das Dipylon hinaus zur etwa 1,5 km entfernten Akademie führte, wo weitere Untersuchungen noch ausstehen.

Vom Südstrang wurden zudem in nacharchaischer Zeit bereits zwei beachtliche Leitungen abgeführt: noch vor der Doppelstollenstrecke eine wegen des brüchigen Gesteins schlecht erhaltene und streckenweise verlegte Leitung für den Stadtteil Kollytos, der so bevölkert war, daß er eine eigene Agora unterhielt. Die Leitung nutzte die Senke zwischen Akropolis und Mouseion-Hügel, die gefällemäßig günstig war.

Besser bekannt ist die Koile-Leitung, die dort, wo der Südstrang in den Weststrang umbiegt, abgeleitet wurde. Die Ausräumung dieses Stollens, der durch harten Kalkfelsen getrieben wurde, gut erhalten ist und unter der antiken Koile-Straße verläuft, erfolgte über eine Länge von rund 250 m, ohne daß das Ende erreicht wurde. Dabei wurden Korrekturen einiger Richtungsfehler beobachtet, wie sie im Gegenortvertrieb zwischen zwei Schächten immer wieder vorkommen. Insgesamt ist diese Leitung mehr als dreimal so lang, rund 860 m, versorgte den ebenfalls dicht besiedelten Stadtteil Koile und führte – das ist das Besondere – darüberhinaus bis in das Gebiet zwischen den Langen Mauern. In diesen Raum zwischen den Mauern zum Piräus, also außerhalb der Stadt, wurden nach Ausbruch des Peloponnesischen Krieges Bewohner Attikas evakuiert. Um diese zu versorgen, mußte die Leitung bis zur wiedergefundenen Vorstadt-Krene reichen.

133

Zusammenfassend läßt sich sagen: soweit erkennbar verliefen viele Leitungen, Haupt- wie Nebenleitungen, Stollen wie Kanäle, über weite Strecken unter antiken Straßen. Leitungsführung und Straßenführung bedingen einander, schon im 6. Jh. v.Chr. Insofern können Untersuchungen zu den Wasserleitungen vielerorts der Auffindung antiker Straßen dienen.

Unter allen Verzweigungen zeigen der Weststrang, die Kollytos- und die Koile-Leitung eine verwandte Planung. Jeweils wurde ein Tal zwischen den Hügeln des südwestlichen Athen gewählt, sowohl aus Gründen des Gefälles als auch wegen der hier gelegen Wohnstadtbereiche; denn deren Bebauung entwickelte sich von den dortigen Hauptverkehrsadern aus, die ihrerseits den Talmulden folgen.

Anders geartet sind die Gegebenheiten im Norden Athens, wo die sanfte und relativ gleichmäßige Neigung des Geländes nach Nordwesten jeglicher Leitungsplanung entgegenkommt. Aus dieser Sicht war von allen Athener Leitungen die Akademie-Leitung am einfachsten zu projektieren und zu realisieren – auf voller Länge.

Abgesehen von den Leitungsverlängerungen lassen sich die einzelnen Zweige des Wasserleitungsnetzes in vier auf die Rangordnung bezogene Kategorien einteilen. Eine solche Klassifizierung schließt leitungstechnischen Kriterien ein und erleichtert damit die Verständigung und die Vergleiche mit Wasserleitungen anderer Städte.

In Athen stellen die außerstädtische Fernleitung und die zwei innerstädtischen Hauptleitungen nördlich und südlich der Akropolis Zuleitungen 1. Ordnung dar. Abzweigende Leitungen 2. Ordnung dienen der Versorgung einzelner Stadtteile, in Athen die Leitungen für die Bezirke Kollytos, Koile, Kerameikos und Akademie. Kurze Zuleitungen zu einzelnen Krenai, die in geringer Entfernung von einer Leitung 1. oder 2. Ordnung erbaut wurden, wie der Pnyx-Arm, gehören der 3. Ordnung an. Kleinere Abzweigungen zur Speisung einzelner Anlagen wie der Brunnen-Arm im Amyneion oder die Wasseruhr auf der Agora, weisen als Leitungen 4. Ordnung im allgemeinen den geringsten Querschnitt auf.

Längenmäßig kommen in der archaischen Erstanlage zu der oben genannten Fernleitung bis zur Gabelung mit annähernd 8000 m für Nord- und Südstrang zusammen abgerundet 1500 m hinzu, ferner der Weststrang, der – auch ohne Anschluß des Kerameikos – mindestens 500 m lang gewesen sein muß. Diese minimal 10.000 m lange Grundlage der archaischen Zeit wurde in klassischer Zeit für weitere Nebenleitungen mit einer Summe der Längen von wenigstens 5500 m genutzt.

Die zahlreichen Leitungs-Rohre selbst wurden detailliert untersucht.[1]

Aufgrund des ungewöhnlich großen Querschnitts der archaischen Rohre und anderer Faktoren hat H. Fahlbusch, dem ich dafür sehr dankbar bin, eine große Leistungsfähigkeit dieser Leitung berechnet. Das bedeutet, daß gleichzeitig mehrere Krenai versorgt werden konnten, daß die Athener Bürger an mehreren, damals schon überdachten Stellen der Stadt frisches Wasser holen konnten, so oft sie wollten und wahrscheinlich auch so viel sie wollten.

Der Nordstrang mündet, wie gesagt, in die Südost-Krene auf der Agora – ein stattlicher Bau mit 125 m² Grundfläche. Die Rekonstruktion dieser nur im Grundriß bekannten, dreiräumigen Krene ist unkompliziert. Der Eingangsbereich läßt sich mit einem Antenbau mit zwei oder drei Säulen vergleichen. In dem tiefer gelegenen westlichen Raum kann – wie üblich – ein Becken mit Brüstung vermutet werden. In dem höher gelegenen östlichen Raum werden Wasserspeier an der Wand und unter diesen Postamente zum Aufstellen der Hydrien angenommen. Diese Kombination von Schöpf- und Zapf-Krene ist ungewöhnlich, aber offenbar wurde auf der Agora die Wahl zwischen stehendem und fließendem Wasser angeboten – je nach Verwendungszweck.

Die Südost-Krene verkörpert bereits jenen Typus der quergelagerten, an der Breitseite zugänglichen Krene, der zukunftsweisend ist und der späterhin vorherrscht. Sie ist zudem die einzige Krene, die von dem spätarchaischen Wasserversorgungssystem erhalten oder aufgefunden ist. Die vier weiteren bekannten Krene-Gebäude sind jüngeren Datums. Zwei von ihnen sollen hier zum Vergleich kurz vorgestellt werden.

Der im Verlauf des 5. und 4. Jhs. v.Chr. steigende Wasserbedarf manifestiert sich in Athen in der Verlängerung des Nordstrangs über die Südost-Krene hinaus nach Westen – in Form eines Steinkanals dicht unter

4. Südwest-Krene, Grundriß.

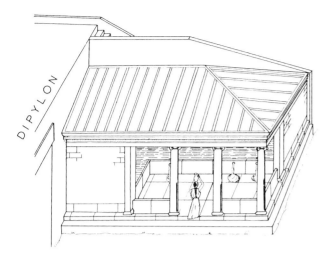

5. *Jüngere Dipylon-Krene, Rekonstruktion.*

7. *Hydria London, British Museum B 332.*

der Agora-Südstraße. Die Wassermenge, die über den Nordstrang die Agora erreichte, kann also nicht gering gewesen sein. Andernfalls hätte man im Abstand von nur 140 m nicht zusätzlich die erheblich größere Südwest-Krene erbaut. Zudem war hier eine regelmäßige und gleichbleibende Wasserzufuhr gewähr-

6. *Hydria William Francis Warden Fund Courtesy, Museum of Fine Arts, Boston (MFA 61.195).*

leistet; das setzt nämlich die im 4. Jh. angeschlossene Wasseruhr voraus, die zunächst nach dem Auslaufprinzip arbeitete und später in eine genauere Einlaufuhr umgearbeitet wurde.

Die Grundrißform der Südwest-Krene – ein L-förmiges Becken und davor eine ebenfalls rechtwinklig umbiegende Stoa – ist unter den Krenai der griechischen Welt selten und scheint einen spezifischen Entwurf Athens wiederzugeben *(Abb. 4)*. Die Dipylon-Krene weist im Winkel des Stadtmauertores einen ähnlichen Grundriß auf *(Abb. 5)*. Die jüngere Bauphase des 4. Jhs. ist im Bodenbereich ungewöhnlich gut erhalten: das wiederum L-förmige Becken konnte man nur durch ein Intercolumnium erreichen, die anderen Intercolumnien wurden mit Schrankenplatten zugesetzt, wohl um eine gewisse Ordnung zu wahren – im Gegensatz zu dem Durcheinander an einer Krene, das Aristophanes rund 100 Jahre zuvor bespöttelte.[2]

Wie Aristophanes so stellen auch die Vasenmaler die hohe Frequenz an den Krenai dar. Aus einem Zeitraum von rund 3 Generationen sind mehr als 150 Vasenbilder mit diesem Thema überliefert, die Mehrzahl sinnigerweise auf Hydrien. Früher hat man versucht, aus diesen Darstellungen Grundrisse abzulesen, ein gescheiterter Versuch.

Ordnet man die Vasenbilder zunächst nach der Zeitfolge und nach den Malern, so führt das weiter. Von einigen wenigen Vorstufen abgesehen kristallisiert sich dann eine Gruppe von Hydrien heraus, die innerhalb kürzester Zeit von dem Lysippides- und dem Antimenes-Maler bemalt wurden, alle um 520 v.Chr. Sie geben sich aufgrund der Beischriften ΚΑΛΛΙΡΡΟΕ als die Enneakrounos-Krene im Ilissostal zu erkennen. Auf diese Stufe folgt eine nicht sehr lange Pause, und erneut tritt das Krene-Thema in noch dichterer Ballung auf, nunmehr vertreten durch den Priamos-Maler und den gleichzeitigen Malern der Leagros-Gruppe.

Diese Bilder gehören alle dem letzten Jahrzehnt des 6. Jhs. v.Chr. an und setzen die Inbetriebnahme der großen Wasserleitung voraus; denn jetzt lassen sich drei, vielleicht auch vier Krene-Gebäude unterscheiden, die durch eine Fülle von Gemeinsamkeiten im Detail verbunden sind.

Zunächst ist ein Säulenbau in Vorderansicht mit zwei bis vier Säulen *in antis* zu nennen, mit Giebel zur Eingangsseite – gut erfaßt auf einer Hydria in Boston *(Abb. 6)*. Dieselbe Krene in Form eines Antenbaus wird auf einer Hydria in London von Hermes und Dionysos in übermenschlicher Größe flankiert *(Abb. 7)*. Die Einbettung einer Krene in ein kultisches Umfeld tritt hier nicht zum ersten Mal auf. Wol aber die Verbindung mit Hermes und Dionysos. Kulte dieser beiden Götter werden in Athen zahlreich überliefert, eine Kultvergesellschaftung beider aber ist nur auf der Agora gegeben, für Hermes Agoraios und Dionysos Lenaios. Mit Hilfe weiterer Quellen läßt es sich mehr als wahrscheinlich machen, daß mit dem Antenbau der Vasenbilder die Südost-Krene auf der Agora gemeint ist – um so mehr, als deren erhaltener Grundriß an der Eingangsseite zwei bis drei Säulen erfordert; es war eben ein Antenbau mit relativ langen Zungenmauern.

Anders präsentiert sich ein Amphiprostylos in Seitenansicht, gleichsam im Schnitt dargestellt, mit der Traufe zur Eingangsseite und dem Giebel zur Schmalseite. Architektonisch richtig liegt der Dachfirst über der Mittelwand, aus der das Wasser nach beiden Seiten austritt; das heißt, diese Krene ist von zwei Seiten zugänglich.

Auf einer Hydria in Rom wurde dieser amphiprostylen Krene der ihr eigene Name beigeschrieben: ΚΡΕΝΕ ΔΙΟΝΥΣΙΑ. Da allerorten zahlreiche Krenai Eigennamen trugen, muß auch der Name ΔΙΟΝΥΣΙΑ eine ganz bestimmte Krene ansprechen. Zudem belegt der linke Wasserspeier, ein Silenskopf anstelle der üblichen Löwenköpfe, einen Dionysischen Bezug. Unter den Dionysos-Heiligtümern Athens kommt hierfür nur das Heiligtum für Dionysos Eleuthereus am Südhang der Akropolis in Betracht, das die Peisistratiden wiederbelebten und favorisierten und das am Südstrang liegt. Bis zu einer Auffindung muß eine Krene in diesem Dionysus-Heiligtum Vermutung bleiben, Indizien aber lassen sich dafür nennen, unter anderem: der

Südstrang muß die Wohngebiete südlich der Akropolis mit Wasser versorgt haben; ferner kann die Nachfolge einer dortigen Krene späterhin das *nymphaeum* in Form eines Monopteros übernommen haben, denn in keiner Kultur gilt die Tradition des Ortes so viel wie in der griechischen.

Gesichert ist schließlich durch die Vasenbilder eine Krene mit zwei bis drei prostylen Säulen, ein Prostylos in Vorderansicht mit Giebel. Sind die genannten Zuordnungen, der Antenbau auf der Agora im Norden und die Krene ΔΙΟΝΥΣΙΑ auf der Südseite der Akropolis, zutreffend, so verbleibt für diesen dritten architektonischen Typus, für den Prostylos, nur ein Ort im Verlauf oder am Ende des Weststrangs, im Stadtteil Melite westlich der Akropolis.

Aus diesen meisterhaft gemalten Hydrienbildern sprudelt das *novum*. Athen besaß als erste Stadt Griechenlands ein derart großes und verzweigtes Wasserversorgungsnetz und besaß zugleich Malerwerkstätten, die diese Nachricht wie Herolde verbreiteten. Diese Botschaft verblieb selten in Athen, sie war vor allem für den Export bestimmt – wie andere Vasen auch. Hier aber wurden Nutzbauten vorgestellt, die eine bewußte Sorglosigkeit um das tägliche Wasser vor Augen führten und die die führende Rolle Athens auf diesem Gebiet dokumentierten.

Historisch fließen die vielen verschiedenartigen Befunde zu folgendem Bild zusammen. Das gesamte Großbauprojekt wurde während der kurzen Alleinherrschaft des Hippias, in den Jahren zwischen 514 und dem Sturz der Tyrannis im Jahre 510 v.Chr. geplant und begonnen – wahrscheinlich an mehreren Stellen gleichzeitig. Alle Befunde sprechen für eine ununterbrochene Durchführung und gegen eine Unterbrechung nach dem Ende des Hippias. Die Wasserleitung wurde in dem Jahrzehnt von 510 bis 500 v.Chr. fertiggestellt und in Betrieb genommen und zwar als einziges der drei Großunternehmen, die von den späten Peisistratiden iniziiert worden waren. Das Olympieion, der Riesentempel für Zeus Olympios, und die Festung Mounichia wurden von der nachfolgenden, demokratisch bestimmten Regierung eingestellt, nicht aber der Weiterbau zugunsten einer geregelten Wasserversorgung.

BIBLIOGRAPHIE

Tölle-Kastenbein, R. 1994, *Das archaische Wasserleitungsnetz für Athen,* Mainz am Rhein.

ANMERKUNGEN

[1] Cf. Tölle-Kastenbein 1994, 46-72.
[2] Aristophanes *Lysistrata,* 327-330.

Priene's Streets and Water Supply

Dora P. Crouch

ROADS AND STREETS

In a Greek city-state, the urban and rural populations formed one political entity, as evident in the metamorphosis of market roads into urban main streets. The fourth century BC city of Priene (on the west coast of modern Turkey) is an elegant example of both this interlacing of urban and rural roads and the type of street pattern called the Hippodamean grid *(Fig. 1)*. Two major roadways led from the rural area into Priene, one east and one west of the broad terrace on which the town was re-built after middle of the fifth century BC. Each of these roads pierced the defensive walls of the city in a set of gates.

From the sea, the approach to the western gate looped along the lower contours of a canyon to the northwest of the site. Heavily-loaded wagons could only have entered the city via the gentle slope of this entrance.

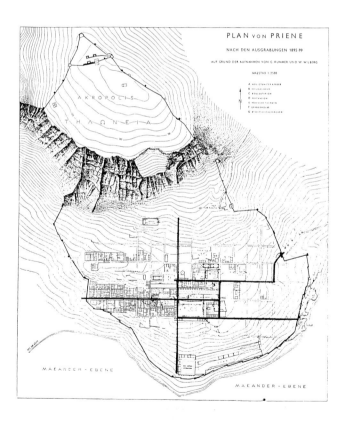

1. Plan of Priene, by Kummer and Wilberg, 1885-89, with Acropolis at the top. (Reprinted by permission of the German Archaeological Institute, Istanbul).

East of the town, from the edge of the Meander River valley, a steeper street entered the northeastern gate and then climbed 90 m up the hill, running along the lower edge of the bouleuterion (city council chamber) opposite the upper edge of the agora, until it reached the great Temple of Athena. Towards the river, a south-eastern gate located near a spring opened to a wide street, stepped in places, which climbed through 110 m elevation, up to the southern edge of the agora. The northeastern street is still used as access to the archaeological site from the village below, but the western and southeastern streets have lost their functions during the two millenia of political and geological change in the region.

A third road to the hinterland was required by spiritual and practical considerations, a road not shown on the map. This road climbed to the acropolis on the mountain top above the terrace where the town was located. Although it was infrequently used, this road was important to the community for several reasons: first, the periodic religious procession used this road when the community showed its devotion by climbing up the steep path to the temple on the acropolis. Standing finally in front of the temple, the devout could see the Mediterranean to the west and Miletus to the south across the Meander River, and give thanks to the deity who had blessed the community with safety and modest riches. Second, the road was traveled more frequently by those responsible for the reservoirs and pressure pipes in the acropolis area. They regularly climbed the road to inspect and tend the water supply of the city. The tanks within the acropolis walls were fed by both lead and terra-cotta pipes, indicating a pressure system bringing water from springs in the higher mountains north of the acropolis *(Fig. 2 and 3)*. By building reservoirs within the acropolis, the ancient engineers made two contributions to the well-being of the city. First, the reservoirs supplied the citadel itself, especially important in case of a siege. Second, the reservoirs relieved the pressure in the waterlines, allowing the water to aereate and purify before being led down to the city in another set of pressure pipes.[1] The access road from town to acropolis, therefore, exhibited the interweaving of practical, aesthetic, and spiritual factors in development of Priene.

137

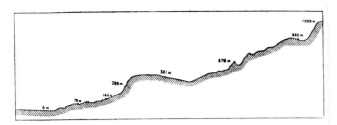

2. Section of Priene and its massif. The city lies between 79 and 144 m, with the Acropolis at 381 m, and the massif rising up to the right (north). (From Martin 1956, 113 Fig. 10, reprinted by permission).

3. Waterline outside the ramparts presumebly in the northeast sector.

GRID

Between the high acropolis and the river valley at the base of the hill, the terraces of the Priene headland were occupied by streets, open plazas, community buildings, and houses, laid out in a regular grid of rectangular city blocks. The tension between the imposed geometric pattern and the natural steep slopes that alternated with terraces was the basis of still-evident urban beauty. A noted American example of this kind of tension is San Francisco, which people from all over the world visit precisely to enjoy the splendid vistas that result from the grid cutting into the hills.

Subtle adjustments of the grid increased both the functionality of Priene, and its aesthetic quality. Except in the public areas and where the slopes were entirely too steep for building, city blocks at Priene were of two standard sizes, with only the agora and gymnasium/stadium exceeding the norm, as drains and supply pipes reveal *(Fig. 4)*. Main streets of the town, which have sidewalks for pedestrians, are wider than residential streets, which do not. Public processions used the wide streets in a great loop around the

agora, terminating at one of the temples for religious ritual or at the theater or bouleuterion for meetings and civic ceremonies. *(Fig. 1)*. The central east-west street is about five meters in width and the two that flank it are nearly as wide. A further adjustment in this central street can be seen at the fountain where many stopped for a drink and to catch their breath *(Fig. 5)*. West of the fountain, the street widened to accomodate persons and carts walking up the hill at different speeds. At the fountain, people could pause in the standing place to the left (uphill) side, while to the right the traffic could continue onward towards the agora along the narrower part of the street.

Only one of the north-south streets was as wide as the east-west streets we have just discussed. That was the stepped street leading up from the agora, past the entrance to the Athena precinct, to terminate in the street that led west to the Demeter Sanctuary. Below the agora, the same wide street was stepped again down to the gymnasium on the lowest terrace of the town. People climbing this steep street could pause and catch glimpses of the cityscape and the wider landscape in which it was set; they might also stop for a drink at another fountain at the west end of the north stoa of the agora.

Most of Priene's streets, including the one from the northeastern gate, were narrower than the main streets – measuring approximately three meters. Streets of this width were ample to accommodate foot traffic and even donkeys or small wagons. In comparison, streets in the ancient core of Rome were no more than 12 English feet (less than 4 m) wide, which was enough when the buildings had one or two stories like Priene, but insufficient when Rome's streets became lined with five-story apartments. Adjusting the width of a street to its function was and is economically and psychologically sound. For example, the lower main street (Spring Gate Street) was wider than the ordinary streets in residential quarters not only for the occasional procession but also for the daily traffic of women, and children going to the spring to get drinking water for family meals.

UTILITIES

Streets were a common good, beyond the capabilities of an individual or family to construct. Building the streets together reinforced a true sense of community among the early residents of Priene. Because of the steep terrain, the potential for flooding and erosion, and the availability of stone, Priene's builders paved the streets and laid pipes and channels below the street surface *(Fig. 6)*. The water-supply-lines and sewage drainage channels of the site, both followed

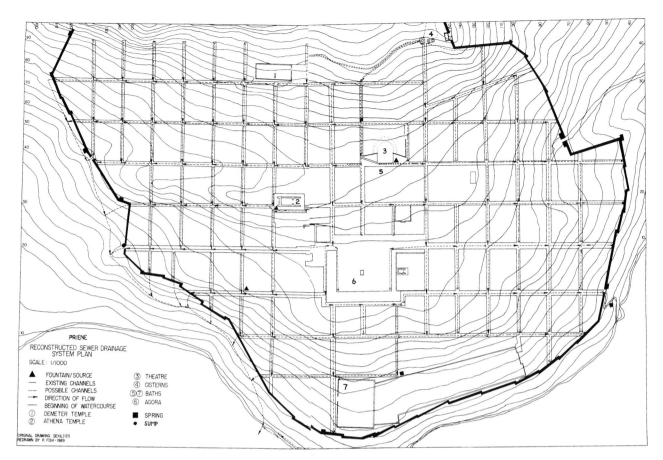

Within the figure:

PRIENE
RECONSTRUCTED SEWER DRAINAGE
SYSTEM PLAN

SCALE : 1/1000

▲ FOUNTAIN/SOURCE
— EXISTING CHANNELS
---- POSSIBLE CHANNELS
•→ DIRECTION OF FLOW
— BEGINNING OF WATERCOURSE
① DEMETER TEMPLE
② ATHENA TEMPLE

③ THEATRE
④ CISTERNS
⑤⑦ BATHS
⑥ AGORA

■ SPRING
• SUMP

ORIGINAL DRAWING SEKIL(12I)
REDRAWN BY P. FISH · 1989

4. Plan of sewer system, Priene. (From Tanriöver based on Wiegand; springs, fountains and sump added by the author).

the general street pattern of the town *(Fig. 4)*:[2] since the mild climate precludes winter freezing, it was not necessary to bury the pipelines deeply as we do in most of the United States. In a Mediterranean climate there is a smaller range of temperatures between summer and winter, day and night, than in more northern climates – 70 degrees fahrenheit difference rather than 120. The 'missing' degrees are those below freezing.

The Mediterranean climate has rain mainly in the winter. Thus it is necessary to make conscious provision for water to use during the dry months of summer. Usually Greek cities solved this problem with a high proportion of cisterns to piped water supply. Reliance on point sources of water (cisterns, wells, and public fountains) at most sites means that we do not often find supply pipelines paralleling the street pattern. In contrast, at Priene the local geology made possible an important variation, with approximately three-quarters of the houses served by piped water and springs. These pipelines followed the street pattern. In the aqueduct from the acropolis level to the reservoirs in the northeast of the city at Priene, the

rock-cut or -constructed drainage channels are trapezoidal in shape, a shape which modern engineers have determined is the most efficient *(Fig. 3)*.[3] Water pipes of terra-cotta, locally fabricated, have been found; some had very thick walls to resist the pressure (head) of the water descending from the great height of the acropolis.

Yet even in a city like Priene with high reliance on point sources for water supply, the municipal government had to contend with storm runoff (often but not always combined with sewage disposal), and therefore had to build drainage channels, which remain as important clues to ancient street patterns. The street pattern of ancient Rhodes, for instance, has been recovered in detail by discoveries of water pipes and sewer channels that demarcate the grid of that city, said to have been designed by Hippodamus himself.[4]

WATER FOR HOUSES

Some houses of Priene were supplied by short pipelines directly tapping seeps in the hill. This is particularly evident in the houses of the pleasant street tuck-

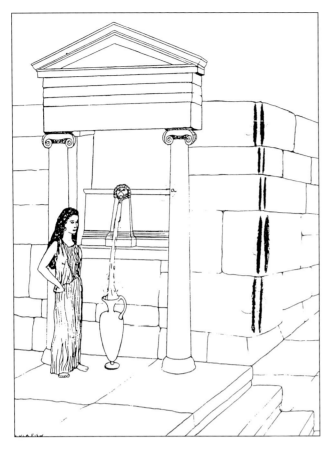

5. Reconstruction of a fountain on the main street in a residential district of Priene. To the right, at the foot of the wall, a large drain passed under the steps.

ed into a declivity between the Temple of Athena and the great slope of the mountain. None of this group have cisterns, but there are pipelines and channels. The overflow of water was caught in low street basins for the animals, and may have irrigated street trees. The residential streets are wide enough to have allowed trees in antiquity, and the water supply was abundant enough to support them, especially since they could be irrigated with either overflow of fresh waters or storm runoff and other waste waters.

Other houses on other streets were supplied by the pressure system from the springs above the Acropolis (mentioned above) via holding tanks just inside the northeast ramparts; from there water flowed by gravity to the houses *(Fig. 4)*. In the autumn of 1993, I had the thrill of discovering a previously unrecorded but beautifully excavated reservoir on the east side of the city, just inside the rampart and downhill from the double reservoir shown on standard plans of the site. Later that year, Ahmet Alkan, then a Ph.D. candidate in hydraulic engineering at Dokuz Eylül University in Izmir, discovered a previously unrecorded water line

from the upper springs, which crosses the eastern stream valley at an appropriate level to supply this reservoir. As of 1994, neither feature had been examined by archaeologists, so their dates are unknown.

Most houses at Priene used the abundant flowing water from pipes for all purposes, but some houses lying on the edge of the terrace to the south of Spring Gate Street, nearest the slope down to the river and farthest from the mountainside, relied on cisterns for sub-potable water for most domestic uses. They obtained drinking water from the spring outside the wall at the end of Spring Gate Street, from the fountain at the 'resting place' on West Main Street (described above), or from other fountains.

GEOLOGY

Local geological resources were the source of building materials not only for the monumental buildings which have preoccupied architectural historians and archaeologists, but also for street paving materials, pipes, and channels. At Priene, these materials were mainly marble and clay. The main streets of Priene were paved with the local stone, which at the same time formed the lids of water supply and drainage channels *(Fig. 6)*.

The geological structure – karstic in nature – of Priene's site also helps to explain its settlement pattern. The massif at Priene has the Mediterranean natural pattern: steep slopes bare or with few trees, but densely wooded on terraces and plateaus *(Fig. 2)*.[5] The more forest cover, the more active is the underlying karst system because of increased acid in the water.[6] Karst geology (an interactive process between water and carbonate rocks, leading to forma-

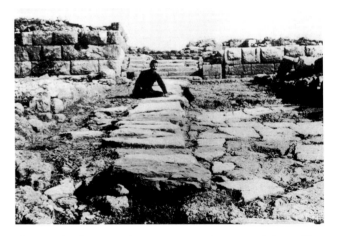

6. Detail of Spring Gate Street with stone slabs still in place over channel, and stone street paving. (From Wiegand 1904, reprinted by permission of the German Archaeological Institute, Istanbul).

tion of shafts, channels, and springs) is most common where soluble rock lies under a permeable but insoluble rock such as sandstone, or the extremely hard marble cap found on the hills at Miletus.[7] Collecting water from a large watershed – water that slowly perculates through fissures in rock – karst springs provide water year round, and can be either used directly or tapped for long-distance waterlines. At Priene the springs and therefore the holding chambers are located above the city, along the seam where the mountain's upper section of karstified limestone meets less soluable marble, and again at the lower seam between marble and impermeable flysch (consolidated clastic material such as conglomerate, sandstone or shale), which lies closer to the urban site.

Thus the mountainous terrain behind the city provided the necessary water which made settlement possible. The karst formation at Priene also facilitated urban drainage. Surface runoff after rain in karst regions concentrates into underground shaft-and-channel systems in the limestone rock, that is, into natural pipelines.[8] It is possible that the sewer system of Priene utilized such a natural pattern, concentrating urban runoff into natural vertical shafts. Drainage from the western main street disappears into the pile of masonry remaining from the western gate. Outside, there is no evidence of erosion from this heavy flow of water; I conjecture that the water does not flow away on the surface of the hill but rather drops into a karst shaft and pours away inside the hill. As part of the research for 'Geology and Settlement: Greco-Roman Patterns', the geologists and hydraulic engineers of our Turkish team are restudying this shaft and other details of the geology of Priene. In the 1994 field work, Alkan and his geologist colleague Talip Güngör discovered what is apparently a reinforced karst shaft some meters east of the stadium, aligned with large stone gutters that drained the stadium area. The stadium had been inserted on a terrace next to a band of karstic springs that were tapped to supply the palaestra bath next door. Apparently the ancient builders also utilized an existing karst shaft for drainage. Since the shaft lay below the city its waste waters would not pollute the urban water supply.

DAILY LIFE

Daily life of Priene took place largely in the courtyards of houses or on the streets. Streets facilitated the work of the town, by making it easier to get from one part of the site to another.[9] The courtyard not only provided a safe and private outdoor space, but also was the usual location of the well-head providing access to the domestic water supply, and of such water-using elements as the washbasin and the pithos or scrubboard for doing laundry. Many families also carried on craft activities in their courtyards, producing items to sell in the agora. In the public realm, water of fountains and baths also served as a focus of activities.

Public and private areas differed in their visible emphasis on water. In the home, water elements were hidden in the courtyard. The street grid emphasized the privacy of the houses by the blank windowless walls lining the streets, the shadow patterns of their recessed doorways punctuating each block.

PORTICOES

More overtly architectural treatment was given in the public realm to water as well as to other aspects of community life. Central business areas were differentiated from residential quarters by the use of street porticoes to signify public open space. Most notable of those at Priene were the porticoes of the agora – the freestanding north portico, on the uphill (northern) side of the main street, and the U-shaped continuous portico around the agora plaza on the south side of the street. These structures sheltered persons and goods from blazing sun or from rain. Their handsome Doric and Ionic columns supported wide roofs, forming open but protected spaces where the busy and the idle could meet, transact business, linger to discuss civic and personal affairs. Fountains, the agora, and the public baths all increased the cohesiveness of the community by fostering amiable interaction. Water supply increased the amenity of these spaces. For the agora, in addition to the fountain at the west end of the north portico, two water lines from the aqueduct terminated in the two south corners at public fountains.

The streets of Priene were closely adapted to the necessities and pleasures of urban life, serving not only as passageways and gathering places, but also as coverings for supply pipes and drains. Streets narrowed in residential areas, widened in public areas. They were equipped with animal watering troughs, provided alcoves for conversation, opened to vistas of the natural surroundings. They evince a high level of urban amenity, equitably available to all the people.

CONCLUSIONS

Since Priene had little rebuilding after the Roman era, its Greek street pattern complete with pipes and channels is easily recovered. The Hippodamean grid of Priene was one of at least five major plan-types used during the eighth through second centuries BC in

laying out Greek cities.[10] Each city made physically evident the set of urban concepts that were current when it was being laid out and first built. Cities thus displayed the Greek preference for corporealizing ideas.[11]

A reevaluation of changing Greek urban patterns must consider both the amount of wealth tied up in the infrastructure – streets, water lines, fountains, plazas, public buildings, houses, sewers, ramparts – and also the durability of these features, especially when made of marble or terra-cotta. Suppose the residents of second century BC Priene had come to prefer the scenographic urbanism of newly-monumentalized Pergamon to their existing grid plan. The cost and practical difficulties of remodeling their city into a system of radiating terraces like Pergamon's would have precluded such an alteration of the whole settlement.

The streets of Priene were arranged to optimize many facets of the community's life. These streets were appropriate to the size and needs of the community, to the local topography, and to the level of technology during the late classical and Hellenistic periods. The elements of the design were simple; their combination was masterful.

BIBLIOGRAPHY

Bradford, J. 1957, *Ancient Landscapes,* London. (reprinted in Bath, 1974)

Crouch, D.P. 1984, The Hellenistic Water System of Morgantina, Sicily: Contributions to the History of Urbanization, *AJA* 88, 353-65, pl. 46-7.

Crouch, D. 1993, *Water Management in Ancient Greek Cities,* New York.

Crouch, D./D. Garr/A. Mundigo 1982, *Spanish City Planning in North America,* Cambridge Mass.

Dilamarter, R.R./S.C. Csallany (eds.) 1977, *Hydrologic Problems in Karst Regions: Proceedings of the International Symposium April 1976,* Bowling Green, Ky.

Doxiadis, C.A. 1972, *Architectural Space in Ancient Greece,* Cambridge Mass.

Fekete, K. 1977, The Development and Management of Karst Water Resources in the City of Pecs and its Vicinity, Hungary, in: Dilamarter, R.R./S.C. Csallany (eds.), 279-85.

Furon, R. 1952-3, Introduction à la Géologie et Hydrogéologie de la Turquie, *Mémoires du musée national d'histoire naturelle,* Serie C, Sciences de la terre, Tome III, Paris, 1-99.

Gage, M. 1978, The Tempo of Geomorphological Change, *Journal of Geology* 78, 619-25.

Hammond, M. 1972, *The City in the Ancient World,* CambridgeMass.

Jones, A.H.M. 1940, *The Greek City from Alexander to Justinian,* Oxford.

Konstantinopoulos, G. 1968, Rhodes, New Finds and Old Problems, *Archaeology* 21, 115-23, pl. 21.

LeGrand, H.E. 1977, Karst Hydrology Related to Environmental Sensitivity, in: Dilamarter, R.R./S.C. Csallany (eds.), 10-18.

Loy, W.S. n.d.: field work 1965-66, *The Land of Nestor: A Physical Geography of the Southwest Peloponnese,* National Academy of Science, Foreign Field Research Program, No. 34.

Martin, R. 1956, *L'urbanisme dans la Grèce antique,* Paris.

Metraux, G. 1978, *Western Greek Land Use and City Planning in the Archaic Period,* New York.

Özis, U. 1985, *Assessment of Karst Water Resources,* in: *IWRA 5th World Congress on Water Resources,* Brussels, 95-102.

Rostovtzeff, M. 1941, *Social and Economic History of the Hellenistic World,* Oxford, 3 vol.

Steel, E.W./T.J. McGhee 1979, *Water Supply and Sewerage,* New York.

Stillwell, R./W.L. MacDonald/M. McAllister 1976, *Princeton Encyclopedia of Classical Sites,* Princeton N.J.

Webster, T.B.L. 1973, *Athenian Culture and Society,* Berkeley.

White, W.B. 1977, Conceptual Models for Carbonate Aquifers: Revisited in: Dilamarter, R.R./S.C. Csallany (eds.), 176-87.

Wiegand, T./H. Schrader, 1904, *Die Wasseranlagen,* Vol. IV of *Priene,* Berlin.

[1] Wiegand/Schrader, Vol IV, 1904; Ünal Özis, now professor of hydraulic engineering at Dokuz Eylül University in Izmir, Turkey, who has studied the site with his students, is skeptical of the use of pressure or lead pipes here.

[2] This map, a composite of two maps in Crouch, 1993, has three sources: a site-study for a senior thesis in hydraulic engineering by Engineer Ahmet Tanriöver, working under Professor Ünal Özis (then at Eke Technical University in Izmir) in 1974; the early publication of Wiegand/Schrader, cited in note 1; and careful inspection of the site itself.

[3] Wiegand/Schrader 1904, Abb. 37; compare with Steel/McGhee 1979, 85.

[4] Konstantinopoulos 1968, 115-23 and pl. 21.

[5] LeGrand 1977, 10-18.

[6] Loy 1965-66, 32.

[7] White 1977, 176-187.

[8] Fekete 1977, 279-85.

[9] Even though this seems to be an obvious benefit, not everyone recognizes it. For instance, at a major river crossing in Nepal, there is a foot bridge, a metal suspension bridge, built in the 1930s, that is used by thousands of people annually. Yet the path from the parking lot for buses to the bridge is not even cleared and smoothed.

[10] Crouch 1993, chapter 5.

[11] Webster 1973.

739 YALE STREET APT. 61 B
SANTA PAULA CA 93060
USA

Aquae Urbis Romae: an historial overview of water in the public life of Rome

Katherine Wentworth Rinne

Water is both metaphor and structure for the City of Rome; both an invisible and apparent form giver. Unconsciously one walks on water in Rome. Underground rivers flow beneath the streets and the sound of rushing water can be heard in streets where it cannot be seen. The memory of the primal structure of water, has been modified by imagination, time, and circumstance into the specifics of place. Linked to topography the Tiber River, sacred springs, wells, aqueducts, conduits and fountains are the nodes and armature along which neighborhoods were founded and the city developed. Fragments of ancient waterworks hint at this underlying structure, while fountains celebrate its civic presence. The grand, libidinous, Renaissance and Baroque fountains are the *loci* of dreams, and a source of tremendous civic pride. Humble neighborhood fontanelle are essential to the identity and daily life of Rome. No Roman is unaware of his fountains, even as he abuses them. They are not, as Clark remarked, "object d'art, held off from life and treated with respect as they would be anywhere else; there is a closeness, an imminence of touch around them that nothing in our life has except dreams and sex".[1] There is no denying them without serious emotional damage.

A BRIEF HISTORY OF WATER IN ROME

Legendary Roman origins are intimately linked to the Tiber River and the sacred springs on and near the Palatine. Cicero mentions that Romulus selected a place abundant in springs when he founded Rome, in 753 BC. He chose a spot near where he and his twin brother Remus had been set adrift to drown in the Tiber River, but were later found by the shepherd Faustulus. Floods, drownings, springs, rivers and water nymphs are all crucial to the story of the founding and nurturing of the city. Indeed, Roman citizenship itself was intimately bound to water. To be banished from the city carried the ultimate punishment of *'ignis et aquae interdictio',* to be excluded from fire and water (Cassius Dio LVI, XXVII, 242).

Roman mythology specifically links the founding and growth of the city – its protection and strength – to water deities and the actual springs, lakes and fountains which were their domains. Writing in AD 97,

Sextus Julius Frontinus, the *curator aquarum* (Chief Commissioner of Water) stated that "from the foundation of the city for 441 years the Romans were content with the use of waters which they drew, either from the Tiber, or from wells, or from springs.
Springs have held, down to the present day, the name of holy things, and are objects of veneration, having the repute of healing the sick; as for example the spring of the prophetic nymphs (Camenae), or Apollo and of Juturna" (Frontinus, *Aq.* 4).

The Fountain of Egeria, located near the Porta Capena, was particularly important in this respect. Sacred since the reverie of Romulus it was the site where Roman law was born. Numa Pompillus, the successor of Romulus, and the second King of Rome was married to the nymph Egeria. Late at night, he visited her at her sacred grove which contained a fountain and grotto. Here he consulted her about matter of law and religion important to the people of Rome. Livy (I 19) wrote that "it was her authority which guided him in the establishment of such rites as were most acceptable to the gods and in the appointment of priests to serve each particular duty". The Vestal Virgins, keepers of the sacred flame, also came to this spring to gather water for ritual purposes, that they carried back to their temple in the forum. This site was held sacred for more than 1000 years.

The growth of the city was physically dependent upon draining the swamps, building sewers and developing a sophisticated aqueduct system to bring water from distant sources to be distributed to Rome's hills. For example, urban expansion into the forum area was impossible until adequate drainage was developed, because the "entire valley between the Palantine and Capitoline hills, as far as the foot of the Quirinal was a stagnant marsh or back-water of the Tiber".[2] The numerous springs on the surrounding hills collected into a stream that flowed into the valley between the Esquiline, Quirinal, Palatine and Capitoline hills. According to Livy this stream, and the marshy area it fed, was drained about 590 BC when Tarquinius Priscus built the Cloaca Maxima, or great drain, that runs through te Forum Romanum, the Velabrum and Forum Boarium to the Tiber. Health conditions were significantly improved, development in low-lying

areas was now possible, and a neutral meeting place (the Forum Romanum) was created at the junction of the Sabine and Latin settlements – the valley between the Quirinal and Palatine hills respectively.

In order to expand to the adjacent hills additional water sources were needed. By the late 4th Century BC the springs and wells mentioned by Frontinus were no longer adequate for current or future needs of the expanding city The construction of the aqueducts – those nourishing tentacles that stretched as far as 40 miles from the ancient city – was the boldest civic act of ancient Rome. Frontinus (*Aq.* 19), with unconcealed pride asked "will anybody compare the idle Pyramids, or those other useless though much renowned works of the Greeks with these aqueducts, with these many indispensable structures?" This sentiment was echoed by Pliny the Elder (*HN* XXXVI 122) who wrote that "if we take careful account of all the abundant supply of water for public buildings, baths, settling-tanks (and) pools ... and of the distance the water travels before entering the city, the height of the arches, the tunneling of mountains, the leveling of routes across deep valleys, one must rate all this as the most remarkable achievement anywhere in the world".

The first aqueduct, the Aqua Appia, was completed in 312 BC to provide water to the existing population in the area surrounding the Circus Maximus, close to the Tiber River. The next aquaducts served areas slightly further afield: the Anio Vetus of 269 BC supplied the Esquiline and was primarily for irrigation; the Marcia of 140 BC ultimately supplied the Capitoline, Aventine and Quirinal hills with highly praised drinking water; and the Tepula of 125 BC supplied the Quirinal. The early aqueducts were primarily intended to provide water for drinking and food production, but the Aqua Virgo, completed in 19 BC by Agrippa, was intended to supply the phenomenal amounts of water necessary for his newly constructed public bath, located to the south of the Pantheon. Although there were already 170 small, independently operated public baths in Rome at this time, his was the first imperial bath.[3] It included extensive pleasure gardens, ornamental fountains, a swimming channel that led to the Tiber, outdoor pools and porticoes. It occupied an area extending from San Andrea della Valle to the Piazza Navona. When he died he left the entire complex to the people of Rome to be used as a public park.

Aware that the city was architecturally unworthy of her position as capital of the Roman Empire Augustus so improved her appearance that he could justifiably boast: "I found Rome built of bricks; I leave her clothed in marble" (Suetonius *Aug* 69). Inherent in this often repeated quote is the notion that Augustus recognized that the City of Rome had a responsibility, as the chief city of Europe and the Mediterranean, to be beautiful and to provide a certain level of amenity to her illustrious international visitors. Indeed, Augustus was exhorted by Maecenas in 29 BC, after he had wrested power from Antony and ended the Civil Wars, to "make this capital beautiful, spare no expense in doing so ... it is right for us who rule over so many people to excel all others in every field of endeavor, and even display of this kind tends to implant respect for us in our allies" (Cassius Dio LII, XXX 112).

The idea of Rome as *axis mundi* was reinforced through the distribution of water, its public display in elaborate fountains, and by the provision of public bathing facilities. Pliny (*HN* XXXVI 121) mentioned that in one year alone, 33 BC, Agrippa, the aedil of Augustus, after repairing the existing aqueducts and cleaning the sewers, built a new aqueduct (the Aqua Julia), 500 ornamental fountains (300 decorated with marble and bronze statues) and 700 basins and pools for public use. Nothing of this scale had ever been attempted in the city, and this abundance of public fountains would not have been possible without the aqueducts.

Few ancient fountains survive; the most notable being the remains of a *nymphaeum* at the *castellum* of the Aqua Julia, built by Agrippa in 33 BC, on the Esquiline hill. The original decorative program of the fountain is unknown, but in AD 222 it was decorated with a monumental water display provided by Alexander Severus. A central triumphal arch was flanked by lower side arches decorated with sculptural trophies. Water entered the display in both jets and cascades, then fell into marble basins, before being distributed to other destinations on the Esquiline. The artist Du Perac documented the fountain, known as the 'Trophies of Marius' in 1575, shortly before it was stripped of its remaining ornament by Pope Sixtus V.[4]

Only descriptions survive of other monumental water features. Suetonius (*Nero* 31) described a *nymphaeum* and artificial lake built for Nero as 'an enormous pool, like a sea ... surrounded by buildings made to resemble cities".[5] Forbes postulates that a "wall fifty feet high, broken with niches and hemi-cycles cased with rare and precious marbles and decrated with statues, formed the background (of the fountain); over and through which poured and rushed streams of

water falling into a basin at the foot of the wall; and then flowing in one long cascade of ten feet fall into a lower basin; hence it ran in a stream into the great artificial lake, where now stands the Colosseum".[6]

The *Notitia regionum urbis Romae,* the official statistics registry of AD 334, records that there were eighteen aqueducts feeding 1.212 public fountains, 11 imperial *thermae,* 926 public baths and 247 reservoirs, as well as 8 bridges across the Tiber.[7] Lanciani calculated that each of the one million Roman inhabitants at that time had a daily water supply of 1800 liters. In comparison, by 1900 each person only received 760 liters.[8]

As the aqueducts deteriorated, were destroyed or abandoned after the 4th century AD, the population shifted away from the dry hills to occupy the land enclosed within the bend of the Tiber (principally the Campus Martius) and a few other isolated areas where there were springs and wells. The population, decimated by warfare and disease, remained fairly low for nearly 1000 years. Krautheimer estimates a population of 90.000 during the pontificate of Pope Gregory VIII in 590, while the *census* of 1527 recorded only 55.000 inhabitants.[9] The Tiber once again became an important source of drinking water. However, a few aquaducts were sporadically repaired throughout the Middle Ages, and continued to supply reduced quantities of water to certain areas of the city. Most notably, the Aqua Virgo was intermittently repaired and continued to supply water to areas near the Pantheon and the Trevi Fountain.[10] These were two of the largest medieval settlements not located adjacent to the Tiber River. The Aqua Traiana was also repaired and supplied water to the Janiculum, the Vatican and portions of Trastevere.

In 1453, Pope Nicholas V completely restored the Aqua Virgo (now called Vergine), bringing a reliable supply of water to the Trevi neighborhood, and spurring increased settlement in this area. Then in 1566 the Campus Martius was ravaged by a typhoid epidemic, forcing Pope Pius V to reassess the fresh water needs of the city. In 1570 Giacomo della Porta presented a plan for 18 new fountains to be located in the low lying areas of the Campus Martius.[11] This was the first major fountain building program since antiquity. The proposed fountains stretched from the Piazza del Popolo, to the Piazza di Spagna and the Trevi Fountain to the east, and to the Porta di Ripetta on the river, south to the Piazza Mattei. Some, like the Pantheon fountain were intended to serve existing communities, while others, like the Piazza del Popolo fountain, were clearly intended to spur urban development. Intended for drinking and ornamental display, these fountains were supplemented by animal and washing troughs often located in the same piazza or in an immediately adjacent street. Many of the proposed fountains were never completed, due to topographic and economic reasons, and it took more than one hundred years to realize those that were built. Roman fountains at this time were fed by gravity and the proposed locations of several fountains were shifted after it was determined that the water pressure, from the low elevation Aqua Vergine, was inadequate to serve them.

In the 16th and 17th centuries, the hills were resupplied with water by the Aqua Felice and the Aqua Paola. The Felice, which terminated at the Moses Fountain in the Piazza di San Bernardo, retapped the same springs as the ancient Aqua Alexandrina and was completed in 1587 to supply the Quirinal, Pincian and Capitoline hills. Pope Sixtus V is generally credited with he innovation for the Aqua Felice, as part of the far-reaching urban design plan implemented during his short pontificate from 1585-1590. However, the plan had emerged gradually over the course of several pontificates and "the route of the aqueduct had been surveyed"[12] and construction was ready to begin when Sixtus V's predecessor, Gregory XIII, died. Sixtus had the intelligence to approve the building plan on his tenth day as Pope. The Felice was immediately put to use to supply the Villa Medici on the Pincian hill and the Quirinal Palace, then under construction.

The Aqua Paola completed by Pope Paul V (1605-1612), revived portions of the ancient Aqua Traiana. Like the Vergine and the Felice, its arrival into the city is celebrated with an elaborate triumphal fountain called a 'mostra', that is based on the ancient *castellum* of Alexander Severus from AD 222, the remains of which can be seen today in the Piazza Vittorio Emmanuele. The Paola enters the city at the highest elevation within the city walls, and is therefore not restricted in its distribution as are the Vergine and the Felice. Because of its elevation it has tremendous pressure and feeds fountains over a wide area including the Piazza of St. Peters, the Piazza Navona and all of Trastevere. The waters of the Paola were quickly determined to be insalubrious, so much of the supply was redirected to ornamental fountains and particularly to industrial purposes, such as the corn mills that operated along the Strada di San Pancrazio from below the Porta San Pancrazio to the Porta Settimiana.

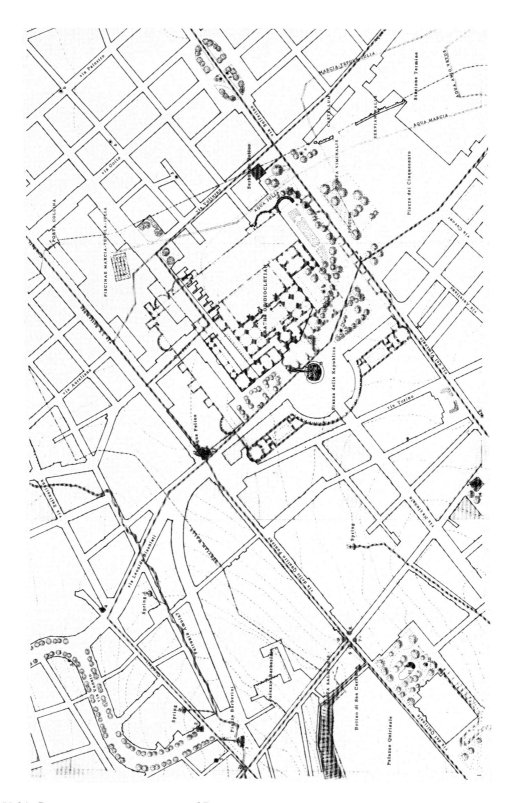

1. Aquae Urbis Romae - a new water map of Rome
FOUNTAINS: 1. the Triton fountain; 2. the bee fountain (current location); 2a. the bee fountain (former location); 3. purification fountain; 4. fountain in Via Bissolati; 5. ABC dog fountain; 6, 7, 8, 9. four corner fountains; 10. public garden fountain; 11. grotto fountain; 12. the Moses fountain; 13. the Naiad fountain.
FONTANELLE (neighborhood drinking fountains) a. wolf's head spout (stone fountains); b. 'nasone' (metal fountains).

In addition to topography, patronage and political influence also determined the locations of many public fountains. For example, Cardinal Ferdinand de Medici, owner of the Villa Medici, donated money to Sixtus V for the purpose of seeing the Aqua Felice project through to fruition. He was then appointed president of the congregation formed to oversee its construction. When the aqueduct opened in 1587 he was granted the right to build fountains to supply his elaborate garden, in exchange for providing, at his expense, a public fountain called the Fontana della Trinita del Monte, in front of his villa.[13] In another instance the Fontana delle Tartarughe, originally intended for the Piazza Giudea, was shifted to the Piazza Mattei at the personal request of Matteo Mattei, whose family palazzo was, and still is located there.[14]

Other individuals were granted water for their palaces, in exchange for providing a small public drinking fountain, such as the Babuino Fountain, originally placed against the wall of the Ludovisi Palace.[15] Sixtus V also gave Matteo Mattei enough peperino marble to build three of the Quattro Fontane. This was in exchange for promising to build his new palace on the same site, one that happened to be crucial to Sixtus V's real estate development plan for the entire area.[16] For more than two hundred years this was a typical arrangement that benefited the public with beautiful drinking fountains, in exchange for financial support of development schemes. This was the major source of public drinking water until the late 19th century, when the fontanella drinking fountain (nicknamed the 'nasone' or big nose) was introduced throughout the city. In 1870 Rome had been named the capital of the new Italian State and experienced a tremendous influx of population. Later, in 1894, a cholera epidemic forced the closing of all public and private wells. Both events generated the need for an increased public supply of pure drinking water.[17]

Prior to the late 19th century (before water was piped directly to most homes) fountains were an essential element in the social life of every family and neighborhood. They were particularly important to women who used them as extensions to their kitchens. They would meet at the fountain to discuss family matters, wash linens and collect water for cooking, drinking and bathing. Fountains were also essential to the development of neighborhood public markets, another major social arena for women.

Until the early 20th century cooking normally took place outside the house in the street, hence fire and water shared the central space of Roman public life, just as they had in antiquity. Roman life was, and still is in large part, lived on the streets and in the piazzas of the city. The street, piazza and fountain were physical extension of the home. The house, dark and dismal, and rarely supplied with water, was in fact so relatively unimportant as to be merely a place to sleep and store one's belongings.

Today water is piped to every home and the role of the public fountain has changed dramatically. Stripped of its essential function of providing pure water for drinking and cooking; no longer the focal point of the social life of women; and often unreachable through barricades of parked cars, fountains still play a vital, though largely unconscious role in the lives of Rome's citizens. In an incredibly dense city they are metaphors for the public gardens that ring the city but do not penetrate its core. In a city with few horizons, they provide an *axis mundi* for each neighborhood. Like beads on an urban rosary, held together by invisible underground conduits, fountains rhythmically punctuate movement through the city and invite one to pause and contemplate. While no longer such a clear extension to family living space, they are still backdrops for the everyday lives of Roman citizens. To every tourist they are the scenes for moments of heightened experience. And finally, water is most simply cool and refreshing, to both body and spirit, as millions of times a day people pause to drink from public fountains.

AQUAE URBIS ROMAE - A NEW WATER MAP OF ROME
(Fig. 1)

In spite of the importance of water, aqueducts, and public fountains to the spiritual, mythical, social, cultural, political and physical life of Rome, there is no currently available monograph, guide or map that deals with water as a system in the public realm of the city. Several important monographs haven been published on the history of Roman fountains (principally from an iconographic or traditional art historical perspective), including *Le Fontane di Roma* by D'Onofrio and *The Waters of Rome* by Morton. Significant technical works dealing with the aqueducts include *Roman Aqueducts and Water Supply* by Hodge, *The Aqueducts of Rome* by Ashby and *De Aqueductu* by Frontinus. However, there is no single work that examines fountains, aqueducts, the Tiber River and its floods, hydrography, fontanelle, animal troughs, underground conduits and distribution systems together as inter-related elements of a single urban system.

The overall objective of my study is to frame fountains, these most visible and tangible symbols of water, within the context of the structure of water (aqueducts, conduits, sewers, the Tiber etc.) and the history of its delivery to the city. This is accomplished through a series of overlays drawn as a single map, titled *Aquae Urbis Romae* that is a first step toward filling this lacuna in Roman urban history. The map, drawn at a scale of 1 to 2000 specifically emphasizes the approximately 400 extant public water features located in the historic center including the following layers of information:

- Well documented fountains such as the Trevi and the Four Rivers fountains.
- Less well known neighborhood fountains that date principally from the 17th to the 19th century such as the Santa Maria Maddelena and the San Simeone fountains.
- Neigborhood fontanelle – the small drinking fountains similar in form to an American fire hydrant, that were distributed throughout the city from 1870 to 1910.
- Trough fountains located primarily at city gates, provided for horses and travelers.[18]
- Fountains located in public gardens and parks, most of which were formerly private.
- Distribution centers and underground conduits that link major public fountains to their aqueducts.
- Current topography at one meter intervals. This information is crucial for understanding urban development, but is rarely included on maps. Topography can define neighborhoods and activities in a way that is not otherwise possible. It is also crucial for understanding the role of water delivery in a gravity driven system.

In addition the map will provide a guide to the memory of water in the city by illustrating:
- The natural hydrography of the land before the founding of the city.
- The course of the Tiber before embankment at the end of the 19th century, and the extent of the 1598 and 1890 floods.
- The location of nearly 100 memoral plaques located throughout the Campus Martius to commemorate Tiber floods.
- Missing, destroyed or relocated fountains. Difficult

to reconstruct, this information provides valuable insights into the growth and organization of neighborhoods, and particularly into the provisioning of pilgrimage routes through the city with water amenities.
- The location of ancient Roman, medieval and modern water mills.
- The location of 16th and 17th century outdoor washing troughs and 18th and 19th century wash houses. These are particularly important for un understanding of the social uses of water and for reconstructing the urban space of women. Once located throughout the city, they have all been demolished or dismantled.

IMPLICATIONS

A comprehensive look at water as an ordering system for the city provides an opportunity to understand how urban design and architecture respond to the multiple grids of public infrastructure such as roads and rivers, which combine with topography and open space as signifcant determinants of city growth, and effect its ultimate form. The *Aquae Urbis Romae* will be a valuable resource for examining the city systematically and will be used by architects, landscape architects, planners, urban designers and historians, students, cartographers, hydrologists and lay persons. Like all maps it will offer a distinct viewpoint from which to study the city. Its my intent that this map, to be available in printed and computer formats, will be a tool for others and a spring-board for new research. A study of water offers a particularly attractive and fruitful opportunity since in varying degrees it is part of every street, building and space in the city. The map will aid research in the following areas, among others: 1) the topography of modern Rome and its relationship to the ancient city; 2) the development of neighborhoods and the growth of the city; 3) water, gender and public space; 4) the relationship between religious and political processions and the distribution of water; 5) the consecration of public space, in the capital of Christendom, through the introduction of water as a symbol of the virgin; 6) water and the iconography of power; 7) the link between the public display and distribution of water and the growth of the tourist industry since Imperial Rome.

Clark, E. 1952, *Rome and a villa,* Garden City.

Du Perac, F. 1575, *Vestigi dell'antichità di Roma,* Roma.

Fedeli, C. 1898, *The waters of Rome,* London.

Forbes, R.J. 1899, *The Roman aqueducts,* Leiden.

Krautheimer, R. 1980, *Rome, profile of a city,* 312-1308, Princeton.

Lanciani, R. 1967, *The ruins and excavations of ancient Rome,* New York.

Morton, H.V. 1966, *The waters of Rome,* London.

D'Onofrio, C. 1986, *Le Fontane di Roma,* Roma.

Pastor, L. 1932, *History of the Popes,* XXII, St. Louis.

Yegül, F. 1992, *Baths and bathing in classical antiquity,* Cambridge Mass.

NOTES

1 Clark 1952, 36.

2 Lanciani 1967, 56.

3 Yegül 1992. See for a discussion of the physical and social changes engendered by the introduction of imperial baths.

4 Du Perac 1575.

5 The *nymphaeum* was destroyed before Suetonius was born and he would only have known about it second hand.

6 Forbes 1899, 27.

7 Lanciani 1897, 88.

8 Lanciani 1897, 57. Based on a daily flow of 1.747.311 m^3 in AD 334, and a supply of only 379.080 m^3 per day in 1900, for a population of one half million.

9 Krautheimer 1980, 65 and 232.

10 Krautheimer 1980, 252.

11 'Pianta con le condutture da costruire per la diramazione dell'acqua Vergine'. Original drawing (1570) Vatican City.

12 Morton 1966, 120.

13 Pastor 1932, 208-210.

14 D'Onofrio 1986, 124.

15 D'Onofrio 1986, 134.

16 D'Onofrio 1986, 222.

17 Fedeli 1898, 4.

18 In the 19th century these were provided for tram horses bringing 'commuters' into the city. Prior to that time horse troughs were located throughout the city in larger piazzas and streets, as in the Piazza Navona and the Piazza Colonna.

MASSACHUSETTS INSTITUTE OF TECHNOLOGY
SCHOOL OF ARCHITECTURE AND PLANNING
77 MASSACHUSETTS AVENUE, 7-231
CAMBRDIGE, MASSACHUSETTS 02139
USA

Die Fundorte der Fistulae Aquariae in Rom

Gerda de Kleijn

Die ersten anderthalb Jahrhunderte unserer Zeitrechnung betrachtet man im allgemeinen als einen Zeitraum, in dem das römische Reich seine Hochblüte erlebte. Aus der Stadt Rom, dem Zentrum, aus dem das Reich erwachsen war, ist uns einerseits vieles bekannt, anderseits steht noch eine Anzahl von Fragen offen. Eine der Fragen der sozialökonomischen Geschichte worüber Althistoriker noch immer debattieren, ist die von den Lebensumständen der Leute in der Stadt. Soll man Rom in der Kaiserzeit betrachten als eine Stadt, in der man gut verweilen konnte, mit entscheidenden Einrichtungen in vielen Bereichen für die meisten Einwohner, wenn auch nicht für die gesamte Einwohnerschaft der Stadt? Oder weist die Stadt mehr Ähnlichkeit auf mit, zum Beispiel, den Großstädten des industrialisierenden Westeuropas des neunzehnten Jahrhunderts mit ihren Armenvierteln und ihren mangelhaften Sanitäranlagen?[1]

Die Kentnisse über die stadtrömische Wasserversorgung sind aber noch unzureichend in diese Debatte mit einbezogen.[2] Meistens macht man uns nur aufmerksam auf die Vielzahl von Aquädukten oder auf die Menge des einfließenden Wassers. Die Wasserverteilung ist, in diesem Zusammenhang, bis heute kaum beachtet worden.[3]

Eine der Kenndaten, die in erster Linie jede flüchtige Skizze des Stadtlebens ermitteln, ist das von den zirka 800.000 Einwohnern benutzte Stadtgebiet. Weiter wird der Entwicklung des Stadtumfangs in den ersten Jahrhunderten der Kaiserzeit Beachtung geschenkt. Dabei stellen die *fistulae aquariae* (Wasserleitungsbleirohre), auf denen als Aufschrift der Name einer Privatperson, meistens im Genitiv, angelegt ist, eine wichtige Informationsquelle dar. Zuerst werden die Grenzen der Stadt und die Entwicklung des Raumgebrauches besprochen. Dann wird eingegangen auf die Information, die unsere Kenntnis der antiken Wasserversorgung zusammen mit einigen Passagen aus Frontins Traktat *De Aquis Urbis Romae* und die erwähnten *fistula*-Aufschriften darbieten kann. Abschließend gibt es einige Schlußfolgerungen.

STADTGEBIET

Zum Feststellen der Ausdehnung des Stadtgebietes könnte man die Stadtgrenze ansehen. Wo hat sie sich befunden? Es gibt mehrere Möglichkeiten, u.a. das *pomerium* (eine sakrale, wiederholt verlegte Grenze), die geschlossene Ortschaft, eine Zollgrenze des Kaisers Vespasians oder den ersten Meilenstein an den Wegen. Diese Grenzen sind ungleich und ihre genauen Verläufe sind zum größten Teil nicht bekannt.[4] Konkretest sind die beiden Stadtmauern: die Mauer, die Servius Tullius, dem vorletzten König Roms (6. Jahrhundert v.Chr.) zugeschrieben, aber erst später, im vierten Jahrhundert v.Chr., gebaut worden ist, und die aurelianische Mauer, genannt nach einem Kaiser des dritten Jahrhunderts (270-275) n.Chr.

Bloß das Vorkommen dieser beiden Mauern macht klar, das man, in einem gewissen Moment in den dazwischenliegenden Jahrhunderten außerhalb der Urmauer ansässig geworden ist. Das bedeutet selbstverständlich nicht, daß man sich gleichzeitig ausbreitete über ein großes Gebiet um die Altstadt herum. Das Wohnen in nächster Nähe der Stadt blieb für die meisten Leute attraktiv, weil man täglich dort zu tun hatte. Das trifft zu gleichermaßen für Personen der Elite, die im Zentrum öffentliche Ämter ausübten, und für die kleinen Leute, die im Binnenhafen am Tiberufer arbeiteten und nicht über moderne öffentliche Verkehrsmittel verfügen konnten. Das Überschreiten der Urmauer geschah wahrscheinlich in der ersten Hälfte des ersten Jahrhunderts v.Chr. Damit ist die Stadtgrenze nicht mehr konkret, aber konzeptuell.

Frontin, *curator aquarum* der Stadt Rom hat sein Traktat *De Aquis Urbis Romae,* die wichtigste literarische Quelle unserer Kenntnis der Wasserversorgung dieser Stadt, geschrieben am Ende des ersten Jahrhunderts unserer Zeitrechnung. In diesem Bereich ist sein Stadtkonzept von höchstem Interesse. Mit Bruun, der denkt, Frontins Stadtkonzept umfasse fast das ganze *suburbium,* bin ich nicht einverstanden.[5] Meiner Meinung nach hantiert Frontin ein praxisbezogenes Konzept, das heißt, die Stadt über die er schreibt, ist die ganze geschlossene Ortschaft seiner Zeit, die *continentia tecta.* Dies erweist sich in seiner Angabe zur Verteilung des öffentlichen Wassers - lediglich in der Stadt - zu den vorhandenen Vierteln, *regiones.* Und ein Ort hinter dem Garten des Pallas, wo man die Aqua Iulia speist mit Wasser der Aqua Claudia, umschreibt er als in der Nähe von - nicht in - der Stadt (Frontin *Aq.* 69,3).

STÄDTISCHER RAUM

Für unsere Kenntnis über die Stellen, wo man im ersten Jahrhundert v.Chr. wohnte, sind wir zum größten

153

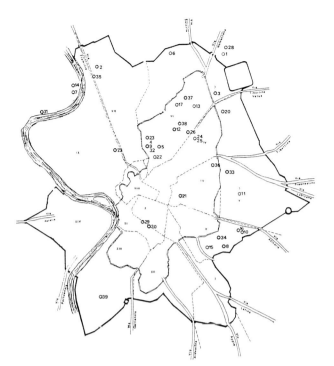

1. Fundorte der fistulae des 1. Jahrhunderts, Rom.

2. Fundorte der fistulae des 1. Jahrhunderts, suburbium.

Teil angewiesen auf die antike Literatur, in der hauptsächlich die Elite figuriert. Sie hat ihre Häuser besonders dicht neben dem Forum Romanum, dem politischen Zentrum. Der neben dem Forum liegende Palatin ist der exclusivste Wohnhügel der Stadt. Weiter entfernt vom Zentrum sind noch einzelne Wohnungen Wohlhabender attestiert werden. Andere Konzentrationen als der Palatin und die Umgebung des Forums können zu dieser Zeit nicht nachgewiesen worden. Gerade außerhalb der Stadtbebauung, ja sogar innerhalb der republikanischen Mauer findet man Landhäuser mit großen Anlagen umgeben, *horti* genannt. Wie ein Band umgeben sie die Stadt.[6]

Es läßt sich folgern, daß am Ende der Republik (etwa 30 v.Chr.) die Wohlhabenden insbesondere innerhalb der servianischen Mauer wohnten, und daß im Westen und Norden der Stadt luxuriöse Villenviertel den Übergang bildeten ins Land. Im Osten schließt sich die Stadt bis zur Erweiterung des Maecenas jäh ab von ihrer Umgebung. Am undeutlichsten ist die Situation am Campus Martius und an der Südseite der Stadt.

Wo sich die Wohnungen der Armen befunden haben ist am schwierigsten nachzuweisen. Eine *insula*, oft erwähnt als Mietskaserne, ist nicht wie die andere.[7] Es sind großzügige Appartements gefunden und man kennt einen zukünftigen Senator, der in einer *insula* auf dem Palatin wohnte. Das reine Vorkommen einer *insula* indiziert also keine ärmliche Bewohnung eines Viertels.

Jedenfalls wohnte man in den dreißiger Jahren des ersten Jahrhunderts v.Chr. nach Varro (*De re rustica* 3,2,6) auf dem Campus Martius außerhalb, jedoch in der Nähe, der Urmauer. Und nach Philo von Alexandrië (*Leg. ad Caium* 155-157) wohnten in der augusteischen Zeit freigelassene Juden und andere Orientalen in einem Viertel auf dem rechten Tiberufer.

Nach den Bürgerkriegen, die das römische Reich am Ende der Republik heimgesucht haben, ist bis weit in die Kaiserzeit ein umfassendes Bauprogramm erledigt worden, bei dem im Stadtzentrum Raum freigemacht worden ist für öffentliche Bauten. Auch auf dem Campus Martius erschienen von Süd nach Nord immer mehr öffentliche Gebäude. Außerdem monopolisierten die Kaiser und ihre Familien immermehr den Palatin.

Hatte dies zur Folge, daß die Elite sich zurückzog auf das Land, oder bevorzugte sie die nächste Nähe des politischen Zentrums und baute sich neue Häuser an einer anderen Stelle in der Stadt? Bei dieser Frage können die *fistulae aquariae* uns vielleicht helfen.

WASSERVERSORGUNG

Von größer Wichtigkeit ist, sich zu realisieren, daß nicht jedermann fließendes Wasser ins Haus leiten konnte. Die frühesten römischen Aquädukte beabsichtigten die öffentliche Wasserversorgung der Stadt zu speisen. Während der Republik ist, nach Frontin, nur einzelnen

154

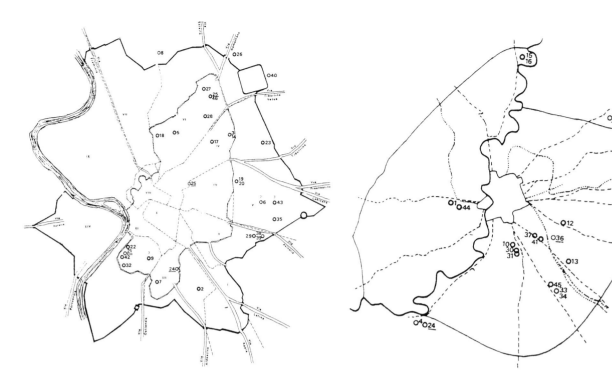

3. Fundorte der fistulae des 2. Jahrhunderts, Rom.

4. Fundorte der fistulae des 2. Jahrhunderts, suburbium.

Personen wegen ihre Verdienste um den Staat, eine Privatwasserleitung bewilligt worden. Weiter verkaufte man das Wasser was aus den Brunnenbecken überfloß an Bäder und Tuchwalkereien (Frontin, *Aq.* 94,3-5). Man muß dies nicht so sehr wörtlich nehmen, illegale Wasserableitungen und Wassermißbrauch kamen ganz bestimmt vor. Jedoch, in der Übergangsperiode von der Republik in die Kaiserzeit nahm Agrippa, der wichtigste Mitarbeiter Kaiser Augustus, wo es sich um praktische Fragen handelte, die ganze Wasserversorgung der Stadt auf seine Rechnung, baute neue Aquädukte und reorganisierte das Leitungsnetz. Nach dem Verscheiden Agrippas formalisierte Augustus die getroffenen Reglungen. Die Privilegienbewilligung kam in die Hände des Kaisers. Im Laufe der ersten Jahrhunderte unserer Zeitrechnung entwickelte sich ein Verfahren, welches die Bewillig- ung nicht unmittelbar nach dem Tod eines Konzessionsinhabers widerrief. Das Sonderrecht war leichter zu bekommen, es wurde allmählich an ein Grundstück gebunden. Jedoch in Rom blieb eine Privatwasserleitung am exclusivsten, und deshalb begehrenswert. Es gab also keine Gründe sich zu schämen wegen seines Names auf Wasserleitungsrohren.

Nach Bruun sind in Rom und seinem Umkreis Tausende von Bleirohren aus dem Altertum gefunden worden.[8] Um die letzte Jahrhundertwende hat Dressel die Rohre mit Aufschrift aufgenommen in das *Corpus Inscrip-*

tionum Latinarum. Das macht, zusammen mit später gefundenen Rohren, etwa 300 Privatnamen im Genitiv. Man kann annehmen, daß der Name des ersten Konzessionärs auf den Bleirohren geschrieben ist. Ecks Forschung des Sozialstatus dieser Privatleute hat dargelegt, daß fast alle erwähnten Namen zu Personen höchsten Standes gehören und/oder des unmittelbaren Bekanntenkreises der Kaiser.[9] Es ist plausibel, daß eine *fistula* mit Aufschrift angebracht war zwischen einem Verteiler *(castellum)* und der Stelle, wo das Wasser benutzt werden sollte. Findet man eine solche *fistula in situ* dann ist das dazugehörige Haus wahrscheinlich nicht weit entfernt. Dies gilt sicherlich für Rom, wo sich zur Zeit Frontins 247 *castella* befunden haben müssen (Frontin *Aq.* 78,3). Um so schöner ist es, wenn eine *fistula* in den Überresten eines Hauses vorgefunden wird. Falls der Fundort einer aufgeschriebenen *fistula* zuverlässig überliefert worden ist, muß das dazugehörige Haus oder die dazugehörige Villa in der nächsten Nähe dieses Fundorts gestanden haben.

FUNDORTE

Wo nun sind die *fistulae* vorgefunden worden? Es wird sich zeigen an Hand einiger Abbildungen. Zur Datierung ist die Arbeit Ecks benutzt.[10] Lediglich die Bleirohre, von denen der Fundort ziemlich zuverlässig

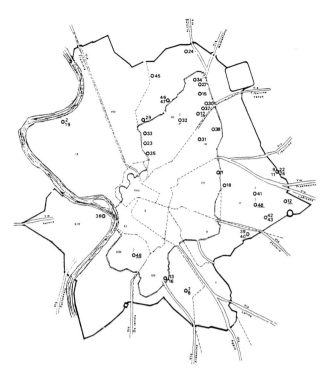

5. *Fundorte der fistulae des 3. Jahrhunderts, Rom.*

6. *Fundorte der fistulae des 3. Jahrhunderts, suburbium.*

überliefert worden ist, sind aufgenommen.

Im ersten Jahrhundert n.Chr. sind die meisten *fistulae* mit Aufschrift von Privatleuten vorgefunden innerhalb und in nächster Nähe der servianischen Mauer. Neuanschlüsse sind konzentriert am Quirinal. Außerhalb der Urmauer hat man einzelne gefunden im Südosten *(Abb. 1)*.

Im *suburbium* sind im ersten Jhdt. nur einzelne *fistulae* vorgefunden. Die Wasserleitung des L. Nonius Asprenas (Nr. 27) beim 8. Meilenstein an der Via Ostiensis war höchstwahrscheinlich verbunden mit der Wasserversorgung Ostias, oder bezog ihr Wasser unmittelbar vom Gebiet der Wasserleitungsbrunnen Ostias.[11] Etwas ähnliches muß der Fall sein, wenn es sich handelt um die *fistulae* des L. Funisulanus Vettonianus (Nr. 18), gefunden beim 8. Meilenstein an der Via Nomentana *(Abb. 2)*. Sie gehörten also nicht zu der Wasserversorgung der Stadt Rom.

Die Fundorte der Privat-*fistulae* des zweiten Jahrhunderts lassen eine bescheidene Verschiebung sehen. An der Südseite, wo im ersten Jhdt. nur am Caelius eine kleine Konzentration attestiert worden ist, sind neue Wasseranschlüsse vorgefunden am Aventin, innerhalb der Urmauer. Das Bild ändert sich kaum. *(Abb. 3)*.

Auffällig aber ist die wachsende Quantität, die in einiger Distanz zur geschlossenen Ortschaft vorgefunden ist. Für einzelne trifft zu was schon zum ersten Jhdt. gesagt ist, nämlich daß sie gefunden worden sind an solchen Stellen, daß ein Anschluß an die stadtrömische Wasserleitung nicht wahrscheinlich ist. Außer der *fistula* beim 8. Meilenstein der Via Ostiensis und der Via

Nomentana gilt dies ebensosehr für die Rohre der Calpurnii (Nr. 15 und 16) bei Prima Porta und die des Aurelius Prosenus (Nr. 11) der Via Labicana. Die Nummern 1 und 44 sind gefunden an der Kreuzung der Aqua Traiana mit der Via Aurelia. Die Rohre südöstlich der Stadt, hingegen, befinden sich nicht fern von der gemeinsamen Trasse der meisten Aquädukte. Bei der Villa der Quintilii (Nr. 34 und 35) sieht man Überreste eines Aquäduktes, das Wasser leitet, aller Wahrscheinlichkeit nach, aus der Aqua Claudia *(Abb. 4)*. Aus dem dritten Jhdt. hat man in *regio* VI an der Außenseite der servianischen Mauer Neuanschlüsse vorgefunden am Nordhang des Quirinals. Übrigens unterscheidet sich das Bild der *fistula*-fundorte dieses Jhdts. nicht wirklich vom Bild der vorangehenden Perioden, auch nicht im *suburbium (Abb. 5 und 6)*.

SCHLUSS

Auf Grund von literarischen Quellen kann man voraussetzen, daß Rom am Ende des ersten Jahrhunderts n.Chr. wahrscheinlich die Altstadt zusammen mit einigen Erweiterungsgebieten umfaßt hat: An der Westseite in Transtiberim, im Norden das Marsfeld und an der Südseite ein Gebiet die Via Appia entlang.

Die Fundorte der Wasserleitungsbleirohre mit Aufschriften von Privatpersonen indizieren keine bedeutende Stadterweiterung in den ersten Jahrhunderten der Kaiserzeit. Sie zeigen dagegen hauptsächlich Häuser mit neuen Wasseranschlüssen innerhalb der Altstadt.

BIBLIOGRAPHIE

Bruun, Chr. 1991, *The water supply of ancient Rome. A study of Roman imperial administration,* Helsinki.

Champlin, E. 1982, The suburbium of Rome, *AJAH* 7, 97-117.

Eck, W. 1982, Die fistulae aquariae der Stadt Rom. Zum Einfluß des sozialen Status auf administratives Handeln, *Tituli* IV, 197-225.

Evans, H.B. 1993, *Water distribution in ancient Rome. The evidence of Frontinus,* Ann Arbour.

Grimal, P. 1984³, *Les Jardins romains,* Paris.

Meiggs, R. 1973², *Roman Ostia,* Oxford.

Packer, J.E. 1967, Housing and population in imperial Ostia and Rome, *JRS* 57, 80-95.

Scobie, A. 1986, Slums, sanitation and mortality in the Roman world, *Klio* 68, 399-433.

Wasserversorgung I 1989⁴, *Wasserversorgung im antiken Rom,* München/Wien.

KATHOLIEKE UNIVERSITEIT NIJMEGEN -
VAKGROEP GESCHIEDENIS
POSTBUS 9103
NL-6500 HD NIJMEGEN
NIEDERLANDE

ANMERKUNGEN

[1] Scobie 1986.

[2] Für die Wasserversorgung Roms siehe z.B.: Wasserversorgung I.

[3] Siehe aber Evans 1993.

[4] Champlin 1982, 97.

[5] Bruun 1991, 148 suggeriert, Frontinus Stadtkonzept umfasse das Gebiet innerhalb des 7. Meilensteins an den Wegen.

[6] Grimal 1984.

[7] Packer 1967.

[8] Bruun 1991, 20.

[9] Eck 1982.

[10] Eck 1982.

[11] Die Strecke der Wasserleitung Ostias: Meiggs 1973, 112-113.

Neuere Ergebnisse aus der hydraulischen Untersuchung des Wasserversorgungssystems des antiken Susita (Israel)

Henning Fahlbusch
Bernd Rottgardt

Einleitung

Über die Wasserversorgung der antiken Stadt Susita, hoch das Ostufers des Sees Genezareth im heutigen Israel überragend *(Abb. 1),* hat Peleg (1989) bereits referiert. Ben David (1989) hat darüber einen längeren Aufsatz in Hebräisch verfaßt, dessen Übersetzung durch Peleg (1992) manche ein Detailergebnis zugänglich gemacht hat.

Nicht zuletzt das Interesse an den von Vitruv erwähnten Colluviarien, die uns möglicherweise in Form der

Anbohrungen der Basaltrohre im Verlauf der Druckrohrleitung auch hier in Susita begegnen, ließ den Wunsch reifen, das gesamte Wasserversorgungssystem des einstigen Bischofssitzes einschließlich der Druckrohrleitung genauer zu untersuchen.

Es gelang, die German-Israeli-Foundation als potentiellen Finanzier eines Forschungsvorhabens ausfindig zu machen und die Tel Aviv University und die Fachhochschule Lübeck als Forschungsinstitutionen zusammenzubringen.

Wir sind der Stiftung zu großem Dank verpflichtet, daß sie in der Tat das Vorhaben finanziert hat. Über ein Teilergebnis als Folge der Trassenvermessung und der darauf basierenden hydraulischen Berechnung, soll hier kurz berichtet werden.

Geschichte

Die uns bekannte Geschichte Susitas ist leider sehr kurz, so daß über die historischen Fakten zur Stadt- und Bevölkerungsentwicklung und, damit korrespondierend, des Wasserbedarfes kaum Aussagen möglich sind.

Vermutlich als Festungsanlage im 2. Jahrhundert v.Chr. unter dem Namen Hippos gegründet (Epstein 1967), muß der Ort relativ schnell aufgeblüht sein, so daß er 63 v.Chr. nach der Eroberung durch Pompejus eine der Städte der Decapolis wurde. Unter Herodes gehörte er zum jüdischen Reich, danach zur römischen Provinz Syrien. Glaubt man der These von Tzaferis (1990), so bildeten das 2. und 3. Jahrhundert n.Chr. die höchste Blüteepoche der Stadt.

In byzantinischer Zeit muß das Christentum das tägliche Leben der hier wohnenden Menschen dominiert haben, so daß Susita als regionales Zentrum Bischofssitz wurde.

Die persische Eroberung anfangs des 7. Jahrhunderts ist vermutlich grausam gewesen, dagegen ergaben sich die Einwohner bei der arabischen Okkupation 637 n.Chr., so daß diesmal wohl ein Gemetzel unterblieb (Peleg 1993). Die einheitliche Ausrichtung der umgestürzten Säulen der Basilika wird auf das Erdbeben 747 n.Chr. zurückgeführt. Es hat den Anschein, als sei Susita nach diesem Ereignis als Siedlungsplatz aufgegeben worden.

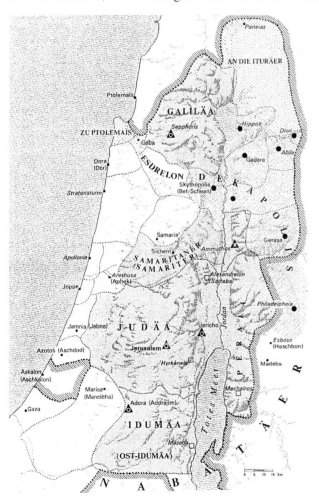

1. Lageplan - Israel mit See Genezareth um 50 v.Chr. (nach Aharoni/Avi-Yonah 1990).

Das Klima im Raum des Sees Genezareth ist semiarid. Im Winterhalbjahr fallen etwa 400 mm Niederschlag, während im Sommer die Sonne vom Himmel brennt und alle Pflanzen verdorrt, wenn sie nicht im Einzugsbereich einer Quelle wachsen oder künstlich bewässert werden.

Das Niederschlagswasser, das nicht direkt abfließt, sickert durch Spalten und Klüfte in der felsigen Deckschicht aus Basalt und tritt über oder in dem nahezu undurchlässigen unter dem Basalt anstehenden weichen Kalkgestein oft konzentriert an den Hängen der einzelnen Täler als Quelle zutage.

Bei einer Fahrt entlang des Ostufers vom See Genezareth nach Norden sieht man zur Rechten hoch am Hang eine Reihe solcher Quellen, die sich vor allem im Sommer und Herbst durch ein üppiges Grün von der ansonsten braunen, vertrockneten Vegetation abzeichnen.

In den Seitentälern gibt es viele weitere kleinere Quellen, die insbesondere für Böschungsbrüche oder sogar große Geländerutschungen der Nordhänge verantwortlich sind. Solche Vorgänge werden vor allem durch Erdbeben initiiert, bei denen das labile Gleichgewicht zwischen antreibenden und widerstehenden Kräften an den Böschungen gestört wird.

Darüberhinaus sprudeln auch eine kleinere Anzahl größerer Quellen. Offensichtlich wurde Ain Fiq, unterhalb des heutigen Kibbutz Afiq gelegen, bereits in der Antike gefaßt und zur Versorgung einer Badeanlage genutzt.

Die Quelle El Adeseh am Südhang des Wadi El Al, unterhalb des heutigen Dorfes Gshur, wies anscheinend schon in der Antike eine reichhaltige Schüttung auf *(Abb. 2)*.

Dasselbe gilt für die Quelle Umm Quanatir, deren Wasser noch heute durch ein Quellhaus, vermutlich aus römischer Zeit, austritt.

DIE WASSERVERSORGUNG DER AKROPOLIS

ALLGEMEINES

Auf der Akropolis sind bisher weder Quellen noch Tiefbrunnen noch umfangreiche Zisternensysteme zur Speicherung von Regenwasser aus der frühen Zeit der Siedlungsgeschichte bekannt. Da wohl auszuschließen ist, daß die ersten Bewohner der Festung das Wasser vom See Genezareth herauftrugen, ist dennoch anzunehmen, daß Niederschlagswasser in Zisternen gespeichert wurde. Vermutlich dürften diese bei einer intensiven archäologischen Untersuchung der Stadt nachgewiesen werden.

Mit Aufblühen der Stadt wird, wie bereits in vielen anderen kleineren und größeren Regionalzentren in der Antike, der Wunsch nach einer Versorgung mit frischem Wasser entstanden sein, und, wie ebenfalls an anderen Orten üblich, es wird versucht worden sein, die nächstgelegenen Quellen zu fassen und deren Wasser an den Burgberg heranzuführen.

In der militärischen Karte der Region im Maßstab 1:50.000 sind bis zu einer Entfernung von maximal vier Kilometer südlich von Susita insgesamt vier Quellen am Osthang des Sees Genezareth auf einem Niveau oberhalb der Akropolis verzeichnet. Es ist daher kaum ein Zufall, daß es Tsuk 1993 gelang, an einer Stelle einen Kanal in einer von Süden kommenden Trasse, die auf den Hügel südlich von Susita zulief, nachzuweisen *(Abb. 2)*.

Ob das Wasser dann von hier bereits in einer Druckleitung aus Basaltrohren auf die Akropolis geleitet wurde, kann derzeit nicht entschieden werden, ist aber durchaus denkbar, da der nachgewiesene und eingemessene Punkt nicht nur deutlich über der höch-Stelle auf der Akropolis sondern auch über dem vermutlichen Einlaufbecken der Druckleitung liegt.

Inzwischen ist noch ein weiterer Punkt dieses Stranges hinzugekommen, so daß vielleicht sogar nach einem Nivellement Aussagen über das Gefälle dieser Südleitung möglich sind.

UNTERER KANAL (U)

Treffen die heutigen Beobachtungen über die Schüttungen der erwähnten Quellen auch für die Verhältnisse in der Antike zu, wovon wir derzeit ausgehen, so dürfte das Wasserdargebot aus dieser Südleitung begrenzt gewesen sein. Es liegt daher nahe, daß die Bewohner eines durchaus bedeutenden Ortes das Geld dafür zur Verfügung stellten, die Wasserversorgung durch den Bau einer weiteren Versorgungsader zu verbessern.

Diese zweite Wasserleitung dürfte der Untere Kanal (U) sein, der im gesamten Bereich zwischen dem Hügel südlich der Akropolis entlang der Hänge bis unterhalb des Dorfes Gshur an einer Reihe von Stellen immer wieder nachgewiesen werden konnte.

Der Querschnitt des Gerinnes *(Abb. 3)* weist eine mittlere Breite von 36 cm auf. Es wäre wünschenswert zu erfahren, auf welches antike System dies etwas ungewöhnliches Maß zurückzuführen ist.

Sohle und Wangen waren verputzt. Auf dem Putz zeigt im Bereich von Mitspe Ofir die Oberkante einer Sinterschicht an, daß die Abflußtiefe hier etwa 19 cm betragen haben dürfte *(Abb. 4)*.

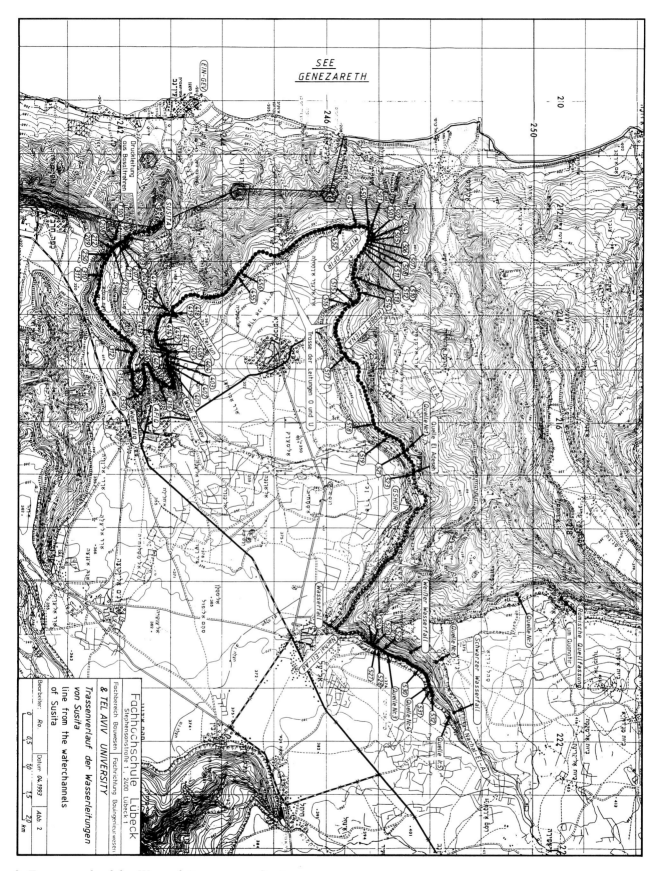

2. Trassenverlauf der Wasserleitungen von Susita.

3. Freigelegter Querschnitt der Unteren Leitung (U).

Unregelmäßige Basaltplatten als Decksteine sollten eine größere Verschmutzung des Wassers verhindern. Da bei solch einer groben Abdeckung natürlich Staub und durch Wind transportierter Sand ins Wasser ge-

langte, sind in gewissen Abständen Sandfänge angeordnet, in denen sich Sedimente und gröbere Schwebstoffe ablagern konnten *(Abb. 5)*. Solche Sandfänge sind nicht ungewöhnlich und z.B. von Rakob (1974) für die römische Leitung von Zaghouan nach Karthago beschrieben.

Die Tatsache, daß dieser Kanal bisher nur für den Bereich zwischen Gshur und Susita erwähnt wurde, ergibt sich aus dem Längsschnitt *(Abb. 8)*. Wenngleich eine antike Quellfassung an dieser Stelle bisher nicht nachgewiesen werden konnte, läßt der Längsschnitt aber vermuten, daß der untere Kanal bei der Quelle El Adeseh unterhalb des Dorfes seinen planmäßigen Anfang gehabt hat.

Der Gradient der Leitung weist von hier bis zum Punkt 316 einen nahezu konstanten Wert von 2 ‰ über eine Länge von mehr als 13 km auf. Im Bereich der anschließenden dreieinhalb km nimmt das Gefälle auf 4.75 ‰ zu, bevor die Leitung quasi als steile Schußrinne zum Einlaufbecken der Druckleitung ausgebildet ist.

Die Frage stellt sich naturgemäß, warum die Bauherren ein derart kleines Gefälle gewählt haben. Beim Blick auf den Lageplan *(Abb. 2)* wird deutlich, daß zum einen die Leitung offenbar oberhalb des Kliffs südlich von Punkt 455 geführt werden sollte. Zum anderen zeigte die örtliche Begehung, daß der gesamte fast zwei Kilometer lange Abschnitt zwischen den Punkten 310 und 312 durch Hangrutsche zerstört worden ist und die Erde sich offenbar noch weiter bewegt. Dies läßt sich aus den Bruchkanten im Belag der heutigen Straße deutlich erkennen.

Auch in der Antike dürfte klar gewesen sein, daß eine Passage eines derart gestörten bzw. gefährdeten Hanges nur oberhalb der entsprechenden Böschungsbruchkanten möglich ist. Daher dürfte es das Bestre-

4. Sinterablagerungen an bergseitiger Kanalwange der Unteren Leitung (U) im Bereich Mitspe Ofir.

5. Sandfang im Verlauf der Unteren Leitung (U).

ben der Baumeister gewesen sein, die Trasse möglichst hoch ins Wadi Afiq einmünden zu lassen.

OBERE LEITUNG (O)

Aus den früheren Untersuchungen im Bereich südlich der Akropolis bzw. Mitspe Ofir war bekannt, daß wenige Meter über der vorher beschriebenen Leitung ein zweiter Kanal ähnlicher Bauart verlief *(Abb. 6)*.

Die Funde zwischen diesen Orten konnten erst nach der Vermessung im Verlauf der Untersuchungskampagne eindeutig den verschiedenen Trassen zugeordnet werden. Demnach gehörten die Punkte 314, 401, 406, 409, 414 und 418 zur Oberen Leitung. Kanalaufwärts von Punkt 510 konnten keine Spuren mehr nachgewiesen werden.

Derzeit wird versucht, durch Interpretation von Satellitenaufnahmen Hinweise auf die Leitung zu erhalten. Die ersten Analysen, ausgehend von sowjetischen Schwarzweißfotos, die mit den Farben von Landsataufnahmen überlagert und dann computer-mäßig variiert werden, sind aber noch nicht erfolgreich verlaufen, vermutlich weil die Auflösung der Bilder noch nicht klein genug ist. In den nächsten Monaten werden neuere Fotos und dann hoffentlich bessere Ergebnisse erwartet.

Im Bereich von Mitspe Ofir konnte die Oberkante der Sinterablagerungen an einer bergseitigen Wange 12 cm über der Sohle eingemessen werden *(Abb. 7)*. Da aber im unteren vier cm starken Bereich über der Sohle offensichtlich tonige Sedimente die Sinteranlagerungen an der Wange verhinderten, dürfte die Abflußtiefe wohl nur acht cm betragen haben.

Wie der Längsschnitt *(Abb. 8)* zeigt, sind die Baumeister bei dieser Oberen Leitung (O) ähnlich vorgegangen, wie bei der Unteren (U). Das Gefälle zwischen Mitspe Ofir und dem Wadi Afiq wurde zu kon-

7. *Sinterablagerungen an bergseitiger Kanalwange der Oberen Leitung (O) im Bereich Mitspe Ofir.*

stant nur 1.1 ‰ festgestellt. Auf den folgenden drei Kilometer ist es mit 3.4 ‰ vergleichsweise steiler ausgebildet, um dann im letzten Abschnitt bis zur Druckleitung wieder eine steile Schußrinne zu sein. Klar erkennbar wird dabei das Bestreben, die Trasse im Vergleich zu der der Unteren Leitung (U) auf deutlich höherem Niveau ins Wadi Afiq einmünden zu lassen und dort zu führen.

Bei einer Extrapolation des Längsschnittes der Oberen Leitung (O) ins Oberwasser mit konstantem Gefälle, entsprechend der Situation der Unteren Leitung (U) und ausgehend von Mitspe Ofir, treffen die Schnittlinien beider Kanäle bei der Quelle El Adeseh zusammen *(Abb. 8)*. Diese Tatsache legt den Schluß nahe, daß beide Leitungen hier, bei ein und derselben Quelle, begonnen haben.

Wie die anschließend erläuterten Ergebnisse der hydraulischen Untersuchungen zeigen, wurde die Leistungsfähigkeit des unteren Kanals bei weitem nicht

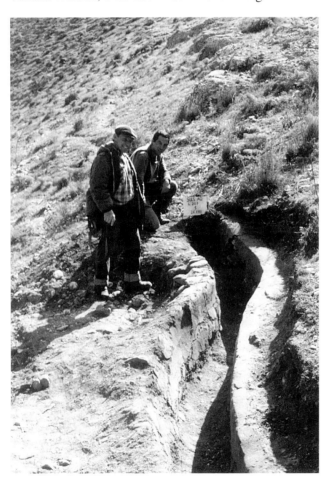

6. *Querschnitt der Oberen Leitung (O) am Hang südlich der Akropolis.*

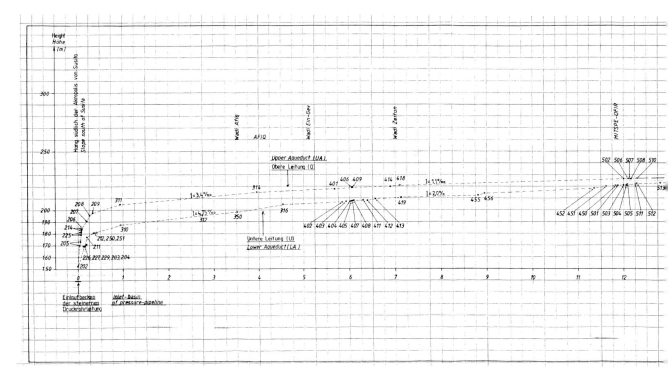

8. Längsschnitt der Wasserleitungen von Susita.

ausgenutzt. Der Neubau eines zweiten Kanals erscheint daher also nur sinnvoll, wenn die bestehende Untere Leitung (U) zumindest partiell zerstört war und nicht repariert werden konnte. Solch eine Zerstörung ist durchaus durch die bereits beschriebenen Böschungsbrüche am Südhang des Wadi Afiq insbesondere als Folge eines Erdbebens zu vermuten. Eine Passage der bruchgefährdeten Bereiche wäre nur durch eine Trassenführung auf höherem Niveau möglich.

HYDRAULISCHE BERECHNUNGEN

Ohne Kenntnis des Kanalgefälles hat Peleg (1989) die maximale Leistungsfähigkeit des voll durchflossenen Querschnitts zu deutlich über Q = 100 l/s für beide Leitungen abgeschätzt.

Die jetzt vorhandenen Meßdaten gestatten hingegen eine deutlich genauere Berechnung des Durchflußes nach Manning/Gauckler/Strickler. Dabei wurden folgende Parameter zugrunde gelegt:

9. Hydraulische Leistungsfähigkeit der Kanäle.

10. Leitungsreste im Nachal El Al.

164

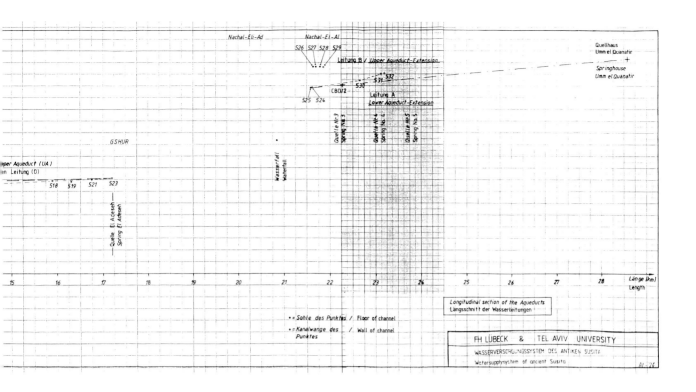

Longitudinal section of the Aqueducts
Längsschnitt der Wasserleitungen

FH LÜBECK & TEL AVIV UNIVERSITY
WASSERVERSORGUNGSSYSTEM DES ANTIKEN SUSITA
Watersupplysystem of ancient Susita

Gerinnebreite	b = 36 cm (Unterer Kanal)
	b = 31 cm (Oberer Kanal)
Rauheitsbeiwert	k = 55 m$^{1/3}$/s
Gefälle	I = 3 ‰ (Unterer Kanal)
	I = 0.9 ‰ (Oberer Kanal)

Nach den Berechnungen lag die Leistungsfähigkeit beider Kanäle in der Tat bei weitüber 100 l/s, wären sie bis zur möglichen Abflußtiefe von etwa 70 cm durchflossen gewesen. Die tatsächliche Abflußtiefe konnte, wie erwähnt, aufgrund der Sinterablagerungen wie folgt festgestellt werden:

Abflußtiefe h = 19 cm (Unterer Kanal U)
 h = 8 cm (Oberer Kanal O)

Unter Berücksichtigung dieser Werte ergibt sich gemäß *Abb. 9* für die Untere Leitung (U) ein Durchfluß von etwa Q = 42 l/s und für die Obere (O) eine Zahl von knapp Q = 5.8 l/s.
Folgt man dem vorher geäußerten Gedanken, daß das Wasser der Quelle El Adeseh im Oberen Kanal nach Zerstörung des Unteren nach Susita geleitet wurde, so zeigen die Ergebnisse der hydraulischen Berechnung, daß der Abfluß in der späteren Leitung (O) im Vergleich zu dem der Leitung (U) kleiner geworden ist. Dies kann durchaus die Folge des vermuteten Erdbe-

bens gewesen sein.
Sollte sich die Schüttung der Quelle hingegen nicht geändert haben, muß zusätzliches Wasser von anderer Herkunft im älteren Unteren Kanal (U) nach Susita geleitet worden sein.

LEITUNGEN IM OBEREN NACHAL EL AL

Bereits von Ben David (1989) wurden am Osthang im oberen Nachal El Al unterhalb des Kliffes in schwer zugänglichem Gebiet, das ebenfalls durch zahlreiche Böschungsbrüche charakterisiert ist, zwei übereinander liegende Leitungsabschnitte z.T. auf Stützmauern festgestellt *(Abb. 10)*. Ihre Kote liegt um 76 m bzw. 95 m über der des Kanals beim Dorf Gshur *(Abb. 8)*. Nach den bisherigen Erfahrungen dürfte es sich bei der tieferen um die ältere (A), bei der höheren um die jüngere Leitung (B) handeln.
Wegen des sich aus dem unterschiedlichen Niveau der Kanäle bei Gshur bzw. im Nachal El Al ergebenden großen Gefällesprunges war nicht sicher, ob die letzteren Kanalreste zur Leitung nach Susita in Beziehung gebracht werden konnten. Das Ergebnis der Vermessung belegt aber ein eindeutiges Gefälle in Richtung Süden, somit in Richtung auf Gshur und damit die Trasse nach Susita. Allerdings konnte die Verbindung mit den bisher besprochenen beiden Kanälen

nicht nachgewiesen werden.

Prinzipiell ist die Überwindung eines solchen Gefällesprungs im Heiligen Land nichts Ungewöhnliches. Garbrecht/Netzer (1991) haben solch eine Verbindung zwischen einem hoch- bzw. niedrigliegenden Trassenast bei der Versorgungsleitung der Hasmonäerpaläste in Jericho aus dem Wadi Quelt bereits für die antike

11. *Quellfassung Umm Quanatir nach Schumacher (1888).*

Leitung nachgewiesen. Und auch heute noch wird dort das Wasser eines Bewässerungskanals in einer Schußrinne über rund 40 m Höhe in der Fallinie ins Tal geleitet. Der Längsschnitt der zweite Trasse in demselben Versorgungssystem von Ein Auja weist einen Sprung von ca. 13 m auf, um das Wasser in die Leitung, die von den Na'aranquellen gespeist wird, einzuleiten.

Letztere Situation ist auch für die Verbindung der Leitungsabschnitte aus dem Nachal El Al mit einem vielleicht ins Oberwasser verlängerten Kanal ausgehend von der Quelle El Adeseh vorstellbar. Schumacher (1888) weist in seiner Karte auf eine alte Wasserleitung im fraglichen Abschnitt hin, jedoch konnte diese Angabe bisher im Gelände nicht verifiziert werden.

Dennoch bleibt die Frage offen, woher das Wasser der Leitung im Nachal El Al genommen wurde. Bisher wurde angenommen, daß Wasser aus dem Quellgebiet nordöstlich des Schwarzen Wasserfalls in den Kanal eingespeist worden ist. Allerdings war es offensichtlich das Bestreben der Baumeister in der Antike, nach Möglichkeit einzelne Quellen zu fassen und deren Wasser zur Versorgung der städtischen Bevölkerung zu nutzen.

Bei einer Verlängerung der Trasse um nur gut fünf Kilometer ins Oberwasser, ausgehend von Punkt 532, ist die Quellfassung Umm Quanatir auf korrespondierender Höhe bekannt. Nach den Erfahrungen bei ähnlichen antiken Kanälen erscheint daher nicht ausge-

schlossen, daß die von Schumacher dort aufgenommene Quellfassung *(Abb. 11)* mit dem Kanal im Nachal El Al in Verbindung gebracht werden kann.

Diese Quellfassung ist nach Ansicht von Baugeschichtlern vermutlich in römischer Zeit gebaut worden. Sie ist daher deutlich älter als die große Synagoge des Ortes in unmittelbarer Nachbarschaft, die ins 5. Jahrhundert n.Chr. datiert wird.

Nach diesen hypothetischen Überlegungen dürfte also das Wasser in der Unteren Leitung (U) nicht nur von der Quelle El Adeseh sondern auch möglicherweise von Umm Quanatir über einen vergleisweise hoch gelegenen Leitungsast (A) im Nachal El Al nach Susita geleitet worden sein.

Wird die zuvor angenommene These akzeptiert, daß ein Erdbeben die Böschungsbrüche und damit die Zerstörung der Leitung im Wadi Afiq verursacht hat, so dürfte dies Ereignis auch zu großen Rutschungen im Nachal El Al mit gleicher Wirkung auf die Wasserleitung geführt haben. Im Gelände sind heute noch deutlich die Spuren solcher Erdrutsche erkennbar *(Abb. 12)*.

Wie der archäologische Befund belegt, ist auch hier versucht worden, den Kanal entsprechend der Oberen Leitung (O) auf höherem Niveau neu zu erstellen. Sollte dieser Ast (B) aber an letztere (O) angeschlossen werden, so zeigt das Ergebnis der hydraulischen Berechnung, daß diese Verbindung entweder gar nicht oder nur für kurze Zeit existiert hat, denn sonst hätten die Sinterablagerungen im Oberen Kanal (O) eine größere Abflußtiefe andeuten müssen.

Wird wiederum angenommen, daß die Zerstörung dieser Leitung (B) ebenfalls durch ein Erdbeben erfolgt ist, so dürfte der zeitliche Abstand zwischen beiden Ereignissen nicht sehr groß sein.

Nach den Ausführungen von Kallner-Amiran (1950/-51) gibt es in der Mitte des vierten Jahrhunderts

12. *Spuren von Hangrutschungen östlich von Geshur Hippos (Susita).*

n.Chr. F⌐ lbeben in Palestina in den Jah-
ren 34⌐ .Chr., 365 n.Chr und mögli-
cherwei⌐ Die Ereignisse, insbesondere
das 2.⌐ und das 3. von 365 n.Chr.
könnter⌐ haus mit den Leitungszerstö-
rungen in Verbindung gebracht werden.
Sind die vorher geäußerten Hypothesen richtig, dann
dürfte gegen Ende des 4. Jahrh. n.Chr. kein Wasser
mehr von Umm Quanatir nach Susita geleitet worden
sein. Es hätte daher für eine örtliche Nutzung voll zur
Verfügung gestanden.

ZUSAMMENFASSUNG

Das antike Susita wurde in römischer Zeit nacheinan-
der durch verschiedene Kanäle mit Wasser versorgt.
Zur Ergänzung des Zuflußes aus der Südleitung wur-
de vermutlich das Wasser der Quelle El Adeseh ge-
faßt und in einem Kanal nach Susita geleitet. Nach-
gewiesene Leitungsreste bezeugen die Existenz wei-
terer Kanäle.
Die Vermessung der Trassen hat ergeben, daß die
Obere Leitung (O) vermutlich die Untere (U), die

durch Böschungsbrüche als Folge eines Erdbebens
zerstört worden sein dürfte, ersetzt hat. Dabei wird
dieselbe Quelle El Adeseh unterhalb des Dorfes
Gshur Ausgangspunkt des Kanals gewesen sein.
Die hydraulische Berechnung des Abflußes in den
Kanälen hat ergeben, daß der Untere Kanal (U) zu-
sätzlich von einer weiteren Quelle versorgt wurde.
Dafür kommt die Quelle Umm Quanatir infrage, de-
ren Wasser über den unteren Leitungsabschnitt (A) im
Nachal El Al geleitet worden sein dürfte.
Dasselbe Ereignis, das die Untere Leitung (U) zer-
stört hat, dürfte auch entsprechende Schäden bei der
Leitung (A) verursacht haben. Nach dem archäologi-
schen Befund und der hydraulischen Berechnung
wird der zweite Ast (B) im Nachal El Al nicht oder
nur für sehr kurze Zeit an die Obere Leitung (O) an-
geschlossen gewesen sein.
Mitte des 4. Jahrhunderts gibt es Hinweise auf zeit-
lich eng beieinander liegende Erdbeben, die die Zer-
störungen verursacht haben könnten.Sind diese Über-
legungen richtig, dürfte das Wasser von Umm Qua-
natir zur örtlichen Nutzung im 5. Jahrhundert n.Chr.
zur Verfügung gestanden haben.

BIBLIOGRAPHIE

Aharoni Y./M. Avi-Yonah 1990, *Der Bibelatlas,* Augsburg.
Ben David, Ch. 1989, Die Wasserleitung von Susita, *Antike Wasserleitungen in Eretz Israel,* Jerusalem, 133-140 (hebräisch übersetzt von Peleg, J. 1992)
Epstein, C. 1976, Hippos (Sussita), *Encyclopedia of Archaeological Excavations in the Holy Land,* Jerusalem, 521-523.
Garbrecht G./E. Netzer 1991, Die Wasserversorgung des geschichtlichen Jericho und seiner königlichen Anlagen (Gut, Winterpaläste), *MInstWasser* 115, Braunschweig/Jerusalem.
Kallner-Amiran, D.H. 1950-51, A revised Earthquake-Catalogue of Palestine, *IsrExplJ* 1 4, 223-246.

Peleg, J. 1989, Die Wasserleitungen nach Hippos und ihr Steindüker, *MInstWasser* 103, Braunschweig, 323-336.
Peleg, J.: mündliche Kommunikation 1993.
Rakob, F. 1974, Das Quellheiligtum in Zaghouan und die römische Wasserleitung nach Karthago, *RM* 41-88.
Schumacher, G. 1888, *The Jaulan,* London.
Tsaferis, V. 1990, The largest archaeological site on the east bank of the Sea of Galilee was once a thriving city of the Decapolis awaits the spade, *Biblical Archaeological Review,* 50-58.

FACHHOCHSCHULE LÜBECK
STEPHENSONSTRASSE 3
D-2400 LÜBECK
DEUTSCHLAND

167

Incrustations at the Castellum Divisorium at Nîmes

Paul Kessener

The aqueduct of Nîmes is probably best known for the Pont du Gard. The aqueduct was built at about 19 BC, and ran from the Source d'Eure near the modern Uzès to Nîmes. It is some 50 km long. The aqueduct ended in a *castellum divisorium,* which is situated only 17 m below the source at Uzès. The *castellum* was originally excavated by Pelet in 1844, who found remains of paintings with fish and dolphins on the wall surrounding the *castellum.* The *castellum* is said to have served as a kind of ornate pavilion, apart from its function as a distribution device.[1] It is presently located at the Rue de la Lampèze, a hilly street in the northern part of Nîmes not far from the centre.

The *castellum* consists of a circular basin of 5.5 m in diameter and 141 cm deep. The wall of the basin is equipped with 10 large circular holes, through which the water flowed to the city in lead pipes. These pipes had an inner diameter of about 30 cm *(Fig. 1).*[2] The floor of the *castellum* shows three orifices (inner diameter 44 cm) that could be closed off presumably by stone lids. The three orifices correspond to a single discharge channel possibly serving a *naumachia.*[3] The water entered the basin through a rectangular opening more or less opposite from the circular holes *(Fig. 2).* The rectangular opening is the so called entrance channnel, which is in fact the very end of the Nîmes aqueduct, and to which the attention of the reader will be drawn.

The entrance channel is 120 cm wide and 127 cm high. It is covered by a large stone slab, which is part

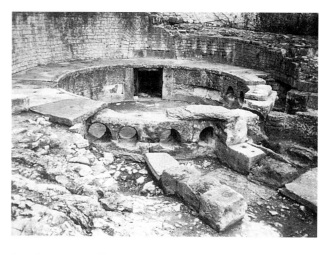

2. *Nîmes castellum. Water entered the circular basin through the rectangular opening in the back.*

of the pavement surrounding the basin. *Fig. 2* shows the stone slabs of the surrounding pavement. One may recognize the holes that were used for lifting the stone slabs into their present position. The covering stone of the entrance channel is, apart from a similar lifting hole and a hole associated with the metal ballustrade that originally surrounded the basin, equipped with an additional 8 holes, which may be seen when looking at the stone from above *(Fig. 3).* There are 2 round holes perforating the covering stone (8 cm in diameter and 120 cm apart), and 6 rectangular holes (about 5 x 5 cm) in a row in between these

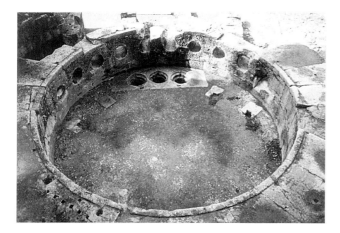

1. *The castellum divisorium as seen from above the entrance channel.*

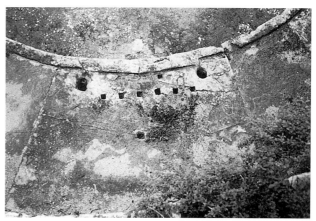

3. *Detail of covering stone of entrance channel, seen from above. Basin in upper part of picture.*

2 round holes, but a bit further away from the outer edge of the covering stone. The imaginary lines in between the centers of the round holes and of the rectangular holes run parallel (separated by a distance of about 10 cm). The 2 round holes correspond to 2 vertical grooves in the side walls of the entrance channel. These grooves are some 7.5 cm wide and 3 cm deep, and extend to the floor of the channel. In the floor of the channel the vertical grooves are connected by a third and narrower groove. The groove in the floor contains a lead rim (about 1.5 cm thick), being the remains of the lead seal which was attested for by Pelet.[4]

The 2 round holes in the covering stone, the corresponding vertical grooves in the side walls, and the lead rim in the floor have been explained to the extent that the entrance channel was equipped with a kind of double sluice gate. One part is thought to have been fixed to the floor and sealed off by means of the lead seal, the other part moving up and down behind it. In the reconstruction of Stübinger *(Fig. 4)*, the movable plate was operated by means of a windlass mounted on the stone pavement, the connecting cables or chains passing through the two round holes. The six rectangular holes are thought to have been equipped with metal rods sticking in the channel from above, serving as a grill. Several explanations of the purpose of the arrangement have been suggested in the past.

Pelet thought that the sluice gate was meant to close off the aqueduct entirely: "Cette disposition indique évidemment l'existence d'une vanne à fermer l'aqueduc".[5] But why close off an aqueduct at its very end, causing the aqueduct to overflow upstream with the danger of damaging the entrance channel? It would be wiser and easier to divert the water at an upstream location if one wishes to stop the flow of water into the *castellum*.

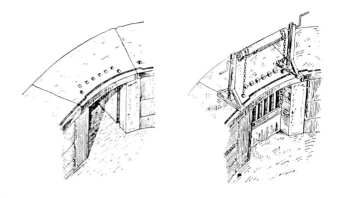

4. Reconstruction of the entrance channel equipped with double sluice gate operated by a windlass (Stübinger 1909, 279).

Hodge on the other hand suggested that the sluice gate was moved up and down as to create turbulence inside the channel as a means for clearing the channel from debris. The sluice gate also could act as a measuring device for the amount of water delivered to the *castellum*, the depth of flow over the top of the gate being a measure of the the discharge, but, as Hodge correctly remarked, one does not need a variable gate for that.[6]

Hauck discussed the possibility that the arrangement served as a measuring device for the discharge by means of a submerged orifice, possibly under constant head (constant water pressure) *(Fig. 5)*, the position of the movable plate being an indication for the discharge,[7] an opinion that is essentialy shared by Fabre.[8]

Thus there are several explanations of the arrangement, which do not appear to be consistent with each other, and, in one way or another, leave many questions unanswered. There is no clear consensus of what

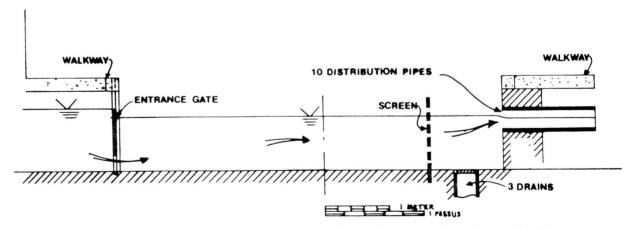

5. Reconstruction of Hauck (1987, 396): measuring the discharge by means of a submerged orifice.

the sluice gate was constructed for nor how it was operated. None of the explanations, however, have taken into account the exact shape of the incrustations inside the channel. It will be shown in the following discussion that these incrustations allow detailed conclusions about the construction and function of the arrangement with which the entrance channel was equipped.

Roman aqueducts are generally known to be heavily incrusted due to the Roman preference for hard water.[9] The incrustations (sinter) inside the Nîmes aqueduct measure up to thicknesses of more than 45 cm, thereby heavily interfering with the capacity of the channel.[10] Incrustations on all sides of aqueduct channel in a continuous layer, including the underside of the top covering, are known to exist, e.g. in the cource of the Aqua Marcia near the Rocca di Papa, and the Annio Novus at Ostoriola. This is a sure sign that at

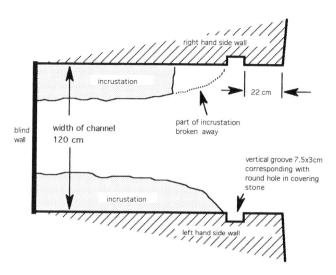

7. Horizontal cross-section of entrance channel, at medium heigh (± 60 cm). Incrustation on side walls, some 17 cm thick (in drawing exaggerated), extend from vertical groove up to (and beyond) blind wall.

some instance the channel ran completely full due to insufficient capacity.[11] During the middle ages the calcareous substance composing the incrustations was sometimes used as building material. The incrustations of the Köln aqueduct were of such high quality that they were exported as substitution for marble.[12]

A closer look at the entrance channel (Fig. 6) reveals the thick layers of calcareous incrustation on the side walls and on the underside of the covering stone. Part of the incrustation on the east side wall (up to 75 cm from the beginning of the channel) has been broken away in the past, but a similar shape of the incrustations on either side wall may be assumed for reason of the symmetrical form of the incrustations on both side walls further up inside the channel. There is, however, not much incrustation to be seen on the floor of the channel just behind the lead rim. Moreover, the incrustations on the side walls and covering stone do not form a continuous mass. They are separated at the edges, shaped as 3 cushions side by side, 2 hanging on the side walls, and 1 hanging from the underside of the covering stone, touching each others at the corners. The maximum thickness of the incrustations is about 17 cm on the side walls as well as on the covering stone. This suggests for one thing that the side walls and the underside of the covering stone were simultaneously and for equal time spans in contact with the water flowing inside the channel.

The incrustations on the side walls extend inside the channel up to a blind wall, which prevents further inspection, some 2 m from the beginning of the chan-

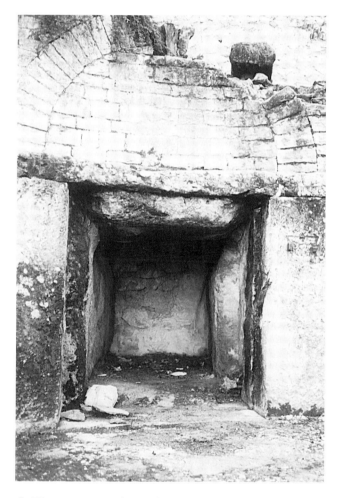

6. The entrance channel of the Nîmes aqueduct into its castellum divisorium. The heavy incrustations on side walls and underside of covering stone are easily observed.

nel. This wall was probably built in connection with the construction of the 'Ancien Citadel' in 1685, which destroyed most of the arriving aqueduct. (Inside the citadel, where at present extensive building activities are executed, no remains of the aqueduct channel could be traced by the author). *Fig. 7* shows a horizontal cross section of the channel, at medium height. The incrustations extend from the vertical grooves up to the blind wall, and surely no incrustations are to be expected in the vertical grooves if something has been moving up and down inside the grooves.

The calcareous incrustation on the underside of the covering stone, as shown in vertical cross section along the longitudinal axis of the channel *(Fig. 8)*, does extend beyond the plane of the vertical grooves. The thickness is actually largest at the plane of the grooves. Therefore, if something has been moving up and down in the vertical grooves, it was never moved up all the way to the covering stone, since there is no interference with the formation of calcareous deposits. Moreover, the incrustation does not extend up to the blind wall, but it takes a natural end at about 130 cm from the beginning of the channel. Apparently only the first 130 cm of the covering stone have been in contact with the water flowing in the channel, this in contrast to the side walls. Furthermore, there are no holes in the incrustation on the underside of the covering stone corresponding with the six rectangular holes. Actually these six rectangular holes are as deep

as the thickness of the covering stone. Their bottoms are formed by the incrustation material. Something has been sticking in these holes, but not through these holes: we must doubt the existence of a grille as suggested by Stübinger. Also on the floor of the channel there is no incrustation in the area just behind the lead rim, while further inside the channel incrustation may be noted, gradually increasing in thickness to some 10 cm at about 60 cm away from the lead rim.

Summarizing:
1. The absence of incrustations in the vertical grooves suggests that something indeed has been moving up and down in the grooves.
2. The lead rim in the floor, still present, suggests that some part of the arrangement was sealed off, and consequently not movable.
3. The movable part was never pulled up all the way to the covering stone.
4. Because of the observed incrustations and their equal thicknesses, it is clear that the side walls and covering stone have been in contact with the water flowing inside the channel simultaneously and for equal time spans. We must also doubt the existence of a grille as suggested by Stübinger.
5. In view of the separation between the incrustations on side walls and on the underside of the covering stone, we may assume that these were formed separately, while there was no incrustation formed on the floor inside the channel in the area just behind the lead rim in the floor.

From points 1 and 2 we have additional arguments that the entrance channel was indeed equipped with a double sluice gate, the arrangement as described by Pelet. Now we have to see how this sluice gate was operated in accordance with points 3 to 5. From this we maybe are able to deduce why it was operated in such way, and what function it was meant to have.

Let us imagine a newly built aqueduct of Nîmes just put into operating condition with the entrance channel equipped with the double sluice gate. Let us assume that the water is pouring over the top of a lowered gate into the *castellum*, the water level in the *castellum* being low. The depth of flow over the gate is a measure of the discharge.[13] If the sluice gate were to be pulled up to a new height, the water merely would pond up behind the gate, untill it again poured over the gate, the depth of flow being the same after equilibrium was reached. If the gate were pulled up further, the free surface of the water flowing inside the channel would at some instance reach or touch the underside of the covering stone. If the gate were pulled up

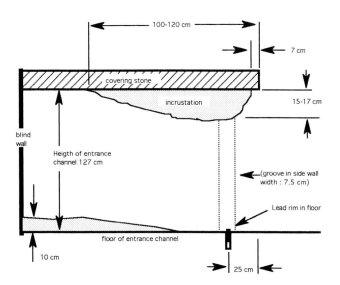

8. Vertical cross-section of entrance channel parallel to longitudinal channel, in middle region of channel. Incrustation on underside of covering stone extending from 7 cm up to 130 cm from the outer edge of the covering stone. Maximum thickness (in drawing exaggerated): 15-17 cm.

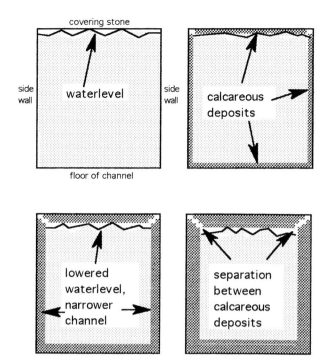

9. *Successive stadia of incrustation on side walls and underside of covering stone of the entrance channel of the aqueduct of Nîmes into its castellum divisorium in case the water level in the entrance channel is kept at a level just reaching the underside of the covering stone by means of operating the movable sluice gate (not shown).*

even higher, the channel would be completely filled with water, and the aqueduct would start to overflow somewhere upstream. We would in that case expect incrustations to be formed in a continuous layer on side walls and underside of the covering stone. But, as we have seen, this is not the case.

If, however, the sluice gate was operated in such way that the water surface just reached the underside of the covering stone, turbulences occurring more readily in the middle section of the channel due to the larger velocity of the water in this part would cause the underside to get wet preferably in the middle part. In the upper left hand part of *Fig. 9*, which depicts a vertical cross section of the newly built channel just behind the sluice gate inside the channel, the water just touches the covering stone. The sluice gate itself is not shown.

After a sufficient time a layer of calcareous deposits will have been formed on side walls and underside of the covering stone. Hereby the effective area through which the water is able to pour into the *castellum* will be reduced. The sluice gate has subsequently to be lowered as to avoid impairment of the discharge and to prevent overflow upstream. Consequently, the upper ends of the side walls are no longer in contact with the water, and incrustations will stop to be formed there. On the other hand, because of the incrustations on the side walls, the channel has become a bit narrower. The area of the underside of the covering stone that is liable to get wet and incrusted has also become narrower. This process repeats itself in time, and the result is that incrustations in the very corners of the channel are prevented. Also, due to ponding of the water behind the gate, debris and dirt would tend to accumulate behind it and settle on the floor of the channel, thereby preventing incrustations to be formed on the floor proper.

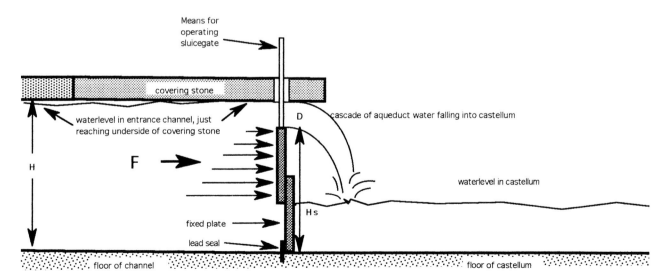

10. *Reconstruction of the double sluice gate at the Nîmes castellum. Water pressure onto movable gate increases with depth (low water level in castellum).*

Table 1

Material of plates	Weight of plate (kgf)	μfr	Friction force (kgf) (min/max)	Force needed for pulling plate upward (kgf)	Force needed for pushing plate downward (kgf)
Wood	15	0.2 *)	60 - 95	75 - 110	45 - 80
Lead	240	1.0 **)	300 - 470	540 - 710	60 - 230

*) For wood on wood, wet condition (see R.C.Weast, Handbook of Chemistry and Physics, CRC, Cleveland Ohio, 1972).

**) For lead on lead, wet condition (observation by author).

Assuming that the sluice gate was operated in this way, we are able to explain the typical separation of the incrustations in the corners of the channel, and the absence of incrustations on the floor of the channel behind the sluice gate. We are also able to understand that, as the water pours over the top of the gate, the underside of the covering stone will be in contact with the water at the position of the gate: thus calcareous deposits on the underside of the covering stone will be formed beyond the plane of the vertical grooves. This is in contrast with the side walls. And, due to the continuous lowering of the water level inside the channel, only a limited and diminishing area of the underside of the covering stone will be in contact with the water and thus become incrusted. So now we may reconstruct *(Fig. 10):* the sluice gate was lowered and raised from above according to the daily discharge of the aqueduct in such way that the free surface of the water just reached the underside of the covering stone, which became increasingly incrusted over time.

Now that we have seen the way in which the double sluice gate operated, we have to answer the question: how, and why, was it done? In the reconstruction of Stübinger *(Fig. 4)* the movable plate was thought to be operated by means of a windlass. Is this realistic? When we examine the forces acting on the gate with a low water level in the *castellum,* we see that the water pressure onto the movable gate increases with the depth in the water. The total horizontal force pressing onto the movable gate may be calculated, and is quite considerable: up to 470 kgf for the aqueduct running at full capacity.[14] Due to this force there will be considerable friction in between the movable and the fixed plate when trying to operate the sluice gate. If the movable plate is to move down by itself, that is by gravity (as in the reconstruction of Stübinger), the weight of the movable plate must be greater than this

friction force. Two probable options for the material of the sluice gates are wood and lead, and the friction force may be calculated for either situation. In both cases the friction force is greater than the weigth of the movable gate *(Table 1).*[15] Thus the gate has to be forced down in order to lower it, the forces required

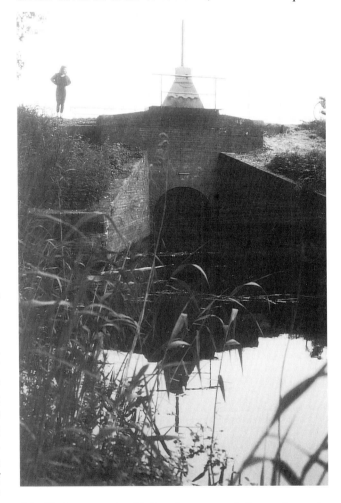

11. Sluice gate in Holland, operated from above by means of a geared contraption.

174

ranging from about 45 to 230 kgf, depending on the material and the depth of flow over the gate. Forces may even become greater in case the movable plate gets stuck in the grooves by misalignment or debris. The material of choice would probably be wood because of its stiffness. The lead plates (especially the fixed plate) may be subject to bending due to the large forces exerted on them by the water pressure in case the water level in the *castellum* is low (e.g. when the *castellum* is drained through the 3 large holes in the floor). Impairment of proper functioning of the sluice gates would be the result. Moreover, for the wooden plates the forces required to operate the sluice gate would be limited to 45-110 kgf.

The situation of having to force a sluice gate downward is not uncommon today, as we can see in *Fig. 11*. This sluice gate in Holland is operated from above by means of a geared contraption on top of the gate. The iron sluice gate is forced downward by means of a worm drive. Metal gearing constructions of this size, and that were able to handle forces of such magnitude, are not known from Roman times. But the Roman engineer knew very well how to work with lever beams. A levering mechanism reduces the forces of the operator according to the proportions of the lengths of lever arms. When lifting a load, the support or rotation point for the lever beam must, of course,

be able to with stand the weigth of the load as well as the force exerted by the operator. Otherwise the support would be pushed down or crushed. On the other hand, if we want to push something down, this rotation point must be able to withstand a similar force directed upward. If the sluice gate was to be operated by means of a lever mechanism, a (perforated) stone slab would do perfectly for support when pulling up, lifting, the sluice gate. When lowering the sluice gate however, the stone slab should be able to withstand a considerable force directed upward. Thus, if we do not wish to lift or turn over this stone, instead of lowering the movable plate, the perforated stone must be fixed tightly onto to the covering stone. (This applies also for any other operating mechanism mounted on the covering stone.)

Connections in between stone blocks were known and widely used in Roman times, e.g. in the form of an iron or bronze bar extending into a hole cut in each block and fixed by molten lead poured and hammered around it. Requirements in reliablity of such connection between the perforated stone and the covering stone were high in view of the daily use of the lever mechanism and the forces required. The designers surely would not limit themselves to one connection only. The six rectangular holes in the covering stone could very well serve such purpose. The holes would

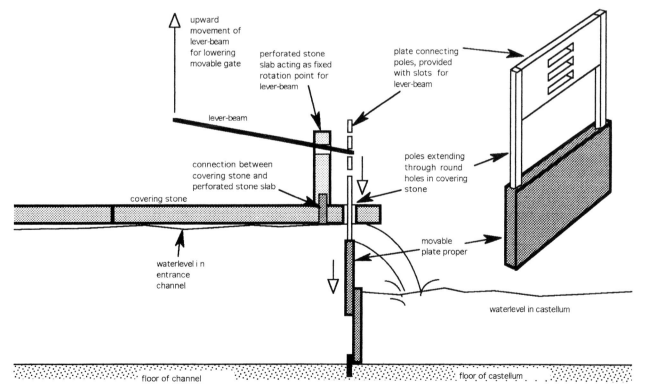

12. Reconstruction of operation of movable plate by means of lever mechanism. Fine adjustments in position of the movable plate could thus be realized.

enable six separate connections in a row, while the horizontal distance in between the rectangular holes and movable gate is about 10 cm. Thus the total length of the lever beam would be limited to some 100-120 cm, if we assume that 5-10 kgf is a convenient force for the *castellarius* to handle, allowing for fine adjustments of the sluice gate.

Fig.12 shows the reconstruction of the sluice gate, complete with its operating lever mechanism. Two poles were sticking through the round holes in the covering stone. These poles were connected to the movable plate below it, and interconnected above it, e.g. by a wooden plate equipped with slots. A perforated stone slab fixed to the covering stone by means of the six rectangular holes served as support for one or more lever beams.

By operating the sluice gate in the way described above, one could actually see the water pouring into the *castellum* at all times and under all conditions of varying discharge. This was pleasant to the eye, and the *castellum* is said to have been an ornate pavilion, visited by the public admiring such object of civic pride.[16] But it could also serve as an elegant device for monitoring the discharge of the aqueduct: the depth of flow D and the height of the gate Hs are related: D+Hs=H, H being the height of the channel. The higher the sluice gate is raised, the lower the discharge. The height of the poles sticking out above the covering stone is a direct indication for the discharge of the aqueduct, and was possibly compared with a fixed measuring rod mounted on the covering stone as a gauge. Any changes in discharge were easily noted and quickly reacted upon by the *castellarius*. Easy to be observed and understood by the visitor, who could actually see for himself how much water was delivered to the *castellum,* and subsequenly to the city where he lived.

BIBLIOGRAPHY

Fabre G./J.-L. Fiches/J.-L. Paillet 1991, *l'Aqueduc de Nîmes et le Pont du Gard, Archéologie, Géosystème et Histoire,* Conseil général du Gard.

Grewe, K. 1992, *Aquädukt-Marmor,* Stuttgart.

Hauck, G.F.W./R.A. Novak 1987, Interaction of Flow and Incrustation in the Roman Aqueduct of Nîmes, *Journal of Hydraulic Engineering* 113, 141-157.

Hauck, G.F.W./R.A. Novak 1988, Water Flow in the Castellum at Nîmes, *AJA* 92, 393-407.

Hauck, G.F.W. 1989, The Roman Aqueduct of Nîmes, *Sc. Am.,* March, 78-84.

Hodge, A.T. 1984, How did Frontinus measure the Quinaria?, *AJA* 88, 205-216.

Hodge, A.T. 1992, *Roman Aqueducts and Water Supply,* London, 1992.

Liberati, A.M./R. de Rosa 1987, *Gli Acquedotti di Roma,* Rome.

Pelet, A. 1876, *Description des Monuments Grecs et Romains,* Nîmes.

Stübinger, O. 1909, Die Römischen Wasserleitungen von Nîmes und Arles, *Zeitschrift für Geschichte der Architektur,* Beiheft 3, Heidelberg.

Urquhart, L.C. 1940, *Civil Engineering Handbook,* New York.

[1] Pelet 1874.
[2] Hodge 1992, 288 n. 31.
[3] Hodge 1992, 289.
[4] Hodge 1992, 287 n. 26.
[5] Hauck 1988, 397.
[6] Hodge 1984, 216.
[7] Hauck 1988, 400; 1989, 83.
[8] Fabre 1991, 130.
[9] This is not true for all Roman aqueducts. The aqueducts of Lyon are a notable exception (Burdy, personal communication).
[10] Hauck 1987.
[11] Liberati 1987; Hodge 1992, 413 n. 8.
[12] Grewe 1992.
[13] The discharge Q over a sharp crested weir is a function of head H over the weir, the length L of the weir, and weir factor K (which is determined by the head H and the height of the weir): $Q = K \times L \times H^{3/2}$ (Urquhart 1940, 305). The discharge of the Source d'Eure at Uzès at the beginning of the aqueduct is assumed to have been ranging from 210 to 450 l/sec (Hauck 1988, 396). The calculated corresponding heads (depths of flow, disregarding surface contraction) over the sluice gate of the Nîmes *castellum* are 20 and 35 cm respectively.

VAN SLICHTENHORSTSTRAAT 13
NL-6524 JH NIJMEGEN
THE NETHERLANDS

[14] Assuming the plate being 60 cm high and 120 cm wide, this force (in kgf) equals to

$$0.12 \cdot \int_{D}^{D+60} H dH,$$

D being the depth of flow (in cm) over the sluice gate (neglecting surface contraction).
For a minimum and maximum depth of flow over the sluice gate of 20 and 35 cm, this force amounts to 300 and 470 kgf respectively.
[15] The friction force Ffr between two bodies is a function of the force F with which these two bodies are pressed against each other: Ffr = µfr x F, where µfr (the friction coefficient) depends on the characteristics of the material of the bodies. For plate dimensions of 120 x 60 x 3 cm, the friction force and the forces needed to operate the sluice gate, for minimum and maximum depths of flow over the gate, may be calculated as presented in *Table 1*.
[16] Hodge 1992, 285.

Systems of Water Control - The Evidence of some African Castellae

Simon Ellis

This paper re-examines the functions of a *castellum aquae* on the basis of examples found in North Africa, most notably the author's recent excavations at Carthage. It suggests that different architectural forms of *castella* represent different solutions to the problem of distributing water to the cities. Discussion will concentrate on the archaeological evidence and consider what evidence there is in the physical remains that proves that the structure carried out the functions ascribed to them.

THE FUNCTION OF A CASTELLUM

The form of *castellum* with which I am concerned is sometimes known as a *castellum divisorium;* a building which divides the flow of water into several channels. It was a building with a purely practical function - to separate a single flow of water into several channels.

The more control that could be exercised over the amount of water entering each channel the more efficiently would the overall supply of water be used. The gains in efficiency would result from the ability to divert surplus water to areas of shortage, setting priorities for supply, and avoiding drought or glut in different parts of the city.

The Romans soon realised that one way of controlling the population of a city was to control its water supply. They expended enormous effort bringing the water supply to the city. In this the aqueduct system resembles the administration of the *annona* which was developed to bring grain to the people of Rome. The *annona* was designed to keep the people contented and avoid civic disturbance. In many ways aqueducts fulfilled the same purpose. The use of aqueducts allowed government to keep the citizens amused, by the provision of public baths, fountains and other diversions.

Controls were necessary when aqueduct flow varied, especially when there was too strong a flow after very heavy rains, or 'monsoon' conditions. But there seems little direct evidence in texts to suggest how the Romans coped in these conditions. The provision of secondary *castella,* or large water tanks, at points of distribution within the towns, as at Pompeii, may have served to even out minor variations of supply, but there is little clear evidence as to how the Romans coped with massive fluctuations.

It was not of course possible to simply turn off the flow of an aqueduct. The flow had to be redirected or else it would simply back up along the channel of delivery. If an exit from a *castellum* was blocked off it would by necessity lead to a relative increase in supply to the other exits. If the main entrant to the *castellum* was restricted the flow would have to be run off, further up the aqueduct.

THE CARTHAGE CASTELLUM

The Carthage *castellum (Figs. 1 and 2)* was located just outside the fifth century AD town walls on the

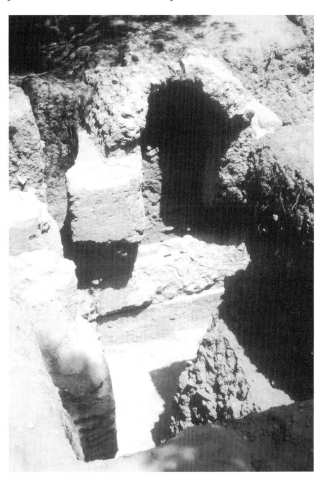

1. The castellum at Carthage.

179

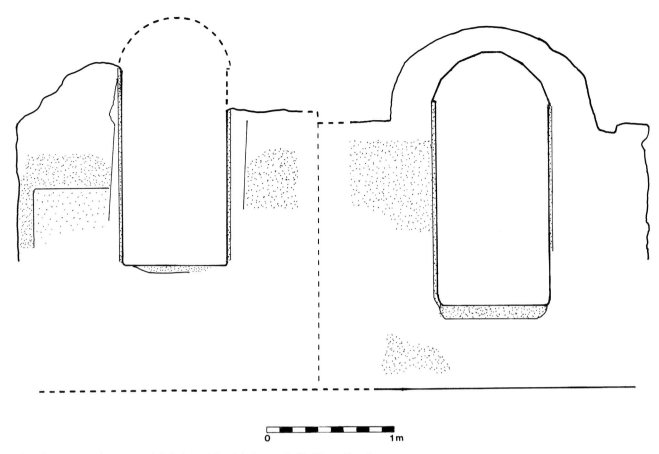

2. Elevation of entrant (right) and La Malga exit (left) at Carthage.

northern edge of the city. It was 2.5 x 2.5 m in plan and 2.8 m high (to the apex of preserved aqueduct vault). The Zaghouan aqueduct[1] enters the *castellum* from the north-west at an angle of 90° to the *castellum*.

A preserved outlet from the south-west side of the *castellum* turns through an elbow bend before running alongside the largest public cisterns in the city, at La Malga.[2] The outlet from the *castellum* to the south-east, which would have led to the Bordj Djedid cisterns and the Antonine Baths,[3] has been completely destroyed. The north-eastern wall of the *castellum* has also been completely robbed, but since this face points away from the ancient city it is highly unlikely that there was any outlet on this side.

The basic function of the *castellum* is clear. It was to divide the flow from the Zaghouan aqueduct, approximately in half. The outlets led to the two major groups of public cisterns in Carthage, Bordj Djedid and La Malga. Both cistern groups were situated on the high ground on the north side of the city. The preserved outlet to the La Malga cisterns is of very similar proportions to the aqueduct entrant, although it was at a 30 cm higher elevation. The fact that the

Bordj Djedid outlet is directly opposite the aqueduct entrant suggests that it was regarded as the most important supply.[4]

The whole *castellum* is a single structure built at the same time as the aqueduct. The *castellum* was set on a raft of dressed limestone blocks that established a precise level of 26.65 m ASL. This raft extends well below the foundations of both the aqueduct entrant and the La Malga outlet. The left wall of the aqueduct entrant curves round to meet the right wall of the La Malga outlet (as viewed from within the *castellum*). The foundations and the curve of the wall indicate that the whole building belongs to one pre-planned conception.

THE SLUICE GATE

Two sets of cuts at the mouth of the La Malga outlet are suggestive of systems to alter the flow into that channel. Firstly to the left of the outlet there is a shallow recess 10 cm deep, 60 cm wide and about 50 cm high *(Fig. 2)*. The *opus signinum* lining of the tank runs smoothly round the recess, indicating that it is an original feature. The most likely function for this re-

cess would be to hold a gate that closed over the lower half of the La Malga outlet channel.

There are no signs of any fastenings to the masonry which could have been used to move such a gate, but there is some damage to the immediate mouth of the channel, and it is possible that such attachments have been lost, or deliberately removed.

Although the gate closed against the direction of the current, the water would have been moving slowly after filling the main body of the *castellum*. Ideally the gate would have been placed on the right hand side of the outlet where it would have closed with the current.

The gate could have closed in two ways. Firstly it could have slid across the mouth of the channel, in which case it would have required guide rails to manouvre it. Secondly it could have pivoted on a pole attached to the left hand side of the channel swinging round in the horizontal plane to meet the right hand side jamb. The movement here would have been just the same as closing the door in a house.

The second possibility would seem to be the most likely operation. If the gate had been on rails there would most likely be some sign of fittings despite the slight damage to the masonry. The attachment of a pole to the left hand jamb would not require much more than some form of binding. The gate would still require some form of binding on the right hand jamb to stop the oncoming current opening it.

Such an operation suggests that the gate was not very susceptible to fine adjustments, and could not be used to control the precise quantity of water entering the channel. The gate functioned simply to close off the channel. At times of shortage, or when the La Malga cisterns were full the entrant to them could be cut off. The gate could not be used to deliver a measured flow to the cisterns, or to deliver a quantity of water to match demand.

In theory if there was a very strong rush of water down the aqueduct it could have passed into the La Malga channel over the top of the gate. However, such a flood is unlikely considering that the top of the gate was 1.4 m above the floor of the *castellum,* and 35 cm above the normal surface of the water as marked by the deposits of sinter in the aqueduct.

The La Malga *castellum* thus established an absolute priority between the two exit channels, in which the Antonine Baths and the Bordj Djedid cisterns were given precedence over the La Malga cisterns. When the water flow was low it was the Antonine Baths that received the main flow. When water was plentiful and the La Malga cisterns became full it is likely that the Baths received the excess, unless the water level rose to a truly exceptional depth.

OTHER EVIDENCE FOR SLUICE GATES

This lack of precise control over water outflow is also demonstrated at Nîmes and Pompeii.

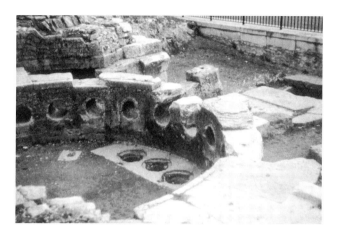

3. The castellum at Nîmes. Note presence of sockets on edges of drains in base of tank.

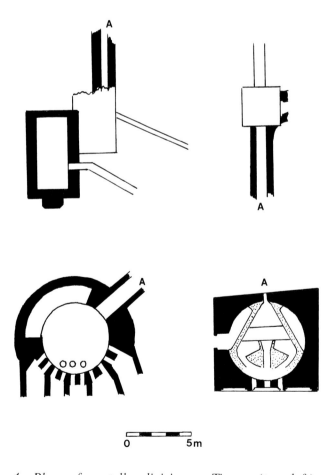

4. Plan of castella divisiorum Tipasa (top left), Carthage (top right), Nîmes (bottom left), and Pompeii (bottom right). A marks aqueduct entrant.

181

At Nîmes (*Figs. 3 and 4*) the evidence for a sluice gate is in the aqueduct entrant and consist of grooves 8 cm wide in the sides of the channel and 3 cm wide in its base. The latter contained traces of lead, which was likely to have held a permanent fitting.[5] In the slab that forms the cover to the entrant there is a line of six small square holes, with one more hole at each end of the line slightly further forward towards the *castellum*. From this evidence modern authors have reconstructed an elaborate system of gates controlling flow into the *castellum*, or measuring the discharge of the aqueduct.[6]

Such an arrangement does not lend itself to precise control of water distribution to the city. If the *castellum* was designed to control the water supply of the city it would be more effective to provide gates on the outlets from the *castellum* rather than the entrant. Restriction of flow at the entrant could lead to water backing up in the main channel. Restriction on the flow into the outlets would permit surplus in one part of the city to be directed to another district. Hodge[7] recognised this problem and argued that the gate at the aqueduct entrant was for measuring the water supply not controlling it.

Another system of sluices has been proposed across the central part of the Nîmes *castellum*, where four stones with sockets for c. 10 cm wide uprights are set into the floor. Further sockets are cut into the edges of two of the three main drains in the floor of the *castellum*. The whole structure would seem to form a curved fixture that was placed in front of all the outlets, including significantly, the main drains in the *castellum* floor.

In order for these sluices to control the supply of water to the outlets they would have to be some partitioning between the sluices and the pipe mouths. The outlet pipes at Nîmes are paired, and each pair of pipes rests within a masonry channel. If the sockets formed the supports for sluices across the *castellum* and partitions between the pipes then the partitions would divide the water flow according to the pairs of outlets.

However there is no direct evidence for the function, or the nature, of these sluices. Whatever function they fulfilled applied to all the exits from the *castellum* including the presumed drains in its floor. It is more likely to have been some form of grill for filtration. If precise control of the flow out of the castellum was required it would have been most efficient to construct sluices attached to the mouths of each exit.

There is thus no direct evidence that the *castellum* at Nîmes provided any precise control over the amount of water supplied to different parts of the city.

At Pompeii there is evidence that the *castellum* did to some extent control the relative flow between the different outlets, though as at Nîmes there was no control over the overall level of flow through the *castellum*.

The overall form of the Pompeii *castellum* is like Nîmes. The outlet pipes themselves are all placed on the far side of the structure opposite the entrant. A masonry features separated each of the outlet pipes. The gates were held by bronze fastenings attached to the masonry between the outlets, and lead settings in the walls at each end. The framework for the gates was thus fixed.

The precise form of these gates seems to be more hypothetical.[8] It is supposed that they were solid barriers, but there is no evidence for any mechanism to raise or lower them. This system of water control is not compatible with precise control of water flow. It did not function to regulate flow so much as to establish priorities between the three outlets. Instead of adjusting, or even redirecting flow from one outlet to another, a board simply blocked or restricted the flow into that particular channel.

The *castellum* at Pompeii thus did not function to balance out supply against competing demands. It simply prioritised connection to the supply. In sum, at Pompeii, as at Carthage, there is evidence that the relative supply of water to different destinations was controlled. However at both sites it was 'all or nothing' - more a question of establishing priorities rather than precise balancing of the flow delivered in each direction.

THE SEALING OF THE LA MALGA CHANNEL

The second set of cuts on the La Malga outlet is a secondary feature. Each side of the mouth was cut back with a 10 cm wide and 10 cm deep cut that was just off vertical. This cut away the *opus signinum* lining of the outlet. Once again there is no sign of fastenings. It is strange that the waterproof lining was cut away, unless the channel was not to hold water any more. I would suggest that this second set of cuts represents a complete sealing off of the La Malga branch at a late date.

One possible historical context might be the Byzantine Reconquest of the city in AD 533. It is known (Procopius *Buildings* 6.5.10) that Justinian restored the Antonine Baths at this time. It may well be that the aqueduct was then reserved exclusively for the restored public monument. Conventional wisdom[9] would suggest that much of the city was in disarray after the Vandal occupation, and thus may not have been in a position to accept the aqueduct supply.

THE ARCHITECTURAL FORM OF THE CASTELLUM AND SYSTEMS OF WATER DISTRIBUTION

CIRCULAR CASTELLA

The best known form of Roman *castellum* is circular as at Pompeii and Nîmes. This consists of a circular tank with a single main aqueduct entrant on one side and multiple exits, three at Pompeii and ten at Nîmes (*Fig. 4*), opposite. Both *castella* are situated just on the edges of the ancient towns concerned. This is the most efficient position from which to distribute water in a single operation. Water is conveyed direct to the main centres of use by means of a large number of small pipes to run short distances.

From the time of its first discovery the comparison of the Pompeiian *castellum* with Vitruvius' (*De Architectura* VIII 7,1) threefold division of waters into private, public and fountains has been made.[10] The most recent authorities[11] conclude that water was distributed primarily according to geography not according to use. This means the outlets of a *castellum* were arranged to cover a certain catchment area rather than to serve particular kinds of building.

RECTANGULAR CASTELLA

If we are counting numbers of recorded structures then rectangular *castella* such as that at Carthage are more common than those with a circular form. Although discussion tends to focus on Nîmes and Pompeii, they do not form the commonest architectural type in the archaeological record.

Several rectangular *castella* have been found in North Africa. Rectangular *castella* rarely appear to have had more than two exits. With only two exits the rectangular *castellum* may be seen as more of a simple 'junction' box to split the flow rather than a centre of distribution.

There is some evidence from several rectangular *castella* for the destination of the flow from individual outlets. At Tipasa (*Fig. 4*) a channel 14 cm wide by 24-28 cm high diverged from a rectangular *castellum* to a *nymphaeum* some 15 m away.[12] While one outlet from the small *castellum* at the end of the aqueduct headed off for the nearby *nymphaeum,* the second emptied into an adjoining cistern. The cistern was too small to have been a public facility, and probably served a particular building within which it lay.[13]

An early 1906 excavation of another rectangular *castellum* from modern Tunisia, at Tebourba has recently been republished.[14] It apparently had three outlets to the baths, theatre, and public cisterns. According to the excavator vertical cuts on the mouths of each outlet allowed sluices to be moved in front of them. This should be accepted with some caution given the early date of the excavation, and the example of secondary cuts at Carthage.

At Carthage it would appear that approximately half the flow of the Zaghouan aqueduct was directed to the Bordj Djedid cisterns whose principal function was to feed the neighbouring Antonine Baths, the third largest baths in the Roman Empire. The other half of the flow was directed towards the major public cisterns of La Malga. The outlet from the *castellum* towards the baths was located directly opposite the entrant, marking it out as the most important flow.

The rectangular basin may form part of a slightly different distribution system to the circular basin. The circular basin is more useful to redistribute the water into many pipes at once. One basin, on the edge of the city may have served to direct flow throughout a town, and the flow was more determined by catchment than by any particular building.

The rectangular basin tends to split the flow into only two or three channels, which were often directed to particular facilities. There may thus have been a series of rectangular basins halving and halving the flow again and again.

CONCLUSIONS

Roman *castella* were used to establish the priorities of water distribution in times of shortage or surplus. From the remains at Pompeii and Carthage it would seem that in time of shortage un-necessary supplies were simply cut off rather than being scaled down.

The Romans used a variety of architectural solutions for this problem. This paper has discussed two possible systems using circular and rectangular *castella*. It would be wrong to identify the rectangular *castellum* as an African type. Nevertheless discussion has shown that the term *castellum* can apply to different forms of building that carried out the same task of dividing the water supply in different ways.

BIBLIOGRAPHY

Aupert, P. 1974, *Le Nymphée de Tipasa,* Ecole Française de Rome, Rome.

Eschebach, H. 1983, Die innerstadische Gebrauchwasser-versorgung dargestellt am Beispiel Pompejis, in J.-P. Boucher (ed.) *Journées d'études sur les aqueducs romains,* Paris.

Evans, H. 1994, *Water Distribution in Ancient Rome: the Evidence of Frontinus,* Univ. of Michigan, Ann Arbor.

Hauck, G./R. Novak 1988, Water flow in the castellum at Nîmes, *AJA* 92, 393-406.

Hodge, A.T. 1984, How did Frontinus measure the quinaria?, *AJA* 88, 205-216.

Hodge, A.T. 1992, *Roman Aqueducts and Water Supply,* London.

Lasalle, V. 1980, *The Pont du Gard and the Roman Aqueduct of Nîmes,* Montpellier.

Leveau, P./J.-L. Paillet 1976, *L'alimentation en eau de Caesarea de Mauretanie et l'aqueduc de Cherchel,* Paris.

Lézine, A. 1968, *Les thermes d'Antonin à Carthage,* Tunis.

Mau, A. 1904, Ausgrabungen von Pompeii: Kastell der Wasserleitung, *RM* 19, 41-50.

Rakob, F. 1974, Das Quellenheiligtum in Zaghouan und die römische Wasserleitung nach Karthago, *RM* , 41-88.

Verité, J. 1989, Le site de La Malga à Carthage, *CEDAC Bulletin* 10, 41-48.

NOTES

[1] The definitive publication of the aqueduct is Rakob 1974.

[2] It is at present not entirely clear how the aqueduct channel emptied into the La Malga cisterns. There is some evidence for the continuation of the channel beyond them. The La Malga cisterns have never been fully studied. A useful bibliography of early descriptions of the site can be found in Verité 1989.

[3] Lézine 1968 remains the most important publication on the Antonine Baths, though many new insights concerning their funcion have been gained through the recent work of Verité 1989.

[4] The Antonine Baths to which it led was the largest public baths in the western provinces outside Rome.

[5] Hauck/Novak 1988, 393.

[6] Hodge 1984, Hauck /Novak 1988.

[7] Hodge 1984.

[8] See discussions by various authors in this volume.

[9] In truth there is very little precise archaeological evidence concerning the condition of the city at the time of the Byzantine Reconquest.

[10] Since the first reports about the building Mau 1904, 48-9.

[11] Hodge 1992, 282-284, Evans 1994, 7-8.

[12] Aupert 1974, 49-51, Leveau/Paillet 1976, 126.

[13] The interpretation of Hodge (1992, 61) is rather ambiguous on this point.

[14] Hodge 1992, 289-291.

DEPARTMENT OF ANCIENT HISTORY
UNIVERSITY OF ST ANDREWS
SCOTLAND

Bildung von Sinterablagerungen in Wassersystemen

Winfried Müller

1 EINLEITUNG

Die Härte des Trinkwassers, ihre Entstehung, die Kalkabscheidungstendenz mit ihren Randfaktoren sind sehr komplex. Durch neue Forschungen werden weitere Erkenntnisse gewonnen, die insbesondere für einige Wasseraufbereitungsverfahren, wie z.B. Entsäuerung, Enthärtung und Entkarbonatisierung, wichtig sind. Hier werden nur die Punkte angesprochen, die für das Verständnis des Kalk-Kohlensäure-Gleichgewichts und die Kalkabscheidung wesentlich sind. Um allgemein verständlich zu bleiben, werden einige Aussagen sehr vereinfacht. Wer sich mit dem Problem intensiver beschäftigen möchte, dem steht ausreichend Literatur (DVGW 1993, Sigg und Stumm 1989) zur Verfügung, die jedoch mindestens Grundkenntnisse der Wasserchemie voraussetzt.

2 WASSERHÄRTE UND IHRE ENTSTEHUNG

Härtebildner sind die Erdalkalimetalle Calcium und Magnesium. Ihre Karbonate, genauer ihre Hydrogenkarbonate (auch Bikarbonate genannt), bilden die Karbonathärte. In das Wasser gelangen sie über den Untergrund, wenn dieser z.B. Kalk ($CaCO_3$) oder Dolomit ($CaCO_3 \cdot MgCO_3$) enthält. Die beiden Gesteine sind in Wasser nahezu unlöslich. Es muß eine chemische Umwandlung stattfinden, zu der Kohlensäure nötig ist. Vom Regen wird in der Luft und in belebten Bodenschichten Kohlendioxid (CO_2) aufgenommen (Kohlendioxid wird neuerdings als Kohlenstoffdioxid bezeichnet, hier wird die allgemein übliche Bezeichnung beibehalten) *(Abb. 1)*. In Wasser gelöst, entsteht Kohlensäure (H_2CO_3). Diese relativ schwache Säure kann Kalk angreifen, vereinfacht gilt:

$$CaCO_3 + CO_2 + H_2O <=> Ca^{2+} + 2HCO_3^-$$

Der Vorgang ist umkehrbar.

Das so entstandene Calciumhydrogenkarbonat ist wasserlöslich, wenn ausreichend Kohlensäure im Wasser ist, es ist eine Komplexreaktion. Beim Kalk-Kohlensäure-Gleichgewicht entspricht die im Wasser vorhandene 'freie Kohlensäure' exakt der dem Gehalt an Calcium- und Hydrogenkarbonat entsprechenden 'Gleichgewichts-Kohlensäure'. Überwiegt die freie Kohlensäure, ist das Wasser kalkaggressiv, bei Kohlensäuremangel besteht Kalkabscheidungstendenz.

1. Wege des Wassers im Untergrund, Kalklösevorgang.

Der Regen nimmt aus der Luft noch weitere Säurereste (vorwiegend Verbrennungsrückstände) auf; so entsteht der 'saure Regen'. Kann sich das Niederschlagswasser im Boden nicht abreagieren, bleibt das Wasser weich, aber auch sauer. Es kann Metalle und andere Werkstoffe angreifen. Durch Schwermetallionen kann das Wasser ungesund werden. Nach der heutigen Trinkwasserverordnung muß aus diesem Grund der pH-Wert einerseits im zulässigen Bereich (6,5 - 9,5) sein, andererseits darf er nicht mehr als 0,2 Einheiten unter dem pH-Wert bei Calciumkarbonatsättigung liegen. Den Römern standen für Druckleitungen nur Bleirohre zur Verfügung. Es war bekannt, daß weiches Wasser diese Rohre angriff und es zu Bleivergiftungen kam. Aus diesem Grund bevorzugten die Römer härteres Wasser.

Sind Calcium und Magnesium an Sulfate, seltener an Chloride gekoppelt, entsteht die Nichtkarbonathärte. Da meist im Untergrund anstehender Gips ($CaSO_4$ $2H_2O$) gelöst wird, spricht man auch von Sulfathärte oder bleibender Härte. Diese Salze werden erst abgeschieden, wenn das Wasser verdunstet, sie können hier vernachlässigt werden. Alkalimetalle, wie Natrium oder Kalium, bilden lösliche Salze, die somit ebenfalls nicht berücksichtigt werden brauchen.

Auch ein Laie kann leicht erkennen, ob es sich um weiches oder hartes Wasser handelt. Hartes Wasser

schmeckt besser. Es bildet jedoch beim Waschen Kalkseife (Rand an der Badewanne). Letztere Eigenschaft wurde in der Vergangenheit verwendet, um die Härtegrade zu bestimmen. Weiches Wasser schmeckt in der Regel langweilig. Beim Händewaschen läßt sich die Seife schlechter abspülen.

3 KALKAUSFALL

Kalk ist im Wasser in Form von Calciumhydrogenkarbonat $Ca(HCO_3)_2$ im Wasser gelöst. Zur Lösung sind sowohl Kohlendioxid CO_2 als auch Wasser H_2O erforderlich. Verdunstet das Wasser, müssen die gelösten Salze auskristallisieren. Nacheinander fallen Kalk, Gips, Kochsalz u.s.w. aus. Ändert sich der Gehalt an Kohlendioxid, wird das Kalk-Kohlensäure-Gleichgewicht gestört. Dabei steigt der Kohlensäurebedarf bei höherer Karbonathärte nicht linear sondern in höherer Potenz. Werden Wässer mit deutlich unterschiedlicher Karbonathärte gemischt, entsteht so ein kalkangreifendes Mischwasser, obwohl beide Wässer vorher im Kalk-Kohlensäure-Gleichgewicht waren.

Häufiger ist in Wassersystemen, die mit geringem Druck betrieben werden, Kohlendioxid-Verlust und somit Kalkabscheidungstendenz. In kaltem Wasser sind Gase, wie Kohlendioxid oder Sauerstoff, besser lösbar als in warmem Wasser. Beim Kochen werden Gase ausgetrieben, so entsteht die Kalkkruste im Teekessel. Doch machen sich auch schon geringere Temperaturunterschiede bemerkbar. So sind bei Wasser von 10 °C 0,96 g/m^3 CO_2 und 11,24 g/m^3 O_2 lösbar, bei 25 °C nur noch 0,44 g/m^3 CO_2 und 8,38 g/m^3 O_2. Diese Angabe gilt für einen Luftdruck von 1 bar. Je höher der Druck, um so besser die Fähigkeit, Gas zu lösen. So kann gasgesättigtes Wasser milchig erscheinen, wenn es aus dem Wasserhahn fließt. Im Rohr herrscht hoher Druck, der bei der Entnahme zusammenbricht.

In der Praxis ist Kalkausfall im Trinkwasserbereich meist auf Gasaustausch zurückzuführen. Wird Wasser belüftet, verändert sich oft der Gasgehalt. Da in der Luft der Kohlendioxid-Gehalt im Vergleich zu Sauerstoff und Stickstoff gering ist, wird bei Belüftung des Wassers Sauerstoff und Stickstoff aufgenommen und dafür Kohlendioxid abgeschieden. Das Wasser wird kalkabscheidend. Der Gasaustausch ist um so stärker, je intensiver der Wasser-Luft-Kontakt ist.

Generell gilt jedoch, daß bei Wasser mit Kalkabscheidungstendenz nicht zwangsweise Kalkausfall auftreten muß. Selbst bei übersättigtem Wasser bedarf es oft des Anstoßes durch Kristallisationskerne. Hat

durch feine Wasserverunreinigungen oder an rauhen Rohrinnenflächen das Kristallwachstum begonnen, bauen sich stärkere Schichten auf. Je nach Niederschlagsmenge, Grundwasserstand und Fließgeschwindigkeit im Untergrund kann die Abscheidung mehr oder weniger stark sein. Bei Starkregen und Schneeschmelze fließt das Wasser insbesondere in den Spalten und Klüften von karstigem Untergrund relativ schnell und hat dann eine erhöhte Schleppkraft. Die mitgeführten Trübstoffe, wie Ton, Eisen- und Manganoxid, verfärben die Sinterschichten. Da große Niederschlagsmengen oft jahreszeitlich bedingt sind, entsteht der Eindruck von 'Jahresringen'.

Wasser kann schon beim Quellaustritt kalkabscheidend sein. Es bildet dann um Zweige und Wurzeln Kalkkrusten, die sich immer mehr aufbauen. Kann Wasser dabei verdunsten, wird der Vorgang verstärkt. So entstehen poröse bis dichte Bänke von Süßwasserkalk, von Kalksinter und Kalktuff. Im kleinen kann der Ablauf bei der Tropfsteinbildung nachvollzogen werden.

Berühmt sind die Sinterterrassen von Pamukkale in der Türkei *(Abb. 2)*. Hier tritt in einem Quelltopf perlendes Thermalwasser aus. Unter den herrschenden Klimabedingungen scheidet sich Schicht um Schicht ab und erhöht so das 'Pamuk-Kale = Baumwollschloß'. Dabei wird gasförmiges Kohlendioxid schon in den oberen Erdschichten ausgeschieden. Da dieses Gas schwerer als Luft ist, reichert es sich in den Spalten und Klüften des Gesteins an. Ein Höhleneingang in den unmittelbar in der Nähe liegenden Ruinen von Hierapolis wird als Tor zur Unterwelt bezeichnet. Es wird berichtet, daß früher Priester zusammen mit Tieren in die 'Unterwelt' abgestiegen sind. Durch besondere Atemtechnik, eventuell auch durch deponierte Luftvorräte in Tierhäuten, brachten sie es fertig, in

2. Sinterterrassen von Pamukkale/Türkei.

3. *Mineralwasserleitung aus Asbestzementrohren mit ringförmigen Ablagerungen, Baden-Baden.*

4. *Sinterbildung in einer Quellableitung, (das Guß-rohr ist von außen ankorrodiert).*

der Kohlendioxid-Atmosphäre zu überleben, die mitgeführten Tiere starben. So demonstrierten sie ihre Macht. Noch heute liegen immer wieder tote Tiere vor dem Höhleneingang.

4 SINTERBILDUNG IN WASSERSYSTEMEN

4.1 KALKAUSFALL IN DRUCKLEITUNGEN

Im Regelfall gibt es in Druckleitungen keine Probleme durch Kalkausfall. In geschlossenen Systemen nimmt der Druck mit dem Gefälle in Fließrichtung zu. Bei ausreichender Wassererneuerung erhöht sich auch die Temperatur nur unwesentlich. So kommt es nur selten zu Gasabscheidungen. Nur wenn Wasser mit starker Abscheidungstendenz (z.B. Mineralwasser) in Rohre eingeleitet wird, scheidet sich so lange Kalk rundum an allen Rohrinnenflächen ab, bis sich das Kalk-Kohlensäure-Gleichgewicht eingestellt hat *(Abb. 3)*.

Einige Sonderfälle sind erwähnenswert. Bei starkem Gefällwechsel, z.B. beim Übergang vor einer horizontalen Leitung in einen Steilabfall, will das Wasser schneller abfließen, als es von hinten nachkommt. Es kann zu Unterdruck und so zu Gasabscheidung mit Kalkausfall kommen *(Abb. 4)*. Beachtlicher Druckunterschied kann an Engpässen und Drosselstellen auftreten. So ist Kalkausfall hinter einer Meßdüse *(calix)* möglich. In spätrömisch/byzantinischer Zeit hatten Tonrohre oft deutlich eingezogene Spitzenden, auch hier ist Kalkabscheidung nicht auszuschließen. Durch Fremdkörper in der Leitung können sich Wirbel bilden und so Gas abgeschieden werden. In den

aufgeführten Fällen wird Kalk meist in griesiger Form (kleine Kristalle) abgeschieden. Es können sich an der Rohrsohle Ablagerungen bilden, deren Partikel im weiteren Verlauf fixiert und untereinander verkittet werden.

4.2 KALKAUSFALL IN SYSTEMEN MIT FREIEM WASSERSPIEGEL

In Gerinnen, überdeckten Kanälen und Rohren mit Teilfüllung ist ständig Luftkontakt und somit Gasaustausch gegeben. Je länger das Wasser fließt, um so mehr CO_2-Verlust tritt auf. So wird sogar Wasser, das anfänglich im Kalk-Kohlensäure-Gleichgewicht war, nach längerer Fließstrecke kalkabscheidend. Die Form der entstehenden Kalkkrusten ist abhängig vom Wasserstand im Gerinne, seinen Schwankungen (bis hin zum Versiegen) dem Wasseraustausch über den Gerinnequerschnitt und dem Wellengang *(Abb. 5)*.

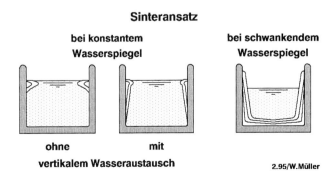

5. *Sinteransatz in Freispiegelgerinnen, Ausbildung je nach den Betriebsbedingungen.*

6. *Tonrinnen mit seitlichem Sinteransatz bei konstantem Wasserspiegel, Athen/Griechenland.*

Bei konstantem Wasserspiegel werden sich an dessen Oberkante Wulste ausbilden. Ist kein Wasseraustausch in vertikaler Richtung, werden diese kräftig und schmal sein. Wird das Wasser verwirbelt und gelangt so belüftetes Wasser nach unten, sind die Wulste flacher und laufen nach unten allmählich aus *(Abb. 6)*.

Bei schwankendem Wasserspiegel bilden sich von unten her seitliche Keile, die den Querschnitt mehr und mehr einengen. So steigt der Wasserspiegel mit den Jahren an *(Abb. 7)*. Am Boden des Gerinnes wird nicht in jedem Fall Kalk abgeschieden. Möglicherweise verhindern mitgeführte bzw. abgelagerte Trübstoffe, daß der Kalk fest haftet.

Abweichungen vom Regelfall, d.h. vom Fluß in der geraden Leitung sind möglich bei Richtungsänderungen, Abstürzen und einseitiger Strömung. Baumängel, Schadensstellen und Einbrüche sowie Fremdkörper, die den Querschnitt einengen, können zu Verwirbelung und zu anderer Sinterbildung führen. In Aquädukten haben sich teilweise so starke Kalkschichten gebildet, daß es sich lohnte, die Stücke auszubrechen. Sie wurden zu feinen Steinmetzarbeiten, wie Altartafeln und Grabplatten verarbeitet (Grewe 1991).

4.3 KALKAUSFALL IN SCHÄCHTEN UND WASSERKAMMERN

Plätschert Wasser in freiem Fall in ein Wasserbecken oder stürzt es gar aus größerer Höhe ab, kann Kalk in anderer Form abgeschieden werden. Bei stärker kalk-

7. *Sinteransatz im Aquädukt nach Köln, Wasserspiegel wechselnd, bei Breitenbenden in der Eifel.*

8. *Kalkabscheidung an undichten Stellen des High-Level-Aquädukts nach Caesarea/Israel.*

abscheidendem Wasser kann als Folge der intensiven Belüftung unter dem Einlauf Kalk in Form kleiner Kristalle ausfallen. Diese 'grießige' Ablagerung ist schwer und läßt sich mit Wasser nur mit Mühe ausspülen. Öfter bildet sich bei härterem Wasser eine Schwimmschicht aus Calciumkarbonat. Wird die Schicht zu schwer, sinken Teilstückchen davon ab. Unter der Lupe ist erkennbar, daß die Plättchen einseitig relativ glatt und auf der Gegenseite kristallin sind.

Bei schwankendem Wasserspiegel im Becken kann sich an den Wänden im Wasserspiegelbereich (sog. Wasserwechselzone) Kalk anlagern. Diese Schichten sind in der Regel wesentlich dünner als in Rohrleitungen.

4.4 Kalkabscheidung durch Auftrocknen

Der Vollständigkeit halber sei noch erwähnt, daß sich Sinterschichten auch bilden können, wenn Leckstellen auftreten. Wurden Aquädukte undicht, sickerte Wasser aus und vertrocknete. Zurück blieben die gelösten Salze. Aus dem Erscheinungsbild kann oftmals auf die Art des Schadens und etwa auf die Verlust-menge geschlossen werden *(Abb. 8)*. Liefen Wasserbecken oder Verteilertürme über, schieden sich an deren Außenseiten und um die Rohre Kalkkrusten und Sinterschichten ab, die im Einzelfall das ganze Bauwerk umhüllen und unkenntlich machen konnten.

5 Zusammenfassung

In vorrömischer und vor allem in römischer Zeit wurde härteres Wasser wegen des besseren Geschmacks und der geringeren Korrosionsgefahr in Bleileitungen bevorzugt. Wird solches Wasser belüftet, kann Kalk ausfallen. Je nach den Betriebsbedingungen ändert sich das Aussehen der Sinterschichten. Die verschiedenen Wasservorkommen variieren im Gehalt an Wasserinhaltsstoffen und Verunreinigungen. So entsteht dichter oder poröser Sinter mit weißen, gelblichen (Lehm), rötlichbraunen (Eisen) bis schwärzlichen (Mangan) Schichten. Es kann nicht von einer Wasserleitung auf eine andere geschlossen werden, insbesondere weil sich in einem Aquädukt die Kalkabscheidungstendenz vom Beginn bis zu dessen Ende deutlich verstärken kann. Im Einzelfall muß versucht werden den ehemaligen Betriebszustand an Hand der vorgefundenen Sinterablagerungen nachzuvollziehen.

Bibliographie

DVGW 1993, *Wasserchemie für Ingenieure,* München/Wien.
Grewe, K. 1991, *Aquäduktmarmor,* Stuttgart.
Sigg, L./W. Stumm 1989, *Aquatische Chemie,* Zürich.

Aichelbergstrasse 615
D-73230 Kirchheim Teck
Deutschland

Dichtungsmörtel und Betone in der Antike*

Roman Malinowski

EINFÜHRUNG

Dieser Beitrag bietet eine Übersicht über Mörtel, Betone, Betonteile und -bauten in der geschichtlichen Entwicklung von dem Neoliticum bis in die Zeit des Römischen Imperiums. Auch andere mit dem Beton zusammenwirkende und konkurrierende Baustoffe wie Stein, Ziegel, Gips und Asphalt werden beobachtet. Literaturangaben der Antike (Vitruv) und der modernen Verfasser sind mit Ergebnissen eigener Felduntersuchungen (in Zusammenarbeit mit Archäologen) und Laborprüfungsdaten durchflochten. Aufgrund diesen Angaben werden Folgerungen über die Baustoffe, die Herstellungsverfahren und das Verständnis der statischen Arbeit der Konstruktion von Seiten der Bauleute und Ingenieure in den unterschiedlichen Perioden vorgelegt. Auch der Einfluß der antiken Lösungen und ihre wissenschaftlichen Gründe auf den modernen Beton und Betonwissenschaften wird beurteilt.

1. HOCHFESTER KALKMÖRTEL UND BETON DES NEOLITICUM 7000-4000 V.CHR.

Auf der Suche nach den gemäß der Bibel zerstörten Mauern von Jericho (ca. 1200 v.Chr.) wurden unter vielen Schichten Häuser aus Lehmziegel auf hart gepacktem Kalkbetonfußboden mit polierter Oberfläche entdeckt.[1] Die organischen Funde wurden mittels C14-Analyse auf 7000 v.Chr. datiert. Bei späteren Ausgrabungen an vielen neolitischen Fundstellen sind insbesondere im östlichen Teil des Mittelmeerraumes Fußböden mit ähnlicher Oberflächenbehandlung gefunden worden. Der berühmte Archäologe Wooley nennt die Siedler dieser Plätze 'Volk der polierten Fußböden'.[2] Ähnliche Fußböden und Mörtel wurden an vielen Stellen des Nahen Ostens und auch in Europa bei neueren Ausgrabungen gefunden. An der Untersuchung der Baustoffe von einigen war der Verfasser beteiligt.[3]
Der Terrazzofußboden von Çayönü Tepeçi besteht aus Kalkmörtel mit dicht eingeschlagenen Kalksteinen. Der Beton ist von großer Festigkeit, die zerbrochenen Steine an der Oberfläche deuten auf ein außergewöhnlich starkes Einrammen hin. An vielen Stellen sind Zeichen des Schleifens der Oberfläche zu beobachten. In Viftahel (Israel) wurde eine 180 m² große Fußbodenoberfläche entdeckt aus dichtem, hochfes-

tem Mörtel und Beton mit Kalk als Bindemittel und Kalkstein als Zuschlagstoff. Ein- und Zweischichtmörtel wurden vermutlich in frischem Zustand genau geglättet und poliert *(Abb. 1)*. Die physikalischen und mechanischen Eigenschaften sowie die chemischmineralogische Struktur der Mörtel wurde untersucht und eine außergewöhnliche Dichte von 2,2 g/cm³ und eine Festigkeit von 40,0 MPa – wie bei modernem Beton – nachgewiesen. Kleine Stücke von gebranntem Ton und Beton mit gleichem Zuschlag deuten auf Reste einer Ofenauskleidung zum Kalkbrennen hin.

1. Kalkbetonfußboden mit polierter Oberfläche.

Der hydraulische Mörtel von Dosariya (Südost Saudi-Arabien) aus Kalk, Diatomiterde und Quarzsand mit den Abdrücken von Palmstämmen ist als eine der ersten Puzzolane und als die erste armierte Betonkonstruktion der Geschichte zu betrachten *(Abb. 2)*.
Der hohe Stand der Kalkbetontechnik im Neoliticum deutet eine lange vorherige Entwicklung an, und datiert auf mindestens 10.000 v.Chr. In den folgenden Perioden kommt ein Regress in Anwendung der Betonfußböden und des Kalkes vor. Sowohl der sagenhafte Aufschwung wie der 'plötzliche' Rückgang und ihre Ursachen sind Thema wichtiger Forschung von Archäologen und Technikhistorikern. Allgemeine Anschauung ist, daß Kalkbrennen und Kalköfen in die vorkeramische neolitische Periode gehören und zwar vor der Tonbrennerei. Als erste 'industrielle' Feuerung – Pyrotechnik – beeinflußte das Kalk-

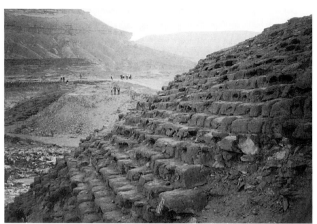

2. Kalkmörtel mit Abdrücken von Palmstämmen. (Photo K. Frifeld Förhistorisk Museum Højbjerg DK).

4. Kafara Damm, der älteste der Welt (2500 v.Chr.).

brennen die Entwicklung der Keramik und Metallurgie.

2. MESOPOTAMIEN – LEHM, GIPS UND ASPHALT-MÖRTEL 4000-1000 V.CHR.

Die Bibel erzählt von dem aus Ziegel und Kalkmörtel gebauten Turm von Babel. Die Zigguraths Tempel waren innen aus Trockenlehmziegeln und Schlammörtel und von außen aus gebrannten Tonziegeln und Kalk- oder Asphaltmörtel bekleidet.[4] In Säulen und Wände der Bauten aus Trockenziegel wurden gebrannte Tonkegel in Lehm oder Asphalt eingepreßt, als Schmuck in Bauten schon in Ur (3000 v.Chr.).

In den großen Mengen der Irrigationskanäle waren die Ufer aus gestampften Lehm. In Großstädten wie Assur, Ninive und Babylon wurden die Kaianlagen mit Asphaltmörtel (Beton) gedichtet *(Abb. 3)*.

Schon im dritten Jahrtausend entwickelten die Völker Mesopotamiens (Vorväter der Sumerer) die Gewölbe,

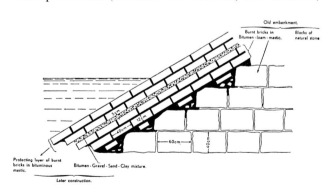

3. Kaianlage in Assur (1300 v.Chr.) mit Asphaltmörtel gedichtet (aus Davey 1962, 131).

erst aus Trockenziegeln und danach aus gebranntem Ton, oft mit Asphaltmörtel gefüllt. Asphaltmörtel, auch Gips und Kalk, wurden in Assyrien, Babilonien und später in Persien angewandt.

3. ÄGYPTEN – GIPS UND LEHM(SCHLAMM)MÖRTEL ALS BINDEMITTEL 3500-1000 V.CHR.

Gipsmörtel und -beton mit Zusatz von Kalksand waren üblich in Monumentalbauten Ägyptens: In Pyramiden und Palästen, auch in der Wasserleitung aus Kupferrohr von Abussir (2450 v.Chr.). Als Dichtungs- und Füllungsmaterial verwendete man Gips und Kalkstein(bruch). Das Verhältnis Gips:Kalkstein war 1:1,5 - 1:2.[5] Erst in der hellenistischen/römischen Periode kommt Kalkmörtel zur Anwendung.[6] In gewöhnlichem Hausbau waren Trockenziegel aus Nilschlamm mit Schlamm als Mörtel verwendet. Aus diesen Baustoffen wurden auch Gewölbe mit großer Spannweite gebaut. Auch Irrigationskanäle und Dämme (Fayum 1500 v.Chr.) der bekannte Nil-Rotes Meer Kanal wurden aus gestampftem und getrocknetem Nilschlamm (Ziegel) gebaut. Der berühmte Kaffara Damm war aus Steinen *(Abb. 4)*.[7]

4. KRETA UND MYKENE, WIEDERGEBURT DER KALK-MÖRTEL, ERFINDUNG DER PUZZOLANASCHEN UND DES ZIEGELSPLITTES 2000-1000 V.CHR.

Während der Schwächung der Mesopotamischen und Ägyptischen Reiche stärkte sich die Position des Minoischen Kreta und Mykene. Zeugen der Blüte sind die Reste der prächtigen Paläste. Zum Palast von Knossos führt eine offene U-formige Wasserleitung

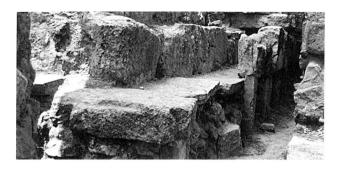

5. Kanalisationsleitung aus Stein und wasserdichtem Kalkmörtel und Gipsmörtelbeton (Aghios Triada, Kreta).

aus Stein mit wasserdichtem Fugenmörtel aus Kalk.[8] Ähnliche Steinleitungen sind in vielen Palästen des minoischen Kreta zu finden *(Abb. 5)*. Die Wasserleitung von Knossos endet mit der ersten in der Welt bekannten Druckleitung, in welcher der Fugenmörtel aus Ätzkalk und Öl gefunden wurde.

Runde Zisternen aus Stein mit Verputz aus Kalkpuzzolan sind üblich auf Kreta wie in Mykene. Die Paläste sind mit verputzten Baderäumen und gut geplanten Kanalisationsanlagen (U-Rohre mit Steindecke) ausgerüstet.[9]

Der Kalkpuzzolanmörtel der Mauer des Malia Palastes aus rektangulären Lehmziegeln und die zum 'Spiegelschein' polierten Mörtel des Phaistos Palastes deuten auf Kenntnisse über die Funktion der Oberflächenbehandlung als Schutz gegen schädliche klimatische Einflüße (die von Vitruvius fast 2000 später erklärt wurde) an.[10]

Der Tunnel vom Palast zu der geheimen Wasserquelle und Zisterne außerhalb Mykene sind mit wasserdichtem Kalkmörtel verputzt.[11] Teile der Mauer und des Fußbodens des Palastes sind aus wasserdichtem Gipsmörtel hergestellt, was auf ägyptische Einflüße deutet. Die berühmte Löwenporte mit einem Steinbalken mit erhöhtem Mittenteil, eine Bogenbrücke aus Stein und die konische Steinkuppel des Atreusgrabes – alle als Trockensteinkonstruktion gebaut – deuten auf neue statische Lösungen der archaischen Griechen hin.

5. DIE PHÖNIZIER ALS SEELEUTE, WASSER- UND HAFENBAULEUTE 2000-1200 V.CHR.

Ewa 2000-1200 v.Chr. infolge von Kriegen und Wanderungen von Ostvölkern wurden die Reiche an den großen Flüssen geschwächt. Die Phönizier beherrschten Städte an den östlichen Küsten des Mittelmeeres (1500-1300 v.Chr.), die danach um 1200 v.Chr. als Vasallen von Assyrien (auch Ägypten) in Besitz von Kreta kamen. Später, 1000-800 v.Chr., schufen sie Häfen und Handelskolonien auf Inseln (Zypern, Sizilien, Balearen, Malta) und ringsherum des Mittelmeeres Nordafrika (Karthago).

Sie waren nicht nur als See- und Handelsleute berühmt, sondern auch als Bauleute, besonders im Schiff-, Wasser- und Hafenbau. Einige ihrer Großbauten waren die Salomonischen Teiche in der Nähe von Hebron, die heute noch benutzt werden, etwa 950 v.Chr. gebaut. Sie wurden durch Herodes um 30 v.Chr. umgebaut und mit wasserdichtem Vielschichtmörtel gedichtet. Als andere sind der Hafen von Eilat (in der Bibel erwähnt), Großhafen von Tyros, Sidon, Byblos und Syracuse erwähnt.[12]

Der in der Bibel (2 Kö 20:20, 2 Ch 30:20) erwähnte Tunnelaquädukt in Jerusalem wurde von König Hiskia – vor der Belagerung der Stadt durch König Sanherib von Assur – gebaut. Der gleichzeitig von zwei entgegengesetzten Seiten in Fels gehauene Tunnel hat am Durchstich eine phönikische Inschrift.

Der 30 km lange Aquädukt desselben Königs Sanherib überquert den Fluß Khora mit einer Bogenbrücke. Der Kanal des Aquäduktes aus wasserdichtem Beton (6 m breit und 0.4 m dick) wurde von Phöniziern gebaut. Von Interesse ist daß 'Khorasan' bis heute in der türkischen Sprache wasserdichter Beton bedeutet.

Der wasserfeste Gips der Zyklopenmauer im Hafen von Kition[13] ist wahrscheinlich eine weitere Entwicklung des ägyptischen und mykenischen wasserfesten Gips-Kalksteinsandmörtels. Dieser wurde im Mittelalter in Norddeutschland benutzt und wird bis heute noch in Frankreich (Paris) angewandt.

6. DIE KLASSISCHE PERIODE: GRIECHENLAND, DIE INSELN UND KOLONIEN, 800-400 V.CHR.

Die Griechen, Mitbewerber und Nachfolger der Phönizier im Mittelmeerbereich, haben die bau- und materialtechnischen Errungenschaften der vorherigen Periode weitergefördert und entwickelt. Die üblichen Baustoffe im Monumentalbau sind Marmor und Kalkstein. Der Fugenverband der geschliffenen Steine der Kolonnen ist hauptsächlich aus Bronze- oder Eisenklammer. Kalkmörtel findet man im wachsender Anwendung in Mauerwerk und als Verputz. Wasserdichte Mörtel finden Anwendung in Fugen der Steine in Kanalanlagen und Wasserleitungen, dazu auch in Straßenbelägen (z.B. Athens Agora und Rhodos).

Einige Beispiele interessanter Lösungen griechischer Ingenieure dieser Periode:

- Marmorimitation: polierter Stuck aus Kalkmörtel mit Marmorpulver der Säulen des Tempels von Agrigent auf Sizilien um 600 v.Chr., ein Ersatz des oft schwer zugänglichen und teuren Naturmarmor (schon früher bekannt in Phaistos, Kreta, 1500 v.Chr.).
- Puzzolan: Die Auskleidung der Zisterne von Kameiros (Rhodos, 500 v.Chr.), scheint als erster griechischer Beton, ein Vorgänger des römischen *opus signinum* zu sein. Gemäß Vitruvs Buch II und VII war der Puzzolansand aus der Gegend von Aetna (Sizilien) und von Misia von den Griechen in Mörtel und Beton benutzt (sicher allerdings in Hafenbauten von Cumae und Neapel).[14]
- Straßendecken aus hydraulischem Kalkmörtel mit Kiesmosaik belegt auf Rhodos um 500 v.Chr. sind als Vorgänger der Wandmosaike von Pella zu betrachten.[15]
- Aquädukte: Die berühmte Tunnelwasserleitung von Samos des Eupalinos (um 600 v.Chr.) war wie die von Hiskia von zwei entgegengesetzten Richtungen gebaut. Teile des Aquäduktes und die Tonrohre des Kanals sind mit wasserfestem Mörtel ausgelegt.[16]
Zu den hochgelegenen Akropolen und Tempeln wurde Wasser unter Druck in dicken Tonrohren geleitet. Die Fugen der Rohre waren mit dem 'wiedererfundenen' minoischen Ätzkalk und Ölmörtel verdichtet.
- Eisenarmierung von Steinbalken: Wenig bekannt in der heutigen Zeit ist die griechische Eisenarmierung von Steinbalken der Propyläen von Mnesicles (Athen, 450 v.Chr.), und der ähnlichen Balken von Agrigent.[17] Trotz irrtümlicher Einlage der Armierung (nämlich in der Druckzone) ist diese Lösung ein Vorgänger der Idee des Stahlbetons.[18]

Diese Lösungen deuten auf eine Kontinuität der Anwendung und eine weitere Entwicklung der archaisch (minoisch-mykenischen) Betontechnik. Diese technischen Errungenschaften waren durch die Arbeiten der griechischen Philosophen und Naturwissenschaftler dieser Zeit wie z.B. Thales von Milet und Pythagoras beeinflußt.

7. DIE HELLENISTISCHE PERIODE 400-100 V.CHR.

Durch die Eroberungen Alexanders des Großen wurde ein bedeutender Teil der antiken Welt kulturell nahegebracht. Die folgenden Jahrhunderte, trotz der Teilung des hellenistischen Imperiums, sind eine Epoche der Blüte der materiellen Kultur, technischen Wissenschaften und großer öffentlicher Bautätigkeit. Städte wie Alexandria, Athen, Pergamon, Ephesos, Paestum und Rhodos wurden bedeutend ausgebaut. Häfen, Wasserversorgungsanlagen, Dämme, Aquädukte, Abwasserkanäle, Kulturzenter, Museen, Bibliotheken sowie Schulen wurden in großer Anzahl gebaut.[19]

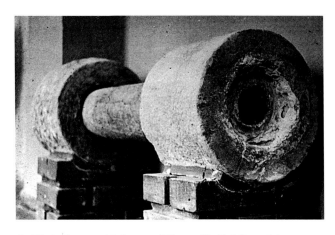

6. *Bleirohr von Ephesos (Photo H. Fahlbusch).*

Beispiele dieser Tätigkeit sind:
- Wasserversorgungsanlagen von Pergamon mit einer Menge von Zisternen verschiedener Größe, Druckwasserleitungen aus Tonrohren (die dreisträngige in Madradag); die berühmteste ist die Druckleitung zu der Zitadelle von Pergamon für Arbeitsdruck von 20 atü, aus Bleirohren in Steinmuffen und einer Dichtung von Ätzkalk und Öl (200 v.Chr.). Ein Beispiel des Bleirohres von Ephesos ist in *Abb. 6* dargestellt.[20]
- Der größte Hafen im Mittelmeer dieser Zeit war Alexandria mit dem Leuchtturm von Pharos, eines der sieben Weltwunder, etwa 100 m hoch, gebaut 250 v.Chr, bis 1200 n.Chr. tätig. Dann wurde er durch Erdbeben zerstört.[21]
- Die Anwendung der wasserbeständigen Ziegelsplitt- und Pozzulanbetone wurde in Häfen des Mittelmeers dieser Periode (z.B. Side, 200 v.Chr.) in Besichtigungen und Prüfungen bestätigt.
- Die Fortsetzung vieler Lösungen z.b. das Polieren von frischem Mörtel (auch Kunstmarmor) als Oberflächenschutz von schwachen aber billigen Baustoffen. Beispiel sind die Säulen des Pergamon Schloßes (200 v.Chr.).
Die bautechnischen Errungenschaften dieser Periode, besonders im Wasser- und Hafenbau, hatten ihre wissenschaftliche Begründung in den Arbeiten der berühmten Philosophen und Denker wie Aristoteles (384-322 v.Chr.). Die größten Verdienste im Gebiete der Technik gehören dem gelehrten Physiker und Erfinder Archimedes (287-212 v.Chr.), dem Vater der Hydraulik sowie seinen Mithelfern und Schülern Ktesibios und Philon von Bizantium. Sie schufen

nicht nur den Grund für die Entwicklung des Wasser-
baus, der Bautechnik und andere Gebiete des ange-
wandten Wissens der Antike, sondern beeinflußten
auch die Entwicklung der modernen Wissenschaften.

8. OPUS CAEMENTICIUM - RÖMISCHER KONSTRUKTIONS-BETON IN MAUERWERK, BÖGEN UND KUPPELN-GEWÖLBEN

Nach seiner sagenhaften Gründung (753 v.Chr.) stand
Rom bis 500 v.Chr. unter politischem, ökonomischem
und kulturellem Einfluß der Etrusker. Im Norden, so-
wie in den griechischen Kolonien der Städte der
Magna Graecia im Süden: Cumae, Neapel, Puteoli,
Paestum und Pompeji. Um 400 übernimmt Rom die
Oberhand, unterwirft erst Etrurien, danach die grie-
chischen Kolonien. Nach dem Sieg über Karthago um
200 v.Chr., beherrscht Rom Italien, Sizilien und den
großen Teil des südlichen und westlichen Mittel-
meeres. Danach, infolge der Schwächung des geteil-
ten Hellenistischen Reiches, kommt es zu der Über-
nahme des östlichen Teiles des Mittelmeeres.[22]

Die Römer waren gute Soldaten, aber auch tüchtige
Bauleute. Dies Interesse am Bauen deutet der Name
des Hochpriesters Roms *pontifex maximus* (großer
Brückenbauer) an. Im Frieden war das Militär an gro-
ßen öffentlichen Bauten wie Straßen und Aquädukten
beteiligt. Steinbau und Backziegel haben die Römer
sowohl von den Etruskern als auch von den Griechen
gelernt. Von den Etruskern kam der Steindoppelbogen
aus Ferrentium, Tuffblöcke für Wände, hochentwik-
kelte bemalte Dachkeramik und wasserdichte Tuff-
mörtel in Tunnelaquädukten. Von Interesse sind auch
die Reste der schilfarmierten Lehmwände der ausge-
brannten Häuser in Aquarossa. Von den Griechen
Süditaliens kamen die schönen Säulen der Tempel
und Theaterbau aus Stein. Die 'Entdeckung' der Puz-
zolane durch die Römer kam nach Besetzung der
Bucht von Neapel und von Cumae. Letztere Stadt war
bis 380 v.Chr. eine griechische Kolonie.

Der erste römische Beton *opus caementicium* fand
Anwendung in den Fundamenten des Concordia Tem-
pels um 200 v.Chr. Die griechischen Ursprünge des
Betons und die Griechen als Meister und Lehrer der
Römer in vielen Gebieten des Baues werden oft von
Vitruv (II, 7, 8) hervorgehoben. Das vermindert aber
nicht den ungeheuren Beitrag der Römer in der
Entwicklung des Betons, besonders auf dem Gebiete
des Wasserbaus. Im Vergleich zu ihren Vorgängern
haben die Römer viel mehr Energie und Kapital in
nützliche, öffentliche Arbeiten investiert, nicht nur
in Rom, sondern auch in allen Teilen des römischen
Imperiums.[23]

In der Tagung von Merida (8. Internationales Sympo-
sium zur Geschichte des Wasserbaus, Okt. 1991)
wurde vom Verfasser der Einfluß der Baustoffe und
der Herstellung auf die Beständigkeit der
Wasserbauten vorgelegt.[24] Die Bedeutung der vitru-
vianischen baustofftechnischen Lösungen, der
Puzzolane und des Ziegelpulvers im Wasserbau, des
Verdichtens des Betons für die Erhöhung der
Festigkeit und das Polieren als Oberflächenschutz für
Sicherung und Dauerhaftigkeit der Bauten wurden
diskutiert. In Feldstudien und Laboruntersuchungen
wurde die Anwendung dieser Baustoffe, das
Verfahren und ihr günstiger Einfluß auf die
Beständigkeit bestätigt. Die empirischen Grunde und
Erläuterungen der vitruvianischen Baustoffkunde
stimmen im allgemeinen mit den Anschauungen der
modernen Materialwissenschaft überein.

Paragraph 8 dieses Aufsatzes ist den römischen
Betonkonstruktionen und ihrer Anwendung und
Funktion in Mauerwerk, Bögen, Gewölben und
Kuppeln gewidmet. Der Einfluß der Konstruktion auf
die Stabilität und Beständigkeit des Bauwerks, wie
auch Probleme der Mitwirkung Baustoff/Herstel-
lung/Konstruktion werden behandelt.

8.1 OPUS CAEMENTICIUM IN MAUERWERK

Die verschiedenen Arten der römischen Mauerwerke
aus Beton sind gemäß Vitruv (II, 7) nachstehend dar-
gestellt:[25]

- *opus reticulatum*: Beton in Tuffsteinfassung aus
 viereckigen konischen Steinen, Ende des 1. Jahr-
 hundert v.Chr.
- *opus incertum*: eine Entwicklung des griechischen
 'Emplekton' in drei Varianten, 'ältere', 'neuere'
 und mit Ziegel verstärkt, in einer Steinfassung.
 Opus incertum ist auch in Holzschalung gegossen.
 Die Abdrücke der Schalung sind oft sichtbar.
- *opus testaceum*: in Ziegelfassade (*testa* = Ziegel)
 mit Arbeitsschalung oder mit Ziegelbruchzuschlag.
- *opus mixtum*: Fassade aus Stein und Backziegel in
 Schichten, Aquäduktpfeiler.
- *opus signinum*: gemäß Vitruv (VIII, 7, 14) Wasser-
 bauten, Zisternen u.a. mit Kalkpuzzolanmörtel und
 eingestampften Steinen.

Folgende Entwicklung im Bereich des Betons ist zu
notieren:
- von ausfüllender zu tragender Funktion
- von separat eingelegtem Mörtel und Stein zu
 homogenem Guß
- von schwachem Kalk- zum Puzzolanbeton.

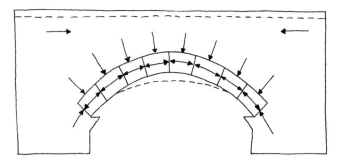

7. *Schema der Druckverwandlung an einem Bogen (nach Gordon 1978, 188).*

Das Mauerwerk ist in Wirklichkeit eine komposite Konstruktion der mitwirkenden Baustoffe. Im allgemeinen war das Mauerwerk verputzt und die Oberfläche geglättet und poliert.

8.2 Opus caementicium in Bögen und Gewölben

Der Einfluß des Bogens auf die Bedingungen der statischen Arbeit der Konstruktion wurde analysiert: der Bogen übernimmt die vertikalen Lasten und verwandelt sie in horizontalen Druck, der auch im oberen Teil der Konstruktion wirkt.[26] Das von der Zeit abhängige Kriechen erhöht diesen Druck *(Abb. 7)*.

Dies erklärt warum der Betonkanal des Aquäduktes von Caesarea auf einer Länge von vielen Kilometern

8. *Aquäduktbrücke von Caesarea (Israel).*

ohne Dilatation gebaut, rißfrei ist *(Abb. 8)*. Ein anderes Beispiel ist die Vielfachbogenmauer der byzantinischen Fildami-Zisterne (Istanbul), welche den horizontalen Wasserdruck übernimmt.[27] Diese Art von Gewölbemauer ist in modernen Wasserspeichern und Dammbauten in Anwendung.

Bei größeren Spannweiten wurden Ziegelrippen als Verstärkung (Armierung) der Konstruktion aus Beton angewandt.[28] Die Herstellung und Funktion der Ziegelrippen sind sehr interessant.[29] Die Ziegel wurden auf der Schalung verlegt und vermörtelt. Nach der Verhärtung des Fugenmörtels wird der Beton zwischen die Rippen gegossen, verdichtet und gehärtet. Nach dem Hartwerden wird das Gewölbe von der Schalung befreit.

Kreuzgewölbe bilden 'natürliche Rippen', welche die Druckkräfte übernehmen und senkrecht auf Säule oder Mauer verlegen. In Betongewölben wurden die 'natürlichen Rippen' mit der Zeit durch in vorweg gebauten Ziegelrippen ersetzt.

8.3 Opus caementicium - Gewölbe, Arkaden des Colosseum, Rom 70-80 n.Chr.

Das Colosseum, 188 m lang und 155,5 m breit, bot Platz für 50.000 Zuschauer und war bis 1900 die größte Arena der Welt. Ein Querschnitt der tragenden Betonkonstruktion ist in *Abb. 9* dargestellt. Das 4-stöckige Gebäude steht auf einem riesigen Betonfundament von 12 m Höhe und 52 m Breite, welches in Ziegelsplittbeton gegossen wurde.[30] Die steife monolitische Konstruktion der Arena besteht aus vielen hunderten Pfeilern, Bögen und einsteigenden Ringen von Arkadengewölben und radial angeordneten Treppenhäusern und Podesten, welche die Konstruktion der Zuschauersitze tragen.[31] Die äußere 4-stöckige Travertinfassade ist aus Marmorkolonnen und Steinblöcken mit Bronze- und Eisenklammerverband aus

Schnitt und Aufriß (s. Bf. II)

A Ur-Bau
B Aufstockung

a 1. Geschoß
b 2. Geschoß
c 2½. Geschoß
d 3. Geschoß
e 4. Geschoß
f 5. Geschoß

9. *Querschnitt der tragenden Betonkonstruktion des Colosseums (Rom) (aus Müller/Vogel 1974, 240).*

gerüstet. Nur das Fundament ist aus Ziegelsplittbeton-guß, alle andere Bauelemente (Pfeiler, Bögen, Ge-wölbe, Treppenhäuser und Podeste) sind aus *opus testaceum* mit Ziegelauskleidung.

Die Reste des 2000-jährigern Gebäudes deuten außer-gewöhnliche Stabilität und Beständigkeit an. Die Schäden wurden hauptsächlich durch Erdbeben, Ab-bau von Marmorplatten, Steinen, Ziegeln und Dieb-stahl von Metallteilen nach Roms Fall verursacht.

8.4 OPUS CAEMENTICIUM IN KUPPELN - PANTHEON, DIOCLETIANSTHERMEN - LEICHTBETON MIT ZIEGELRIPPEN ARMIERT

Kuppeln mit kleinen Durchmessern, etwa 10 m, wurden für runde Tempel von Vitruv beschrieben (IV, 8). Sie waren hauptsächlich aus *opus caementi-cium* mit Ziegelsplittzuschlag hergestellt. In der ersten Hälfte des zweiten nachchristlichen Jahrhunderts beginnt eine neue Entwicklung im Betonbau, die Überdeckung von großen Räumen in Tempeln und Bädern durch mit Ziegelrippen armier-te Betonkuppeln.[32]

Das Pantheon wurde 27 v.Chr. von Agrippa gebaut. Das Gebäude wurde infolge von Bränden vielmals restauriert z.b. von Titus um 80 n.Chr., von Hadrian 127 n.Chr. Zwischen 200-300 n.Chr. bekam es wahr-scheinlich seine heutige Form. Bis 1900 war die Kup-pel vom Pantheon die größte Betonkuppel der Welt. Die Kuppel besteht aus einer inneren und einer äußeren Schale aus Leichtbeton von unterschiedlicher Dichte und Festigkeit und ist mit Kassetten versehen, welche das Gewicht der riesigen Konstruktion min-dern: Teile der vertikalen Balken zwischen den Kassetten sind aus Ziegelrippen mit Bögen verstärkt und stützten den Druckring der Lichtöffnung (am Giebel der Kuppel) *(Abb. 10)*. Die Herstellung und Funktion dieser Ziegelrippenkonstruktion ist ähnlich wie die der Ripppen in Gewölben (cf. Paragraph 8.2). Nach der Herstellung und dem Härten des Fugen-mörtels, entlasten die Ziegelrippen und Bögen die Schalung während des Gießens und der Härtung des Betons. Nach der Erhärtung und des Ausschalens übernimmt die bewehrte komposite Konstruktion die Drucklasten. Die steifen gedrückten Ziegelrippen und Bögen kompensieren die Kriech- und Schwinddefor-mationen des Betons und verhindern die Rißbildung und sichern die Beständigkeit.

Eine ähnliche Betonkuppel aus Leichtbeton Kassetten und Ziegelrippen findet man in den Diocletiansther-men, heute die Kirche der Santa Maria degli Angeli in Rom. Es ist zu bewundern, daß solche Konstruktio-nen nur intuitionmäßig ohne statische Berechnungen hergestellt werden konnten.

10. Mit Bogen verstärkte Ziegelrippen die den Druckring der Lichtöffnung stützen - Pantheon (Rom) (aus Choisy 1938 gemäß Piranesi G.B.).

8.5 OPUS CAEMENTICIUM - RÖMISCHER EISENBETON UND SEINE VORGÄNGER

Um besser Zug- und Biegelasten und Deformationen auszuweichen, hat der Mensch seit ältester Zeit schwache, spröde und dehnbare Baustoffe mit steifen und 'zugstarken' Einlagen bewehrt. So wurden die Lehmziegel, Auskleidung von Öfen (Kalk, Ton) mit Stroh oder Ästchen verstärkt.[33] In seiner Forschung hat Lamprecht Eisenverstärkung des römischen Be-tons älteren Angaben gemäß mit neuen Funden in Köln bestätigt. Die Anwendung von Eisenstäben und Eisenbögen wurde von Vitruv (V 10, 3) erwähnt aber nicht als Bewehrung des Betons. Ihre Funktion ist nicht für Zug bestimmt. Patente und Anwendung des modernen Eisenbetons kamen erst in 1860.

ZUSAMMENFASSUNG

Die Meilensteine der vorrömischen 7000-jährigen Entwicklung des Mörtels und Betons:

I. Die Neolithische Betonrevolution: während des vorkeramischen Neoliticums (10000-5000 v.Chr.)

erlebte man die sagenhafte Erscheinung vom Aufschwung und vom Rückgang der hochfesten Kalkmörtel und Kalkbetone der 'Völker des polierten Fußböden' und der spätere Rückgang des Betons. Die neuen Bindemittel und Mörtel werden in Mesopotamien, Zigurat und in Ägyptens Pyramiden verwendet wie Schlamm, Asphalt und Gipsmörtel (4000-2000 v.Chr.).

II. Die Renaissance: in dieser Epoche wendete man zum ersten Mal 'bewußt' die wasserbeständigen Kalk- und Kalkpuzzolanmörtel (auch Ziegelmehl) an in der Ägäis (Kreta und Mykene), ebenso das Polieren für Oberflächenschutz in Wasserleitungen, Zisternen und Bädern; Ätzkalk und Öl als Dichtungsmörtel in der Druckleitung von Knossos (2000-1400 v.Chr.).
Während der Kolonisation der Mittelmeerküste und Ägäis durch die Seevölker, Phönizier und Griechen der archaischen Periode fing man an die Wasserversorgungs- und Hafenbautechnik zu entwickeln und Dichtungsmörtel aus Kalk/Puzzolan und seewasserbeständigem Gips (Kition, Zypern) anzuwenden (1500-500 v.Chr.).

III. Der griechische Beitrag: die Griechen haben die minoischen Lösungen des Kalkmörtels für Oberflächenschutz (und Malerei), Stuck und Kunstmarmor weiter verfeinert. Man kannte schon die bedeutende Anwendung der Druckleitungen und des Dichtungsmörtels (Ätzkalk und Öl). Den ersten griechischen Zisternenbeton mit Puzzolanen aus Thera (Santorini) baute man in Kameiros, Rhodos. Die Steinbalken der Propyläen hat man mit Eisen armiert. Durch die Beherrschung des Vorderen und Mittleren Orient durch Alexander den Großen und durch den Hellenismus entwickelte sich der Städtebau, der Wasser- und Hafenbau, die Naturwissenschaften wie auch die angewandten Wissenschaften.

IV. Der römische *opus caementicium*, der Vorgänger des modernen Konstruktionsbetons:
- Übernahme der existierenden Technik und der empirisch-wissenschaftlichen Grundlagen von den Griechen. Vitruvs Zehn Bücher über Architektur und über Baustoffkunde, Bautechnik, Herstellung und Konstrukstionslehre.
- Baustoffe:

- Puzzolane - Anwendung und Exploitation nach Beherrschung von Cumae und der Neapelbucht.
- Ziegelfeinsplitt und -mehl zur Erhöhung der Festigkeit von wasserfestem Mörtel.
- Proportionierung von Sand und Kalk bis Puzzolanmörtel.
- Zusätze wie Öl für Dichtung und Erhöhung der Beständigkeit.
- Herstellungsverfahren:
 - Verdichten, Einrammen von Steinen, Gußbeton.
 - Polieren der Oberfläche als Beständigkeitsmaßnahme.
 - Nachbehandlung des Betons, Imprägnierung.
- Gründe der Konstruktion mit Anwendung von Beton in:
 - Grundbau, Mauerwerk, Bögen, Gewölbe
 - Hausbau, Monumentalbauten, Tempel
 - Hafenbau, Wasserbauten, Militäranlagen.

Das Verdienst von Vitruv auf dem Gebiete Beton ist, daß er den Stand der damaligen Technik und Wissenschaft systematisch dargestellt hat. Als Ingenieur und wahrscheinlich auch als Bauberater des Augustus und als Verfasser hat er die Entwicklung des Betonbauens wesentlich beeinflußt.
Die große römische 'Betonrevolution' kam nach dem Tode Vitruvs im 1. bis 3. Jahrhundert unserer Zeitrechnung durch die massive und erfolgreiche Anwendung des Betons in Mauerwerk, Bögen, Gewölben und Kuppeln, in Kombination mit Ziegel- (und auch Stein) als Fassung und als Bewehrung (Rippen).
Der Beton (und Mörtel) wurde von Füllungsstoff in ein hauptbindendes und tragendes Material der Bauten umgewandelt und in allen öffentlichen Bauten des Hoch-, Tief-, Wasser- und Hafenbaus im Römischen Imperium angewandt. Nach Roms Fall nur noch in Byzanz, im Ottomanischen Reich und im maurischen Spanien.

Daß die Lösungen der Antike und der römischen Ingenieure und Bautechniker einen Einfluß auf die aktuelle Betontechnik hatten, ist ohne Zweifel. Trotz ungeheurer Entwicklung der modernen Bindemittel und neuen Betonarten, ist vieles zu erforschen und zu lernen, bezugnehmend auf die antiken und römischen Lösungen und Verfahren.

———————

BIBLIOGRAPHIE

Choisy, A. 1873, *L'art de Batir chez le Romains,* Paris (in russischer Übersetzung Moskau 1938).

Davey, N. 1962, *A History of Building Materials,* London.

Müller, W./G. Vogel 1974, *DTV Atlas zür Baukunst* I, München.

Evans, A. 1930, *The Palace of Minos,* London.

Frifelt, K./ R. Malinowski 1993, *Prehistoric Hydraulic Mortars,* Stockholm BFR.

Garbrecht, G. a.o. 1990, Untersuchung antiker Anlagen zur Wasserspeicherung in Fayum/Ägypten, *MittInstWasser* 107.

Gordon, J. E. 1978, *Structures,* Penguin Middlesex.

Keuyon, K. 1969³, *Archaeology in the Holy Land,* London.

Kienast, H.J. 1987/88, Der Tunnel des Eupalinos auf Samos, *Mannheimer Forum.*

Kingery, W.D. et al. 1976, *Beginnings of Pyrotechnology,* Cambridge, 133-150.

Lamprecht, H.O. 1993, *Opus Caementicium,* Düsseldorf.

Lucas, A. 1948, *Ancient Egyptian Materials and Industries,* London.

Malinowski R./H. Fahlbusch, 1981, Dichtungsmörtel von fünf Rohrleitungen im Ägäisch-anatolischen Raum, *MittInst Wasser* 71.

Malinowski, R. 1979, *Concrete and mortars of Ancient Aqueducts,* Detroit ACI.C.I.

Malinowski, R. 1988, *Durable Prehistoric and Ancient Mortars and Concrete,* Compiègne.

Malinowski, R. 1991, *Prehistory of Concrete,* Detroit ACI.A.C.

Malinowski, R. 1993, Dichtungsmörtel und Betone der antiken Wasserbauten T. I, *MittInstWasser* 117.

Neuburger, A. 1921, *Die Technik des Altertums,* Leipzig.

Orlandos, A. 1968, *Le materiaux de Construction et la Techn. Architect,* Paris.

Sandström, G. 1968, *The Man the Builder,* Stockholm.

Sprague de Camp, L. 1963, *The Ancient Engineers,* New York (in polnischer Übersetzung Warschau 1973).

Shaw, J. W. 1971, *Minoan Architecture: Materials and Techniques,* Rome.

Prestell, J. 1974, *Vitruvius, Zehn Bücher über Architektur,* Baden-Baden.

Wooley, L. 1958, *History unearthed,* London.

ANMERKUNGEN

* Die vorliegende Arbeit ist eine Zusammenfassung von zwei Vorlesungen, einer in Merida 1991 und der anderen in Pompei 1994. Sie hat keinen Anspruch auf eine systematische wissenschaftliche Abhandlung. Der Verfasser hofft, daß die Arbeit als Anregung für weitere Studien im Gebiete antiker Baustoffe und Baukonstruktionen dienen wird.

Der Verfasser dankt allen, die an der Vorbereitung und Publikation dieser Arbeit geholfen haben.

[1] Keuyon 1969³, 44-57.
[2] Woolley 1958, 133-150; Kingery 1976, 44-57; Malinowski 1991.
[3] Frifelt/Malinowski 1993.
[4] Neuburger 1921, 406; Davey 1962, 128-133.
[5] Neuburger 1921, 406; Davey 1962, 209.
[6] Lucas 1948.
[7] Garbrecht 1990, 128.
[8] Evans 1930, 142, 243.
[9] Shaw 1971, 207-224.
[10] Malinowski 1979.
[11] Neuburger 1921, 294, 393.
[12] Neuburger 1921, 416-421.
[13] Malinowski 1988, 223-224.
[14] Vitruv, übersetzt von Prestell 1974.
[15] Neuburger 1921, 425-427.
[16] Kienast 1987, 204-206.
[17] Gordon 1978, 132-188.
[18] Orlandos 1968, 144; Malinowski 1988, 240.
[19] Spraque de Camp 1963.
[20] Malinowski/Fahlbusch 1981; Malinowski 1988.
[21] Sprague de Camp 1963, 158-161.
[22] Sprague de Camp 1963, 186-203.
[23] Sprague de Camp 1963, 216-225.
[24] Malinowski 1979; Malinowski 1988; Malinowski 1993.
[25] Davey 1962; Lamprecht 1993.
[26] Davey 1962; Gordon 1978, 188-189; Malinowski 1979.
[27] Lamprecht 1993.
[28] Davey 1962, 142-146.
[29] Müller/Vogel 1974, 42-48.
[30] Lamprecht 1993, 10, 189-190, 208-210, 216-219.
[31] Müller/Vogel 1974, 240-243.
[32] Müller/Vogel 1974, 252-253.
[33] Malinowski 1991; Malinowski 1993.

SVEALIDEN 3D
S-43239 MÖLNDAL
SCHWEDEN

PRINTED ON PERMANENT PAPER • IMPRIME SUR PAPIER PERMANENT • GEDRUKT OP DUURZAAM PAPIER - ISO 9706

ORIENTALISTE, KLEIN DALENSTRAAT 42, B-3020 HERENT